Gift of the

Museum of Biblical Art

New York 2005 - 2015

The Critical Response to Andy Warhol

Recent Titles in
Critical Responses in Arts and Letters

The Critical Response to ANDY WARHOL

Edited by ALAN R. PRATT

Critical Responses in Arts and Letters, Number 25
Cameron Northouse, Series Adviser

GREENWOOD PRESS
Westport, Connecticut • London

Library of Congress Cataloging-in-Publication Data

The critical response to Andy Warhol / edited by Alan R. Pratt.
 p. cm.—(Critical responses in arts and letters, ISSN
1057–0993 ; no. 25)
 Includes bibliographical references and index.
 ISBN 0–313–29291–4 (alk. paper)
 1. Warhol, Andy, 1928– —Criticism and interpretation.
I. Pratt, Alan R., 1953– . II. Series.
NX512.W37C75 1997
700′.92—dc20 96–36509

British Library Cataloguing in Publication Data is available.

Library of Congress Catalog Card Number: 96–36509
ISBN: 0–313–29291–4
ISSN: 1057–0993

First published in 1997

Greenwood Press, 88 Post Road West, Westport, CT 06881
An imprint of Greenwood Publishing Group, Inc.

Printed in the United States of America

The paper used in this book complies with the
Permanent Paper Standard issued by the National
Information Standards Organization (Z39.48–1984).

10 9 8 7 6 5 4 3 2 1

Copyright Acknowledgments:

The editor and the publisher gratefully acknowledge permission for use of the following material:

Michael Fried, "New York Letter," *Art International*, Vol. 6, no. 10 (December 1962): 57. Reprinted with permission of *Art International*, Paris.

Henry Geldzahler, "Andy Warhol," *Art International*, Vol. 8, no. 3 (April 1964): 34-35. Reprinted with permission of *Art International*, Paris.

Grace Glueck, "Art Notes: Boom?" *The New York Times* (10 May 1964): 19. Copyright © 1964 by The New York Times Company. Reprinted by permission.

Robert Rosenblum, "Saint Andrew," *Newsweek* (7 December 1964): 100-106. Copyright © 1964, Newsweek, Inc. All rights reserved. Reprinted by permission.

Bosley Crowther, "The Underground Overflows," *The New York Times* (11 December 1966), Sec. 2:1. Copyright © 1966 by The New York Times Company. Reprinted by permission.

Lucy R. Lippard, excerpts from *Pop Art* (New York: Oxford University Press, 1966): 97-101. From *Pop Art* by Lucy Lippard/Adrian Forty. Copyright © 1966, 1967, 1970, Thames and Hudson, Inc. Reprinted by permission of the publisher.

Paul Bergin, "Andy Warhol: The Artist as Machine," *Art Journal,* Vol. 26, no. 4 (Summer 1967): 359-63. Reprinted by permission of the College Art Association, Inc.

Gerard Malanga, "Andy Warhol on Automation: An Interview," *Chelsea* (1968): 83-86. Reprinted with permission of *Chelsea*.

Leticia Kent, "Andy Warhol: 'I Thought Everyone Was Kidding,'" *The Village Voice* (12 September 1968), Sec. 1:1. Reprinted by permission of the author and *The Village Voice*.

Paul Carroll, "What's a Warhol?" *Playboy,* Vol. 16, no. 9 (September 1969): 132-34. Reprinted with permission of the author.

John Perreault, "Andy Warhol," *Vogue* 155 (March 1970): 65-206. Reprinted by permission of the author.

Joseph Masheck, "Warhol's Early Manipulations of the Mundane: The Vanderbilt Cookbook of 1961, " *Art in America*, Vol. 59 (May-June 1971): 54-59. Reprinted by permission of the author.

John Canaday, "Art: Huge Andy Warhol Retrospective at Whitney," *The New York Times* (1 May 1971), Sec. 2:21. Copyright © 1971 by The New York Times Company. Reprinted by permission.

John Canaday, "Brillo Boxes, Red Cows, and the Great Soup Manipulation. . . ," *The New York Times* (9 May 1971), Sec. 2:23. Copyright © 1971 by The New York Times Company. Reprinted by permission.

CONTENTS

2. THE NINETEEN SEVENTIES

SERIES FOREWORD

Critical Responses in Arts and Letters is designed to present a documentary history of highlights in the critical reception to the body of work of writers and artists and to individual works that are generally considered to be of major importance. The focus of each volume in this series is basically historical. The introductions to each volume are themselves brief histories of the critical response an author, artist, or individual work has received. This response is then further illustrated by reprinting a strong representation of the major critical reviews and articles that collectively have produced the author's, artist's or work's critical reputation.

The scope of *Critical Responses in Arts and Letters* knows no chronological or geographical boundaries. Volumes under preparation include studies of individuals from around the world and in both contemporary and historical periods.

Each volume is the work of an individual editor, who surveys the entire body of criticism on a single author, artist, or work. The editor then selects the best material to depict the critical response received by an author or artist over his/her entire career. Documents produced by the author or artist may also be included when the editor finds that they are necessary to a full understanding of the materials at hand. In circumstances where previous, isolated volumes of criticism on a particular individual or work exist, the editor carefully selects material that better reflects the nature and directions of the critical response over time.

In addition to the introduction and the documentary section, the editor of each volume is free to solicit new essays on areas that may not have been adequately dealt with in previous criticism. For volumes on living writers and artists, new

interviews may be included, again at the discretion of the volume's editor. The volumes also provide a supplementary bibliography and are fully indexed.

While each volume in *Critical Response in Arts and Letters* is unique, it is also hoped that in combination they will form a useful, documentary history of the critical response to the arts, and one that can be easily and profitably employed by students and scholars.

Cameron Northouse

PREFACE

The Critical Response to Andy Warhol advances our understanding of the most controversial artist of the century. With more than sixty samples of criticism reprinted from books, art and news magazines, professional journals, newspapers, and film reviews, the collection includes some of the most important and best examples of Warhol criticism and provides access to material which is no longer easily obtainable. Organized chronologically, the criticism has been selected on the basis of its value in interpreting Warhol's artistic legacy. The diverse nature of these texts enables readers to compare critical and popular reactions as well as follow the evolution of the criticism. In addition, as unrevised art history, the material offers additional insight into issues related to art criticism, art history, and the machinery of culture.

The last section of the book contains five new essays that specifically address Warhol's relationship with the critics. My own essay examines the critical response to Warhol's films. Steven Kurtz, professor of art criticism at Carnegie Mellon University, considers the implications of Warhol's celebrity; and Jonathan Crane, a professor of communications at the University of North Carolina, Charlotte, discusses the Death and Disaster Series. Faiyaz Kara, a professional writer in Toronto who has studied Warhol extensively, assesses the critical reaction to Warhol's thirty books. The concluding essay by Steve Jones, professor of humanities at Embry-Riddle Aeronautical University, focuses on Warhol's iconic soup cans. A selected bibliography of over one-hundred entries and a detailed subject index providing a complete, cross-referenced directory to the assembled criticism completes the book.

I would like to thank Embry-Riddle Aeronautical University which graciously supported this project in a variety of ways, providing the research assistance of

Stefan Kageman, Patrick Kokorian, and Jesse Rudgunas; the technical expertise of Carol Liptak; and the persevering staff of Hunt Memorial Library, especially Deborah Shafer whose resourcefulness made this project easier. I would also like to thank the series editor Cameron Northouse for his guidance and my wife Bonnie for her intelligent and devoted participation in this project.

Alan Pratt, Ph.D.
Ormond Beach, FL

INTRODUCTION

The Warhol Legacy
Alan Pratt

If a man takes fifty Campbell's Soup Cans and paints them on a canvas, it is not
the retinal image which concerns us. What interests us is the concept that wants
to put fifty Campbell's Soup Cans on canvas.
—Marcel Duchamp[1]

In more than one hundred books and in more than a thousand articles, writers
have either adored or despised Andy Warhol, and no other artist has ever aroused
such impassioned praise and vehement condemnation. Warhol has been assailed
as a cultural hooligan, an opportunistic hack who cannibalized others' images; for
others, he's the artist of the century, a creative genius and prophetic social
commentator.

After thirty years of scrutiny, curators, critics, and art historians still dispute
the significance of the Warhol legacy. As recently as February 1995, for
example, Warhol figured prominently in a poll conducted by *ARTnews* which
asked who were the most over- or underrated artists of the century. Andrew
Graham-Dixon, chief art critic for *The Independent*, London, peevishly notes that
the attention Warhol receives is inflated far beyond his significance: "I don't
know why I keep hearing about Warhol shows. We don't need forty exhibitions
explaining what he did. . .if you can't see it, you're dumb"; while Mark Stevens,

art critic for the *New Republic*, concludes that the artist is the most underrated *and* overrated artist of the century.[2]

Graham-Dixon's irritation and Stevens' ambivalence typify themes that dominate the critical reception of Warhol. The extremely contradictory range of criticism and its sheer volume declare that Warhol's artistic statement struck a nerve, raising aesthetic issues that still baffle the experts; and from the perspective of the late twentieth century, it's clear that Warhol occupies a singularly important niche in art history.

Warhol Criticism

Just what does Warhol criticism reveal? Warhol made his public debut as a fine artist in 1952 with his first exhibit of fifteen drawings based on the writings of Truman Capote. In his many exhibitions through the 1950s, however, he was essentially ignored. A brief notice in the *New York Times* from a 1959 Bodley Gallery show, the artist's seventh, dismissed Warhol's illustrations for his cookbook *Wild Raspberries* with a single tepid comment: "clever frivolity in excelsis."[3] In his pursuit of what he called "museum quality art," Warhol finally abandoned his drawings of feet, golden shoes, beautiful boys, and filigreed figures in 1961. His window display for Bonwit Teller in April of the same year presented themes and styles markedly different from those that made him a commercial success; the display's background of blowup comic book images is conceivably his first appearance as a Pop artist.[4]

When Warhol hit his stride in the early sixties by appropriating images from advertising design and serializing them with a hands-off austerity, he became a lightening rod for criticism. Many of the claims about his work from this early period have become bromides, modified and reiterated through the years. There are those who've been convinced that Warhol's work reflects an optimistic affirmation of the contemporary scene, a fun-loving and hip celebration of American consumerism.[5] Others hold that Warhol's consumer images are indeed a mirror of the times, but reflect instead the superficiality of a media-driven consumer culture.[6] Max Kozloff's 1962 fulmination against the "new vulgarians" exemplifies a wholly pessimistic reading of Warhol's kind of art. While Kozloff wasn't sure whether Pop artists were sinister, pathological, or just boring, he dismissed them as a "pin-headed and contemptible style of gum-chewers, bobby soxers, and, worse, delinquents."[7]

For a number of reasons, Warhol infuriated all kinds of people, and his detractors count him among the most pin-headed. Whatever his stupefying images mean, that anyone would pretend they represent serious art is simply outrageous.

Not surprisingly, critics have excoriated Warhol's work in caustic harangues and in coy, I-get-the-joke satires. Some writers, especially insulted, have taken great delight in ferociously condemning Warhol as a nihilist, his art an aesthetic hoax that's not merely contemptible but downright dangerous.[8] Apparently, anti-Warhol passion stimulates the muses because among the damning reviews is some of the finest—and most amusing—invective ever penned.[9]

Because of the volume of criticism, commentators soon found it necessary to chart its course by identifying thematic patterns. As early as 1970, Marxist critic Rainer Crone tried to make sense of the myriad approaches:

> There are points of orientation from which we can begin: Warhol's choice of subject; the importance of content over form in this work; the concept of "documentary realism," and his connections with photography that make the paintings documents; painting and machine production; and finally, the similarity of intent that makes it instructive to compare the work of Warhol and Duchamp.[10]

Seventeen years later, Thomas Crow summarized the primary problems in the evolution of Warhol's reputation, maintaining that they revolve around three issues:

> . . .whether or not his art 1. fosters critical or subversive apprehension of mass culture and the power of the image as commodity 2. succumbs in an innocent but telling way to the numbing power 3. exploits it cynically and meretriciously.[11]

The formal issues Crone focuses on have proven to be enduring areas of contention, but Crow's view of the debate calls attention to the dominant feature emerging from the Warhol controversy. After thirty years of analysis, it's the utter *lack* of consensus that's most readily apparent. It is the seemingly unresolvable character of Warhol's work that is most intriguing, which paradoxically makes it both receptive *and* resistant to interpretation.

Studying the public perception of the artist in 1966, Lucy Lippard noticed that "Warhol's films and his art mean either nothing or a great deal. The choice is the viewer's. . . ."[12] In retrospect, Lippard's early, tentative appraisal is revealing. While the images Warhol stumbled across have a deep resonance with the public, the problem of interpreting them is, depending one's point of view, simple or complex. It's obvious that spectators' intentions have always been a part of what they experience, but with Warhol's images the phenomenon is evidently

compounded. Steve Jones, who most recently addressed this feature of Warhol's work, agrees: "They present a text that can be read, but they provide no clear point of view from which to establish a meaning."[13] Add Warhol's own ambivalence about his "no comment" works, and viewers have been able to read almost anything into them, seeing them as celebration or satire, as boring or provocative, ideologically charged or neutral.

In the current polemic, Warhol's reputation still depends on the reviewer's ideological or art-historical preoccupations. If, as has been suggested, Warhol succeeded in redefining the art experience,[14] then the critical response required redefinition as well. In retrospect, it appears that one problem that confronted critics and journalists was that established critical approaches simply didn't lend themselves to an art which they perceived as "artless, styleless, and anonymous."[15]

While the debate hasn't resolved itself, three interconnected issues figure prominently in the disagreements about Warhol's reputation: his persona, his originality, and his antecedents. And what makes these areas of contention so compelling is their connection to the theory and practice of modernism, its reassessment, and its transformation.

Warhol's Persona

The problematic nature of Warhol's critical reputation is attributable, in part, to the evasive, equivocal persona he cultivated—the calculated indifference, the monosyllabic rejoinder, the flat, vacuous affect of the I-think-everybody-should-be-a-machine Warhol. And while it's true that he suffered from a debilitating shyness, he nevertheless delighted in baffling his critics. Typical of his exasperating performance is his anti-theoretical response when asked to defend himself from detractors: "I can't; they're right."[16] Warhol talked about himself in his books, particularly in the *Philosophy of Andy Warhol* (1975), *Andy Warhol's Exposures* (1979) and *POPism* (1980), but these autobiographical comments are suspect and of little value in understanding his intentions. And while they meticulously document his day-to-day affairs, even Warhol's diaries—all 807 pages, reduced from some 20,000—are superficial glimpses into high society which reveal little about his motivation or work. When Warhol was asked to set the record straight, he would neither confirm nor deny anything, proposing instead, "Why don't your make it up?"[17]

In reviewing Warhol's life, then, it's often impossible to distinguish the authentic Warhol from the act. As a result, a significant portion of the critical response addresses, if only anecdotally, Warhol's personality. And with little

that's reliable to go on, critics have enjoyed wide latitude in extrapolating or inventing motives for him. The notion that he designed his images to mirror contemporary culture, for example, contradicts Warhol's own explanations. He repeatedly insisted his art intended no social comment at all, that it was only a vehicle for furthering his self-interests, ostensibly, his ambitions for fortune and fame.[18]

Psychological interpretations have argued that Warhol's one-dimensional persona is another comment on the consumer culture reflected in his silkscreens, that is, flat, mindless, and superficial. Others have focused on Warhol's personality to demonstrate that his work reflects his voyeuristic proclivities. From this perspective, Warhol's verbatim, recorded novels, his hobby of taping conversations, the thousands of snapshots he took, his development of *Interview* magazine, and particularly the cold, emotionless stare of his films are all symptoms of an obsessive need to observe.[19]

In this decade, psychology is more frequently being employed to evaluate Warhol's art. Recently, critic Kynaston McShine suggested that the ambiguity of Warhol's images reflects the artist's ambiguous feelings about himself and his appearance.[20] Bradford Collins has also explored the connection between the artist's personality and his work. Contradicting notions that it is devoid of personal content, Bradford maintains that Warhol's choice of subject matter is a symptom of his crippling psychological problems. Accordingly, the entire evolution of his work documents a process of desensitization and self-alienation.[21] Steve Kurtz has taken a similar premise one step further in his contention that Warhol's celebration of consumption was escapist, a dehumanizing ploy which allowed him to become like the products he appropriated.[22]

Warhol's Originality

Like the problems of personality which have intrigued critics for years, the issue of Warhol's artistic legitimacy has also been the basis of ongoing debate. In all that has been written about him, one of the most frequently referenced incidents is his decision to solicit advice from both friends and art experts about where he should be heading artistically. As the story goes, Warhol would show two painted versions of his Coca-Cola bottle, one version derived from the principles of abstract expressionism, a high-energy interpretation complete with drippings of paint. The other version was the polished and depersonalized commercial icon. Gallery director Ivan Karp told Warhol pointedly he preferred the latter, that, in fact, the only paintings of his that were worth anything were the "cold straightforward works."[23] And Warhol reported that Emile De Antonio,

a film maker who had helped Robert Rauchenberg and Jasper Johns, gave him the
same advice:

> "One of these is a piece of shit, simply a little bit of everything. The other is
> remarkable—it's our society, it's who we are, it's absolutely beautiful and naked
>" That afternoon was an important one for me.[24]

Warhol heeded his friends' advice and continued his practice of soliciting
ideas from others. The subjects of some of his most famous works—the soup
cans, dollar bills, flowers, and cows—were apparently recommendations. It's
known, for instance, that Warhol sent his assistant to the grocery store to select
suitable subjects for his paintings, and Henry Geldzahler takes credit for
suggesting the influential Death and Disaster Series, and later, as an anodyne, the
Flower prints of 1964.[25] Like other questions about the artist, however, just who
suggested the subjects depends on whom one asks. Art dealer and interior
decorator Muriel Latow may have recommended that Warhol paint the
Campbell's soup cans.[26] But Ultra Violet, an early Factory denizen, claims to
have met Warhol at a luncheonette and, during their conversation, suggested that
he paint the soup cans stacked behind the counter.[27]

That Warhol borrowed his images from others, from photographs,
advertisements, and food labels and developed a technique by which they were
serially mass-produced by anonymous Factory hands remains one of the most
contentious issues in the criticism. By erasing himself from his creations,
minimizing the artist's responsibility, the significance of talent, and the value of
originality, Warhol challenged presumptions about what art is supposed to be and
how one is to experience it. This abnegation of responsibility was deemed
unethical, if not subversive, by the critical audience, further fueling the
controversy about whether or not his work should even be regarded as art.
Additionally, it's maintained, his decision to let others decide fomented a crisis
of creativity similar to that provoked by the Dadaists forty years earlier—albeit
with far more significant consequences.

Warhol's Antecedents
From the beginning, critics have addressed the connections between what
Warhol was doing and what Marcel Duchamp had done. It was Duchamp who
in 1914 broke the rules and outraged the art world when he began exhibiting his
objets trouvés, the coat-stands, bottle racks, and bicycle wheels. Duchamp, critics
suggested, had shown Warhol that appropriating common consumer items could

be art. But while Duchamp challenged the assumptions about originality with his readymades and helped stimulate the camp attitude that served to make Pop art cool, he was more or less dismissed as a crank. His *objets* were deemed to be attention-grabbing pranks and his attitude toward progressive modernist goals an aberration.

Nevertheless, just as Dada's aesthetic conceits aimed at the destruction of social reality, many critics suspected that Pop art merely updated Dada praxis, that its artists were Neo-Dadaists, a new generation of cultural saboteurs. Warhol was a particularly culpable pioneer of cultural nihilism because the silkscreened soup cans, bottles, and such were perceived to be the apotheoses of the readymade.[28] Interestingly, his first New York exhibition as a Pop artist scheduled for the prestigious Martha Jackson Gallery was canceled because of this association with Dadaism: "As this gallery is devoted to artists of an earlier generation," Jackson wrote Warhol,

> I feel I must take a stand to support their [the Abstract Expressionists'] continuing efforts rather than confuse issues here by beginning to show contemporary Dada. The introduction of your paintings has already had very bad repercussions for us.[29]

While Warhol was seen to be carrying the counter-traditional experiments of modernism to extremes, he was also perceived to be detaching himself from modernist practices altogether.

Warhol and Modernism

As the criticism makes clear, Warhol appalled the art establishment because he represented a complete transvaluation of the aesthetic principles that had dominated for several generations. Many artists of the late 1950s were following the reigning attitude to "make it new" established before the First World War and expressed in the emotional intensity of Expressionism, the machine-production aesthetic cultivated at the Bauhaus, and the commitment to authentic expression that motivated Abstract Expressionists. With the public's growing tolerance of Pop art, however, the continued relevance of this forty-year "heroic struggle" was questionable. Never awfully popular with the public anyway, non-figurative expression, the standard-bearer of high-modernism, seemed dated, its transcendentalist goals silly, and the self-absorbed passion of its artists old-fashioned.

What for years modernists had deliberately ignored or contemptuously spurned, Warhol embraced. As appropriated mass-culture images, his "art" was indistinguishable from advertising—meaning it was crass and pedestrian—and thus lampooned the modern emphasis on noble sentiment and good taste. No doubt Warhol's comments about art, that it should be effortless, that it's a business having nothing to do with transcendence, truth, or sentiment, also infuriated detractors.[30]

Both Warhol's subject matter and his flippant attitudes toward the conventions of the art world were the antithesis of the high-seriousness of modernism. And the rub of it was that his celebrations of the inconsequential were being taken seriously. It was a nasty slap in the face for those seeped in the myths of modernism. The barbarians had breeched the walls of high culture, successfully injecting cultural detritus into the rarified realm. Whether it was a step forward or backward is at the center of the controversy. Regardless, the Warhol aesthetic contributed to the breakdown of the hierarchial conventions of modernism, dissolving distinctions between commercial design and serious art and the boundaries between popular taste and high culture—or, as some would have it, between trash and excellence. Critic Benjamin Buchloh describes the momentous significance of the attitudinal shift as the "triumph of mass culture over high culture."[31]

As many observers now agree, the early 1960s mark the beginnings of a postmodern sensibility, where the modernist desire for closure and aesthetic autonomy has been rapidly replaced with indeterminacy and eclecticism.[32] If that's true, Warhol's art forecast and then highlighted the changes that were occurring. And it has been argued that his art anticipated many ploys of this aesthetic new world, including the emphasis on irony, appropriation, and commonism, as well as promoting intellectual engagement through negation.[33] One can only wonder if Warhol anticipated that artistic expression would become the eviscerated tool of mass media.

In reviewing the critical record, one can conclude that Warhol's role in art history is as a transitional figure. Stylistically his work is a bellwether, and the critical issues raised about him often converge with those at the center of the modern/postmodern debate. As a "mirror of the times," Warhol criticism reflects the trepidation and enthusiasm in response to shifting paradigms. Lippard's proposition is still valid—Warhol's images *are* ambiguous. It's this ambiguity that gives his work its edge. His images function as a sort of cultural Rorschach blot allowing for the projection of personalities, theoretical orientations, and

ideological biases. Why put fifty Cambell's soup cans on canvas? So far, there are scores of explanations.

Andy Warhol, if nothing else, has played an important role in acquainting us with the seemingly impenetrable ambiguity which is at the center of the postmodern experience. No doubt, however, he would have shrugged off this reading too. He once told Bob Colacello, longtime editor of *Interview*, that "Criticism is so old fashioned. Why don't you just put in a lot of gossip."[34]

NOTES

1. Quoted in Samuel Adams Green, "Andy Warhol," *The New Art*, ed. Gregory Battcock (New York: E.P. Dutton & Co., Inc., 1966), 229.

2. Paul Gardner, "Who Are the Most Underrated and Overrated Artists?" *ARTnews* (February 1995): 110-115.

3. Stuart Preston, "Art North of the Border," *The New York Times*, 5 December 1959, 20.

4. Kynaston Mcshine, Introduction, *Andy Warhol: A Retrospective* (New York: Museum of Modern Art, 1989), 14.

5. See for example Dennis Sporre, *The Creative Impulse*, 2nd ed. (New York: Prentice Hall, 1990), 453.

6. Art historian Eric Shanes, for example, argues that "by manipulating images and the public persona of the artist, he [Warhol] threw back in our faces the contradictions and superficialities of contemporary culture and art." Eric Shanes, *Andy Warhol* (New York: Portland House, 1991), 5. See also Carter Ratcliff, *Andy Warhol* (New York: Abbeville Press, 1983), 26 and Rainer Crone, *Andy Warhol* (New York: Praeger, 1970), 29.

7. Max Kozloff, "Metaphysical Disgust, and the New Vulgarians." *Art International* (March 1962): 34-36.

8. In 1968, Leslie Fiedler warned that Pop art is "whatever its overt politics, subversive: a threat to all hierarchies insofar as it is hostile to order and ordering in its own realm." Leslie Fiedler, "Cross the Border—Close that Gap: Postmodernism," *American Literature Since 1900*. ed. M. Cunliffe. (London: Barrie and Jenkins, 1968), 359.

9. A favorite example is John Simon's scathing review of *The Chelsea Girls (1966)*: "Well, Andy Warhol's *The Chelsea Girls* is full-length with a vengeance. It goes on for about 3½ hours on two separate but equally dismal screens. Thus really lasting seven hours. But because a minute of Warhol's brand of boredom is easily the equivalent of an hour of the Hollywood kind, the actual duration is 17½ days." John Simon, *Private Screenings* (New York: Macmillan, 1967), 261.

10. Crone (note 6), 53.

11. Thomas Crow, "Saturday Disasters: Trace and Reference in Early Warhol," *Art in America* (May 1987): 130.

12. Lippard's judgment here is remarkable. She continues by comparing this characteristic ambiguity of Warhol's work with other artists who've since been associated with postmodern aesthetics: "The choice is the viewers', as it is with the plays of Beckett and Albee, the films of Antonioni, and the novels of Butor, Sarraute, or Robbe-Grillet." Lucy Lippard, *Pop Art* (New York: Oxford University Press, 1966), 99. An excerpt from *Pop Art* including this discussion is reprinted here.

13. Steve Jones, "Warhol's Allegorical Icons," *The Critical Response to Andy Warhol* (New York: Greenwood Publishing, 1996), 286.

14. For a discussion of Warhol's redefinition of the aesthetic experience, see Benjamin H. D. Buchloh, "Andy Warhol's One-Dimensional Art: 1956-1966." *Andy Warhol: A Retrospective* (New York: Museum of Modern Art, 1989), 57.

15. Ellen Johnson, "The Image Duplicators—Lichtenstein, Rauschenberg, Warhol." *Canadian Art* (Jan./Feb. 1966), 17. Reprinted here.

16. Quoted in Chuck Workman, *Superstar* (Van Nuys, Calif.: Marilyn Lewis Entertainment, Ltd., 1991), video.

17. Quoted in Paul Bergin, "Andy Warhol: The Artist as Machine." *Art Journal* Vol. 26, no. 4 (Summer, 1967), 359. Reprinted here.

18. Factory denizen Ultra Violet asked Warhol what really motivated him. She recounted, "'Instant recognition.' By whom? 'The world.'" Ultra Violet, *Famous for 15 Minutes* (New York: Harcourt Brace Jovanovich, 1988), 6.

19. The first to extensively develop this view was critic Peter Gidal in *Andy Warhol: Films and Paintings* (London: Studio Vista, 1971). Two years later Stephen Koch offered a

similar opinion in *Stargazer: Andy Warhol's World and His Films* (New York: Praeger, 1973, Second Edition, New York: M. Boyars, 1985).

20. Mcshine (note 4), 13.

21. Bradford Collins, "The Metaphysical Nose Job: the Remaking of Warhola 1960-1968," *Arts Magazine* (February 1988): 47-55. Reprinted here.

22. Steven Kurtz, "Popular Aporia: The Absence of Social Criticism in the Work of Andy Warhol," *The Critical Response to Andy Warhol* (New York: Greenwood Publishing, 1996), 250-261.

23. John Wilcock, *The Autobiography and Sex Life of Andy Warhol* (New York: Other Scenes, 1971), n.p.

24. Andy Warhol and Pat Hackett, *POPism: The Warhol '60s* (New York: Harcourt Brace Jovanovich, 1980; Reprinted New York: Harper and Row, 1983), 6.

25. For a discussion of the creative role of Warhol's assistant Nathan Gluck see Patrick Smith, *Andy Warhol and His Films* (Ann Arbor: UMI Research Press, *1986), 169.* During a lunch together in June 1962, Geldzahler told Warhol, "That's enough affirmation of life. . . . It's enough affirmation of soup and Coke bottles. Maybe everything isn't so fabulous in America. It's time for some death. That's what's really happening." The New York *Daily News* headline that day was "129 DIE IN JET." Quoted in Shanes (note 6), 20. Later Geldzahler reportedly told Warhol that he had done enough death pictures and that it was perhaps time for "life," showing him some flowers in a magazine. Warhol followed the advice, directing his assistant to have silkscreens made of a photograph of four poppies by Patricia Caulfield which appeared in *Modern Photograph*; see Victor Bockris, *The Life and Death of Andy Warhol* (New York: Bantam Books, 1989), 158.

26. Ted Carey, a friend of both Latow and Warhol, recalled an evening together in December 1961 when for a fee of fifty dollars Latow suggested pictures of money or soup cans: "Andy said, 'So Muriel, you've got fabulous ideas. Can't you give me and idea?' . . . And so Muriel said, 'What do you like more than anything else in the world?' So Andy said, 'I don't know. What?' So she said, 'Money. The thing that means more to you and that you like more than anything else in the world is money. You should paint pictures of money.' And so Andy said, 'Oh, that's wonderful.' 'So then either that or,' she said, 'you've got to find something that's recognizable to almost everybody. Something that you see every day that everybody would recognize. Something like a can of Campbell's soup.' So Andy said, 'Oh, that sounds fabulous.'" Quoted in Shanes (note 6), 16.

27. Violet (note 18), 90.

28. Calvin Tomkins, *The World of Marcel Duchamp* (New York: Time-Life Publications, 1966), 169.

29. Martha Jackson, letter to Andy Warhol, 20 July 1962. Quoted in Buchloh (note 14), 42.

30. "Business art is the step that comes after Art. I started as a commercial artist, and I want to finish as a business artist. After I did the thing called 'art' or whatever it's called, I went into business art. I wanted to be an Art Businessman or a Business Artist. Being good in business is the most fascinating kind of art." Andy Warhol, *The Philosophy of Andy Warhol: From A to B & Back Again* (New York: Harcourt Brace Jovanovich, 1975), 72.

31. Buchloh (note 14), 40. Buchloh argues convincingly that Warhol's career in microcosm reflects the macrocosmic synthesis of high culture, mass culture, and the culture industry (39-57).

32. While "postmodernism" is a remarkably diffuse concept, Joseph Natoli's definition is helpful: "Postmodernity's assertion of the value of inclusive 'both/or' thinking deliberately contests the exclusive 'either/or' binary oppositions of modernity. Postmodern paradox, ambiguity, irony, indeterminacy, and contingency are seen to replace modern closure, unity, order, the absolute, and the rational.. . . What disappears with this shift is the comforting security--ethical, ontological, epistemological--that 'reason' offered with the modern paradigm: hierarchy and system are put into question, as intellectual grounds and foundations crumble under our feet." Joseph Natoli and Linda Hutcheon, Editors, Introduction, *A Postmodern Reader* (Albany: State University of New York Press, 1993), ix.

33. Robert Rosenblum contends that Warhol's pictures have "nourished the vast public domain," of images, and his aesthetic formulas have been imitated by a number of contemporary artists, including Rodney Buice, Elaine Sturtevant, Richard Pettibone, Mike Bidlo, Allen Midgette, and Mark Lancaster. Warhol has been so influential, in fact, Rosenblum suggests that the last quarter of the century will be known as the "Age of Warhol." Robert Rosenblum, "Warhol as Art History," *Andy Warhol: A Retrospective* (New York: Museum of Modern Art, 1989), 26. Marxist critic Fredric Jameson identifies Warhol as one of the most significant postmodern artists. Among these he includes Cage, Ashbery, Sollers, Robert Wilson, Ishmael Reed, Michael Show, and Beckett. Fredric Jameson, *Postmodernism, Or the Cultural Logic of Late Capitalism* (Duke University Press, 1991), 26.

34. Quoted in Bob Colacello, *Holy Terror* (New York: HarperCollins, 1990), 62.

CHRONOLOGY

In the 1960s, Andy Warhol was one of the most famous artists in the world, and by the time he died in 1987, he had churned out an enormous body of work. His commercial production, drawings, paintings, sculpture, portraits, photographs, the thousands and thousands of mechanically reproduced images, his books (more than twenty), and hundreds of films make him one of the most prolific artists of the century.

1928 6 August, born Andrew Warhola in Pittsburgh, PA, to Andrej (Andrew) Warhola and Julia Zavacsky. His father immigrated to the United Stated from Czechoslovakia in 1913; mother followed in 1921. Brothers: Paul (born 1922) and John (born 1925). Father works in construction, later as a coal miner in West Virginia.

1936-37 Has a "nervous breakdown" (Saint Vitus's dance).

1942 Father dies 15 May after a three-year illness (tuberculous peritonitis).

1945 Graduates from Schenley High School, Pittsburgh.

1945-49 Attends Carnegie Institute of Technology in Pittsburgh. Meets Philip Pearlstein, a fellow student. Teaches art part-time at Irene Kaufman Settlement and during the summers works as a window decorator for Joseph Horne department store.

1947 Art editor of the student magazine.

1949 Graduates with a B.F.A. Moves to New York City and briefly shares apartment with Pearlstein. Begins using the name Warhol. Meets Tina Fredericks,

art editor of *Glamour*. Does advertisements for magazines, department stores, record companies, including Tiber Press, Columbia Records, *Vogue*, *Seventeen*, *Glamour*, *Harper's Bazaar*, and I. Miller. Also designs window displays, book jackets, cards, and stationary.

1950 His mother moves to New York to live with him.

1952 First solo exhibition held at Hugo Gallery, New York. Includes drawings to illustrate stories by Truman Capote. This is the first of seven individual exhibitions during the 1950s. Receives Art Directors' Club award for newspaper advertising art.

1953 Publishes *Love is a Pink Cake* and *A is an Alphabet* with Ralph Ward which he uses as promotional gifts.

1954 Publishes a limited edition of *Twenty-five Cats Name Sam and One Blue Pussy*. Receives Certificate of Excellence from American Institute for Graphic Arts.

1955 Publishes *A la Recherche du Shoe Perdu* with Ralph Pomeroy.

1956 Award for Distinctive merit presented by the Art Directors' Club. Travels around the world with Charles Lisanby.

1957 Receives Art Directors Club Award for Distinctive Merit for I. Miller shoe advertisements. Publishes *The Gold Book*. Has nose altered.

1959 Meets filmmaker Emile de Antonio.

1960 Makes first paintings of comic strips heroes: *Dick Tracy, Saturday's Popeye, Superman*.

1961 Creates window display for Bonwit Teller using his comic strip paintings. Sees Roy Lichtenstein's comic book paintings for the first time. Buys drawings by Jasper Johns. Meets Ivan Karp and Henry Geldzahler.

1962 Makes paintings of dollar bills, coke bottles, Campbell soup cans, Elvis, Marilyn, and other celebrities. *Campbell's Soup Cans* exhibited by Irving Blum

at Ferus Gallery, Los Angeles. Makes first silkscreens. Begins Death and Disaster Series.

1963 Buys a 16mm movie camera. Shoots *Sleep, Kiss, Eat, Blowjob* and other films. Moves studio to 231 East Forty-seventh Street, which becomes the Factory. Meets Gerard Malanga, who becomes his assistant, and Jonas Mekas, director of the Film Makers' Cooperative. Begins wearing a silver wig.

1964 Shows *Flower* series at Galerie Ileana Sonnabend, Paris. *Thirteen Most Wanted Men* displayed at New York World's Fair is painted over for political reasons. Receives Independent Film Award from *Film Culture* magazine. Makes Brillo boxes, self-portraits. Shoots first sound film, *Harlot.* Also shoots other films, among them, *Empire, Couch, Thirteen Most Beautiful Women.*

1965 Electric Chairs, Cow Wallpaper. Begins working with Paul Morrissey, Lou Reed, and Ronnie Cutrone. Warhol announces his retirement from painting. Selected films: *The Thirteen Most Beautiful Boys, Vinyl, Poor Little Rich Girl, Restaurant, Hedy, My Hustler.*

1966 Exhibits Cow Wallpaper and Silver Pillows (Clouds) with Leo Castelli Gallery. Produces the Exploding Plastic Inevitable, a multimedia event featuring Nico and the Velvet Underground. Releases *The Chelsea Girls,* his first commercially successful film. Begins work on **** (Four Stars). Other films: *Bufferin (Gerald Malanga Reads Poetry), Whips, Eating Too Fast (Blow-Job #2), The Velvet Underground And Nico, Nico (A Symphony in Sound).*

1967 Designs album cover for the first Velvet Underground album which he also produced. Publishes *Andy Warhol's Index.* Meets Frederick Hughes, Joe Dallesandro, and Candy Darling. Hires Allen Midgette to impersonate him at various speaking engagements. Moves the Factory to 33 Union Square West. Selected films: *I, a Man, Bike Boy, Construction–Destruction, Nude Restaurant, The Loves of Ondine* (originally a segment of ****), *Lonesome Cowboys.*

1968 Publishes *A: A Novel.* Meets Jed Johnson. On June 3rd, Valerie Solanis, founder of Society for Cutting Up Men (SCUM), shoots Warhol at the Factory. He nearly dies. Films: *Blue Movie (Fuck), Flesh.* With *Flesh,* Paul Morrissey becomes the de facto director of Warhol films.

1969 *Blue Movie* ruled obscene. Warhol undergoes further surgeries in connection with the shooting. First issue of *Interview* magazine appears. Morrissey directs *Surfing Movie* and *Trash*.

1971 His play *Pork* opens in London.

1972 Maos. Begins painting again, primarily portraits of celebrities, a focus which continues with nearly one thousand commissions during the remainder of his career. Mother dies. Films: *Women in Revolt, Heat.*

1974 Moves Factory to 860 Broadway. Films: *Andy Warhol's Frankenstein* and *Andy Warhol's Dracula.*

1975 Publishes *the Philosophy of Andy Warhol (From A to B and Back Again).* Major retrospective exhibition held at Kunsthaus, Zurich.

1976 Skulls, Hammer and Sickle series.

1977 Athletes, Torsos. Film: *Andy Warhol's Bad* (directed by Jed Johnson).

1978 Oxidations, Shadows.

1979 Retrospectives, Reversals. Publishes *Andy Warhol's Exposures.*

1980 Portraits of Jews of the Twentieth Century. Publishes *POPism: the Warhol 60's* with Pat Hackett. Produces *Andy Warhol's TV.*

1981 Dollar Signs, Knives, Guns, Myths.

1982 Goethes, Stadiums.

1983 Endangered Species series.

1984 Renaissance Paintings, Munchs, Rorschachs. Collaborates with Jean-Michel Basquiat.

1985 Ads. Publishes *America.*

1986 Camouflages, Cars, Flowers, Self-Portraits.

1987 Beethovens. February 22, dies following gall-bladder surgery in New York.

I

THE NINETEEN SIXTIES

Michael Fried, "New York Letter," *Art International* **6, no. 10 (December 1962): 57.**

Of all the painters working today in the service—or thrall—of a popular icongraphy, Andy Warhol is probably the most single-minded and the most spectacular. His current show at the Stable appears to have been done in a combination paint and silk-screen technique: I'm not sure about this, but it seems as if he laid down areas of bright color first, then printed the silk-screen pattern in black over them and finally used paint again to put in details. The technical result is brilliant, and there are passages of fine, sharp painting as well, though in this latter respect Warhol is inconsistent: he can handle paint well but it is not his chief, nor perhaps even a major concern, and he is capable of showing things that are quite badly painted for the sake of the image they embody. And in fact the success of individual paintings depends only partly (though possibly more than Warhol might like) on the quality of paint-handling. Even more it has to do with the choice of subject matter, with the particular image selected for reproduction—which lays him open to the danger of an evanescence he can do nothing about. An art like Warhol's is necessarily parasitic upon the myths of its time, and indirectly therefore upon the machinery of fame and publicity that market these myths: and it is not at all unlikely that the myths that move us will be unintelligible (for at best starkly dated) to generations that follow. This is said not to denigrate Warhol's work but to characterize it and the risks it runs—and, I admit, to register an advance protest against the advent of a generation that will not be as moved by Warhol's beautiful, vulgar, heart-breaking icons of Marilyn Monroe as I am. These I think are the most successful pieces in the show, far

more successful than, for example, the comparable heads of Troy Donahue—because the fact remains that Marilyn is one of the overriding myths of our time while Donahue is not, and there is a consequent element of subjectivity that enters into the choice of the latter and mars the effect. (Epic poets and pop artists have to work with the mythical material as it is given: their art is necessarily impersonal, and there is barely any room for personal predilection.) Warhol's large canvas of Elvis Presley heads fell somewhere between the other two.

Another painting I thought especially successful was the large match-book cover reading "Drink Coca-Cola"; though I thought the even larger canvas with rows of Coke bottles rather cluttered and fussy and without the clarity of the match-book, in which Warhol's handling of paint was its sharpest and his eye for effective design at its most telling. At his strongest—and I take this to be in the Marilyn Monroe paintings—Warhol has a painterly competence, a sure instinct for vulgarity (as in his choice of colors) and a feeling for what is truly human and pathetic in one of the exemplary myths of our time that I for one find moving; but I am not at all sure that even the best of Warhol's work can much outlast the journalism on which it is forced to depend.

Donald Judd, "Andy Warhol," *Arts Magazine* **37 (January 1963): 49.** Review of exhibition at Stable Gallery.

It seems that the salient metaphysical question lately is "Why does Andy Warhol paint Campbell Soup cans?" The only available answer is "Why not?" The subject matter is a cause for both blame and excessive praise. Actually it is not very interesting to think about the reasons, since it is easy to imagine Warhol's paintings without such subject matter, simply as "overall" paintings of repeated elements. The novelty and the absurdity of the repeated images of Marilyn Monroe, Troy Donahue, and Coca-Cola bottles is not great. Although Warhol thought of using these subjects, he certainly did not think of the format. The mildest aspect of the work is the descriptive sensitivity which is mingled with the stenciled elements. Unlike Lichtenstein, the only person with whom he compares, Warhol does not strictly maintain the commercial scheme, or any other unillusionistic scheme. Also his sensitivity extends to the format: in one painting some bottles are empty, some full and some are half empty: one of Elvis Presley is "over-all" within a rectangle set up and to one side, leaving a border of canvas, the photographs, probably repeated with a silk-screen, often lighten in value

toward one side or are deleted. The repetition should be made more insistent and the variation, if it is necessary, rapid and also insistent. Troy Donahue's head and shoulders are within an oval, which cuts his coat into two red prongs repeating downward. That is pretty clear but could be emphasized. The variation between four small paintings of single heads of M. M. show what might be done with emphatic variations. The best thing about Warhol's work is the color. The colors are often stained; they look like colored inks, and often black is stenciled over them, which produces a peculiar quality. The stained alizarin and the black of some repeated Martinson Coffee cans is interesting, for example. The painting with repeated heads of M. M. has an orange ground. The hair is yellow, the face is purplish pink and the eye-shadow is a greenish cerulean. The black image is stenciled over the flat areas. M. M. is lurid. The gist of this is that Warhol's work is able but general. It certainly has possibilities, but it is so far not exceptional. It should be considered as it is, as should anyone's, and not be harmed or aided by being part of a supposed movement, "pop," "O.K.," neo-Dada, or New Realist or whatever it is. The various artists are too diverse to be given a label anyway.

Henry Geldzahler, "Andy Warhol," *Art International* 8, no. 3 (April 1964): 34-35.

The dead-pan, sweet, know-nothing quality of Andy Warhol's personality is continuous with his paintings. He plays dumb just as his paintings do, but neither deceives us. The paintings are of canned, commercial images, whether Campbell Soup, Marilyn Monroe, or of scenes of destruction and death, an auto crash, an electric chair. The image always has a context and a history before Warhol uses it: he takes the second-hand or the familiar and presents it freshly, with immediacy. We have seen photographs of the electric chair, and of Marilyn Monroe, we have seen Campbell Soup ads, but never in the isolation and starkness of Warhol's presentation. The attitude implicit in his choice of images is much more complex than simple satire, grotesqueness, horror or celebration: We are forced to the personal confrontation in his art with the most vivid representations of sex, food and death but always through the intermediary of previous exposure through movies, the press, television, the entire black and white world of photo-reproduction. We have before us the essential symbols of our daily life drained of their force through repetition. In their isolation and repetition in Warhol's paintings the symbols regain their vigor though they must

always be seen through the haze of second-hand familiarity so many find offensive in his work. The feelings Andy Warhol's paintings evoke in us are socially ordained, the forms of feeling and the expression are what our popular society has evolved and superimposed: there is meant to be little ambiguity in our response. It is here that Warhol knows something he isn't telling. There is no image so simple that it means only one thing, no image so familiar that it has lost its meaning. The impact grows through repetition, the forms dissolve into patterns on the canvas, then regroup in fresh recognition. Through his apparent attempt to exhaust the images we already feel to be fatigued through over-exposure, Warhol proves that the images of his choice are inexhaustible.

There is little casual in the apparently casual art of Andy Warhol. He searches through the magazines and newspapers for images that carry the directness and submerged ambiguity that are his subject matter. A silk-screen is ordered, of a certain size, never the size of the original photograph. The image is then repeated a certain number of times, on a canvas of determined size. The canvas is either left white or painted a uniform background color, or several canvases with backgrounds of different colors are mounted together. The same image is repeated; or several aspects of a subject, as in the portraits and the *Tuna Fish Disaster*, are juxtaposed. The image, which is always black, as in the cheap and ordinary reproductions that surrounds us, is laid down darkly or lightly, in images of equal or differing clarity, in a sequence from dark to light, or in more random, scattered darks and lights. Some local color is then sometimes added by hand, as in the Elizabeth Taylors and certain of the Marilyn Monroes. All these and many more are decisions, which the artist makes, despite the supposedly mechanical technique of silk-screen reproduction. No two artists using silk-screens, even the very same screens, will produce the same, or even similar pictures. The hand and the eye operate in subtle and conclusive ways to describe and characterize the personality and decisions of the artist.

Some of Warhol's ideas about composition come from advertising lay-outs, as do the repeated motifs and, often, the choice of subject and attitude. Perhaps only Léger, Gerald Murphy and Stuart Davis, before Andy Warhol, were interested in the possibilities of appropriating commercial devices, emblems and techniques, the look of the package or the advertisement, to what we consider fine art, traditional painting. But the barriers have been falling one by one. Children's art, art of the insane, primitive art, art executed under drugs have all entered the fine arts through Klee, Dubuffet, Picasso, Pollock and many others. In this context the assimilation of a style and content as oversophisticated and naive as commercial art into the painting of our time can neither surprise nor

shock. No subject or influence can be proscribed in art in our time; nothing is inappropriate, undignified. The surprise is that so wide an area of our culture and experience had been ignored so completely.

Warhol's paintings sometime strike us as not being art at all, as not being enough, as not being sufficiently different from life, from our ordinary experience. The artistry with which they are made is concealed and reveals itself slowly and the brash and brazen image, all we can see at first, becomes, in time, a painting, something we can assimilate into our lives and experience.

Sculpture

Andy Warhol's very flat, photographic, two-dimensional images do not in any way lead to the expectation of sculpture: the possibility is not inherent in his silk-screen, reproductive, serial work. The boxes, three-dimensional sculpture, are, if anything, flatter and more dead pan, less present as image or object than the paintings. They are wooden boxes, constructed commercially to the exact specifications of the cartons they represent: the four sides and top are painted through photographically exact silk screens. The colors, size, the look of Andy Warhol's boxes, stacked rather casually in the studio, are precisely those of bright, clean, as yet unused Del Monte, Heinz, Brillo cartons. They are newly minted: nothing has yet happened to them. This is what differentiates them from the cartons of our grocery and movie experience. Another difference is that, being wooden and completely closed, they are useless. The disposable container, that which holds the commercial products we eat, clean with and live with, becomes the subject of the sculpture: the disposable husk, the invisible, the means of transportation, is the entire interest. And it is possible, and it happens, that we walk by them and ask where the sculpture is.

Movies

Andy Warhol's films conceal their art exactly as his paintings and sculpture do. The apparently sloppy and unedited appearance is fascinating. What holds his work together in all media is the absolute control Andy Warhol has over his own sensibility—a sensibility as sweet and tough, as childish and commercial, as innocent and chic, as anything in our culture. Andy Warhol's eight-hour *Sleep* movie must be infuriating to the impatient or the nervous or to those so busy they cannot allow the eye and the mind to adjust to a quieter, flowing sense of time. What appears boring is the elimination of incident, accident, story, sound and the movie camera. As in Erik Satie's *Vexations* when the same 20-second piece is repeated for eighteen hours, we find that the more that is eliminated the greater

concentration is possible on the spare remaining essentials. The slightest variation becomes an event, something on which we can focus our attention. As less and less happens on the screen, we become satisfied with almost nothing and find the slightest shift in the body of the sleeper or the least movement of the screen, we become satisfied with almost nothing and find the slightest shift in the body of the sleeper or the least movement of the camera interesting enough. The movie is not so much about sleep as it is about our capacity to see the possibilities of an aspect of film carried to its logical conclusion, *reductio ad absurdum* to some, indicating a new awareness to others. Andy Warhol wants to keep his editing to an absolute minimum and allow the camera and the subject to do the work. This of course cannot deny the special qualities of his personality; for it is Andy Warhol that holds the camera and it is through his eyes that we see the scene. Minimal editing accounts for the roughness, the opposite of Hollywood's technical proficiency, and insists constantly that we are looking at a film. There is no chance of losing ourselves in an artificial world. There is, strangely, no make-believe. In painting in the past years we have become increasingly aware of the limitations and special qualities of the medium: texture, two-dimensionality, brushstroke, etc. Andy Warhol's film, in which we are constantly aware of the filmic process, sometimes even seeing the frames that end the reels, frames that any sophisticated movie maker would edit out, makes us aware of exactly the limitations and qualities of film itself. A more incident-filled story would draw our attention from the fact that we are seeing a film. *Sleep*, one of Andy Warhol's first movies, is an indication of what he may soon be able to do: make contentless movies that are exactly filmed still-lifes with the minimum of motion necessary to retain the interested attention of the unprejudiced viewer.

Grace Glueck, "Art Notes: Boom?" *New York Times,* **10 May 1964, p. 19.**
Review of exhibition at Stable Gallery.

"Is this an art gallery or Gristede's warehouse?" said a viewer when pop artist Andy Warhol's new show opened at the Stable Gallery April 12. Stacked from floor to ceiling were some 400 plywood grocery cartons, painted to resemble cardboard and being big-as-life replica trademarks—Brillo, Heinz Ketchup, Campbell's Tomato Juice, and so on. That was the show. As one observer said, "Anti-Art with capital A's."

Last week, a couple of days before closing, enough Warhol cartons had been unloaded to gladden a grocer's heart. At prices ranging from $200 to $400,

depending on size, some collectors had bought five or six at a clip. The show's biggest buyers were a well-known New York collector couple, who spurned the smaller Brillo cartons marked "3¢ Off" which sold for $200 to plunk down $6,000 for 20 of the regular size.

When he heard about *that*, an abstract painter named Jim Harvey felt slightly (but not very) manqué. On the job for the industrial designing firm of Stuart & Gunn, where he is a regularly employed, he had designed the *real* Brillo crate in 1961, and somehow failed and still fails to see its potential. "A good commercial design," he says, "but that's all." What's more, his version is cheaper. Each cardboard carton, duly trademarked, costs the Brillo people between 10 and 15 cents.

Sidney Tillim, "Andy Warhol," *Arts Magazine* **38 (September 1964): 62.**
Review of exhibition at Stable Gallery

There was more to this exhibition than met the eye—and a good thing too. Visible were rooms of facsimile cartons of Brillo, Mott's Apple Juice, del Monte Peaches, Campbell's Tomato Juice and Kellogg's Corn Flakes. The labels of these name brands were silk-screened onto maybe three hundred wood boxes. The place looked like a very neat warehouse. The boxes were sold—and they did sell—singly and in groups. One wondered, of course, if a single box, or a few boxes would reproduce the effect of the ensemble in a gallery where they could so successfully repudiate any art quality whatsoever. For the show was an ideological tour de force, with the dry goods distinguishing its essential nihilism. Another environment, particularly a collection, would at least be a contradiction, unless the collector enjoyed being laughed at. If all Warhol were doing was just trying to gain attention, there would be no purpose in discussing his work. But this new thing which is not art, or, better, which has not enough art, is about art. Actually, Warhol has extended the principle of repetition in his paintings into three dimensions. The multiple image in the flat is now multiplied in the round. The rooms were filled only because they were there. And I presume to believe that his intentions are now much clearer. For the repetition is not important and the resultant quantity is filling, symbolically, a universe with things. The preoccupation with quantity is a defense against space by refusing to decide that anything in it is important. A decision means isolation, responsibility. The decision not to decide is a paradox that is equal to an idea which expresses nothing but then gives it dimension. Correspondingly its mechanical

impersonality delivers the total subjectivity of the artist, and the absence of anxiety in the display but not from the decision to create it is crucial to the validity of the exhibition as a gesture of aggressive passivity. This is what I think the work means. As for art, formally Warhol has given one of the purer expressions of the problems facing post-Abstract Expressionist art. And the labeling represents an ingratiating device that at the same time signifies a poignant desire to communicate. The visual emptiness of it all is the price he seems willing to pay for an instant of sublime but compulsive negation.

Robert Rosenblum, "Saint Andrew," *Newsweek,* **7 December 1964, pp.100-106.**

"Terrific!" said the smiling young man, backed up against the wall by a mounting crush of people. The young man was artist Andy Warhol, and the crush was a tidal wave of guests at a party given to celebrate the opening of his latest show in New York last week. The wave grew to fantastic proportions. The dancing guests, jammed together in the big West Side apartment, frugged in place, like a mob of bears back-scratching against the trees of a thick forest. A *New York Times* photographer retrieved the wrong coat from a gigantic pile of overwear. The pile grew so surrealistically high that Norman Mailer, who arrived late, was led solicitously aside by the host to park his vestments in private. Such is success in New York's Babel of art.

There in the midst of the Beatle-rocking bedlam was the 32-year-old artist, listening to the twanging anthems of triumph with his elfin smile, dancing only with his pale blue eyes, looking with this mysterious white hair and happy nose, like the offspring of a union between Peter Pan and W.C. Fields.

Warhol is in truth the Peter Pan of the current art scene. He is already a legend of pop art with this world-famous paintings of Campbell's Soup cans, Marilyn Monroe, tabloid front pages, and American ways of dying. He paints the gamy glamour of mass society with the lobotomized glee that characterizes the cooled-off generation. Now his theme is *Flowers*, but the garish, neon-colored flowers of cafeteria window boxes—Broadway blooms for Broadway glooms.

Before his opening at the Leo Castelli Gallery last week, Warhol looked happily at the fields of painted flora in his vast studio, a glittering arena covered entirely in aluminum foil and silver paint. "I waited till after the election," he said. "I was going to make the show all Goldwater if he won, because then

everything would go, art would go ... But now it's going to be flowers—they're the fashion this year. They look like a cheap awning. They're terrific!"

Inky Smudges: And flowers it was, done in Warhol's new system in which he has a blown-up photograph converted into a silk screen. Warhol then forces varying thicknesses of paint through the screens onto canvas and adds color. This process produces a series of images that are the same but different, like the inky smudges of newspaper photos rubbed by millions of hands that carry them around the city.

Henry Geldzahler, the brilliant young assistant curator of American art at the Metropolitan Museum, calls Warhol "a sensibility as sweet and tough, as childish and commercial, as innocent and chick, as anything in our culture." He is the true primitive of pop art, possessing the kind of traumatized naivete that seems to be the closest thing to innocence our hip age can provide. He lives in a three-story house on Lexington Avenue, a house crammed with the eccentrically elegant artifacts of a bizarre civilization—old carrousel horses, a carnival punching-bag machine, a giant wooden Coke bottle, a crushed-car sculpture by John Chamberlain.

Everything is art, says Warhol, "You go to a museum, and they say this is art and the little squares are hanging on the wall. But everything is art, and nothing is art. Because I think everything is beautiful—if it's right." For Warhol, "right" means "not faking it"—being what you are, and the difference between right and not right is "style." "Style—like in de Kooning or Kline. It comes out in their brush stroke—the energy, the character, not just a painting technique."

Machine: But the intensely personal style that is the mark of a de Kooning or Kline is not for Warhol. He is the most blatant of the new personalities of pop—the "anti-sensibility" man who reacts in a euphoric monotone that is half ecstasy, half hibernation. That is way he turned to the mass-production techniques of silk screen. "I think everybody should be a machine. I think everybody should be like everybody. That seems to be what is happening now."

So Warhol's weapon against the loneliness of differentiation is a kind of happy regression, back to the undifferentiated childhood world of giant images and soothing repetition. But, because he is a man, not a child, the big image and the repeating image are a sort of fetish, just like the huge Carmen Miranda wedgie he has on a table at home, or like the giant shoe ad which won him the Art Director's Club Medal in 1957, when he was still a commercial artist.

From the fetishes of commercial art to the super-fetishes of commercial art to the super-fetishes of painting was a logical step for Warhol. Like all pop artists, he saw the pathos and charm of the obsolescent images of mass culture, from a comic strip to an overwhelmingly unattainable movie beauty. Like all artists, the content of his life is dedicated to the obsessions of his art. "I used to have the same soup lunch every day for twenty years. So I painted soup cans." But it is the final fillip of an absurd elegance that makes pop art, and Warhol adds: "I used to want to live at the Waldorf Towers and have soup and a sandwich."

The elegance of his soup cans, his silk-screened serried ranks of Marilyn pouts or Troy Donahue smirks—even the elegance of his stark, silvery electric chairs and joltingly smudged car crashes—all have bought Warhol success (his bigger pictures sell for about $5,000) and easy entry to that new hip world of blurred genders and sharp characters, the polyestered successors to Scott Fitzgerald's golden youth. These violently groomed, perversely beautiful people want art, fun, ease, and unimpeded momentum in every conceivable direction. Pop art is their art.

Tics: Warhol has recently turned to filmmaking. After only a year behind the camera he has already been called by one critic "the most important experimental filmmaker now working." He is a star of the Film-Makers' Co-operative, and several of his short films were shown as a kind of added attraction at the recent New York Film Festival. Warhol's films are the logical extension, one might say the *reductio ad absurdum*, of his deadpan celebrations of everyday phenomena. His first film, *Sleep*, was six hours of a camera watching a sleeping man. The movie's only action was the twitches, tics, and heavings of his Morphean movements.

Other Warhol films are called *Eat*, a study of a masticating countenance, *Kiss*, a close look at nonstop osculation, and *Empire*, an eight-hour zoological study of the Empire State Building. "It's terrific!" says Warhol of *Empire*. It's blurry because the building moves in the wind. You see the lights come on, and the stars—it's fantastic, beautiful."

Jonas Mekas, the guiding force in the Film-Makers' Co-op, calls Warhol's films "meditations on life...almost religious...a looking at daily activities like sleeping or eating. It's a saying 'Yes' to life." Last week Warhol was saying Yes in his last opus. It is his contribution to the current Jean Harlow craze, except that Harlow is played by a man—Mario Montez—a leading "superstar" in the "underground" movies. On a couch in his studio the dark Montez,

transformed into a chalky-white "Gene" Harlow, delicately chomped a banana next to a real blond superstarlet, Carol Koshinskie, while a superloud record of "Swan Lake" blasted away in the background.

The next night Warhol was back, this time in front of another Co-op director's camera. Gregroy Markopoulos was making a mythological epic in which Warhol played the Greek god Oceanus. Dressed in black jeans, skindiver's black tunic, streamers of silver paper, and a sea-shell codpiece, Warhol pedaled majestically on an Exercycle for fifteen minutes. "He's a happy person," said Markopoulos, "The kind of character Aeschylus had in mind for the god of the sea." The next night Warhol, togged out in soup and fish—the same black jeans, plus white shirt and tuxedo jacket—attended a move-watching party at the home of Jane Holzer, the *Vogue* cover girl. "Baby Jane," called by Vogue editor Dianan Vreeland "the most contemporary girl I know," is a Warhol superstar. With her mane of blond hair, her hyperthyroid drive and buckshot hedonism, she epitomizes the pants-wearing young set who feed on the hybrid world of pop, flick, and hip.

Teeth: At the party, Jane, as usual, ate nothing but candy. Warhol circulated among young wraiths from the world of fashion and frolic. Jane's real-estate broker husband watched impassively, like a character in a Mailer story, while on the screen Baby Jane's face in gigantic close-up chewed gum and brushed her teeth. A hypnotic pop tension built up, broken by Hollywood producer Sam Spiegel's wife shouting "We're all turned on to you, baby."

Such are the orgiastic climaxes of Warhol's world. It is a strange world, "a chaos stylized against chaos." Andy's so nice, says Jane Holzer. "There's no hang-up or anything; he makes you feel good." In an age structured for spectators, Warhol is the supreme, accepting spectator. "He's been called a voyeur," says writer-art dealer Ivan Karp. "While the other pop artists depict common things, Andy is in a sense a victim of common things; he genuinely admires them. How can you describe him—he's like a saint—Saint Andrew."

At his studio last week, Warhol was finishing a series of silk screens of Jacqueline Kennedy after the assassination—the only non-flower picture in his show. He kneeled on the floor in green rubber gloves, spreading paint through the screen with a wooden bar—a craftsman absorbed in his work. "That picture of her at the swearing in of President Johnson was so good," he said. "Maybe I should have made the whole show just Jackie. It's terrific."

Marianne Hancock, "Soup's On," *Arts Magazine* 39 (May/June 1965): 16-18.
Statement by Ivan Karp made at a meeting of the Society of Illustrators.

With dark glasses protecting him like a mask, with white hair falling like a comic wig over his ashy face and dark black hair, in high-heeled boots and tight black pants, Andy Warhol endured lunch at the Society of Illustrators. On hand to question his integrity were almost a hundred illustrators; and this was remarkable because the last time the Society served artist for lunch, only twelve people came. But Mr. Warhol is high camp; his name pulls, and his icy portraits of tomato-soup cans rouse strong and sometimes hostile emotions.

Mr. Warhol remained inscrutable throughout the examination. Obviously, whether or not he means to put people on, he must deny that this is what he means, and the matter of Mr. Warhol's sincerity remained his own mysterious business.

He protected himself by saying very little, answering only those questions which permitted a *yes* or *no* reply, and even this was more leeway than he needed. With one exception, Mr. Warhol said, "No."

He was well spoken for, nevertheless. Mr. Ivan Karp of the Castelli Gallery, where Mr. Warhol and his fellow Pop artists hang, answered for him eloquently. (Surely *he* wore dark glasses from sympathy rather than shyness.) In fact, so united were Mr. Karp and his client that they seemed to be playing a ventriloquist trick on the illustrators: Mr, Karp spoke and Mr. Warhol did not move his lips.

Mr. Karp began with a defense of Mr. Warhol's subjects. He said that Pop art, any art, is based on the belief that there is no object in the world that is not beautiful when it is seen purely, for its own sake—beautiful in one of beauty's many aspects. An object may be brutally, hideously, boring, mechanically, even terrifying beautiful. He mentioned Goya's *Disasters of War*, those disembowelments, executions and rapes. He referred to Chardin's loaves of bread and glasses of wine—objects that Chardin took from their humble place in the kitchen and gave eternal beauty.

Mr. Karp suggested that his water glass, if we would look at it purely, was the living end. "And Mr. Warhol in 1962, by taking a can of Campbell's tomato soup out of its context in a supermarket, by blowing it up, potting it on canvas, and adding something ineffable of his own—and what Mr. Warhol added is very subtle—transfigured that can of soup and raised it to the level of spiritual importance. By his act of transmutation he created beauty and meaning."

The illustrators smiled.

"And do not think," Mr. Karp continued, "that I may be deceived, that you could paint some large realistic label and hand it to me as art. I have a trained eye and I would instantly recognize such a deception—that is, if any of you could think of doing such a dastardly thing." He then praised Mr. Warhol's gift of seeing purely and invited the illustrators to speak their minds freely.

The first illustrator asked Mr. Warhol if there wasn't something commercial in his choice of subjects.

"No," said Mr. Warhol softly.

"Certainly not," said Mr. Karp, "if I understand your question. After all there are only a hundred people in the United States who buy Pop art. You know yourself that the illustrators in this room make more money per hour, per piece, than a fine artist can count on. Mr. Warhol has no assurance that he will sell what he produces.

"But of course there are rewards. Mr. Warhol has three fan clubs in New York and his fans write a great many letters. If Mr. Warhol doesn't mind, I'll show you one of them." He took the label from a large family-size can of soup from his pocket and held it up so that the illustrators could see but not decipher the message written on the back. The illustrators laughed. "They always write on soup labels," Mr. Karp said.

"Mr. Warhol," said another illustrator, "Isn't it true that on a recent occasion you signed some twelve-cent soup-can labels which subsequently sold for as much as fifteen dollars? Don't you think that whatever you have done to make tomato soup meaningful and beautiful was denigrated when you signed those labels?"

Mr. Warhol said, "No."

Mr. Karp said, "We no longer think of soup cans as soup cans. The pure virgin soup can has been transformed by Mr. Warhol. Tomato soup will never be just tomato soup again."

"She was raped," said an illustrator.

Mr. Karp smiled. "In effect Mr. Warhol signed his name to autograph a symbol that is universally recognized as his own."

"Mr. Warhol, do you mean to be funny?"

Mr. Warhol said, "No."

"Mr. Warhol, do you mean to give offense? Are you hostile to society? Are you protesting anything?"

Mr. Warhol said, "No."

"Although Mr. Warhol has no wish to give offense," said Mr. Karp, "he is not disturbed by your taking offense. We welcome your cruel feelings more than we would your indifference. After all, Michelangelo's ceiling was considered

coarse. His contemporaries found it too muscular, too naked. Van Gogh made twenty-seven dollars from his painting—pardon me, francs—and he exhibited constantly. Rembrandt was not well thought of. Any pioneer may be misunderstood. But Mr. Warhol's work and the work of other Pop artists, Lichtenstein and Jasper Johns, already has an influence. I expect that influence to grow."

"Mr. Warhol, don't you feel Pop art is parasitic?"

Mr. Warhol said, "No."

Mr. Karp said, "If by parasitic you mean derivative, may I point out that I looked at your exhibit downstairs and everything I saw there was derivative. You have borrowed the trappings and techniques of the fine arts to hide behind. You are what I call the *cognoscenti*. You know everything. You invent nothing. Mr. Warhol, on the other hand, takes his inspiration from things in our society and shows them to us as if we had never seen them before."

"Why doesn't Mr. Warhol paint that glass of water?"

"Chardin painted that glass of water."

"Mr. Warhol, isn't your work mechanical and cold?"

"Yes, said Mr. Karp, "Mr. Warhol's art is mechanically cold. Art is a pendulum, and in part the trend toward impersonal art is a reaction to Expressionism. After romantic personal involvement, comes an art you call cold."

"Mr. Warhol, there is a trend in Pop art toward pornography. I understand that much of what is being done in Pop art cannot be exhibited. I was recently asked by a friend whether he should buy, for a large sum, a blown-up French post card which cannot be described in mixed company. Is this a valid thing to hang in the living room?"

"Let me say," said Mr. Karp, "that sex is as interesting to people as tomato soup. Leonardo, Rembrandt, Renoir—any artist you can name has painted pornography which cannot be exhibited."

"Mr. Warhol, aren't people offended when they buy a painting of a soup can, an original of yours for fifteen hundred dollars and then you reproduce that same painting thirty-two times?"

Mr. Warhol did not answer and Mr. Karp said, "If Mr. Warhol chooses to do things easily and quickly rather than slowly and tediously, if repetition and mechanicalness are significant aspects of Mr. Warhol's art, you may be offended or not as you will. But as a matter of fact, Mr. Warhol is extraordinarily inventive and original, and this is a prime requisite for survival among artists. A dozen contemporaries working in the same vein can foresee in a year what an

artist would achieve if he had ten years to develop his art naturally. The pressure is terrible. Many a good artist has been foreseen and done in by his peers. But I do not believe this will happen to Mr. Warhol."

"What do the Campbell people think about your work, Mr. Warhol?"

Since this could not be answered with *yes* or *no*, Mr. Karp replied. "They think very little about it. The Campbell people are a staid, conservative people. For three years, after Mr. Warhol glorified tomato soup, they said nothing. But recently they gave their retiring president one of Andy's paintings as a going-away gift. And if I may judge by the expression on the old man's face in the newspaper, there is nothing he wanted less."

"Mr. Warhol, aside from the packaging and the can itself, speaking of the contents, what do you think of tomato soup?"

Then and only then did Mr. Warhol speak freely. "I love it," he said.

Ellen H. Johnson, "The Image Duplicators—Lichtenstein, Rauschenberg and Warhol," *Canadian Art* **23 (January-February 1966): 12-19.**

Since modern art begins its history of protest, ironically enough, with a second-hand image, Manet's *Déjeuner sur L'herbe* of 1863, one may wonder at the opposition aroused in many historians and critics by an extreme form of this same procedure in contemporary art. When Manet composed his *Déjeuner sur L'herbe* from an engraving by Marcantonio Ralmondi after a lost painting by Raphael, he was not, on the face of it, departing too much from a long established tradition of making new art directly from old art. But two factors at least distinguish Manet's art from, say, Reynold's painting *Mrs. Siddons as the Tragic Muse* in the weighty pose of Michelangelo's *Isaiah*, namely: the consciousness of modernity and the strong flavor of protest that one senses in Manet's position. If one can not actually hear him say, "Let us beat them at their own game and give them the unpalatable NOW in a tradition-soaked package," still one cannot miss the conflict in his attitude toward tradition and the new.

Andy Warhol was hardly thinking of Manet when he stencilled a photograph of Marilyn Monroe on canvas, but his act is not so completely different as might be expected, given the intervention of a century of changing values. Of course there are many complex differences; my point is simply that the seed of the new attitude was sown a long time before Dada, and the historically mixed soil of protest and tradition continues to nourish our art.

Art comes from art, and art comes from nature. Even in abstract painting, what the artist sees, what he perceives and experiences with his eyes, impels his form. And what does the young New York artist see? Caught in traffic jams, packed in buses, subways, elevators, or spending a quiet evening at home, never has the human being been such a captive of the printed image, constantly changing and endlessly repeated: in books, newspapers and magazines, on the shifting world of the TV or movie screen, the blaring billboards, highway signs, giant lighted ads for hotels, theaters, stores—everywhere pictured products and pictured people beckoning, commanding and assaulting. These are the fields of Suffolk and the Fontainebleau Forest of our painters. Machine images in a machine-made world. Is the way Lichtenstein selects his images from the millions at hand so different from the way the landscape painter selected his picturesque view? Lichtenstein is not "copying" his landscape any more than Constable was. It is the landscape itself that has changed, not the degree of the artist's creativity—which in spite of all the redefinitions that art has undergone in the last hundred years, is still concerned with how the artist *forms* the raw material he chooses.

The subject of Lichtenstein's painting is not so much the subject of the selected comic or advertisement as it is the style in which those images are presented: brashly simplified and exaggerated, catching the eye immediately. His *Craig* is not about a young girl tenderly thinking the name of her lover (the word "lover" probably interjects too much reality into the never-never land of comic romances); it is about comics, their conventions, style, artifice and sentimentality. Why do pulp-magazine romances continue to be called "comics?" Because they are just that: funny, ridiculous. Some grown-ups take them instead of sedatives to go to sleep; other less grown-up adults take them instead of the real thing. A man of Lichtenstein's sensitivity and sophisticated humor could not be other than amused by the pretentious seriousness of comic romances (the witty comics Lichtenstein leaves alone). Even so, mockery is I think a peripheral factor in Lichtenstein's choice of subject matter. Like many artists before him, he wanted to do something so ordinary that it was outlandish, he wanted to show that art could be made out of something as crass as a comic. When the contemporary artists says that he wants to make a painting so "strong," "offensive" or "despicable" that no one would want to have it, he is voicing an impulse that has motivated much fine art of the distant as well as immediate past.

The desire to make art from something "despicable" is not a whim on the part of our young artists but a serious need to make art *real* again in their terms. In their willingness to get out on their own limb, the young painters in the United

States are following the path set by the great innovators of the New York school. They dare to do something difficult, if not impossible. Lichtenstein says as much: "I like to put myself in a kind of tight spot." He does so by using the anonymous subjects and clichés of comics and industrial design for his serious and personal art which deliberately conceals its formal character in its risky closeness to models which are as far removed as possible from normal aesthetic considerations.

The closer Lichtenstein's painting approaches its source the more astonishing is its distinction from it. First, he reveals his individuality in his choice of subjects. His comics fall into two groups: the ideal girl of the popular romance living on love but sexless as an IBM card, or the virile, witty he calls "fascist" heroes in violent battle. One actually *hears* the guns roaring and planes crashing in the bursting shapes and colors of those pictures and in the amazing quality of sound and action in their words, "Voomp! Takka Takka, Blang, Varoom! Blam, Brattata."

Because Lichtenstein wants his motifs to be anonymous, he does not choose them from the most widely circulated serial comics but from single stories, preferably out-of-date issues which can be found in the well-stocked shops of the comic antiquarians on Times Square. He clips images which attract him for their formal and evocative possibilities and in so doing again reveals his individuality in the way he crops them and changes their format. From a firmly designed drawing, usually in color, he constructs the carefully built-up painting, which looks like a comic but is no more a comic than Paulus Potter's cows are cows. The anonymous, machine-*like* character of Lichtenstein's painting fits his cool, noncommittal presentation of his subjects. He tells us that he likes the contradiction between the emotional subject and the unemotional technique; he must also like the ironical tension between real emotion and its comic travesty, between serious art and its silly source. He forges a refined and personal style from a vulgar and anonymous idiom.

It is not just that he enlarges the comic and puts it in a new context, but he gives it scale; he makes a monumental painting from a trifle. Comparing Lichtenstein's *"I know how you must feel, Brad"* with its comics source, one sees how he proceeds. Eliminating inessentials, he dispenses with finger-nails and forearm muscle indications, cuts the number of lines throughout and more tellingly states and varies their curved or angular character. He changes the colors and gives them more force (from a dull red to a bright blue in the dress, from dirty yellow to brilliant gold in the hair), thus further idealizing the ideal girl of the comics; he intensifies the range and contrast of values; makes the flabby

landscape background into a jagged, expressive pattern; transforms the vague rocket-like shape on the left into a neat vertical column (compare baroque portrait formulae) and realigns the whole into a quiet, steady vertical-horizontal-pyramidal structure. The head is squarely centered and over it the words float like a halo. the analogy to madonna compositions may be an art historian's fancy or possibly an unconscious allusion on the part of an educated painter or, considering Lichtenstein's cultivated humor, a deliberate quip at the icons of today.

Lichtenstein is interested and amused by the symbols and "iconography" of the comics: the linear conventions for nose, mouth, eyes; the particular shapes of eyebrows and forehead creases for different emotions (happiness, misery, confusion); the wavy think-balloons rising from the head by a series of bubbles, the talk-balloons by an arrow; exclamation points for speech; three dots for thought, etc. It is perhaps not too exaggerated to suggest that these formulae recall Seurat's dominants (descendants of the historic modes)—rising lines, light values and warm hues for gaiety and so on. Lichtenstein's resemblance to Seurat is sometimes noted on the basis of technique; however, Lichtenstein's dots are much smaller and completely uniform in size, shape and colour and they often do effect retinal fusion—orange through yellow and red, purple through red and blue. But there are more significant similarities between Lichtenstein and Seurat in style and content; expression of the everyday subject in a classic form, the lively combination of organic and geometric and of humor and gravity, the reliance on silhouette and line or edge, and the mechanical *look* of the painting.

In his painting of comics and advertisements Lichtenstein retains not only the appearance of the printing technique but also the commercial style itself, even exaggerating its mannered drawing. The slick black contours in *"I know how you must feel, Brad"* wittily parody the crazy "grace" of the pointed fingers, narrow wrist, swelling hips and breast and the flowing blond hair of the comic. But for all the mannerism in Lichtenstein's American beauty (who numbers the Comtesse d'Haussonville of Ingres among her ancestors), the total work is a powerful, commanding painting at least as far removed from the original comic as Seurat's paintings are from Chéret's posters.

Lichtenstein will probably add some Seurats to his series of quotations from other artists. He has made "Lichtensteins" from Picassos and from Picasso's translations of Delacroix and from Mondrian as well as from ads for household products and, most recently, several landscapes and skyscapes suggested by travel photographs. With his classical bent it is not surprising that he is also now making drawings and paintings after photographs of ancient architecture. But all of these second-hand picturers are unmistakably Lichtenstein's, including the

much-discussed black and while painting from an illustration of a diagram by Erie Loran of a Cézanne portrait of Madame Cézanne. Surely one of the reasons that Lichtenstein chose that motif is because he was startled and amused by the discrepancy between the complex painting of Cézanne and Loran's simple diagram—from which Lichtenstein made a stark and impressive painting.

The interest of Lichtenstein, Rauschenberg, Warhol and many other artists in ready-made images stems not only from the abundance of such material around us but beyond that from the machine orientation of our environment. This interest is not uniquely contemporary—witness Monet's *Bare Saint-Lazare* series, Seurat's *Eiffel Tower* and Le Corbusier's "machines for living." Artists have long been fascinated by the technological aspect of our civilization and have used it as metaphor, tool and challenge; and now Andy Warhol says he thinks everybody should be a machine. The twentieth-century painters who have been particularly influential on the group we are discussing often took their imagery or style from the industrial world, Duchamp and Picabia in their metaphorical machines and Léger with his crisp forms working like well-oiled pistons.

Léger's shapes resemble the machines themselves. Lichtenstein's paintings are intended to look machine made, and recently he has had some manufactured in porcelain enamel on steel, but from his personal, handmade designs; whereas Warhol and Rauschenberg themselves use the machine process in the paintings they make with silk screens commercially produced from photographs. Apparently Warhol preceded Rauschenberg in this practice, although the latter had been moving in the direction and had gotten something of a related effect with his earlier transfers (frottages) from newsprint. (Parenthetically, Warhol painted comics—Superman, Popeye, Dick Tracy, etc.—in 1960 before and unknown to Lichtenstein.) Warhol's use of silk screen images is more mechanical, more "pure" than that of Rauschenberg who tends to treat them disrespectfully, as it were, more as a part of his "palette." Warhol uses them straight; Rauschenberg combines them freely with painting and drawing, as the cubists had done with collage. At first working only in black and white, Rauschenberg now combines the filter of the four color separation process as though these were exactly his choice from a rich and complex palette.

Mixing hand-made art with machine-made art, mixing photographs of reality with photographs of reproduction of paintings, Rauschenberg ranges wider and freer than Lichtenstein or Warhol. He never makes a picture of a single image. He does not imitate ready-made images like Lichtenstein nor does he represent them as Warhol does. Rauschenberg consumes them. A hyper-responsive dynamo, he snatches the images and symbols of modern life as they flash by and

converts them, superbly refined but still poignantly themselves, into pictorial and evocative energy. He has photographic silk screens made from new photographs (and some that he himself took) of our world of motion—trucks, ships, planes, space investigator, street signs, sports shots—and from postcards of the Statute of Liberty, display cards of oranges, pictures of mosquitoes and reproductions of Michelangelo, Rubens and Velazquez. These images form his urban and study environment; they are the glass, bottle, pipe and guitar. cubist compositions and they tell as much about Rauschenberg's world as the cubists' iconography reveals of their more closed-in environment. Like Picasso, Rauschenberg forces the things to "put up with" the pictorial light into which he transforms them, but having brought the object back into painting in no uncertain terms, he now allows its mechanically produced image more life of its own than Picasso allowed the actual piece of rope or wallpaper.

Rauschenberg gives new power to the dynamic means of the cubists: he speeds up the simultaneous, multiple viewpoint befitting a more mobile observer and a faster changing world; his distortions in scale are more fantastic (the sparrow is larger than the Statue of Liberty); his shifts in space and meaning are more abrupt; and the dialogue between substance and illusion and between art and reality is ever more complex. Although his silk screen paintings are actually flat, in effect they are similar to his combines: the two dimensional photograph of Kennedy in his familiar finger-pointing gesture is as startling and as physically *present* as the actual eagle is in *Canyon*. On the other hand, sometimes the most palpable image is the least "real" one—as the Venus printed from a silk screen from a photograph of a reproduction of a painting. It cannot be entirely insignificant that the two paintings which appear most frequently in his work, Rubens' *Toilet of Venus* and the Rokeby *Venus and Cupid,* are figures whose backs are turned to us and whose faces we see only reflected in a mirror. Reality is veiled in the mirror reflections and in the whole field of second-hand images, reminding us that we live in a world of illusions—shadows of shadows of actuality. Much of the "new realism" is far from realistic, dealing as it does with fantasy and the kind of illusion that our synthetic culture nourishes. Feeding on illustrated capsules, any one of the 7,156,487 subscribers to *Life* could tell you that the title for this article comes from Roy Lichtenstein's painting. *What? Why did you ask that? What do you know about my image duplicator?*

Besides those already noted, surely there must be other factors involved in the contemporary practice of image duplicating. Is there not a genuine feeling of affinity with commercial methods and design, a sense that "This is my kind of world and I shall use what I want of it for my own work"? That, combined with

the stimulus of a risky alignment—how mechanical can one get and still be an artist? Andy Warhol most dramatically marries the two worlds and his commitment to the machine is most outspoken. (When asked about some rolled canvases stacked against the wall of his studio, "those? Oh, they're just hand-made pictures!") Warhol is completely at home in the world of commercial art and entertainment; he understands its style, speaks its language, works to its music, loves it movies and, as everyone knows, makes astonishing films of his own.

Warhol wants his pictures to be artless, styleless, anonymous, painted without his interference. He solemnly denies that he makes any aesthetic decisions—a pretty piece of nonsense. He selects the image in the first place, determines the size of its enlargement, how many times it will be repeated on a given work, where it will be placed each time on the canvas, whether or not he likes accidental effects and irregularities, what the color of the ground will be, how to group the colors in a composition of variously colored panels. These are just a few of the aesthetic problems that the Warhol machine faces and solves. As Franz Kline said to the man who described Barnett Newman's paintings as too simple, "Sounds very complicated to me!" Warhol's denial of the art in his art may be half pose and half genuine regret that it is not possible for an artist to rid himself of himself and become completely anonymous. If he is an artist, what he makes will be his art whether he does it with a machine or with his finger-nails. The attraction of the anonymous to so many artists of this generation is one reason for choosing the common object and image. Warhol selects the most mass-reproduced photographs of entertainment stars, personalities in the news, commodities, and disasters because they have been repeated so much that they have lost their meaning. And so he repeats them again—and gives them new meaning.

Whether consciously or not, Warhol and other image duplicators are making a comment on the monstrous repetition our machines have bred: millions of the same car, the same dress, the same soup can, similar offices and dwellings repeating the same unit layer above layer: the same number of windows in the same pattern, the same number and distribution of rooms, filled with people sitting at the same kind of desks, typing the same kind of letters or reading the same paper or magazine, studying the same textbook, looking at the same TV program. How many of the same weapon to blow it all up?

Andy Warhol professes to like it. Perhaps he does. In any case it is one of the things his pictures mean.

Another aspect of our environment which Warhol's and Rauschenberg's work reflects is its movement, constant change and scattering of time. Warhol has conveyed this quality in his work since 1961 but he also expresses its antithesis: the serial coup cans, Coca-Cola bottles and movie stars repeated in a regular rhythm, row on row, are static images rescued from time and motion. A quality of absoluteness, of the suspension of time, is expressed in the slowly drawn horizontal bands of *Blue Electric Chair*; and the film *Sleep* silently extends time. On the other hand, Warhol often evokes the sensation of movement in time, partly though overlapping the images and breaking their vertical alignment. The baseball players hit and run and the disasters flicker like the moving frames of a film. Shifting time is evoked in the multiple portraits (as those of Mrs. Scull and Mrs. Kennedy), composed of several different photographs repeated, reversed and variously cropped. This effect of time in sequence is heightened by the subject being at differing distances from the camera and there being, in the case of *Ethel Scull*, a variety of background colors. Warhol's color is brilliant, peculiarly contemporary and commercial at its best. The image of Marilyn Monroe, repeated 25 times in gorgeous brazen orange, bluish-pink, yellow and green, forms horizontal bands and stripes like boxes of Tide on an assembly line or an alphabet painting by Jasper Johns. Warhol named several single portraits of the movie star *Grape ... Mint ... Peach ... Cherry Marilyn Monroe*, all very much "artificial flavor and coloring added." The woman who admired a reproduction of a Van Gogh at Bloomingdales and asked the clerk to order it for her in green should have asked Andy Warhol. He could do that—supply a picture in the customer's choice of color; at least it might amuse him to say that he would. But that fancy does not minimize Warhol's distinguished power as a colorist. The blue ground with black images in *The Texan*, that mysterious and impressive painting with its jagged shapes recalling the somber compositions of Clyfford Still, is like the acrylic blue lights penetrating the black of an airfield at night. Besides using industrial colors, Warhol has made a further alliance with technology in painting pictures with actual light. *Blue Girlie* is in white paint revealing nothing until strobe light is directed on it to produce a startling blue composition like a figure photographed in the depths of the sea.

Reference to Still and other abstract expressionists suggests that Warhol and many of his contemporaries might be called abstract objectivists, which would be no more ridiculous than some of the other names applied to them—and just as useless. I mention it only because the banality and omnipresence of the images they use more readily make way for an art "dealing primarily with forms," a Picasso defined cubism. With cubist paintings one first sees forms which require

considerable unscrambling to get them back to objects; whereas many people still have not seen the form for the objects in the new painting. The cubists stressed form by undermining subject matter and these contemporary artists reveal the insignificance of their subject matter by blatantly reproducing it. The latter procedure makes it more difficult for the spectator, but is only a round about way of going to the same place.

Nonetheless, the things reproduced keep flashing back to our consciousness so that the tension between abstraction and subject can never quite be laid to rest—and not meant to be. Present in cubism, that conflict is heightened in the new painting, as is the tension between anonymity and artistic individuality.

The whole struggle for the impersonal and anonymous on the part of so many contemporary artists is related to what T.S. Eliot wrote a long time ago: "Poetry is not turning loose of emotion, but an escape from emotion; is not the expression of personality, but an escape from personality. But, of course, only those who have personality and emotion know what it means to want to escape from "them."

Aldo Pellegrini, *New Tendencies in Art,* New York: Crown Publishers, (1968), 228. Trans.: Robin Carson

Andy Warhol is another exponent of the orthodox line of pop. Since 1961 he has used silk screening for his reproductions (as Rauschenberg also did); he reproduces the images in a different size from the original, which serves as a base, and prints them on a white or monochrome canvas showing the image in various shades of intensity, or else he reproduces them on canvases of different colors mounted together. After this phase he became interested in scenes of violence typical of American life: scenes of executions in the electric chair, traffic accidents, repeated in juxtaposed series. These too are mass images, avidly appreciated by the masses, who feel enormously attracted by the phenomena of violence. Warhol takes these scenes from news photos, by which they acquire impersonality, a very individual sort of distance. They are mechanical images, impersonal and antisentimental. Horror thus acquires the same passive and indifferent quality as a can of Campbell soup. In 1965 he exhibited a series of flowers, also taken from advertising illustrations, as if to erase his impressions of disaster and death, but they were flat flowers,with lifeless colors, anonymous, from advertising, and they produce the same sensation of emptiness and anguished distance as his scenes of disaster. Warhol's works convey a curious sensation of unreality, as if we lived in an artificial world that is a reflection of another,

distant and real world where the beings and the things really live. This manner of transmitting the American way of life, in spite of the total absence of opinion on Warhol's part (who limits himself to saying that everything is "pretty"), is the sharpest criticism of a mechanized and dehumanized life.

Bosley Crowther, "The Underground Overflows," *New York Times,* **11 December 1966, sec. 2, p. 1.**

It has come time to wag a warning finger at Andy Warhol and his underground friends and tell them, politely but firmly, that they are pushing a reckless thing too far.

It was all right so long as these adventurers in the realm of independent cinema stayed in Greenwich Village or on the south side of 42nd Street and splattered their naughty-boy pictures on congenial basement screens—or even sent them around to college outlets for the edification of undergraduate voyeurs.

But now that their underground has surfaced on West 57th Street and taken over a theater with carpets, the Cinema Rendezvous, where they have installed Mr. Warhol's most ambitious peep-show put-on, *The Chelsea Girls,* it is time for permissive adults to stop winking at their too-precocious pranks and start calling a lot of their cut-ups—especially this one—exactly what they are.

A Spoke in the Wheel

It is particularly important to put a stout spoke in Mr. Warhol's wheel and make it plain how flimsy his spontaneous and unrehearsed filming is, because too many hopeful film-makers, like the youngsters in the cinema schools, about whom I was writing with sanguine admiration last week, are letting themselves be influenced by Mr. Warhol's frankly lackadaisical style and by the clatter of adulation he has got from the underground.

Certainly if this picture should do well on 57th Street, on the strength of the prurient interest and the cultist curiosity it might arouse, this could be a further encouragement to the tentative march uptown and could foster a cinema movement that has already taken a dark and dangerous turn.

So let's get it said without quibbling that this seamy *The Chelsea Girls* is really nothing more than an extensive and pretentious entertainment for voyeurs, letting them peer (I should add, quickly, for all of three and a half hours!) at what is presumably happening in several rooms of a New York hotel. And what it looks at are manifestations of a very small segment of New York life—the lower

level of degenerate dope-pushers, lesbians and homosexuals, as distinct from the upper level perverts who are obviously outside the interest of this morbidly exhibitionistic film.

Already some sympathetic critics have hailed it as a shattering tour de force that artfully reveals a composite of the Great Society. But this is absurdly overstating a documentation which, at best, shows the squalor of a few unfortunate people—and not very artfully at that.

There are technical virtuosities. Mr. Warhol elaborately employs the split screen (two pictures at the same time), which has become quite popular in the underground. The sound-track is frequently distorted to give a fuzzy effect to dialogue or a sort of psychedelic tonality to the musical score. Shots are held for several minutes, with the camera zooming in from time to time to take a look at an irrelevant detail, then zooming out again. Frequently the images go blurry, as though the lens of the camera has glazed with too much uninterrupted looking. This is tough on the optic nerves. And scenes are frequently ended only when the film in the camera runs out, with an ostentatious flickering of the end-holes, and that panel goes white.

They Call This Art?

This may all be intended to remind us that we are only looking at a film. The cameras have been set up to record a movie. They are totally disinterested. So, evidently, is the director (if there is a director). And they call this art!

However, there are a few places where Mr. Warhol uses the two-panel screen to suggest a dramatic statement, maudlin though it may be. There is a set-up in which a fat, old, drunken woman is hideously berating her homosexual son who is in a room with a pensive young woman who has been established in a previous sequence as a strident lesbian. Then, on the other panel, comes a color image of the head of a young man (maybe the same one) lisping monotonously of his degenerate life. Then the mother disappears and in that panel appear three or four lesbians, seemingly paying some attention to the maunderings of the young man.

Or there is an interminable sequence in which a flaming homosexual man rambles on and on in a narcotized state about being the Pope and qualified to hear a young woman's confession, while in the other panel is the face of a beautiful blonde, looking wistful. There is a certain irony and pity hinted here in this evident juxtaposition of beauty and a beast.

Clearly the aesthetic principle on which Mr. Warhol works is to saturate or hypnotize the viewer into an insensible state.

No Cocteau He

But if anyone has a notion that Mr. Warhol's films—either this one or several others that have been floating around in the underground—might compare with such avant-garde classics as Luis Buñuel's *The Andalusian Dog* or Jean Cocteau's *The Blood of a Poet* or even Alfred Leslie's and Robert Frank's more recent *Pull My Daisy* with its famous narration by Jack Kerouac, they should forget it. This film most closely compares to such latter-day documentations of freaks and degenerates as Jacopetti's *Mondo Cane* and *Women of the World*.

It is too bad about Mr. Warhol, because he certainly seems to be eager as an prolific filmmaker who might do some meaningful work. There's a lot to be done with the split-screen, which we've already seen sensationally used for exposition purposes in movies at the World's Fair. There is also room for irreverence and iconoclasm in scanning the contemporary scene. But, heaven knows, there are more than homosexuals and dope addicts and washed-out women in this world! Mr. Warhol and his underground fellows might vary their obsessions with decay by making a couple of films about filmmakers who are too solemn to see the absurdity in themselves. That would be a good put-on. But it would be at their own expense.

Lucy R Lippard, *Pop Art* (New York: Oxford University Press, 1966), 97-101.

Warhol aligns himself with the spectator who looks on the horrors of modern life as he would look at a TV film, without involvement, without more than slight irritation at the interruption by a commercial, or more than slight emotion at tear-jerking or calamitous events. In this respect Warhol is far more true than [Peter] Saul to the attitudes of our technological society. Not everyone is so apathetic that he will watch a rape or murder without acting to prevent it, but many are. Most of us are unmoved by the public and private disasters that touched and enraged artists and thinkers in the 1930's. After World War II the tear glands of the world dried up from over-use. It is this world for which Warhol is spokesman; few can throw the first stone. Perhaps the reason the visual humanisms of the last decade have by and large failed so miserably with their horrified withdrawal, tormented expressionism, or mutilated-victim protest, is because their supposedly universal vases are not in fact shared by their audience. Since *everyone* understands the process of dehumanization blatantly and impersonally described by Warhol, his work is more likely to produce a positive attitude than the righteous indignation of those who are *against* anything in the

present, and *for* nothing but a vague, outmoded nostalgia. As Warhol has pointed out, "Those who talk about individuality most are the ones who most object to deviation, and in a few years it may be the other way around. Some day everybody will probably be thinking alike; that's what seems to be happening." These ideas find parallels in those of the French painter Jean Dubuffet, who has said: "My system rests on the identical character of all men If all painters signed their works with this one name: picture painted by Man, this question of differentiating, classifying, measuring men by various standards, would be meaningless.... What interests me is not cake, but bread," and asserts his anti-cultural position by saying that his aim is to bring "disparaged values into the limelight." Statements such as these provoked as much antagonism in the early 1950's as Warhol's do today, although the artistic results are poles apart.

While Warhol may be the most impersonal of the Pop artists, he too draws his subjects from his own experience—that second-hand experience which we all share. He has run the gamut of Pop subjects, with love and its commercialization and vulgarization a constant favorite. Warhol likes the idea that his life has dominated him. The Death and Disaster paintings, despite, or rather because of, their 'mechanical' execution, become one of the few forceful statements on this aspect of American life to be found in recent American painting. Just as we are fascinated by the newspaper or magazine photographs that are their sources, so we are doubly titillated by confronting these photographs in a less casual context—that of art—even if, as Warhol points out, "when you see a gruesome picture over and over again, it doesn't really have effect." Rhetoric is no longer either necessary or significant: our senses are so overloaded with artificial emotion from politicians' speeches, bad movies, bad art, ladies' magazines, and TV soap operas that a *stark* repetition like Warhol's means more than an ultra-expressionist portrayal of accident victims ever could. Gesture is of prime importance in the new art. It is neither the physical gesture of the Expressionist nor the ironic gesture of Duchamp, but an unequivocal act that is both simple-minded and intellectually complex. Warhol's films and his art mean either nothing or a great deal. The choice is the viewer's, as it is with the plays of Becket and Albee, the films of Antonioni, and the novels of Butor, Sarraute, or Robbe-Grillet. The more that is left out, the more can be seen of what is left. In Warhol's 'box show' at the Stable Gallery in 1964, which consisted of piles of wooden boxes simulating supermarket cartons with the brand insignias silk-screened on the sides, (Brillo, Heinz, Del Monte, Campbell's), the idea was paramount, but the idea became concrete only in visible form. Oldenburg, whose art is quite different from Warhol's, admired this show because it was "a very

clear statement, and I admire clear statements.... There's a degree of removal from actual boxes, and they become an object that is not really a box, so in a sense they are an illusion of a box and that places them in the realm of art."

Whether or not Warhol is indifferent to his subjects does not affect our own responses. He wants an art that will appeal to everybody, and his 'products' range form soup to cheesecake, Brillo to Marilyn Monroe, nose surgery to Jacqueline Kennedy. He is the most popular of the Pop artists; he did the cover for the 'teen-age' edition of *Time*, yet his *Most Wanted Men* were erased from the side of a New York World's Fair building as too controversial. Warhol is not by a long shot the best artist today, by virtue of his leadership of the uncompromisingly conceptual branch of abstract art. Warhol is greatly admired by many younger artists, even though he is also the center of a fashionable cult whose extravagant homages inevitably arouse suspicion.

Paul Bergin, "Andy Warhol: The Artist as Machine," *Art Journal* **26, no.
 4 (Summer 1967): 359-363.**

Andy Warhol the man is a difficult creature to grasp. His art, at least some parts of it, is familiar to us; so familiar, in fact, that it is becoming difficult not to think immediately of Warhol whenever we see a can of soup or an automobile accident. Yet in spite of this almost-over-powering presence of his work, Andy Warhol has managed to keep himself apart, a kind of enigma, a striking enigma, it is true, with his artificially grey hair, dark glasses and leather clothing, but an enigma nevertheless. His presence is a striking as one of his canvases, and just as devoid of a narrative sense. Warhol offers his image, his mask, for public consumption, but deprives the public of anything more. Asked about his background he once replied, "Why don't you make it up?" The remark is characteristic. It shows Warhol's unwillingness to expose himself beyond his public mask. The exact function of this image will be taken up later; but it should be mentioned now that Warhol apparently would prefer not to be thought of as a man, with a past, no matter how obscure, and a future, but as a unique entity, a thing of our day, who sprang into existence fully grown to do his work and who will someday vanish just as abruptly and mysteriously. That we know such is not the case doesn't matter. The presence of the desire, although it has remained largely unarticulated, is more important than the objective possibility. With regard to the public, Warhol does not want to exist outside of his image. For all intents and purposes, the image *is* Andy Warhol. This emphasis upon a stylized

exterior and the lack of concern for anything other than the obvious is a major theme in Warhol's art, as well as in his deportment.

All of Warhol's art takes shape and exists close to the unconscious. It is not conceived in a conscious mind; neither is it intellectually precise. Warhol's images are the products of "a semi-aware mind that duplicates without the awareness of the original identity." Warhol sees without reflecting and reproduces without understanding. We are left with an image—nothing more. Warhol's is the art of the machine but not, it should be made clear, a glorification of it, such as attempted by the futurists. Warhol's work is a statement, not a song. It is art stripped of personality and emotion and concerned only with the image, the obvious. It is art *of* the machine, not *about* it. The machine is, to the artist, a way of life, representative of a unique field of twentieth-century experience, and all of Warhol's art is a striving to express the machine in the machine's own terms.

Warhol attempts this through the use of primarily two devices, or approaches. First, and of the most importance in terms of "doctrine," is the already-mentioned approach to and reproduction of the subject. This lack of consciousness, this emphasis upon mere reproduction of the image without any understanding of its original identity, is the act of a machine. Whirl, click, and there you are, ma'am, another can of soup. Besides this mechanistic approach to this subject matter, Warhol comes yet closer to the machine through the use of a mechanical aid in his painting and sculpture—his now-famous silk screen. There are a number of advantages to the use of a silk screen, some of which Warhol has made haste to mention. First of all, it is easier to silk-screen images than to paint them freehand. Warhol is very fond, judging from the number of times he has mentioned this, of letting people know that he, like any well-designed machine, acts along the lines of least resistance. Also, the use of the silk screen permits his assistant to turn out an original Andy Warhol as easily as Warhol himself. The artist apparently wants his studio to be considered more of an "art factory" than an artist's studio in the traditional sense. Everything is part of his continuing attempt to give expression to the machine. The lack of consciousness, the employment of the easiest means of reproduction, the number similarity of the "end products"—in his search for the most valid means of expressing the machine, the artist himself has become one.

If the machine remains the artist's main concern in all of his work, the way in which he expresses it differs with each of the four main phases, or types, of his work. Probably the best known of these is his "commercial product" phase. Although all of his work in one way or another relates to the mass-produced

machine product, and consequently to marketing, this phase best deserves to be called commercial due to the *exclusively* commercial nature of the subject matter. With the exception of the Brillo carton sculpture, Warhol's overriding interest in these works is food. For the first time in history, man is able to satisfy his hunger with food untouched by human hands, machine food. Food is the most elementary of our needs and the availability of it in such a sterile, inviolate, form is, in itself, an eloquent expression of the mechanistic trend which has made it possible to satisfy all our material needs with the products of machines. Warhol recognized this and in his commercial work, most notably in the Campbell's Soup canvases, he presents us with images which are the final reduction of the importance of the machine in our lives—art untouched by human hands. The sterility of the subject matter is magnified to such an extent in these works that they emerge ultimately as a brilliant statement of the influence of the machine on our everyday lives. The choice of such elementary subject matter is indicative of a certain amount of genius at Warhol's command; because they are so common, so everyday, Warhol's images reduce the statement to inescapable terms. The commercial works are the least subtle and most mechanistic of Warhol's works. A machine is incapable of subtlety and in these works that fact is brought across via the power and authority of the canvas and sculpture. There is no escape from one of these works.

Warhol's flower paintings express the twentieth-century machine in different terms, deliberately calling upon the viewer to make a comparison between Warhol's flowers and "real" flowers. In the commercial works there is no need to go beyond the canvas itself to realize what Warhol is saying, but the flower pictures demand at least a rudimentary knowledge of what flowers look like before any sense can be made of them. Warhol's flowers are the flowers of the city rather than of the field. Flat and unrealistic, they bring to mind both the plastic artificial flowers so common in our society and the floral print designs stamped into fabric, especially that of awnings. The latter is the obvious reference, Warhol's flower images are the machines flowers of the twentieth century. They are flower images stripped of their flowerness, the reduction of the flowers which gape at us from awnings, wallpaper and contemporary centerpieces. Silk-screened onto the canvas, Warhol's flowers reside there in all their machine-made glory, a valid presentation of the twentieth-century flower or, as Allen Ginsberg put it in "In Back of The Real," the "Flower of Industry." Warhol as a conscious mind seems to be active in these pictures, as they are more subtle than the commercial works. This may, however, be a function of the

subject matter rather than of the artist, and my observation is, at any rate, merely a personal reaction.

A third phase of Warhol's work, the death-image paintings are the most striking of his creations and, to me, the most interesting as well. In these pictures, news photographs of suicides and auto accidents are silk-screened onto the canvas, sometimes blown up in size but more often arranged in rows and repeated a number of times. The colors used are the black and white of the original photo and the result is a striking, if at first somewhat enigmatic, visual experience. The most common ideas seen in these canvases are the theme of the automobile accident and the technique of "side-by-side" or repeated images. The automobile theme at once links the death-image pictures, which at first may seem to mark a departure from Warhol's earlier ideas, to the pervading theme of the machine. The machine-death link here exhibited is a strange one and one which constitutes a danger to anyone too ready to impose his own value system onto the painting. The juxtaposition of the machine (automobile) and death is likely to cause the casual observer to cry, "Here's what he's been trying to tell us all along! The machine is an agent of death. The machine is killing us!" The people who fall into such a trap do so almost consciously, searching for an easy way out of what is in reality a very complex, I think Warhol's most complex, series. The most obvious mistake such people make is the placement of too much emphasis upon the machine which is *depicted* and not enough on that one which does the *depicting*. The at-first shocking image of an automobile accident has, probably because it is, after all, a news photo, something of a narrative sense, which is an element completely absent from Warhol's other work. The casual observer is likely, then, to regard these paintings as didactic, Warhol as a low-tone Goya. Such a person is likely to think the repetition of the image an immature attempt to drive the "message" home. Overlooked in this incorrect interpretation is the fact that the source of the image is a news photo, taken by a camera, which is incapable of making a value judgement and reproduced by a printing press, also a machine and also lacking a conscious mind. It is in this twice-removed way that the artist receives the image. He has no contact with the death itself and can react then only to the image, not the actual death. The sources of the images are important, but it is the technique of repeated images that finally convinces the sincere observer that the artist is not making a value judgement. The repeated image technique was used in a few of Warhol's commercial works but was less striking, probably because we are used to seeing soup cans and boxes stacked up. The death images, however, when stacked up force the viewer to do a double take, force him to consider the picture longer than he might have and finally force

him, if he is observing the canvas at all objectively, to admit that the repetition renders the image meaningless. The death image is seen to be just another product of the twentieth-century machine, and as such is neither better nor worse than any of its other products. The death image is neither good nor bad; it *is*. The automobile—death link in the image itself *may* hint at a connection between the two, but the relationship remains undeveloped, if, in fact, it is there at all.

Finally, some consideration should be given to the portraits Warhol has done. In the long run, it may be these works which emerge as his best, because in the portraits, especially in those of Marilyn Monroe and Elizabeth Taylor, the artist has carried his theme of the machine product to its logical, if disquieting, conclusion—people as machine products, commercial property.

The portrait of Elizabeth Taylor is representative of Warhol's portraiture and it provides a good example of my point. The background of the canvas is chartreuse; onto this the image of Elizabeth Taylor's face has been silk-screened and amateurishly daubed with comic-book colors. The hair is a black shape, perfectly flat except for a small area at the top which is highlighted with chartreuse. The lips are a smear of red in the general vicinity of the mouth; the eyes are surrounded by monstrous patches of blue eye shadow and the skin is a pale, rather uncomfortable pink. The painting is at once shocking, familiar, and garishly eloquent, for in this picture Warhol shows Elizabeth Taylor's transformation from woman to public property. We do not see Elizabeth Taylor the woman on Warhol's canvas we see only her public image, what John Rublowsky calls her "mask." The woman is not at all visible in the picture; yet we know that somewhere behind the mask is a woman. In the canvas it is impossible to see the woman for the mask and in real life, it must be admitted, it isn't much easier. In a case like Miss Taylor's, it is difficult, in some cases impossible, to determine where the public mask ends and the person begins. Elizabeth Taylor is a commercial property, as commercial as a can of Campbell's soup, albeit turned out by a different type of machine. She is a thing of our day, and whether we like her or wish for the old *National Velvet* girl we cannot escape her, as we cannot escape soup or death. Miss Taylor is the person become machine product, commercial property, and Warhol's portrait of her is the final reduction of the theme of the machine, the central concern of all his work.

Warhol's idea of a person's public mask, his commercial aspect, exhibited in the portraits relates at once to the artist's personal behavior. Warhol's own personal mask, discussed earlier, doesn't seem unlike those in his portraits, and when one considers the commercial aspect of the portraits it becomes clear that the function of the mask is, in both instances, the same. Seen in this light,

Warhol becomes his own greatest work. His appearance, his actions, and his flippancy are all part of Warhol's public mask and it is hard, almost impossible, to distinguish the man from the image.

This offering by Warhol of himself as probably the best example of his art allows him to fit in perfectly with the art world that surrounds him and is his, as well as his contemporaries', primary outlet. Alfred Kazin told me recently of his conviction that in our age art has taken on a new authority. Although he was speaking specifically of literature, the same phenomenon is easily observable in the contemporary art world. Contemporary art has become, for a great number of people, a means of social advancement, a way of showing that one has taste and, more important, "connections." One's collection, especially of just-recognized artists, is one's social ticket and great care is taken and a good deal of money spent to amass a significant number of significant works. The collecting and display of contemporary art has become a very serious business. The emphasis is placed on the personality rather than on the work and personal contact with a given artist is sought after as a further item of social prestige. As one collector is reported to have put it, "I collect Jasper Johns." The grammar is significant. It tends to show that in contemporary America the artist, rather than the art, has become the commodity. That Warhol fits in easily can be immediately seen. Warhol has made himself a commercial product and as such has offered himself to the art "establishment." He has recognized their game and decided to play it, and in doing so has stayed within the scope of his art. Warhol's docile acceptance of a world which other artists, even other pop artists, have rejected as, at the very least, depressing, as well as his decidedly unpoetic work, clearly marks him as the primitive of the pop art scene. The pop artist, James Dine, speaking of the contemporary art world, has said, "I felt like a commodity, because no one really knew or cared about my work." Warhol, on the other hand, *wants* to be a commodity and has attempted to become one. He, probably more than any other artist, is one with his work and this exterior fact adds something to his art.

Yet, even after we accept this position of Warhol, we must *acknowledge certain failures in his art*. Most obvious is the problem raised whenever two words, constantly used in talking of Warhol, enter the conversation. The words, "like" and "delight," bring up the problem of consciousness, supposedly absent from Warhol's work. Warhol has time and time again claimed that he *likes* soup cans, Brillo boxes and floral print designs. Yet at least as many times as he has said this he has claimed, "I want to be a machine." We know that a machine is incapable of liking or, as a number of critics have put it, "taking delight" in,

anything. If the validity of Warhol's art depends on his actually becoming the machine, it surely fails. If we interpret "like" to mean "accept" the problem is not solved but merely put off. Even acceptance presupposes a conscious mind, an element supposedly banished from Warhol's work. Sartre would have it that any acceptance involves a corresponding rejection. The act of selection is, as we know, a conscious one. Every sensible person knows that an artist must edit, but we also know that a machine is incapable of the act. If Warhol is serious about wanting to be a machine, he should not edit at all. In doing so he is giving his art the lie. This may seem like nit-picking but Warhol's art is expounding what amounts to a new aesthetic and when the art fails the theory, even on a semantic level, it is significant.

Whenever a new school of art comes into prominence I suppose the obvious question is: "What do we do after this?" Usually more of an expression of frustration and dismay than an intelligent question, it nonetheless takes on definite significance when the art in question is that of Andy Warhol, or of the whole popular-image school for that matter. In Warhol's art, impact has superseded order and this immediately relates his art to such short-lived and self-defeating movements as representational surrealism and, most notably, dada. If pop art is not, in itself, dadaistic in nature, it has given birth to a movement which is a revival of dadaist and is even more open to charlatanism than the original movement. I mean "yes art," in which the old dadaist idea of found-object art has been given new life. But it has all been tried before, by the original dadaists, and found to be self-defeating. This revival can hope for no better fate. It would seem, then, that at least on this front, pop art has defeated itself—by giving birth to a self-defeating child. I am at present aware of only two artists who have absorbed the pop influence and moved on, successfully, to newer things—Jasper Johns, whose newest paintings show as such the influence of action painting as of pop art and are really a return to open experimentation, and Howard Jones, whose light paintings combine the poetic allusion of some of the other pop artists and the regard for the machine exhibited by Warhol. On all other fronts, pop art, and especially that of Andy Warhol, seems to have defeated itself.

It would be comfortable to be able to sum up Warhol in a simple sentence, to say that his art is either good or bad. It just isn't possible. His art fails in certain ways but it excels brilliantly in others. Some of his work is hardly worth bothering with and some of it is potentially great. It remains for Warhol himself, who is still very young, to show us how (or whether) to remember him.

Gerard Malanga, "Andy Warhol on Automation: An Interview," *Chelsea*
 18 (1968): 83-86.

Q. Do you feel that the moment of truth on automation is coming a lot sooner
than most people realize?

*A. I have always considered that the substitution of the internal combustion
engine for automation marked a very important and exciting milestone in the
progress of mankind.*

Q. But what is the truth about automation?

A. You don't have to think a lot.

Q. How do you feel about the 35,000 or more U.S. workers who are losing their
jobs to machines.

A. I don't feel sorry for them. It will give them more time to relax.

Q. Do you feel that automation has been responsible for the nation-wide coin
shortage?

A. Possibly: but I hope for the coin extinction.

Q. What does the computer mean to you?

A. The computer is just another machine.

Q. Do you feel that the alternative to automation is economic suicide?

A. Absolutely not.

Q. You have said many times in the past that you, yourself, would like to be a
machine. Does this mean that you sense what you are doing and are able to take
over operations to correct any mistakes or initiate the next step?

*A. Yes. The power of man has grown in every sphere except over himself.
Never in the field of action have events seemed so harshly to dwarf personalities.*

Rarely in history have brutal facts so dominated thought or has such a wide-spread individual virtue found so dim a collective focus. The fearful question confronts us, have our problems got beyond our control? Undoubtedly, we are passing through a phase where this may be so: but this will change with the rise of automation, because mankind will understand eras and how they really open and close.

Q. Purists speak of cybernation, in which a master machine is used to run other machines, as in a factory. Using this definition would you then say that you are a Purist?

A. Not yet.

Q. Would you like to replace human effort?

A. Yes.

Q. Why?

A. Because human effort is too hard.

Q. Close-tolerance "silk-screening" involves highly skilled technicians. What would happen, let's say, if you had the chance to acquire taped programmed machines with digital signals to guide the intricate silk-screen printing which is ordinarily done by me?

A. Everything would be done with more efficiency.

Q. Would you say that I have a property right to my job? I mean I own my job for life?

A. No.

Q. If my job vanishes into a technological limbo, won't another open up somewhere in this "factory?"

A. Possibly. It's all a matter of doing something else.

Q. Will I make more?

A. *Yes.*

Q. How will you meet the challenge of automation?

A. *By becoming part of it.*

Q. What will you do with all this leisure time created for you by automation?

A. *Sit back and relax.*

Q. Will you devote yourself to life-enhancing hobbies?

A. *No.*

Q. What does human judgment mean to you?

A. *Human judgment doesn't mean anything to me. Human judgment cannot exist in the world of automation. "Problems" must be solved. Without judgment there can be no problems.*

Q. Are you patient with little solutions and try to get as many as you can so they'll add up to something?

A. *What I try to do is to avoid solving problems. Problems are too hard and too many. I don't think accumulating solutions really add up to something. They only create more problems that must be solved.*

Q. Do you, then, feel that we're moving into a period, most probably a permanent period, where the main characteristic of the world will be change?

A. *Change is the same without being different. We live in a world where we do not notice change: therefore what does change only enhances itself a little more each day.*

Q. Dissect the meaning of automation.

A. Automation is a way of making things easy. Automation just gives you something to do.

Leticia Kent, "Andy Warhol: 'I Thought Everyone Was Kidding,'" *Village Voice,* 12 September 1968, sec. 1, p. 1.

Andy Warhol is alive and well. Last Thursday, accompanied by the inevitable coterie of business associates and superstars, Warhol went out on the town. It was the underground film-maker's first public appearance since last June, when, as everyone knows, he was shot down by Valerie Solanas, a writer who had played in his film, *I, a Man.*

We were sitting around a table at Casey's Restaurant. Viva, reigning superstar, and Paul Morrissey, Warhol's producer and technical director, were regaling their chief with tales of recent assaults upon their persons.

"We are constantly under attack," claims Viva. Very charming she is, and plenty paranoid: "Andy's shooting was part of a conspiracy against the cultural revolution. Recently a man leapt over three empty rows in a cinema and punched me as hard as he could." Viva's vexed, misunderstood expression made everyone laugh. "It was during the greenhouse scene of '*Amities Particulteres*' and I giggled and said, 'Gay among the gladioli, or faggot among the ferns.' It was supposedly a sensitive homosexual film—so tacky.

"I was also attacked in my apartment the other night"—she went on in a Holly Golightly monologue—"by someone whom I had never before seen. It turns out he's a professional attacker. All he does is beat up people. I really did a job on him. I think I fractured his skull. I've never seen so much blood . . ."

"Well, it's our year for crazy people. It really is," observed Warhol, wincing as though in pain.

"Feel all right?" asked the reporter.

The silver haired Warhol hesitated. "Uh mmm—sort of; I can't really tell," he said softly.

"Have you rethought your life-style since the shooting?" asked the reporter.

"I've been thinking about it," conceded Warhol. "I'm trying to decide whether I should pretend to be real or fake it. I had always thought everyone was kidding. But now I know they're not." He looked worried. "I'm not sure if I should pretend that things are real or that they're fake. You see," said Warhol, craning his head absently, "to pretend something's real, I'd have to fake it. Then people would think I'm doing it real."

"Do you think you had any complicity in the shooting," persisted the reporter, "in the sense of encouraging those around you to act out their fantasies?"

"I don't know,"Warhol replied, denying that he had ever encouraged anyone to act out his fantasies. His voice trailed off. "I guess I really don't know what people do. I just always think they're kidding."

Were his stars actually shooting dope in *Chelsea Girls*?

"I never really knew," he insisted. "I suppose they must have been. I thought they were kidding."

Did he think Valerie Solanas was kidding when she shot him?

Warhol shrugged and said his back was turned at the time. He had known Valerie Solanas four years. At first, when she showed him her manuscript *Up Your Ass*, he had thought she was a lady cop. Later, he had come to regard her as a serious writer, but he had sensed that she was disturbed so he avoided her. Sometimes she would telephone him late at night. Her nocturnal nagging was in the nature of crank calls. Once, when she needed money, Warhol had used her in a film. She never complained that she was ill-used.

Valerie Solanas's grievance, Warhol learned too late, was that she imagined he had conspired with publisher Maurice Girodias to defraud her of her works. Girodias had in fact given her an advance to write a book, but the publisher barely knew Warhol and had do business dealings with him. Now Valerie Solanas is in a mental institution.

"It happened so quickly," Warhol recalled. "She met me downstairs and we rode up in the elevator together. I turned around and it sort of happened . . ."

"So it was a surprise?"

"Oh, it was a surprise," Warhol said, "but the bigger surprise was that she had dressed up for the occasion. She wore lipstick, eye makeup, her hair was combed. And she looked so pretty in a dress . . ."

Warhol still likes Valerie Solanas: "I've never really disliked anyone. And I don't think she was responsible for what she did. It was just one of those things."

Wasn't that the same as his thinking that everyone was kissing? Shouldn't he be more angry and compassionate? After all, he had been badly hurt.

"Uh mmm," Warhol hesitated. His dark blue eyes burned straight ahead. He spoke quietly as if his voice box were sound-proofed. "I can't feel anything against Valerie Solanas," he said. "When you hurt another person, you never know how much it pains."

Was he in pain?

"Uh mmm, the whole idea of the shoot was painful," Warhol nodded. "It slows you up some. I can't do the things I want to do, and I am so scarred I look like a Dior dress. I'm afraid to take a shower." He giggled weakly. "It's sort of awful, looking in the mirror and seeing all the scars. It's scary. I close my eyes. But it doesn't look that bad. The scars are really very beautiful; they look pretty in a funny way. It's just that they are a reminder that I'm still sick and I don't know if I will ever be well again." Warhol fell silent. The clatter of silver and china filled Casey's. So did small talk.

"Since I was shot," Warhol went on, hypnotized by the central idea of his own resurrection, "everything is such a dream to me. I don't know that anything is about. Like I don't even know whether or not I'm really alive or—whether I died. It's sad. Like I can't say hello or goodbye to people. Life is like a dream. What would you call that?"

"Are you afraid?" asked the reporter.

"That's so funny," Warhol laughed as if to diminish his dread. "I wasn't afraid before. And having been dead once, I shouldn't feel fear. But I am afraid. I don't understand why. I am afraid of God alone, and I wasn't before. I am afraid to go to the factory."

Having spoken his fear, Warhol seemed relieved. He pulled a false mustache from his pocket and offered it to Viva, who pasted it above her thin-lipped mouth. It as no good, he decided, and took it back.

"What now?" asked the reporter.

"I'm thinking about getting busy again—if I can do it, said Warhol.

"With the same philosophical slant?"

"Well, I guess people thought we were so silly and we weren't. Now maybe we'll have to fake a little and be serious. But then," Warhol said, going on like a litany, "that would be faking seriousness which is sort of faking. But we were serious before so now we might have to fake a little just to make ourselves look serious."

"Do you laugh all the way to the bank?" asked the reporter, grasping at a realistic straw.

"For the first time we would have made some money this year," Warhol said, "but my hospital bills took all of that. Our grosses are very big, but the net is practically nil. And we plow what we net back into our experimental films. But the Beatles have a lot of money and we're trying to talk them into setting up a non-acting foundation for us."

"For your non-films?"

"Yes."

Then Andy Warhol and company walked to a party celebrating the
completion of a Hollywood movie, *Midnight Cowboy*, where Warhol, insulated
by two superstars, Nico and Ultra Violet, sat on a verandah and chatted with
British screen director John Schlesinger. He talked about how quickly Hollywood
films had caught up with underground films. He found himself beset with
admirers. He seemed glad to be alive.

**Gillo Dorfles, *Kitsch: The World of Bad Taste* (New York: Bell Publishing,
1969), 294.**

And if one refers to more recent manifestations, how can he deny the
presence of kitsch elements in many of the works of major American pop artists?
Some of Oldenburg's gigantic 'soft' still-lifes; some of Rauschenbergs stuffed
eagles; some of Wesselmann's lowest-grade advertizing posters with their nudes;
Kienholz's bar and other of his environments (which by themselves are enough
to give us a condensed idea of USA kitsch atmosphere); and some of
Lichtenstein's recent poster imitations (the first examples of which, made from
blowing-up his famous comic-strips, were never kitsch anyway, the languid
sunsets of his *Landscapes* and lastly, Warhol's *Mona Lisas*, with the myth
presented in a pop manner (the pictures repeated on the canvas also geometrically)
as with the Marilyn Monroes and the Jackie Kennedys, almost as if the three
personalities were linked by a common history. The pop process which has been
of decisive importance in the recent artistic scene has, in fact, brought to light two
apparently contradictory facts: 1) the way in which modern man—especially in
the USA—is surrounded almost everywhere by kitsch elements which he does not
even notice (the European arriving for the first time in the USA notices them
before the grandiose character of the general prospect and the robustness of
certain new perspectives have completely annulled his own 'historical' sensitivity
which, on the first approach, was jolted by this massive presence of kitsch); 2)
the way in which, on the other hand, these same kitsch elements have an
undeniable charm of their own which—where they have been used out of
context—is translated into the authentic work of art.

Paul Carroll, "What's a Warhol?" *Playboy* **16, no. 9 (September 1969):132-34, 140, 278-82.**

"I want to make an orgy movie," Andy Warhol said recently. "The orgy is what's happening now."

In the folklore of the Sixties, Andy Warhol is our hip Jay Gatsby: a shadowy, voyeuristic, vaguely sinister host with albino-chalk skin, silver hair, dark sunglasses and black-leather motorcycle jacket, who presides over a melange of kinky sex, drugs and smoking revolvers.

"The blond guru of a nightmare world, photographing depravity and calling it truth," was how *Time* characterized the underground-film maker 15 months ago, when two bullets from a .32-caliber automatic—fired by a man-hating woman who had played a bit role in one of his films—almost killed him, puncturing his spleen, liver, stomach, esophagus and both lungs. As he underwent a critical six-and-a-half-hour operation by a team of four surgeons at Columbus Hospital in Manhattan, the mass media poured forth stories of how Warhol surrounds himself with "freakily named people—Viva, Ultra, Violet, International Velvet, Ingrid Superstar—playing at games of lust, perversion, drug taking and brutality before his crotchety cameras." And when Warhol had recovered sufficiently to attend a roast-pig picnic given last October by friends in Greenwich Village, *New York Times* critic John Leonard described the artist as "a Moon-Man, a sort of spectral janitor . . . looking as though he had dropped from a star."

Helping inflame the critical imagination have been such Warhol movies as *The Chelsea Girls* (1966), with scenes depicting: two homosexuals lolling in Jockey shorts and bathrobe on a crumpled bed: a fat girl shooting speed with a needle into her buttock without bothering to take down her jeans ("It's quicker this way," she smiles into the camera); a willowy Lesbian sadistically bullying three girlfriends by sticking pins into their knees and forcing them to participate in harsh slave-master conversations; a homosexual named Ondine wearing a necklace that looks like Hell's Angels' chains, injecting amphetamine into his veins and announcing that as Pope of Greenwich Village, his flock consists of inverts, perverts and junkies, and then exploding into a tantrum directed against a hostile young girl whose "sins" he's been hearing in confession; and a transvestite in wig, false eyelashes, lipstick and satin evening gown, camping it up and singing in imitation of Hollywood sirens of the Thirties and Forties.

Other Warhol movies show scenes of rape, male prostitution and sadomasochistic bondage involving leather halters and torture masks. *Blow Job*

begins with a trouser being unzipped, then focuses for 45 minutes on a man's face as it expresses passivity, then happiness as an act of fellatio is being performed on him. *Fuck*, or *Blue Movie* shows a boy and a girl making love in bed and in the bathroom of a New York apartment.

Many establishment critics denounce such Warhol movies as "seamy," "exhibitionistic," "sadistic," "dirty," "half Bosch and half bosh," "sewage," "a peep show," "freakish," "physically filthy," "desperate," "gloomy," "decadent," "Dadaistic provocation," "travelogues of a modern hell," "sordid," "vicious," "too candid," "ruthless," "perverse," "pernicious: and "spontaneous eruptions of the id." Warhol has been scolded as being a commercial purveyor of prurience and a pathetic voyeur—who gets his kicks from peering through a Peeping Tom camera at orgiasts as they soap their bare behinds in showers, exhibit tufts of pubic hair, breasts and limp penises, and engage in teasing sexual foreplay and occasional intrusions into the various bodily orifices.

Other critics and movie *aficionados* insist that such sick scenes both document and satirize the decadence of American society. Critic Sheldon Renan has opined that Warhol's films collectively comprise a definitive commentary on the socialites, starlets, addicts, homosexuals, fashion models, artists and people on the make in New York's "bizarre demimonde." *The New York Times* calls the world depicted in his cinema "a searing vision of hell, symptomatic of the corruption of the Great Society, from godlessness to white power, the profit system and napalm."

In addition to their purported social content, Warhol's movies have also been hailed by some for their innovations in cinema technique. For such early films as *Eat* (1963), the director was awarded in 1964 the Sixth Independent Film Award—sponsored by underground-film maker Jonas Mekas' *Film Culture*—with this citation: "Andy Warhol is taking cinema back to its origins—to the days of Luminére—for a rejuvenation and a cleansing The world becomes transposed, intensified, electrified. We see it sharper than before." What Warhol tries to do with the film is what James Joyce did with the novel, argues former *New York Times* critic Brian O'Doherty, "and it is a measure of Warhol's achievement that the comparison is not laughable."

Warhol rarely directs and seldom edits a movie; he simply turns the camera on a bare-chested young man sleeping and exhibits it as a six-hour film called *Sleep*; or he focuses on the top of the Empire State Building and lets the camera grind away as *Empire*. One day in 1964, he asked Henry Geldzahler—curator of contemporary arts at the Metropolitan Museum of Art—to sit on a couch in his studio. Warhol turned a loaded camera on Geldzahler and then walked away,

without imparting a hint of direction. "Andy played a record for an hour or so in the back of the studio," Geldzahler recalls, "and because I was completely alone, I became a kind of still life. Gradually, I went through my entire vocabulary of gestures as I sat smoking a cigar. That movie," he claims, "is the best portrait of me ever done."

Warhol's movies—he's made some 150 since 1963 but exhibits only the few he feels are "interesting"—are just part of his output during the past ten years in a wide range of media. "Whatever Andy does," observes artist Claes Oldenburg, "he tries to be first and best."

Certainly he defies categorization. Characteristically, he's one of the very few major American artists to begin as a highly successful commercial artist. His elegant, often whimsical illustrations for women's shoe ads prompted *Women's Wear Daily* to hail him in the late Fifties as "the Leonardo da Vinci of the shoe trade"; in 1957, one of his ads won the coveted Art Directors Club Medal: and his 1961 Lord & Taylor window display featuring paintings of blowups of *Dick Tracy* comic strip characters is considered by some the first chapter of the book of *Genesis* according to pop art.

Soon after the comic-strip paintings, Warhol established himself as a pioneer of pop with cool, clinically exact and scrupulously deadpan paintings of Campbell's soup cans, silk-screen portraits of Marilyn Monroe, Jackie Kennedy and Elvis Presley, sculpture of Brillo boxes and wallpaper displaying multiple, identical busts of a cow. Each of these works had an impersonal, mechanical and even assembly-line character; and each image was done in multiples: 50 paintings of the same can of black-bean soup, 25 identical Brillo boxes, 100 images of the same cow. Impersonality was also evident in the celebrity portraits. Each was made from a tabloid or movie-magazine photo. And frequently, Warhol let assistants complete a painting or a sculpture for him. "The things I want to show are mechanical," he explained. "I think somebody should be able to do all my paintings for me. It would be so great if more people took up silk screens, so that no one would know whether my picture was mine or somebody else's."

Today, Warhol's assembly-line creations are considered collector's items and—by some—even contemporary classics. Next month, an exhibition celebrating the 100th anniversary of the Metropolitan Museum of Art will feature Warhol paintings including 32 Campbell's soup cans and 35 silk-screen portraits of noted pop-art collector Mrs. Ethel Scull based on a four-for-a-quarter Times Square snapshot. "The show will contain some 300 works which I feel are the best done during the past 30 years, explained Henry Geldzahler, who is

assembling the exhibition. "Such a show could not be compiled without a representative sample of Andy's art."

"I'm a retired artist," Warhol announced in 1965, at the height of his pop-art fame and success, when soup-can paintings were selling for $5,000, a celebrity portrait for $10,000. He began making films full time. From the beginning, his movies were unlike any others in the history of cinema. A customary complaint was—and is—that they are grindingly boring. "Most people would rather hear about a Warhol movie than sit through one." observes David Katzive, film critic and curator at the Museum of Contemporary Art in Chicago. "But the point is: One relishes Warhol's *concept*, which is terrific." The concept was revolutionary, if nothing else. Film the most ordinary subjects at an unvaried pace and then exhibit them for unprecedented lengths of time.

Psychedelic mixed-media entertainment is another art form at which Warhol has dabbled—and pioneered. His 1965-1966 extravaganza of dancers and rock musicians—*The Exploding Plastic Inevitable*—was one of the first to explore the possibilities of a show combining electronic music, dance, strobe lights and film. "Andy's like a Renaissance artist: He tries everything," observed a Lower East Side poet.

Last winter, Warhol wrote his first "novel." He calls it *a*. It consists of 451 pages of totally unedited manuscript transcribed from tapes Warhol made as he followed Ondine for 24 hours as he gossiped, quarreled, wooed and talked with friends, lovers, enemies, waitresses and cabdrivers. At first, *a* strikes most readers as a bore. Most of the time, you can't tell who is talking to whom about what; moreover, all misspellings made by the high school girls who transcribed the tapes were religiously reprinted, as were all typographical errors; and at least a third of the sentences simply make no sense whatsoever. But gradually, two elements begin to fascinate. Ondine emerges as a witty, irreverent and engaging character; and it becomes obvious that this is how most people actually sound as they talk with one another. *a* is a genuine microcosm of the world of words, fractured sentences, grunts, giggles, commands, pleas, rhetoric, pop-tune titles, squawks from taxi radios, TV-commercial diction, the oblique, sometimes radiantly direct idiom of the heart and the blablabla that surrounds us every day and often far into the night.

Warhol is also entering television. His recent widely discussed commercial for Schrafft's restaurant chain was a long, voluptuous panning shot of a chocolate, with "all the mistakes TV can make kept in," the artist explained. "It's blurry, shady, out of focus." NBC has since invited Warhol to produce a six-hour special. "In New York, apartments have a channel five which allows you to

watch anybody who enters the front door. That will be my show: people walking past the camera," he says. "We'll call it *Nothing Special.*"

Not all fellow artists agree that Warhol's art is either fresh or first-rate. One sculptor feels that he is too anemic: "Andy hasn't got any balls," he claims. "If Warhol's art were the only art around, we'd starve to death." And an underground-film maker charges: "His movies lack the personal involvement and vision that make or break a good movie. Warhol hides behind his camera."

Indeed, Warhol himself is usually as anonymous as his camera. Although internationally famous, he remains enigmatic and mostly in the background; as one of his friends says, "He's the Cheshire cat. Just when you're sure he'll be somewhere, he vanishes." In October 1967, Warhol sent an actor—disguised behind dyed silver hair, sunglasses and leather jacket—to impersonate him on a lecture tour of four West Coast colleges; his explanation once the impersonation was discovered, was that the actor was more like what people expect Andy Warhol to be than he himself could possibly be. A few years ago, he made a movie called *The Andy Warhol Story*, with a young poet and a fragile debutante both playing the role of Andy Warhol. And he does nothing to clear up the confusion about his biography: Various sources list his birth date as 1927, 1930 and 1931, and the place of birth as Philadelphia, Pittsburgh, McKeesport, Pennsylvania, and Providence, Rhode Island. Warhol is apt to suggest that an interviewer make up his own biography of the artist; or he'll say about his life: "It's always been like a dream, I guess"; or about himself: "If you want to know all about Andy Warhol, just look at the surface of my paintings and films and me, and there I am. There's nothing behind it."

Warhol's studio—which he calls the Factory—is even more oddly impersonal than the paintings and films. It is located on the sixth floor of an office building in Manhattan.

One steps from the elevator into a large business office with empty white walls and big windows opening onto Union Square. A gigantic John Chamberlain sculpture—a car squashed for scrap metal?—dominates the room. Two Plexiglas desks face each other near the windows. Manning one desk is 30-year-old Paul Morrissey, the lanky and affable executive director of Warhol Films, Inc. "Most of our calls are business," Morrissey explains, hanging up the phone that rings constantly on his desk. "We're doing all our own distributing now," he continues, describing plans to visit Europe in hopes of selling movies to distributors in Germany and England. Morrissey has been with Warhol since 1965. One of a big Irish Catholic family in the Bronx and a graduate of Fordham, Morrissey is probably sick of hearing it, but he resembles a

priest—asexual and fatherly; he's also maternal, particularly when he fusses around Warhol, whom he seems to feed with a constant, animated supply of information, gossip, opinion and moral support.

Taking care of business at the other desk is Gerald Malanga. Wearing a blue puff-sleeved shirt and leather pants, Malanga, who has worked with Warhol since 1963, is an extremely photogenic young poet, actor, film maker and celebrity in the international pop art-high fashion-hip taste world. "My education began with Andy," Malanga reports. "He's got this great way of brushing things aside with power: What you thought was beautiful changes in front of your eyes. He particularly dislikes and puts down "arty" things for being sentimental and corny. Andy likes clean, plastic images," says Malanga, turning so that his Neapolitan profile will be prominent. Like many in Warhol's group, Malanga is self-absorbed, and it seems to require great effort for him to talk about Warhol. "People say Andy's not serious. It's not true," Malanga continues. "Andy works terribly hard at everything he does—and we both work every day, trying to make our lives into works of art."

Like other members of the Factory, Malanga seems a bit protective of Warhol—and not simply because everybody is nervous about a threatened second attempt on Warhol's life. Quite apart from this understandable concern for his safety, his friends often treat Warhol like a child. Yet, clearly, he's the center of the complex operation, on whom all depend for livelihood and identity.

Warhol steps from the elevator. "I'm sorry I'm late," he says shyly, explaining that he's been visiting his mother in the hospital. Warhol is slight, about five feet ten inches tall, around 40 years old. Although indoors, he keeps on his black bullskin coat and tall olive fedora whose brim has been turned down all around and which looks like a tall Pilgrim hat.

He stands waiting for someone to take the initiative. "How do you feel about that woman being on the loose again?" he's asked. "Oh, they caught her, I just heard," he says. Once again, silence. The silence isn't hostile; it's like a vacuum waiting to be filled.

"Andy's idea of conversation is that somebody should talk to him," Henry Geldzahler has observed. A few years ago, the artist phoned Geldzahler around one A.M. "We've got to talk! We've got to talk!" he said by way of apology. "Well, what do you want to talk about?" Geldzahler asked, after the two met in a bar and the artist just sat there, mute. "Say something!" Warhol pleaded.

Around Warhol, you either do the talking or stare back at him. His appearance is unique—old, yet boyish; New York hip, yet old-country European. High cheekbones give a slightly Slavic look. (His parents emigrated in 1921

from Mikova, Czechoslovakia, to Pennsylvania where his father found work as
a coal miner: he died in 1942.)

Throughout the visit, Warhol keeps clutching a shopping bag, which,
combined with fur coat and hat, suggest the appearance of an aging European
woman. It's as if he were trying to keep his mother well by emulating her. It
also becomes clear that the artist keeps on coat and hat in a calculated attempt to
convey the impression—an accurate one—that Andy Warhol is mysterious, odd,
even a bit bizarre. His outfit, of course, is not what one expects: no sunglasses
nor black-leather jacket. On other occasions—equally unexpected—he does wear
the jacket, usually zippered up over a navyblue blazer or tux jacket.

"Everything Andy does is to attract publicity; he craves it," one veteran
observer of the New York art scene has said. "He wants you to think he's an
oracle—or something." The artist himself has admitted, "I prefer to remain a
mystery."

Warhol sits down on a couch in the big, barnlike, black-walled back room,
where films are screened and occasional silk-screen portraits are made. Asked
what he's been doing lately, he replies, in a low voice: "Oh, I've been thinking
about the philosophy of the fragile," which he then declines to explain or
elaborate. What does he cherish? "I used to like ice cream a lot."

He's famous for such remarks. Many people feel they're smart-ass put-ons.
Sometimes they are. But the Warhol aphorisms—"I like boring things," "I want
to be a machine." "In the future, everybody will be world famous for 15
minutes." "Everything is pretty"—are also concise and accurate expressions of
exactly what the artist means. Such aphorisms are as direct and economical as
the visual images he creates. Moreover, the aphoristic one-liner is also a kind of
armor Warhol wears to protect himself from the public and the press and to
conserve energy for his art and his life.

Making films is what Warhol talks about with the most oneness and ease.
"Films are more interesting than paintings," he feels. "They're really like
portraits, anyway."

"Everybody seems to be making films now," Warhol continues. "A few
years ago, underground films were like visual poems. Now they're turning into
novels." He seems acutely interested in the fact that Norman Mailer has begun
making movies, as well as Susan Sontag, who recently finished her first film in
Sweden.

Warhol is full of plans for more movies. Soon, he says, he'll take his actors
and superstars around the world to shoot in Japan, India and perhaps Paris.
Moreover, Columbia Pictures wants him to make a Hollywood film.

How does he discover the young men and women who act in his movies? "Oh, they're just people we meet. Sometimes, one just comes by the Factory; or we'll meet another at a party; or a friend will tell us about one. It just happens." Of the many males who have appeared in his films, only one has had any previous acting experience: Taylor Meade, the homosexual clown of underground cinema and theater. Warhol never encourages one of his discoveries to take acting lessons; he wants them to act in front of the camera as they do in everyday life.

"Actually, I want to make a movie now using straighter people than the unusual ones we've used." Warhol continues. "Next summer, we'll get five or six people living together for a couple of weeks out in the country, and just shoot everything that happens between them as they get complicated with one another." But he says he wants to shoot his orgy movie first.

In all probability, *Orgy* will be another innovation of sorts. If it's in the spirit of Warhol's other films, it will simply depict couples, threesomes, quarters or sextets going about their sexual business.

Where does the money come from to finance the films and to meet a fairly big payroll? Profits, he declares, are finally coming in from *The Chelsea Girls*—the first underground movie to be exhibited in commercial theaters. It has grossed an estimated $500,000. "But making movies is so expensive," Warhol explains. "We still have to do a portrait once in a while to get money so I can keep experimenting."

Against a wall in the back room of the Factory—ready for delivery—stands a silk-screen portrait consisting of a dozen identical images based on a photo of Mrs. Nelson Rockefeller, which the governor commissioned. It is a companion piece to a Warhol portrait of Rockefeller commissioned by his wife last year.

"The new art is really a business," Warhol feels. "We want to sell shares of our company on the Wall Street stock market." A prominent investor has approached Warhol with a proposal to establish a company built on Warhol's art, as well as on his status as a celebrity. "Andy Warhol is selling not art but a milieu," observes journalist John Wilcock.

Talking about the problems involved in financing his movies, Warhol becomes almost animated; but any question about his personal feelings is invariably met with a cold response. One of the few revealing remarks Warhol has ever made about himself occurs in an episode in *a*, in which a man named the Sugar Plum Fairy is interrogating the artist. "Why do you avoid yourself?" he asks bluntly; and refusing to be satisfied with Warhol's "Huh?", keeps after his prey with even more direct questions. Eventually, Warhol confesses: "Well, I've been hurt so often I don't even care anymore." When the Sugar Plum Fairy

protests that it's nice to have feelings, Warhol objects: "No, I don't really think so. It's too sad. . . . And I'm always, uh, afraid to feel happy because, uh, it just never lasts."

Hints of Warhol's hard-core melancholia appear from time to time, but his unhappiness is never expressed verbally; rather, it manifests itself in a remote, at times quietly desperate expression on his face. One night last winter, Warhol and some of his friends were eating dinner at Casey's—a restaurant in Greenwich Village, where on any night you see a river of marvelous, often astonishing-looking New Yorkers flowing in and out, table-hopping. On this night, they were coolly craning necks to observe Warhol. He sat at a prominent table, silently taping, with portable recorder, one of his superstars, gathering a chapter for *b* or *c* or *d*. At one point, a handsome but rather sharkish youth—who'd sat down and introduced himself as an actor—came on with a strong but guarded homosexual flirtation. The actor seemed only the latest in what must have been a multitude over the years. Warhol shares the plague of most celebrities—the knowledge that many men and women will prostitute themselves in any way in order to become well known by association with him. For a fleeting second, Warhol's face lost its customary interested but noncommittal cool; he looked sad, even frightened. He was polite to the young actor, but he soon turned back to his superstar and the tape recorder.

The artist's sly, understated, ironic wit is as much a part of him as his sadness. "I never wanted to be an artist," he has said. "I wanted to be a tap dancer." I don't believe in paintings on walls anymore: I like empty walls." Such deadpan remarks spoof generations of earnest teachers and critics who pontificate about the commitment of the artist.

"Andy's got such special fun," exclaims Bridget Polk, the cherubic shooter of amphetamine in *The Chelsea Girls*. "He'll phone me at four A.M. and whisper, 'Wasted space. Wasted space. What's in your mind? Wasted space.'"

Fun and gossip are staple ingredients around the Factory. As Warhol sat talking with a visitor on the couch in the screening room, Ingrid Superstar came over to confide that a famous Hollywood beauty from the Thirties and Forties had the hots for her and kept pestering her to visit. "Oh, Ingrid just wants me to talk about her!" Warhol teased. "Is it true you're slightly retarded, Ingrid?" he joked, with a sarcastic edge. Ingrid stuck her tongue out at him and said: "You're boss man around here, baby"; and then, with infectious buffoonery, she mimicked a star being interviewed: "Actually, I love working in Andy's films, because he lets

me do whatever's natural. In *Bike Boy*, I pulled one teat out and started talking
about fried eggs, garbage soup and garlic milk."

Ingrid, a lanky, pretty girl in her early 20s, joined the group in the mid-
Sixties, having moved to New York from New Jersey, where she'd been raised
in a middle-class family and had worked as a secretary. In many ways, she
reminds you of the girl you necked with in the back seat after Friday-night high
school football games.

Backbiting remarks about one another are common among the Warhol group.
One was accused of being money crazy and a puritan faggot. "A mirror walking
in motorcycle boots, looking for his own face to admire" was the comic valentine
given to another. "Andy encourages rivalry among us," says Malanga. "It keeps
things from getting dull—and we often do a better job because of it."

Friendship and occasional love, however, are also apparent in the
relationships among members of the Warhol scene. When one has been away,
he is welcomed with warmth back into the family. One Sunday afternoon,
Nico—another of his superstars—returned from Paris and joined Warhol with four
of his family in a big booth in the back room of Max's Kansas City steak house,
the unofficial club of New York artists, underground-film makers, rock
musicians, poets and pop intelligentsia. By way of welcome, Bridget Polk
interrupted a tape she was making with Warhol about her *Cock Book* (for which
she has invited famous artists to draw their reproductive organs) to lean over and
playfully bite and kiss Nico's long, graceful arm.

Nico is the most ethereal and lovely of Warhol's superstars. Seeing her in
her floor-length cape and listening to her musical, remote talk, one gets the
impression of a medieval German madonna glimpsed in a dream full of images
of spring and sunlight. Others in the Warhol group treat Nico as if she were quite
fragile, and all seem to have a deep affection for her.

The Warhol superstars—often collectively classified as weirdos—are actually
quite distinct from one another. Nico expresses herself in an extremely European
style—elusive, mysterious, dignified, feminine in the traditional manner. So does
Ultra Violet, except that she is far more cerebral. On the other hand, both Ingrid
and Bridget Polk frequently call on a rowdy, straight-from-the-bosom idiom—the
swinging Sixties version of the girl next door as a buddy. Viva talks in an idiom
all her own. In *Bike Boy*, she ad-libs that she'd dig making love on the handle
bars of a motorcycle careening along at 90 miles per hour.

Meanwhile, back at the Factory, Ultra Violet joins Warhol on the couch.
With a face like Hedy Lamarr's in *Ecstasy*, U. V., who looks in her early 30s,
is wearing a violet-satin pants suit, and her brown hair falls in ringlets around her

shoulders. She takes pains to explain that she is the daughter of a well-known French family that manufactures gloves and that for years she was deeply involved in Parisian social and charity affairs and that her good friend is Salvador Dali. Her voice is throaty, rich and velvety, and she strives to produce intelligent, informed quotes for magazine articles and posterity.

"Andy works like a psychoanalyst," Ultra Violet says, after Warhol has excused himself and gone into the front room to talk with a manufacturer who supplies him with Plexiglas. "His camera keeps listening and listening. The actors learn to trust, open up, and it becomes very real. His films show what's happening in people's minds. They're terribly objective reflections of our times."

Other superstars—past and present—also come from wealthy or socially prominent families. Baby Jane Holzer belongs to Park Avenue Jewish society: Viva, daughter of a well-known Syracuse criminal lawyer, attended fashionable Marymount College and the Sorbonne; gorgeous Susan Bottomley, who acts as International Velvet, is a Boston debutante and Edie Sedgwick is the great-niece of the late *Atlantic Monthly* editor Ellery Sedgwick and great-granddaughter of the founder of Groton, the Reverend Endicott Peabody.

Taylor Mead comes from a wealthy Grosse Pointe, Michigan, family. Most of the other male actors, however, are products of tough, lower-class backgrounds. Ondine grew up in the violent Red Hook district of Brooklyn; young Joe D'Allesandro comes from a New York tenement. Almost every young man in Warhol movies portrays a street arab, tough but tender and wounded—like the young Marlon Brando in *On the Waterfront* and *The Wild One*. On film, all of these lads convey either bisexual ambivalence or overt homosexual appeal. Invariably, they are the real stars of Warhol's movies; the women usually provide little more than comic relief. Nobody accuses Warhol of being the new Minsky.

After Warhol says goodbye to the Plexiglas manufacturer—who's been telling him how his son is worried about his future after college—Morrissey asks his advice about some detail in connection with shipment of *The Chelsea Girls* to a Detroit theater. Malanga calls across the room, asking Warhol if he wants to accept an invitation to a party. Ultra Violet begins showing him some photographs of herself taken by Philippe Halsman, asking which photo would make the best publicity shot. Morrissey begins telling him about an article in a forthcoming film quarterly.

"Oh really! How interesting," Warhol says. It is his most characteristic response. He appears genuinely interested, even astonished, no matter how humdrum the event or information.

"Astonishment at the scene—not necessarily celebration but wonderment at the spectacle: That's Andy's whole philosophy," observes Ivan Karp, pop-art novelist and assistant director of the Leo Castelli Gallery. Bridget Polk agrees: "Even a cookie or a chocolate sundae excites him."

Like everything else about him, Warhol's astonishment is basically passive. At times, he reminds one of an existential angel, observing and documenting ordinary reality without imposing his own ideological, aesthetic or emotional preconception or opinion on the Brillo box, on the tabloid photo of President Kennedy's widow at Arlington National Cemetery or on Taylor Mead doing a whimsical St. Vitus' dance in slow motion in front of the camera.

Warhol's art, films and novels can be seen, in fact, as a poignant, almost hopeless but curiously heroic effort to preserve that most perishable of events: the moment as it happens. "Andy's read *a* at least 40 times," Ondine reports. "He keeps reading it because it happened: He was there." In this, Warhol's art reflects how fragile our grasp of each moment of our lives really is and how inexorably each life passes into oblivion. Warhol seems to understand in his bones the aphorism of the late Argentinean poet Antonio Porchia: "One lives in the hope of becoming a memory." His art is instant memory, preserving reality as it is and as it happens.

Once he's chosen something from the chaos of everyday reality to preserve in his art—particularly in his paintings and sculpture—Warhol works extremely hard "at getting the image absolutely right," says Leo Castelli. "He doesn't simply arrive at an image easily and then repeat it senselessly—as many think. That cow wallpaper took him over a year to define."

Almost exclusively, the cool, stark, deadpan images Warhol records in his art come from the ordinary American world: the world of mass-consumer products, mass-circulation magazines, newspapers, TV programs and the world of motorcycle gangs, drug addicts, homosexuals and society girls. In this sense, his art is a vast museum of things as they exist at this time and in this land.

In another sense, Warhol's images reveal a tragic vision, documenting the American way of death: Marilyn Monroe's suicide, Jackie Kennedy's anguish, mangled corpses hanging from car crashes, the atomic cloud, the electric chair at Sing-Sing, a suicide hurtling from an office window, vicious sheriff's dogs mangling Negroes in Selma, Alabama, addicts punishing their bodies with needles and their emotions with drugs.

Also documented are the tragedies of love: a West Coast bike boy unable to establish any rapport with hip Lower East Side girls; homosexuals raping a woman in rage; the bleak, monotonous rituals of sadists and masochists; the

pathos of girls who make clowns of themselves by exhibiting scarecrow bodies and unappetizing breasts; the nomadic loneliness of the male whore; the sad, Babylonian fantasy of the transvestite; the desperate failure of those in the gay world to find the Fountain of Youth. Love and sexuality in Warhol's art are basically tragic. No joy. No consummation. No lasting love. Only a deeply ingrained sadness that communicates the pathos of being unable to find in the present some Eden of infancy or early adolescence.

Warhol's movies also parody and poke fun at sex and heterosexual love. They remind us that our libidinous acts and antics are frequently silly to the point of buffoonery. The old Hollywood's glamorized falsification of sex is mocked outrageously in Warhol's movie *Screen Test*, in which the frothy posturing of a transvestite, actor Mario Montez, lays the clichéed role of the gushing innocent ingénue to its long-overdue rest.

Lonesome Cowboys, Warhol's most recent release, makes merry at the expense of that archetype of American masculinity, the Hollywood Western. *Cowboys* brings the Western full cycle, according to the *Los Angeles Advocate*: "In the first horse operas, the cowboy could love only his horse. Psychological Westerns showed the villains as not all bad. Sadistic Westerns depicted the hero as not all good. Realistic Westerns revealed sex as not bad at all. And in *Lonesome Cowboys*, Viva observes that horses are better than men."

Warhol's art is also a comic, often sarcastic comment on the affluent society, with its ceaseless production and consumption of goods and celebrities. The America of Warhol's art is one in which endless soup cans, tooth-paste tubes and Brillo boxes invade our attention as ceaselessly as the parade of celebrity faces at whom we gaze forever on TV, in magazines and on jumbo posters. On a more biting level, such multiple identical celebrity portraits as Jackie in widow's black or Marilyn with garish magenta lipstick illuminate and indict the brute fact that the tragedy of each lady made a lot of money for a lot of people in the media.

Andy Warhol is often described as a child of media—a personification of technology. Indeed, he seems most at home when surrounded by the latest tape recorder, electric typewriter, silk-screen equipment, cameras and TV sets. When he's in the Factory or in Max's Kansas City or in Casey's or walking across Union Square, his portable Uher-4000 tape recorder is never far from him. He's most content when he can sit for hours recording the talk of one of his friends. Or when he can gaze through the camera lens, shooting whatever happens.

Warhol today, the cool embodiment of technological miracles, impassive behind shades and hard-boiled motorcycle jacket, is a far cry from the extravagant dandy he was in the 1950s. "He was so full of fun, so popular—nothing like the

rather lugubrious, heavy personality he's become," recalls David Mann, director of New York's Bodley Gallery and Warhol's first dealer. "In those years, his house was always filled with the most amusing, fun people: Andy gave the best parties. He had Tiffany fixtures everywhere—long before they became camp."

In recent years, Warhol has become fiercely private. Almost no one gets invited to visit his brownstone on 87th and Lexington. "Andy's been my best friend for years, but I only saw his home on the night he was shot, when Viva and I went to stay with his mother," Bridget Polk admits. "Was I surprised! The house is nothing like you'd think Andy Warhol's home would be. No pop art. Blessed Virgin statues all around the living room. And he's got a big four-poster bed with a night table covered by a lace doily."

Warhol's mother has lived for several years in a basement apartment in the brownstone. "The night he was shot, his mother kept muttering, 'My Andy, they hurt my little Andy!'" Bridget continues. "Actually, it's like Andy really lives with her. She tells him what to do. When you call, she'll eavesdrop on another phone and Andy'll say, 'Hey Mom, get off the phone!'"

Yet outside the house, Warhol and his friends go everywhere together. When it's time to leave the Factory for dinner, absent members are phoned and informed where and when everybody will be that night. Warhol needs his friends as much as they need him. "I can't do anything alone," he admits. Everybody, including Warhol, constantly refers to "we": We made this cowboy movie in Arizona." "We're going to a party." "We want to write another novel."

"If Andy had died from those bullets," Malanga observes, "work at the Factory would continue in much the same way Walt Disney Productions keeps operating. Andy's become an institution.

Not everyone is so heartened by the power of his persona. "Sometimes I thing Andy's just like Satan," Viva admits. "He gets you and you can't get away. I can't seem to go anywhere or make the simplest decision without him." That was also the reason given by the woman who tried to murder him. Poet Gregory Corso once berated Warhol for being evil because he allows women to fall in love with him makes them superstars and, according to Corso, gives them drugs, then drops them cold.

Warhol doesn't supply drugs, claim others intimate with the Factory scene. In fact, he doesn't take drugs at all. "I don't believe in them," he claims. With or without his help, however, other members of the Factory have suffered from "drug abuse": and two are acknowledged amphetamine addicts. After she left Warhol's group, Edie Sedgwick suffered a nervous breakdown, allegedly from

drug abuse, and was institutionalized. Another superstar is a regular on inpatient hospital lists to cure her drug habits.

Nervous breakdowns occur with alarming regularity at the Factory. One girl commits herself every summer to the psychiatric ward at Bellevue Hospital. "The casualty rate," observes journalist Elenore Lester, "is probably somewhat higher than the national average."

In addition to the dark cloud of emotional instability hanging over the Factory, there's also a chronic adolescent restlessness among members of the Warhol group. For most of them, the Factory is the most stable element in their lives. Otherwise, they seem adrift. None is currently married and only Ondine has a steady lover—a young painter, Ivy Nicholson, who admits she wants to marry Warhol, has had four children and four divorces; Nico's son lives with his father in Paris; and Bridget Polk is also a divorcee. Casual affairs, celibacy or occasional sex with one another—"You owe me a fuck, Gerard!" Ingrid announced in a cab last winter—are the lot of the majority of them.

In addition to their nomadic sex lives, few of Warhol's group have permanent homes. Most move from one cheap hotel to another, usually in the Union Square area; a few share apartments; and Ultra Violet lives in a penthouse on the Upper East Side. One member, a brilliant technician and photographer who calls himself Bill Name, has retreated to a small, pitch-black room at the Factory. "He's working things out in his head," says Ondine, "and someday he'll come out again."

One night last February, I found the Warhol group eating dinner in an East Indian restaurant near Union Square. Their table was festive and familial: a lot of civilized and sometimes bitchy gossip about the New York art scene and its regulars with some high-spirited gibing at one another's expense. Warhol saw to it that everybody got enough to eat. In particular, he fed a new young friend named Jed, an extremely rangy, mute Californian. "Take some of my curry," he'd say, shyly—as shyly as Jed would take some and thank him. And Warhol insisted on paying the bill. This is a habitual gesture.

After dinner everybody went his own way into the night. Warhol hailed a cab, saying he was going home to watch TV. "Orson Welles is on the *Late Show* in *Touch of Evil*. I want to see those terrific abstract cuts again."

Is he an important artist? Or even a good one? Perhaps. Perhaps not. I think he's a major artist, and there is certainly no doubting his curiously colorless charisma and his artfully nurtured notoriety, for whatever they may be worth. Watching his cab disappear into the ceaseless traffic circling Union Square, a friend remembered what an anonymous Manhattan voice had said to him a few

days before. "Who? Warhol? Nobody by that name lives here, mister," rasped the voice of the woman who'd answered the number he'd dialed by mistake in an effort to reach the artist. Then she said nasally: "Oh *Andy* Warhol! He's probably off someplace making a movie." Click!

2

THE NINETEEN SEVENTIES

Rainer Crone, *Andy Warhol* **(New York: Praeger Publishers, 1970), 30.**
"The End of Painting." Excerpt.

The last group consists of the *Flowers* paintings, the *Cow Wallpaper*, and the floating *Silver Clouds*. The *Flowers* were produced in vast quantities and all different sizes, from miniature to wall-size (82"x162"), in the Factory. Warhol had found the original photo in a women's magazine; it had won second prize in a contest for the best snapshot taken by a housewife.

The *Flowers* were shown for the first time in November, 1964, in the Leo Castelli Gallery, New York. These pictures are not pure photographic reproductions as those preceding them were; the contours of the flowers were touched up by hand on the screen. These pictures are unique in Warhol's production by virtue of their meaningless image content—a dubious honor shared only by the *Cow Wallpaper* and *Silver Clouds* in all of Warhol's *oeuvre*. They are and will remain strictly decorative, "upper wallpaper,"[69] to use Henry Geldzahler's words. Anyone who detects dehumanizing tendencies in these images is misinterpreting them. Their banal, abstract form is a guage against which to measure Warhol's other work. Color is used strictly decoratively in these pictures, and the flowers are there to carry it—it is their sole function. "I thought the French would probably like flowers because of Renoir and so on,"[70] Warhol commented on his exhibition at Ileana Sonnabend in May 1965. He went on to say, "They're the fashion this year. They look like a cheap awning. They're terrific."[71]

The Factory produced a total of over 900 *Flowers* in all sizes. "Friends come to the Factory and do the work with me. Sometimes there'll be as many as fifteen people in the afternoon, filling the colors and stretching the canvases" (Andy Warhol, 1965). The canvases were stretched after printing on the standard-sized stretchers supplied by the art shop, so the size of the finished picture was determined not only by the size of the image, but also by the stretcher. As a result, images overlapped or were truncated (as in the *Elvis* series) or the borders of the canvases were left unprinted.

NOTES

69. Quoted in: David Bourdon, "Andy Warhol," *The Village Voice*, Dec. 3, 1964.

70. Quoted in: John Ashbery, "Andy Warhol Causes Fuss in Paris," *International Herald Tribune,* May 18, 1965.

71. Quoted in: Robert Rosenblum, "Saint Andrew," *Newsweek*, Dec. 7, 1964, p. 72.

John Perreault, "Andy Warhol," *Vogue,* **March 1970, pp. 65-206.**

Andy Warhol's name is a household work like Ringo, Ultra Brite, or Raquel Welch. Andy Warhol is the most famous artist in America. For millions, Warhol is the artist personified. The ghostly complexion, the silver-white hair, the dark glasses, and the leather jacket combine to make a memorable image, especially in conjunction with sensational headlines: He was shot down by a man-hating "Factory" hopeful the same week that Robert Kennedy was killed, but he survived to expose his scars in the pages of *Esquire*.

Everything Warhol does is news, by accident or design. He starts a travelling lightshow discotheque called The Exploding Plastic Inevitable. He sends a fake "Andy Warhol" on a lecture tour. He eats popcorn in someone else's film.

Some would maintain that Warhol's greatest art work is "Andy Warhol," created by the same perverse but partially illusionary passivity that generated the silk-screen paintings of Pop stars and soda-pop bottles, endlessly repeated, or the marvelous flower paintings, or the helium-filled floating silver pillows, or the cow wallpaper—works that are classics and that, like the major works of Roy Lichtenstein and Claes Oldenburg, have changed the way we look at things.

"Andy Warhol" is a fiction, a disguise. "Andy Warhol" is Andy Warhol's greatest superstar. Warhol is the message of his own mediumistic journeys into the realm of the archetypical. He is the Fool of the Tarot pack, but also the Magician. That Warhol suffers as a person is irrelevant, even perhaps to himself.

There soon will be a retrospective of Warhol's works at the Pasadena Art Museum, a show that will arrive at the Whitney Museum of American Art in New York in 1971. Warhol does not care very much for the idea of a retrospective. He would rather show multiple versions of the same flower painting, which in reality would be a new work. Perhaps because of his fame—fame is always suspect to serious critics—and perhaps because his work cannot be discussed merely on a formal level, Warhol has not received the serious attention that his work deserves. This was probably a blessing. As it stands now, his paintings and other plastic works represent a closed oeuvre, for he has not made any new works for at least three years. Instead, he has devoted himself to his films.

"I think that movies," he told me recently, "are really the new paintings, I'm surprised that they didn't say that maybe thirty years ago, because they really are the new paintings." His shift from paintings to films is totally logical. His characteristic multiple silk-screen renderings of single images is as cinematic as it is Tibetan. It is a short step from the silk screen to the silver screen.

Brigid Polk is one of the stars of *Chelsea Girls*, Warhol's major film. She is also an artist that Warhol seems to want to promote. Her books are underground scandals. I asked Warhol if it were true that Brigid Polk, as reported in the press, had really been doing all of his paintings for him.

"Yes, for the last two years," he answered, following up with a typical contradiction. "She said it because she could say it, because it wasn't true. She just made it up."

Truth is sacred. Lies are the only safe way to get close to the truth, for the truth is unpronounceable. This is central to Warhol's sensibility. The truth is too hard to take. It has to be distanced or framed by numb repetitions. The blow-up silk-screen paintings are made from photographs that are in themselves already several times removed from reality. The repetitions and color-separation simplifications remove them even further and turn the images into icons or thought forms that decoratively symbolize what cannot be symbolized in any other way.

I asked Warhol if he thought of himself as an artist.

"No," he said, "but, I don't understand. I just like everything. Everything looks so terrific and then paintings are like . . . I don't know. I like the walls empty. And then as soon as you put something on them, they look so terrible."

I asked him if he had any pictures where he lives, and he said that he did but that they were just stacked up on the floor. Were they his pictures?

"No, I don't like my own pictures. . . . Do I like other artists? Oh, yes, everybody."

Warhol records everything. His portable tape recorder, housed in a black briefcase, is his latest self-protection device. The microphone is pointed at anyone who approaches, turning the situation into a theater work. He records hours of tape every day but just files the reels away and never listens to them.

Super-groupies, messenger boys, foreign journalists, members of his constantly changing staff and entourage all babble away in front of his stiff mike. He caters to exhibitionists and nonstop confessional monologuists, occasionally goading them on or keeping them at a distance with soft demands: "Did you really go to bed with Allen Ginsberg? Is that boy really your lover? . . . That's a pretty shirt. Where did you get it? It's so-o-o pretty. Did you steal it? Are you stealing things again?"

The Factory (Warhol's Union square headquarters in New York) is now guarded by an elaborate buzzer system and of all things, a stuffed Dalmatian. At the Factory, a labyrinth of invisible activities, rock is on full blast and the telephones ring constantly, pulling Warhol from one end of the huge space to the other. Everybody wants something: money, fame, interviews. Some people just seem to be there to try to get Warhol to buy something: an Oriental rug, old movie posters, or somebody else's dreary paintings. Everybody on the staff, regardless of sex or degree of effeminacy, is introduced as a transvestite. Warhol is making a Hollywood movie called *Blonde on a Bummer*, starring a real transvestite named Candy Darling and this, to some extent, explains the joke.

The main topics the afternoon I was there seemed to be getting the Rolling Stones to pay for a Warhol record jacket that had been turned down and the suicide of the Hollywood gossip columnist Steven Brandt.

"Did he call? Do we have any tapes of him? Where was Viva? Didn't they all go to see the Stones together? Where was Ultra?"

Death, sex, money, and fame were the main themes of the 'sixties: and they have been Warhol's themes also. The art of the 'seventies may add hunger to the list, hunger that is both spiritual and physical. The cannibalism at the end of Godard's film *Weekend* and the cannibalism of the quickie *Night of the Living Dead* are only the first signs, as were Warhol's own films *Eat* and *Blow Job*. One can very easily sympathize with the neo-Swiftian Yippie demand that we eat the dead victims of the war in Vietnam. We are what we eat. We may have to eat ourselves. The serpent devouring itself is the symbol, like the mathematical

sign of an eight on its side, for infinity that is the same as eternity: a grand tape loop, repeating and repeating.

Warhol tapes everything. Once while talking to Warhol on the phone—gossiping, rapping, trying to "get something"—I heard the unmistakable whirl of his tape recorder. It took me off guard for a few minutes, but then I adjusted to it because, after all, I was also taping him.

Everything is being recorded. What we are going to do with these millions of miles of tape and film and television tape and photographs remains to be seen. In some way they protect us. If there are no secrets, if everyone knows everything about everyone else, right down to the most intimate behavior patterns, then there is a certain kind of freedom. My body and what I do to it or what it does to me are as interesting as my signature or my poetry or my prose.

Warhol tapes in much the same way that Lemmie Caution takes snapshots in Godard's *Alphaville* or the son in Resnais's *Muriel* takes photographs and films as a way of gathering evidence. Warhol's taping is both sinister and arbitrary. The arbitrary is often what we interpret as the most sinister. On the other hand Warhol's stiff mike appears to be purposeless and Taoistic. Whatever happens, happens. An odd overtone or undertone, is that a device such as the tape recorder, theoretically designed to aid communication, is used by Warhol to disrupt communication or distance in much the same way that his repeated images of electric chairs or auto accidents cool these images and make them bearable, even beautiful. People perform for his microphone in much the same way that they perform for his movie cameras. They imitate themselves. And since we all imitate ourselves and this imitation is called style, a peculiar kind of reality is captured.

Warhol's novel "*A*" is a transcript of some of his tapes. The transcription was done by high-school girls and the final text retains all their mistakes. If "*A*" is only about tape recording, it is an almost unreadable failure. If it were primarily about tape recording, it should have been issued as a tape. If "*A*" is of any interest at all, it is because it might not really be about tape recording per se, but about transcription, from sound to tape to print. The errors are the most important parts of the book.

Finally, after uproar and waiting and games of all sorts and, above all, ploys, I was ready with *my* tape recorder to interview this famous artist of the sixties, someone whom I did not really know, someone whose actual art I respected, someone as defensive and evasive as myself. Two mirrors facing each other. Two microphones. At one point in the interview the double interview, for my joke was that Warhol was also supposed to be interviewing me—our talk was

interrupted because it was Friday and he had to sign a paycheck for someone. He put down his microphone and said, "Put yours next to mine and they can record each other."

Warhol is not dumb nor is he passive. The passivity to a large extent is a mask and a protective device. After we had relived his famous ploy that "Oh, interviews are great as long as there is someone to tell me what I have to say" and I had countered with, "It doesn't matter what you say: I'll make up the answers when I have to write the article," I went one step too far and was foolish enough to say that there was no real reason to have the interview because I could just as easily make up the whole thing. Disaster. Faint anger vibrations followed by a whole half hour of inane interruptions. The passivity is a mask. Warhol is one of the most vulnerable people I have ever met, but in his own way he is also one of the most aggressive.

It is probably true that most of Warhol's ideas come from other people. People are constantly babbling out projects to him. But Warhol, who as an artist is about choice, not chance, chooses what he needs. Recently, as an art work, partially influenced by "Street Works" and the forthcoming "World Works" (a collaborative effort by Hannah Weiner, the artist Marjorie Strider, and myself), he sent the critics Gregory Battcock and David Bourdon to Paris for Thanksgiving dinner. They were to document the whole occasion. It was David Bourdon's idea, but if it had not been such a good idea, Warhol would have rejected it. His choosing it made it his idea and his art work. He was, as current slang would have it "doing a number" on Documentation Art, World Art, and on critics, whom he now maintains, thanks to Battcock, will be the important artists of the seventies.

The artist Les Levine—for a real glimpse of art world paranoia see Bourdon's *New York* magazine piece of February 10, 1969, on his attempt to arrange a trade of art works between Warhol and Levine—maintains that the people around Warhol represent Warhol's own fantasy life. To extend this metaphor, the superstars, kooks, exhibitionists, and beautiful children are what Warhol is not or what he cannot express. He needs them as much as they need him.

Marcel Duchamp once said that what interested him about Warhol's paintings of repeated soup cans was not the soup cans but the mind of the person who would want to do such a thing. It is not by accident that Warhol has been buying every Duchamp he can lay his hand on. Although it is apparent that Warhol operates much more intuitively than Duchamp, he has always been one of Duchamp's major heirs. Warhol has stopped making paintings just as Duchamp did almost half a century ago, perhaps for different reasons, but with similar

myth-making results. It is not by accident that one of Warhol's silk-screen paintings utilizes the image of the Mona Lisa over and over again. Duchamp reduced the Mona Lisa to a sexual pun that not only illuminated Da Vinci's sexuality and perhaps Duchamp's but became a metaphor for sexuality that goes beyond art or anti-art. Warhol reduces Da Vinci's prototype and Duchamp's meta-metaphor to the same status as repeated rows of Coke bottles.

Everything is interesting. Sex and death and art are as interesting as flowers or cows. Death, nevertheless, is the central theme of Warhol's most important works. The "silence" sign in the electric-chair paintings forms a relationship to the Warhol self-portrait in which his finger is placed up to his lips, recalling the woman in Redon's "Silence." Death is like repeating the same thing over and over again, a trap, a loop. The repetitions create a life of their own.

On the surface, Warhol is not different now from what he was before the shooting that put him on the critical list for several tense weeks. Underneath the cool surface, however, there may indeed be a difference.

"I am afraid of everything now. I used to think that everything was just being funny. But now I don't know. I mean, how can you tell? I can't tell if a person is just being funny or if they're really crazy. It's so-o-o peculiar. I just try to take people for what they are and people who are a little crazy, they're usually so-o-o creative, aren't they? But I just don't know."

David Bourdon, the critic, said that Warhol's nearly tragic shooting-down is his greatest art work and that in some way because of his fascination with death and violence and aberration, he programmed it himself, unconsciously.

Andy Warhol uses people. It occurs to me as I write this that I am using Warhol in order to write something interesting. He is a symbol. But by me using him, he is using me. That is a large part of his genius.

"Do you feel any different now after getting shot and being in the hospital and everything?" I asked him at one point in the interview.

"No, it's all the same. I mean, I can eat everything. But that's different. It feels different."

"What do you mean?"

"I mean . . . maybe it would have been better if I had died."

"Why?"

"I mean it's so-o-o awful. Everything is such a mess. I don't know. It's so hard."

Emotions showed on his face for the first time.

"But you seem so cheerful and active."

"Yes, I know. But you have to . . .you know, you have to pretend."

You have to pretend

Life, like art, becomes a kind of fiction. But was that Andy Warhol speaking, or was it Warhol's "Andy Warhol"?

Joseph Masheck, "Warhol's Early Manipulation of the Mundane: The Vanderbilt Cookbook of 1961," *Art in America* 59 (May-June 1971): 54-59.

Etiquette is about how to act well. It is a mundane, but true, department of esthetics because it is concerned, beyond utility, with the right way of doing something in itself. We know what a serious matter it was in the time of Raphael and Castiglione, and we have come to see that it affected the disposition of Baroque palaces. So it is all the more interesting to find Andy Warhol at the opening of the 1960s illustrating a book by Amy Vanderbilt, the greatest authority on etiquette in America.

Actually, this should to some degree surprise us; if not, we might be making the mistake of treating both Amy and Andy less seriously than they deserve. Far from being a simple case of converging Pop trivialities, of an easy accord between a blasé and casualized high society and slick and chic commercial art, the collaboration was an event of a high order of importance in the social history of recent art, and a kind of microcosmic version of the readjustment of artistic and social relations which only now, a decade later, is beginning to become clear.

Consider that books on etiquette, cooking and "how to" in general are the unadmitted recourse of people who do *not* know, either by breeding or intuition, how to act in the situations that confront them. Most readers of such books are, by definition, people who are at least momentarily out of their element. I mention this now because (a) Amy Vanderbilt's democratizing openness and cheerful adaptability are a rarefaction of widespread attitudes in the ambience of Pop (cf. the now unbelievable turgidity of Emily Post's etiquette book, which Vanderbilt's superseded) and because (b) Andy Warhol's own gliding adaptability always—at least until the assassination attempt—informed him with a mysterious classlessness and, at the same time, a kind of polysocial desirability. Americans have always in some degree enjoyed this social latitude in Europe, even though it never worked the other way around: Henry James had a much easier time in London that Roger Fry had in New York. But Amy and Andy are the first Americans to raise this ease to an ethical esthetic level. Neither, we feel, would be out of place anywhere, while how many places there are in this city alone

where Emily Post could not be at ease! This is an almost moral achievement (cf. Burke: "And vice itself lost half its evil by losing all its grossness").

Warhol and Vanderbilt were obviously on the same wavelength. What we are concerned with at the moment, however, is case of collaboration between the two, at a time when the cards of the 1960s were being shuffled but not yet dealt. Andy, then calling himself Andrew Warhol, on the title page, made the illustrations for *Amy Vanderbilt's Complete Cookbook* (Doubleday, 1961).

It would be a mistake to treat these drawings with entire solemnity, but it would also be a mistake to approach them mock-heroically. While Warhol's cookbook illustrations have never been discussed, it is not, let's face it, as if we came upon a missing Leonardo sketchbook. Nevertheless these modest, unassuming illustrations are indeed absorbing in themselves, and their very modesty and unassumingness are qualities without which it would be impossible to imagine his mature (funny word) style. They are a real link between his merely commercial art infantilia and the fine art which came soon after, and they document his first tinkerings with the esthetic presuppositions of commercial graphics as material for his own play and workmanship.

Consider first the relation of the illustrations, particularly those which are repeated, to the text. Often the same drawing will be used over again once or more in the book. Sometimes, as with the *Pot of Flowers* (pages 12, 85, 259), it is used as a simple typographical decoration, having no direct illustrative function on a given page. But it does not remain an inert cipher: the same *Pot of Flowers* finds a place in *Breakfast Tray* (293)as a represented and useful thing. And the same motif, appropriately expanded (eight blooms instead of four), becomes the centerpiece of a *Buffet Table* (692-93). That is one kind of repetition and modification to which Warhol subjects a motif, and the bluntest.

Another, more complicated and more interesting, kind involves—as in the *Nuremberg Chronicle* —the use of the same picture to illustrate quite different things. But Warhol in the *AVCC* always ties such an illustration to one meaningful place in the text; it may occasionally occur as a pointless embellishment of the page, but it also occurs somewhere where it means exactly that it is. Thus, while in the *Chronicle* the same "illustration" used to represent several cities, is hardly more than an illiterate glyph, in the cookbook a *Leaf-shaped Tray of Canapés*, used as a simple tailpiece to the chapter on "Casserole Meals" (173), also makes a functional appearance in the canapé section (13). That the narrative appearance of such a drawing does not necessarily precede its nonobjective use adds complexity to the illustrations considered as a set by insuring that the nonfunctional repetitions will not strike the reader as mere fading

echoes of something that initially made a point. Thus an interesting stuffed half of *Pineapple on Plate*, which first appears between doughnuts and pancakes (96), assumes selfdemonstrative properties, even though without explicit textual reference, in the context of "Quick and Easy Fruit Desserts" (270). A *Casserole* drawing which first illustrates "Beans for Everybody" (155) appears, blown up in size but otherwise exactly the same, as a picture of *French Pot Roast* (376). It is as if, in the *Nuremberg Chronicle*, Jerusalem really did, in real life, look like just a bigger version of Cologne.

An even more abstract connection is established when Warhol shows something that looks complete in itself, but which is then made to mean more by reference to another version of the same motif. When we first encounter a still life of *Jar, Spoon and Cake Tin* (87), it looks perfectly self-sufficient, but when we see it again later on (114), we are informed that the jar contains "spice."

One narratively amusing remobilization occurs long after we are introduced to the *Chafing Dish* (176). Much later (350), it is suggested that the same device might be used by housewives to coax home suburban husbands who dawdle at Grand Central Station" "If you're a New Yorker and your husband is late during the "R" months, he may well be dropping in to have his stew made before his eyes at the Grand Central Oyster Bar. Rx: Get him a chafing dish and all the makings and let him have this as his culinary specialty at home." Bearing in mind especially the powers of oysters, the text carries us to a point where we realize in a newly Warholean way that sublimation is the heart of art.

The tale of the chafing dish also implicates Amy Vanderbilt's ideas about masculinity. She makes it quite clear in her preface that cooking is not for men: "The men in our family were all quite sure of their roles as men, which in my opinion is the way it should be. My father and grandfather were never to be found in the kitchen mixing a cake" (vii). It is o.k. for men to shop for food and to carve meat, but clearly, for Amy, the Grand Central chafing-dish game is a desperate move. (One can only wonder where this leaves art.)

Because of her attitudes on men and cooking—a curious feature in this radical social leveler—the drawings which show hands carving meat take on an almost ethnological interest. In actual fact, the only times male hands appear in the *AVCC* they are carving: *Carving Rolled Roast* (740), *Porterhouse* (741), *Crown Roast* (742) and *Roast Loin of Pork* (743). These hands are hunkier than all the others which appear, are the only ones with fingernails, and make none but fisty grips on tools. However, when we come to *Carving Poultry* (745), the very last of the carving drawings there are five steps), the dainty, pointy lady's hands take over. Now, quite apart from the gender of cooking, it is an anthropological fact

that in some cultures poultry, as distinct from meat in general, is an exclusively feminine affair.[1]

These particular carving illustrations are also extraordinary scientific in themselves, much more so than the work of many scientific illustrators—who fail to control their tendency to conceptualize. Warhol's instructive sketches never, in any detail, supply wrong data, or information whose superfluity is open to misinterpretation. The reticence on the artist's part is not merely a stylistic trait; it is rationalistically, and almost technologically, masculine. Witness his concern with tools (*Row of Kitchen Tools*, 159, repeated 327; *Barbecue Fork, Kebab, Gloves*, 33). In fact his cheerfully gung-ho attitude toward tasks and their equipment is, in modern painting, probably more suggestive of Léger than of any other individual.

Actually, in a number of ways, Andy Warhol resembles Fernand Léger. Both did book illustrations, both made avant-garde films, both played around with *Mona Lisa* (Andy in 1963), both like the grinning ambience of sport (Andy's current surfing movie), and both, above all, have celebrated the enjoyment of the surface of modern life ("I think I was the first modern French painter to use the objects of our time as artists of other centuries used theirs"). Léger's mustachioed, cigarette-smoking, tattooed, muscle-flexing *Mechanic*, (1920) is a real antecedent of Joe Dallesandro. The big dopey booms of Léger's *Composition with Sunflowers* (1953) are pointed and angular, but in their affected goofiness and naïveté (and in their flatness) they look forward to Warhol's obese *Flowers* of 1964, and, in between, to the *Pot of Flowers* of the cookbook. Warhol's *Seafood Steamer* (335) can also be compared in a general way with the potted plant in Léger's *Composition with Blue Vase*, (1937), and the big aloe form in that picture is a characteristic Léger motif which finds its way into the surface decoration of especially the lower section of the seafood steamer itself. Warhol's row of glasses (62) presents a row of seven glasses in absolute profile. Three of them have the simple, *moderne* Duralex brand fluting that Léger always admired, and in fact Andy's second vessel, a tall, conical soda glass, is the same—this time minus the fluting—as the beautiful classic Duralex example in Léger's *The Siphon* (1924).

The visual parallel with Léger's happy, trusting, accepting indulgence in the inflated abundance of Art Déco life came to strain against the realities of the war (it is interesting that he returned to his aloe device in his murals at the United Nations), in the same way that life is no longer as simple—and that art is not as easily milked from it—for Andy Warhol now as it used to be. More than a

personal trauma, his attempted assassination was the impingement of a quite different and much less morally easy new world for everyone.

Dozens of little sketches of cuts of meat cover four consecutive pages in the center of the cookbook (362-65), illustrating the cuts which are prepared as beef, veal, pork and lamb, and charting which parts of a cow, calf, pig or sheep supply the appropriate material for each. The fact that the carcasses of the animals are rendered in the most diagrammatic way gives them the polite neutrality of maps. In fact, these diagrams, leaving spaces between the parts, like spread-out picture puzzles, omit altogether those parts which might hint either at death (severed heads, paws) or concrete gore.[2] Only their accompanying sketches show the cuts of meat as full-round, plastic forms, and they are separated and jumbled, avoiding any suggestion that they could be fitted together into the shape of a once-living body. I dwell on this quality because it seems so civilized, particularly in comparison with such contemporary phenomena as the old, pseudo-avant-garde abattoir moves of Cinema 16. Warhol's meat cuts leave no doubt in the mind that for a beautiful hunk of Boston Cut, properly cooked, a man has every right to kill a cow. This lucid, Scholastic (the freedom of the letter of the law) moral penetration—a characteristic which in grander circumstances than these illustrations heavily informs works by Warhol (e.g., the complete absence of evidence of sin in *Blow Job*)—is already active in the 1961 *Cookbook*. Certainly the world is different how, as all around us what seemed in the sixties like the disarmed horror of farce now threatens to realize itself in life. Certainly Andy's "disaster" paintings, of 1962-64, have changed their tune over the passing years. But, even there, we have only to remember how much longer Godard took to arrive at *Weekend*.

Certain parallels between drawings of food in the *Cookbook*, including the meat cuts, and Claes Oldenburg could be drawn—particularly the Oldenburg of *Store Days* around the same time. But there is probably a closer relation between Andy's illustrations and the work of Roy Lichtenstein than with anything else in Pop Art. It is particularly suggestive to turn to Lichtenstein's *Standing Rib* (1962), or to compare Warhol's vignette *Portable Barbecue* (36) with Lichtenstein's *Stove*, also painted in 1962, the year after the *Cookbook* appeared. Lichtenstein's picture views a kitchen stove in the same deadpan, homey way, and, as a matter of fact, from a similar angle in space. The comic-book hatching on the door of Warhol's barbecue indicates glass in the same way as the gleams on Lichtenstein's stove, or on the panes of Warhol's own painting of a *Storm Door, 12.88* of 1961.

If we stretched this assertion, so that it made works like Lichtenstein's *Ball of Twine* paintings of 1963 in some way responsible to Warhol (the tidy way they embrace a piece of household equipment and unveil its simple loveliness), we would be wrong, because we would arrive at a point where Warhol and Lichtenstein were working out from common sources of cheap commercial illustration. And yet the *Cookbook* was, in a way, a Step One in that process, for, while it draws upon sources of that kind, it is as deliberately a piece of art illustration as a book of Walter Crane's. While many of the *Cookbook* pictures are superficially on a plane with the line drawings of, say, the Yellow Pages, after a moment their shy estheticism shows through. This is particularly apparent in the "dynamic" drawings, the ones which show hands doing things. The rarefied gentility of the hands squeezing a pastry decorating tube (28) or demonstrating the *Fishery Council Method of Opening Oysters* (344) adumbrates the more bourgeois-ladylike grip on the sponge in Lichtenstein's *Sponge* (1962) or on the aerosol can in his *Spray II* (1961).

How does the Warholean invention differ from the Lichtensteinian development? Perhaps it stops further short of parody. The odd thing is that, while Lichtenstein is generally a painter of greater classic formal strength than Warhol, the painted Lichtenstein how-to-do-it pictures are somewhat weakened by literariness compared with the *Cookbook* illustrations. It is not that Warhol is the better artist; it is that he has subtler hunches and a bigger grasp of the little things that painting and sculpture are as *jobs*.

The actual text of the *AVCC* contains some information of historiographical interest, especially with respect to the Campbell's Soup paintings. The soup cans, which began in 1962 with works like *Four Campbell's Soup Cans*, a piece very compositionally like certain drawings in the *Cookbook*, are Andy Warhol's *Oath of the Horartii* and *Whistler's Mother*. They were his rocket to stardom and the most vivid early statement of his attitude toward the mundane. They are pictures of a superbly apt contemporary American motif, one which readily prompts thoughts of democratic copy-copiousness (and, perhaps, a consequent decline of taste, not felt as too great a price to pay). It is symptomatic of the fact that Amy and Andy are in fundamental accord, that she admits to her cookbook canned soups, provided they are modified, or, we could say *art*ified, by the cook (see "Go-Together Canned Soups," 609-10): note that for both Vanderbilt and Warhol you put art in by reworking "by hand" what is initially *kunstlich*.

The soup can is also a standardized artifact of the television age, when provincial people became aware for the first time that even the implements of their daily lives were determined by mysterious specialists, big wheels in the city.

The can became a little more interesting but a lot more insidious, because your high-school guidance counselor never told you that deciding how the Campbell's can or the Brillo box should look was a job an ordinary guy like you could get. Such work was definitely "white folks; business" and even loftier than getting on "Truth or Consequences." The story of Andy Warhol is the story of a kid from Pennsylvania who followed the stream to its source and, very conscientiously, became a big wheel himself—a much bigger wheel than the designer of the can, bigger even than the *director* of "Truth or Consequences." The first triumph was to go directly from the class in which even reading etiquette books is considered affection to collaborating with the lady who writes them.

In addition, the occupational overtones of the actual soup-can paintings are significant. We should remember that before Warhol it was a commonplace among art students to consider commercial illustrations a category of prostitution in which, they knew, they were almost all doomed. One considered oneself a heroic idealist for three or four years, knowing the eventual sell-out would someday catch up with the inevitability of a shotgun marriage. Warhol liberated himself at least by becoming a "fine" artist who *chose* to paint an advertisement for free—a kind of Mary Magdalene "giving it away."

Once selected, the Campbell's can began to generate nostalgia, which, more than anything formal, is found the soup-can paintings share with Jasper John's Ballantine Ale can sculpture, *Painted bronze*, 1960. Nostalgia of this sort is inevitably Pop, because we want such artifacts, like *inaccessibly public* personalities to endure. We want people like Zsa Zsa Gabor and Mickey Mantle to stay the same, and if they do change we are disappointed because we cannot detect improvement. In her recipe for "Coconut Macaroons" Amy Vanderbilt suggest: "My children enjoy cooking, too, and find the macaroon recipe on the condensed milk can delicious and easy to make" (131). It seems astonishing now that she could so confidently have supported that the label on the milk can would stay precisely the way it looked the day she wrote. How naive the popular sense of style was before Pop Art.

I am interested most of all in the way this project supplied an early occasion for Andy Warhol to show how he could make art by the gentlest esthetic tinkering with what, in the world around him, are artless chores, and because the fun of the *Cookbook* is in finding interesting things for yourself. Take, for instance, the still life of four empty cake tins floating in an incongruous space (75). Each glides freely, oblivious to the spatial axes of the others. They are not simply resting on a flat but undefined surface because their bottoms are not in one plane. Should this in any way suggest Cézanne, we might make a comparison with Erle Loran's

diagram reducing Cézanne's *Still Life with Apples*[3] to an arrangement of dynamic plane's, remembering that Lichtenstein actually made a painting our of Loran's diagram of the *Portrait of Madame Cézanne*[4]—called, of course, *Portrait of Madame Cézanne*. But whether or not the cake tins relate through Loran to Cézanne, the way they sift down like leaves in the air does look forward to Warhol's aluminum floating pillow-balloons of 1966, *Clouds*. And the still life of *Cheese on Board*, which occurs as headpiece and tailpiece to the chapter on cheese (187, 196) supplies another case of chunky, wretched, Cézanne-suggestive forms in space.

The Cubist/Egyptian layout of repeated forms, some in absolute elevation, others in plan, with repetitive diagonals, in the illustrations of *Tea for a Large Crowd* (50) and the various model place settings, would also reward investigation. So would *Buffet Parties* (692-93), the *F-111* of the *AVCC*, which is also in the tradition of artists' table settings (Manet, Bonnard, etc.). Warhol is perfectly right, in a way, when he says that his art doesn't have any deep meanings. It is superficial and it is about superficiality. But, as his modest drawings for Amy Vanderbilt show, he gets a lot into his thin varnish of illusion.

NOTES

1. For example, Conrad Arnsberg, *The Irish Countryman* (Macmillan, 1937; New York: American Museum of Natural History, 1968), p. 61: "They heap ridicule upon the thought of a man's interesting himself in the feminine sphere, in poultry"

2. An indication of the incredible degree to which Andy had his finger on the pulse of the zeitgeist is that meat cuts illustrated by the combination of carcass maps and three-dimensional (photographic) illustrations were not institutionally standardized in the United States until December in the year the *Cookbook* appeared. See National Association of Hotel and Restaurant Meat Purveyors, *Meat Buyer's Guide to Standardized Meat Cuts* (Chicago, 1961).

3. Erle Loran, *Cézanne's Composition: Analysis of his Form with Diagrams and Photographs of His Motifs* (1943); 3rd rev. ed. Berkeley: University of California Press, 1963), diagram ii on p. 41.

4. Ibid., diagram on p. 85.

POSTSCRIPT (1994): While acknowledging this as "the first consideration by an art historian of Warhol's work of this pre-Pop Art period," Patrick S. Smith, *Andy Warhol's Art and Films* (Ann Arbor: U.M.I. Research Press, 1986), 35-36, blames me for not

knowing that in the project at hand "Warhol completed the . . . illustrations by means of a 'ghost' artist." Interesting, in an antiquarian way; but so what? One is reminded of Dürer's mistaking the drawing Raphael sent him from the workshop (for that matter, "factory") was necessarily from his own hand—whereas anything the master could approve would do. And speaking of "ghosts"; does anybody suppose that Mrs. Vanderbilt *thought up* all those recipes *herself*?

I can only thank Smith for reporting that "Warhol was wiliing to give Ted Carey the entire illustrator's fee because, one may suppose, he wanted to be credited and, therefore, associated with the project," because this obviously affirms the *authorship* of Warhol. On the question of Léger's importance, Smith quotes Carey, the subcontractor, as declaring that the drawings are "not influenced by him at all." Well, since when does an artist (commercial artist at that) have the last word on the historio-critical reading of their work? Because "the stipulations of the commission were restrictive," Smith proposed to transfer my remarks to the "I. Miller advertisements in which Warhol *was allowed* to estheticize without restrictions"; but latitude is not the point: what may be taken for granted, is. (Actually, I was aware of the "I. Miller Shore Store" style, only as a critic I hated it even more than its Ben Shahn "original.")

John Canaday, "Art: Huge Andy Warhol Retrospective at Whitney." *New York Times*, **1 May 1971, sec. 2, p. 21.**

Presuming that the place survived last night's private initiation ceremonies, the Whitney Museum opens its Andy Warhol retrospective to the public today and is expecting the biggest crowds since the retrospective of another Andy—Wyeth—who holds the record. That the naughty boy of the 1960's and stanch purveyor of the virtues of 1776 should be the two biggest box office draws in American art gives one pause to think and could, in truth, reduce the mind to jelly if thought about long enough. Better let it ride.

The Warhol show is spectacularly installed, the walls being papered with Andy's own pattern of vermilion cows on sulfur ground. Against this his mammoth serial pictures are installed in billboard size. The plain inescapable fact, which will give pain to his enemies, is that Andy looks better than he has ever looked before. His talent is primarily for display art, and he has never until now—at least not in New York—had such an enormous showcase.

Everything in the exhibition is familiar and the famous tomato soup cans and Brillo boxes have become only historical specimens. Yet the show becomes a shocker in the concentration of certain familiar horrors. Andy the tricky personality takes second place to the sheer hideousness of an electric chair in his multiple variations of a photograph and the ghastliness of the automobile accidents

he reproduces. The *Marilyn Monroe* portraits, which used to look only campy, now look cruel.

In their size and their blatancy such pictures are like updated versions of the canvas sideshow banners that used to advertise the freaks back when circuses were circuses. Might one, for another dime, go inside a hot little room at the Whitney and see the actual electric chair, the smashed automobiles with the bloody clothes of the victims, the embalmed body of the sex goddess?

It is a shivery idea. Andy Warhol is, among other things, the world's coolest manipulator of borrowed material to induce disturbing responses in viewers less cool than himself.

John Canaday, "Brillo Boxes, Red Cows, and the Great Soup Manipulation . . . ," *New York Times,* 9 May 1971, sec. 2, p. 23. Review of exhibition at the Whitney Museum of American Art.

As it must to all men, middle age came to Andy Warhol last week, descending upon him in the form of a retrospective exhibition at the Whitney Museum. Or at least a partial retrospective limited, at his request, to five of his major themes—soup cans, Brillo boxes, portraits, disasters, and flowers, plus, as a background, his red-cow-on-yellow-ground wallpaper.

The limitation nullifies the value of the retrospective as a survey of what Andy Warhol is and how he got that way, but it does indicate that Andy knows where he comes off best. And he comes off better than you might expect. The soup can series, born ten years ago, proves that, with a combination of lucky timing and good management, yesterday's impertinence can become today's classic, while the portraits and disasters, all of them mechanically modified from photographs, are effective tributes to the camera and the cleverness with which its records can be manipulated.

Manipulation is the key to the Warhol story. To being with, he is a manipulator—a very good manipulator—of borrowed material rather than a creator of his own. *("Manipulate: 1. to work or operate with or as with the hand or hands; handle or use, especially with skill." "Create: to cause to come into existence; originate.")* Also—and to his own surprise, I sometimes suspect—the products of his minor talent have been manipulated to create a major reputation. *(Manipulate: 2. to manage or control artfully or by shrewd use of influence," "Create: 2. to portray a character effectively for the first time, said of an actor.")*

Inherent in the Andy Warhol character that critics and curators have been so helpful in creating for the public there is much that is actorish. His name, which is his own, is the best public name for ease of remembering and for arousing images of its bearer since the invention of Theda Bara's, and his face, with its special kind of ugliness, is unforgettable. But what turns the trick is that his personal theatricality has been accentuated by a deliberate reversal of values in his art—the calculated banality of his choices of subject matter.

Andy Warhol varies a tradition of the artist as public gadfly that includes Oscar Wilde when he was being only a dandy and a wit. Wilde and his circle established impertinence and paradox, always dear to the frothiest spirits of morbid cultures, as declarations of esthetic freedom. But this kind of preciousness is a pitfall today. Not only is it traditional in an age when tradition is mistrusted, but it also has to meet the competition of the Wilde standard. Andy Warhol gets out of that one by offering boredom as the final preciosity, indifference in the face of attack as a substitute for witty defense. Once during a dispute over his Brillo series he asked why everyone got so excited about a bunch of boring little boxes.

And yet I would not agree with anyone who would apply the third definition of manipulate, "*to change or falsify for one's own purposes or profit; juggle; rig*" to the Warhol phenomenon. It is not a put-on, although you will never convince a large segment of the public that it isn't. If it was ever partially a put-on, that makes no difference now. The appalling circumstance of the art of the 1960's was that minor talents could not be blown up into major reputations if they offered good material for critics eager to exercise their ingenuity, and entertaining copy for publications ravenous for arresting novelties disguised as culture.

Whatever Andy Warhol might have been under other circumstances, he offered these allures and became a major figure during the nineteen-sixties—not only one of the spectacular personalities in New York, but one of the strongest influences across the land where the magic of instant color printing could bring his work to students in art magazines when it was hardly dry from his own manipulations. Critical pros and cons are beside the point now. It happened, and that it *could* happen legitimizes Andy Warhol under the premise that an artist is an expression of his time even if his time was only a decade, and even if he expressed the worst of it.

It is done, it happened, and there you are. If the Whitney retrospective fails to show us where Andy Warhol came from, it at least carries with it an air of finality as to where he went. And it shows that he traveled in style. It is a big, flashy show, consistently entertaining and here and there something more. There

is no telling, at such close range in time, whether the doctored photographic blow-ups of such figures as Elvis Presley and Marilyn Monroe are as strong as they seem, or only remindful of personalities already strong in our consciousness. But the "Disaster" subjects, particularly the series of an electric chair, are truly disturbing. How odd if Andy Warhol, the pixy of the sixties, should be classified, decades from now, as a master of horror.

Grace Glueck, ". . .Or, Has Andy Warhol Spoiled Success?" *New York Times,* **9 May 1971, sec. 2, p. 23.** Review of exhibition at the Whitney Museum of American Art.

It was a gas in Pasadena, a *punache* in Paris, and *terrific* at London's Tate. Now, after a triumphal four-star tour of world art capitals (like it says in the press release) Andy Warhol's peripatic Popshow has slipped into town for its final appearance at the Whitney Museum. There, generating nostalgia like a bunch of old TV re-runs, are the fruits of a decade's labor, going back to 1961—the Brillo boxes, the soup can and flower paintings, the portraits (of Jackie, Ethel, Marilyn), and the "disasters" (explosions, car crashes, electric chairs)—that rocketed Andy to sixties superstardom.

You can hardly see the works for the wallpaper—the cow's head wallpaper he did in 1966—with which the Whitney's fourth-floor gallery is plastered. But that's the backdrop the artist wants. "We fixed it like this so people could catch the show in a minute and leave," he said, looking like an Andy Warhol doll in his corduroy jeans, sweater and straw hair. "It's old-fashioned. It really is. Now that you've seen it, let's go across the street to Schrafft's."

Even though Warhol's been out of Art and into Cinema for some time, he still keeps in touch with the Scene. "I think everybody's doing such great work now," he said, sipping a straight vodka at Schrafft's (for whom he once did an ice cream commercial). Well, like who? "Girl artists, for instance. They're really doing big things. At the last Whitney Annual, it was the first time you couldn't tell their work from men's."

In fact, as it turns out, Andy and his fellow hands at the Factory, the downtown kibbutz that serves as headquarters for Warhol Films, take a kindly view of Women's Lib. "We are for equal pay, day care centers, free abortions," announced Fred Hughes, Andy's business manager, sitting across the table." "And lipstick for both men and women," added Andy.

Musing over the decade, Andy revealed that Fame, which pursued him until he overtook it, has not made all that much difference. "Even if you're on TV and your picture's on a magazine cover, no one cares the next day," he said, insightfully. "I still do the same things I always did." But visiting his show here and there on its tour, he admits the most exciting thing that happened was having a stranger on a plane talk about having seen it at the Tate. "He went on for about 20 minutes. It gets so you don't quite believe it."

Back home, of course, there are other adventures. Last week *Pork*, the first stage drama authored by Andy, opened at the La Man Experimental Theater. And the next Warhol film, following hard on *Trash*, the smash produced by Andy and directed by Paul Morrissey, will soon be released. It's something called "Politically Involved Girls," or maybe "Blonde on a Bum Trip," (the title is still up in the air) starring those drag queens—Holly Woodlawn, Candy Darling and Jackie Curtis. "I don't know what it's about," Andy said. "They talk a lot. I like to use actors who talk a lot. What I'd really like to do is go back and shoot movies for $300 and still make them entertaining."

Lawrence Alloway, "Art," *The Nation* **202, no. 21 (May 24, 1971): 668-669.**
Review of exhibition at the Whitney Museum.

The big room on the fourth floor of the Whitney Museum looks marvelous now and will until June 20. The Andy Warhol exhibition, arranged by John Coplans for the Pasadena Art Museum, is there and Warhol has finally found a use for the wallpaper he designed several years ago with a large red cow's head as the repeat. It covers the walls, and the pictures, bright and plentiful, are hung against it. Many of the flowers are here, as vivid and insouciant as ever, both the first version, in which green is painted over the grainy black-and-white background of grass, and the later edition which has the bright flowers alone on the black and while, in some ways a prettier effect. The result is something between the Isabella Gardner Museum and a new discotheque.

Warhol has excluded his earlier work and the show begins with the Campbell soup cans in 1961, leaving out the freely drawn and painted works. The soup cans are partly done by hand, partly printed, but the *appearance* of anonymity and the fact of repetition make them characteristic of Warhol's main line as a painter. The silk screen is central to his art and it is used like this: an image is mechanically transferred to a screen which can then be used repeatedly. The amount of paint and the pressure with which it is applied effect the impression

that the screen leaves on the canvas. In one of the Marilyn Monroe paintings, for instance, the image of the star's head ranges from a dark blot to a parched outline. The fixed image takes on a multifarious life. As a byproduct of casual printing, the silk screen gives a kind of automatic "personal handling."

Warhol's pictures all use known imagery, the labels on Campbell's soups, pre-existing photographs, and he has been compared with Duchamp because of their mutual use of the ready-made. However, where Duchamp used the ready-made as an aggressive insertion into the field of art, Warhol uses it to saturate his art with life's traces. All his best pictures are based on photographs in the public domain. When, as in his commissioned portraits, he uses photographs taken expressly for him, or accepts family snapshots, there is a touch of imposture or, at the least, of dullness. The texture of social reality that his choice of public photographs conveys is an essential part of his art. None of his commissioned portraits is among his best works. The literal human presence is much better expressed in his early films. Henry Geldzahler, one of those who sat in front of the camera for Warhol with nothing to do but be there, suggests that "Andy's nature really is (that of) a great portraitist." The quotation is from John Wilcock's first published book of interviews, *The Autobiography and Sex Life of Andy Warhol* (Colorcraft, Inc.).

That the use of ready-made photographs elicits a certain kind of structure, appears from a comparison of the different formats with which Warhol has experimented. The uniform tessellation of identical images is his best form. When the images are inverted or tilted or moved around to make an internal pattern, they lose their normalcy and become design elements, which abates the quoted material's immediacy, as in Liz as *Cleopatra*. Without the constancy of regular repetition, the image tends to jump or float or to collide with the edge of the canvas. It must be straight, though it can be any color, as the electric chair is orange, lavender, or silver. It seems that variation needs to be a sort compatible with the photographic image. Thus the overlapping of one image to produce a metaphor of motion, as in the Elvis paintings, is absolutely coherent, as are changes in the color and clarity of the image. The fading or the loss of detail within the image is like life itself when it has been photographed and reproduced.

What comes across at the Whitney, as never before in smaller exhibitions, is the exhilaration of proliferating images and quirky, glamorous color. There is a sharp charm and verve to his paintings and the only precedent I can think of is, perhaps, Picabia. As Warhol works in runs of set sizes his work has a potential for combination, well used in his show. The smaller flowers, electric chairs and

soup cans, borrowed from different collections, are grouped together in blocks or rows, like the repeating images within the larger paintings. It looks as if the paintings had discovered self-reproduction. Even the larger paintings can be aligned in new neighborhoods: the two well-known Marilyn Monroe paintings from the Burton Tremaine collection, for instance, have temporarily lost their identity as a diptych and are part of a bigger set of Marilyns. A modular structure easily extendable and just as easily cut off anywhere, underlies all Warhol's paintings. This infinite checkerboard is a sufficient structure without other forms of ordering. One of the reasons that Warhol did not wish to show his earlier works is that they are outside this module being one-at-a-time, noninterchangeable pictures. John Coplans was evidently interested in showing them, for they are reproduced and discussed in the book, not a catalogue, that accompanies the exhibition (distributed by the New York Graphic Society).

A few points of detail might be raised concerning paintings included or absent. Certainly, the organizers are not to be blamed for all omissions (I, for one, refused to lend a painting to the show because I was worried about the condition of the paint), but I missed a couple of things. It would have been good to see *The Men In Her Life,* a painting of 1962, in which four figures are turned into a crowd by blurry overlapping, and *1947 White* (1963), one of the best disaster paintings. This is remarkable as an image (a suicide who jumped from a building and fell onto a car, the roof buckled around her body, like a bed or a crusade tomb) and as a painting. It is one of the most successful of the paintings on which Warhol has left irregular margins without interrupting the regular pulse of the repeated image. His most recent work, forty silk screens of flowers on paper, are emptily elaborated with fancy color that swamps and blunts the image; it is the only time I have known Warhol to lose his laconic sense of color and design.

Peter Gidal, *Andy Warhol: Films and Paintings* **(London: Studio Vista Ltd., 1971), 18-19.** Excerpt.

A silkscreen was technically prepared by someone completely absolved from making any artistic, aesthetic decisions. Only then did the artist come in contact with the screen, from which to print his "painting." The technical happenings involved in the silkscreen process are now decisive: how does Gerard Malanga (Warhol's friend and early assistant) hold his end of the screen frame; how hot a day is it today and how much pressure does one therefore apply when rubbing,

over and over again, the black screen ink through the pores of the silken image; how many prints will be made and in what colors; how cold or hot is it, as this affects the drying potential of the ink on paper (or canvas) etc. These seemingly haphazard questions that are part of the technique of making an art product become of paramount importance since they make the changes inherent in the *process*. Warhol has conceptually understood that the differentiation from one image to the next is more important for the fact of its differentiation than for the specific differences manifested (lighter, darker, thicker, etc.). The McLuhanesque "medium is the message," discovered years before by the abstract-expressionist action painters, was now utilized by Andy Warhol in the silkscreen process of painting. He was tuned in to the possibilities inherent in the medium he was using—a sensitivity without which there can be no good art. Time and time again Warhol discerned that the results of a process could shape infinitely more than a stilted gimmicky, "arty" involvement by the artist. He chose to allow the medium to become part of the message, and as we shall see later on, upon selection of process and images rests Warhol's genius. Painterliness as such proved to be unimportant.

David Bourdon, "Warhol as Film Maker," *Art in America* (May-June, 1971): 43-53.

Far from being a neutral and impassive recorder of daily life, or a cinematic journalist documenting present-day depravity, Andy Warhol has constructed a stylized, extremely interpretive view of contemporary life that, however real it might seem on screen, is closer to fantasy than to any kind of reality with which most of us are familiar.

More talked about than seen, more emulated than admired, Andy Warhol's films will probably survive as legends rather than as living classics that people will want to see again and again. Currently, there is a fairly broad consensus that he is among the most important, provocative and influential filmmakers of the sixties. To the general public, he is best known as the originator of the marathon motionless movie, whose petrified camera dutifully records an inactive image, and as the purveyor of voyeuristic nudity, obscenity, homosexuality, transvestism, drugs and various other X-rated activities.

But to art and cinema connoisseurs Warhol has scored many conceptual coups and stylistic innovations: some see him as a "primitive" who has taken cinema

"back to its origins, to the days of Lumiêre, for a rejuvenation and a cleansing" (Jonas Mekas); others see him as an especially gifted recorder of "the seemingly unimportant details that make up our daily lives" (Samuel Adams Green). A lot has been made of how scrupulously he records ordinary events "as they are," and of his beneficent inclination to let his performers just "be themselves." Finally, there has been a great deal of emphasis on his equation of real-time with reel-time—if it takes a man three minutes to eat a banana, that slice of life is filmed and projected for three minutes without cuts. But far from being literal transcriptions of reality, Warhol's films are more inventive, artificial and art-directed than some of his admirers would like to believe.

Warhol made his debut as a filmmaker with fortuitous timing. Being familiar with avant-garde painting, sculpture, music and dance, he was able to approach film with a broader and more sophisticated outlook than was available to most "underground" filmmakers. Some of his initial experiments in 1963 were with single-frame shooting (photographing one frame at a time with a hand-held camera), a stylistic technique already employed by several independent filmmakers, such as Stan Brakhage, Gregory Markopoulos and Taylor Mead. But he soon realized that long takes were the antithesis of what was by then an accepted convention, and so he began making "motionless" movies. Bringing movies to a standstill had less to do with investigating the fundamental nature of film than it to do with the exploration of a then-emerging esthetic—the Minimalist esthetic. He had already experimented with monotony in paintings made up of images identically repeated in regimented rows; and his Minimalist inclinations were reinforced by his awareness of several musical works: John Cage's notorious "silent composition, *4' 33"*; La Monte Young's "eternal" drone music; and the eighteen-hour performance in 1963 of Erik Satie's *Vexations*, an eighty-second piano piece repeated 840 times.

The first phase of Warhol's quasi-fantastic vision was of a spaced-out, slow-motion world in which people really do sleep eight hours, while others devote nearly as much time to such lethargic inactivities as eating a mushroom or smoking a cigar. This is a silent world rendered in contrasty black-and-white, and stripped of any incidental interest and climax. It is usually inhabited by a single performer, seen frontally and in close-up, whose luxury and torment it is to while a an eternity of time on some simple, relatively meaningless task. The camera is stationary, the image seldom varies within the frame, and any movement, action or facial expression is decelerated to such a sluggish pace that it begins to exert a trancelike effect on the viewer—who, like the person on-screen, feels victimized by torpor. The effect is of a microscopic detail that is senseless in itself but

acquires significance through magnification and persistence. Staring at the immobile and inexpressive face on screen, the viewer may think of all the worthwhile things he should be doing instead of sitting there bored out of his mind. Suddenly, the face on screen is charged with melodrama; the performer has uncontrollably blinked or swallowed, and the voluntary action becomes a highly dramatic event as climactic in context as the burning of Atlanta in *Gone with the Wind*. (Warhol once said his best actor was someone who blinked only three times in ten minutes. Question: Aren't you confusing blinking with acting? Warhol: Yes.)

The notion of introducing stillness to movies was a radical idea. No one had to see *Sleep* to be provoked by the very concept of such a movie. The fact that Warhol's early films are still talked about more than they are seen can be interpreted as their strength, demonstrating the power of the idea, or as their defect, suggesting they do not transcend the idea. However, anyone who has actually sat through the films knows how words fail to convey the experience. Consequently it would be wrong to say that Warhol's films are so conceptual that they can be adequately described or experienced in words.

After the outraged reception of *Sleep*, Warhol deliberately set about filming movies of exaggerated length. In most movies, time is compressed so that lengthy activities appear of much shorter duration; but in a Warhol movie, inconsequential activities are prolonged so that the minutes seem to drag like days. To begin with, the duration of the filmed action was totally *artificial*. Who in his right mind spends forty-five minutes eating a mushroom? Warhol instructed his performers to remain as motionless as possible, and to prolong their actions as long as possible. To stretch out the time even further, Warhol frequently filmed the scene at sound speed (twenty-four frames per second), then projected it at silent speed (sixteen frames per second), so that whatever movement the image might be capable of was shown in protracted slow motion. "When nothing happens, you have a chance to think about everything," Warhol explained.

The second phase of Warhol's vision began in 1965, when he started experimenting with sound, color, camera movement, action, narrative and editing. In this phase, the performers became interesting as personalities. Warhol presented a highly selective gallery of gorgeously gaunt, stylishly garbed and imaginatively barbered young men and women who languorously display themselves, but seem reluctant to put their often appealing bodies to any constructive or even self-satisfying use; they spout tedious monologues, as if unwinding from some pent-up paranoia that can be dispelled, or maintained, only through the recital of all their problems, past and present. These sometimes droll,

sometimes pathetic monologists seem quagmired in unsatisfactory roles or situations, and apparently the only way they can sustain their gossamer fantasies is by trying to convince us of their veracity. But their self-image is askew and, like some manic individual striving to keep a grip on reality, they maintain an obsessive stranglehold on their only audience—the camera. Their whole world threatens to slide into oblivion at any moment, and even the riveting gaze of the camera cannot seem to secure it.

The manufactured chitchat and confessional soliloquies seem endless. During the screening of *Sleep*, members of the audience sometimes ran up to the screen and yelled in the slumbering man's ear: "Wake up!" The interminable chatter in the later movies makes people want to scream: "Shut up!" But suddenly, the interminable story trails out in mid-sentence, just a few words before the possible punch line, as the overexposed and blank end of the reel passes through the projector. We are left wanting to know the conclusion of the monologue we could not bring ourselves to listen to. We are made to feel the regrettable transience of what had seemed an excruciatingly boring scene. Those ridiculous people with their tiresome sagas emerge in retrospect as poignant creatures who deserved more of our sympathy and attention.

The feeling of impermanence is one of the strongest impressions left by Warhol's films. No matter how static the image, no matter how lengthy the monologue, no matter how tedious and unendurable the movies seem while we watch them, we are left with a sense of their brevity .

Even the physical record of Warhol's cinematic achievement is beginning to look impermanent. From 1964 through 1967, Warhol's film production was prodigious. Scores of movies were shot, but entire reels and projects were abandoned, and only what was felt to be successful was publicly shown. No authoritative record was ever kept of titles, dates, number of reels, cast and collaborators. Reconstructing the data now is largely a matter of guesswork, although a few attempts have been made to catalogue the oeuvre. The studio film library presently consists of miscellaneous cans of prints randomly stacked in steel cabinets at the rear of the Factory. (Warhol has put the original films in storage, where they are probably in even greater disorder.) Nevertheless, many of the films have been damaged, or have totally vanished; even the original print of *Sleep* is missing. In other cases, such as the twenty-five-hour-long **** (*Four Stars*), cans of films are present, but nobody has any idea in what sequence they were originally shown. The casual attitude toward shooting the movies carried over into their projection. Even in regular screenings at commercial theaters, the reels were inexplicably jumbled, or one reel was deleted from one showing but

not the next, leading to such wholesale variations that some reviewers began citing the date and hour of the performance they had attended. It is unlikely that very many of the films will ever be accurately reconstructed as they were originally screened—which is symptomatic of the "benign neglect" with which Warhol treats all of his work

From the beginning, Warhol was a shrewd and canny photographer who knowingly got the effects he wanted. He expended considerable thought and effort on the proper lighting, angle and setup. In the early movies, he favored strong sidelighting with harsh shadows, and most often concentrated on the frontal image (the most informative and iconic angle), which he centered and tightly framed. Once he had a satisfactory setup, he could turn on the camera's motor and walk away. Later he experimented with zooms and pans. "His zooms are perhaps the first anti-zooms in film history," according to Andrew Sarris, for whom "Warhol's zooms swoop on inessential details with unerring inaccuracy." They seldom correspond to any ostensible narrative or presumed story-line, and seem deliberately inattentive to the on-screen action, often missing significant moments. During the shooting of one scene of *Lonesome Cowboys* in Old Tucson, Viva was nearly urinated upon by her antagonist's horse and then, losing her footing in the mud and falling against the hind legs of her own horse, nearly trampled upon. Warhol missed both events because he was zooming in on a storefront sign across the street.

The sound in Warhol movies, though steadily improving, is still below professional standards. Warhol claims that the bad sound was at first done deliberately, because clear sound was too expensive. More likely, good sound was never really considered a desirable virtue. When *Sleep* was first shown, the accompanying sound was provided by two transistor radios on stage, tuned to different rock stations. When Warhol was invited to show four films at the 1964 New York Film Festival, he commissioned La Monte Young to compose a taped soundtrack that could be used for all four—the droning sound of a bow being played over a brass mortar. Now that Warhol turns the camera off and on during a sequence, he does it without regard for what the performers are saying, so that dialogue is arbitrarily punctuated and blipped without concern for content.

At first, Warhol refused to do any editing. Entire reels might be deleted, but there were no internal cuts within a reel. All the reels were spliced together, end-to-end, including the blank film leader, so that the image was interrupted every three minutes or so by overexposed reel ends, and then flashes of clear light. which became a kind of dynamic interlude between sections of the static image, giving a sense of structural rhythm to the film. Later, he began turning the

camera off and on during a sequence to make the film look cut and also, he says, "to give it texture." Purists, who admire the unedited reality of early Warhol, are distressed that he now stops the camera. "Since everyone says I never stop the camera," Warhol said, "I stop it now, start and stop, and that makes it look cut." To make certain it looks cut, he does not splice out the frames of blank film between scenes that a professional filmmaker would delete. Consequently, when the movie is shown, there are intermittent white flashes, accompanied by a screech on the soundtrack. The strobelike effect has been dubbed the Warhol "strobecut," although technically it is not a cut at all. Like the zooms, the strobecuts do not necessarily relate to anything at all on-screen, but they often make us suspect something has been deliberately eliminated or censored. For the past few years, real editing has been performed on Warhol films in an attempt to make the movies faster-paced and more entertaining.

Over the years, scores of people have contributed their ideas and services to Warhol's movies. In addition to being unusually receptive to other people's suggestions and talents, Warhol has always demonstrated an unstinting willingness to let others collaborate with him. The most enduring and therefore most important collaborator is Paul Morrissey, an independent filmmaker until he joined forces with Warhol in 1965. Morrissey served as executive producer, scriptwriter, editor, oneman crew and business rnanager, and in 1968 began making his own movies under the aegis of Andy Warhol Films, Inc. Morrissey's influence on Warhol productions has been stabilizing and conventionalizing. Under his guidance, there has been a greater emphasis upon narrative (erotic stories with "redeeming social value"), technically competent camera work and sound, better-paced editing—and more routine ambitions. Morrissey's own films, *Flesh* and *Trash*, are slick, formularized versions of Warhol's films—but more professional, and more entertaining. Both *Flesh* and *Trash* have achieved commercial success.

"My influence was that I was a movie person, not an art person," says Morrissey. "An art person would have encouraged Andy to stay with the fixed camera and the rigid structure. Andy's form was extremely stylized, and people thought the content was very frivolous. My notion was that the content is what is said by the people and how they look. The emphasis now is less or very minimally on the form and all on the content. And of course modern art is completely concerned with form and the elimination of content. In that sense, Andy is completely against the grain of modern art, and more in the tradition of reactionary folk art. You can only be a child so long and be revolutionary, and

Andy served his apprenticeship as a revolutionary in the art world and in the movie world. But it's pathetic to see a person not develop and not grow."

Although schematic plot outlines are usually decided upon in advance, Warhol's performers are expected to improvise their own dialogue. "Professional actors and actresses are all wrong for my movies," says Warhol. "They have something in mind." According to Morrissey, it is television that has eliminated the necessity of speaking written lines in front of the camera. He marvels that movie actors are able to speak freely on television talk shows, yet freeze before a movie camera because they are unaccustomed to working without a script. There is complete unanimity in the Warhol company that performers should be capable of making up their own lines. "How can people read other people's words?" Warhol asks. "It sounds so phony." Morrissey, who is more doctrinaire, declares, "If an actor can't make up his own lines, he's no good." Viva, a supreme monologist who describes herself as "the last dying gasp of verbosity." reminds listeners that "Mae West also wrote her own lines." As Viva puts it: "Men seem to have trouble doing these non-script things. It's a natural thing for women and fags—they ramble on. But straight men are much more self-conscious about it."

It is sometimes assumed that Warhol simply pushes people in front of the camera and "lets them be themselves." This impression is seemingly corroborated by his statement quoted by Gene Youngblood: "I leave the camera running until it runs out of film because that way I can catch people being themselves. It's better to act naturally than to set up a scene and act like someone else. You get a better picture of people being themselves instead of trying to act like they're themselves."

But very few people manage to be "themselves" in front of a camera. Warhol lets his performers be "themselves" in roles that correspond to their own characters. He selects people whose looks and personalities almost—but not quite—coincide with the characters he wishes to create. Most often, it is the discrepancies in the behavior of a person trying to impersonate someone similar to himself that register most vividly. Warhol has a ringmaster's ability to make his egocentric superstars expose their private selves. But his diabolical ploy comes into effect when he deliberately goes one step too far, by asking the performer to do something that the performer thinks is degrading or contrary to his nature—for instance, getting slapped around, or fondling someone of the opposite sex.

"People always think that the people we use in our films are less than something," says Morrissey. "Actually everybody we use has to be a thousand

times extra to stand up to our kind of filmmaking. Our people are *more* than actors."

Perhaps the only viable generalization that can be made about Warhol's people is that they do not represent a broad cross-section of Middle America. The range of personality types is surprisingly narrow, and apparently conforms to certain Factory stereotypes. The male roles generally fall into three groups: (I) handsome brutes with splendidly faceted face planes and good muscular definition (Joe Dallesandro, Louis Waldon, Tom Hompertz); (2) raunchy but comical homosexuals who talk as if they had ravenous appetites for sex and drugs but look physically incapable of obtaining either (Taylor Mead, Ondine); and (3) transvestites (Mario Montez, Candy Darling, Holly Woodlawn). The female roles are only slightly more typical: (I) idealized, immaculate beauties who do not have much to say (Nico, Edie Sedgwick); (2) bawdy beauties who talk too much (Viva, Jane Forth); and (3) overweight and overstimulated grotesques (Brigid Polk, Lil Picard, Tally Brown). Most of the characters depicted in Warhol's movies exist on the fringe of society, being societal dropouts or rejects who go on having middleclass values and aspirations. They are not even good at what little they can do. The best-looking men tend to be impotent, and the best-looking women have trouble bedding any man at all. And the transvestites are tacky, with make-do hairdos, runs in their stockings and no falsies.

Often condemned for advocating nudity and homosexuality in his movies, Warhol now finds himself scorned by a younger generation which demands even more sexual liberation. He has managed to antagonize both the Women's Lib and Gay Liberation movements, which lump him among their many reactionary foes. According to Morrissey, "Andy is despised by Gay Liberation and the Women's Revolt, whatever it is, because Andy just presents it and doesn't take a position. An artist's obligation is not to take a position ever, just to present. Andy's basic position on every subject, if he has any, is comical. The absence of a position necessitates a comical attitude to make it bearable. And the most serious position a person can take is the frivolous position."

Warhol recently completed a film on the subject of Women's Lib that will not endear him to that movement, because the cast is comprised almost entirely of transvestites, at least one of which impersonates a lesbian. Around the Factory, this role reversal is considered quite amusing. "It's hard for Andy or any of the female impersonators to put down the movement," says Morrissey, "because it's a subject that neither Andy nor any of the female impersonators have the vaguest notion about. I don't know anything about it either. I hear a little bit about it on

the talk shows—equal pay, etcetera, blah blah. But the logical extension of what they obviously want is to be a man, so why not have men represent them?"

Warhol's interest in film appears to be fading: he is less productive and his few film projects are less ambitious. It is difficult to determine whether his present lethargy is a temporary rest period, or a lasting consequence of the monstrous murder attempt of 1968. He exhibits almost none of the creative drives and ambitions that motivated him before he was gunned down. Despite his camerawork on *Blue Movie* and the unreleased Women's Lib movie (the last films he has photographed himself), he increasingly presents himself as an executive producer, a remote movie mogul whose chief interest is the supervision of an efficient and profitable production company. (Jed Johnson, an intensely quiet young man from California, who has worked at the Factory for three years, now edits and photographs some of the new films.) But when Warhol is not gloating over his supposed retirement from active movie-making, he makes vague murmurs about wanting to do something experimental again.

For a few years in the mid-sixties, Warhol displayed such incredible energy, produced so many paintings, sculptures and movies, that it seems almost unreasonable to expect more from him. From 1964 to 1967, he went through a rapid turnover of cinematic styles—from the stately Giottoesque stability of the early films, to the baroque superimpositions of the middle period, to the episodic sex narratives that culminated in the suppressed *Blue Movie*. In his early films, Warhol deliberately innovated certain conventions for extending and redefining our notion of reality through his unique treatment of the duration of time. But to my mind, the later works are more vibrant, intellectually more challenging and visually more satisfying. His camerawork reached a creative height in **** (*Four Stars*) with superb color photography and brilliant in-camera editing that he has not yet surpassed.

It is a tribute to his originality that his films have had an overwhelming effect upon an entire generation of younger experimental filmmakers, and that they have also had an influence upon such strongly individualistic filmmakers as Jean-Luc Godard, Agnes Varda, Norman Mailer and Shirley Clarke. But more important than the matter of influences is the fact that from the hundreds of reels that passed through his camera there emerged so many dazzling images and memorable scenes—a fragmentary but nonetheless valuable contribution to cinematic art.

Capsule Filmography

Since purchasing his first movie camera in 1963, Andy Warhol has made more than thirty-five feature-length films, and an uncounted number of shorter ones, which can be roughly grouped by the following periods:

1963-64: Silent, black-and-white "motionless" movies. Examples: *Eat, Sleep, Empire, Blow Job, Henry Geldzahler*.

1965: Sound movies, mostly with stationary camera, and occasional use of erratic zooms and pans; some with scripts written by Ronald Tavel. Examples: *Vinyl, Screen Test No. 2, The Life of Juanita Castro, Camp, My Hustler*.

1966: Experiments with multiple projections: *Chelsea Girls*. Experiments with multimedia, combining multiple film projections, slide projections, strobe lights and live rock music in touring sound-and-light show, "Exploding Plastic Inevitable."

1967: All-color, feature-length movies with improvised dialogue and oblique, episodic narratives; some editing. Examples: *I, a Man, Bike Boy, Nude Restaurant*, and segments of **** (*Four Stars*), a twenty-five-hour movie that was originally projected as two dissimilar images superimposed on a single screen.

1968: Location shooting in Oracle, Arizona, and La Jolla, California, of satires on cowboy and surfing movies with exploitation market in mind. Examples: *Lonesome Cowboys, Surf*. Explicit nudity and on-screen copulation: *Blue Movie*. Warhol's associate, Paul Morrissey, makes his first independent production as writer, director and cameraman of *Flesh*.

1969-70: Morrissey's second film, *Trash*. Warhol's semi-retirement to executive producer of Andy Warhol Films. Inc.

Pauline Kael, "The Current Cinema: Mothers," *Deeper into Movies* **(Boston: Little, Brown, 1973), 153-157.**

The up-to-the-minute title *Trash* is perhaps the cleverest ploy of the movie season; it has the advantage of that self-deprecatory humor that makes criticism seem foolish. But (although *Trash* apparently claims nothing for itself) when people are trashing the cities there are sure to be those who will take the poor white trash of the movie as a metaphor for what the city has made of the people in it. The movie, like the Warhol films that preceded it, winks at the concepts of victimization and futility. *Trash*, an Andy Warhol production but written, photographed, and directed by Paul Morrissey, who was known for the factotum of the Warhol factory until his emergence as a separate figure last year, is not

being given a major-art-house release. The assumption is that after the limited success of Warhol's *Lonesome Cowboys* and Morrissey's *Flesh* in the exploitation market the Warhol underground style will finally make contact with a large audience, and Don Rugoff, whose previous releases were *Z, Putney Swope, Elvira Madigan,* and *The Endless Summer*, is handling the picture.

The basic Warhol style was to let the camera run and neither to direct nor to edit what was recorded; since Warhol's friends spent a lot of time loitering in front of the camera while trying to think of something to do and were, by and large, exhibitionists who sought to make themselves interesting by shocking the viewers, the results were acclaimed four years ago as "a searing vision of Hell, symptomatic of the corruption of the Great Society," and all that. But, despite the media buildup and the celebrated review in *Newsweek* acclaiming *The Chelsea Girls* as "the Iliad of the underground," few could sit through the passively recorded, lethargic pictures. A value was claimed for the boringness, but it was not a value audiences responded to. Warhol's movies were not movies to go to; they were conversation pieces, and were soon worn out in talk.

Though *Trash* isn't as torpid as *The Chelsea Girls*, and one can sit through it, Morrissey's work raises some of the same issues as Warhol's about why one should. The Warhol "superstars" generally did the sort of caricature imitations of Hollywood sex goddesses that female impersonators do in night clubs for homosexuals and slumming tourists, and added a backstage view of their won lives, so that one got not only grotesque comedy but the fullest sordidness they could dredge up. Though the media, in their constant appetite for the new, acclaimed it as satire, it really wasn't focused enough for that. The performers didn't put the old movie myths down so much as they put themselves down, acting out a value system in which all that matters in life is to be a glamorous, sexy movie queen. They became what was worst in the old starts, but more so; they tried to become stars by exhibiting their narcissistic self-hatred and spitefulness. They were counterfeit stars willing to mock their failure to pass for genuine but nevertheless hoping that the travesty would make them a new kind of star. Actors in Hollywood needed the break of good roles and a good director, but Warhol was a director only in a nominal sense, and as he let the performers do whatever they wanted, the performers were limited only by their own resourcefulness. Their bitchiness was sometimes witty, their cruelty sometimes vivid, but it was not accidental that, though they became names in the media, they didn't become stars. Stars give the public something that feels new, and they draw us toward them; the superstars were exhibitionists getting their gratification from being part of that Warhol world on the screen, and the audience, reduced to onlookers, judged

them—rightly—as people, not as actors. And as people they were like the self-disgusted, gregarious, quarrelsome people in bars and street fights—people to be avoided. A popular hit like *Tobacco Road* might employ the humor of degradation, but it was understood that we were watching actors, and though the ostensible purpose was to call attention to the degradation, the real purpose was to present comedy. In Warhol's bohemian Tobacco Road, the people flaunted their own dishevelment and their own nausea, and it was all so depressing that even when they did funny things, one didn't feel much like laughing.

The aesthetic that some discerned in Warhol's films—that he was purifying cinema by taking it back to simple, static recording—cannot be claimed for Morrissey. Though the visual interest in *Trash* is negligible and the sound is abysmal, the explanation is surely poverty and incompetence, because Morrissey, while he has kept the Warhol films' ambience of exhibitionism and degradation, has joined this to the techniques of the Theatre of the Absurd and the Theatre of the Ridiculous in a relatively conventional narrative. *Trash*, which appears to be semi-improvised, is a classically structured porno comedy about an impotent junkie (Joe Dallesandro) whose sort-of-wife (Holly Woodlawn) is trying to get them on welfare. She pretends to the welfare office that she is pregnant, and plans to take her pregnant sister's unwanted child. Morrissey knows exploitation possibilities, and he has a dramatic sense of shock; the movie opens on the hero's bare, blemished behind, and then the camera moves around to reveal that, despite the best efforts of a girl who is working on him, he is indeed, and graphically, impotent. The movie proceeds by a series of rather familiar absurdist revue-style sequences: other women try, unsuccessfully, to rouse the hero, and the wife's hopes of welfare fade (because the welfare investigator wants the fabulous-forties shoes that the wife found in a garbage can, and she refuses to give them up). As the wife's highest aspiration is to get on welfare, and as the wife isn't even a woman (Holly Woodlawn is a female impersonator) the element of the grotesque is certainly present. *Trash* is steeped in a sense of grotesque parody, but of what isn't clear. Mostly, it seems to be the knocked-out couple doing a put-on of marriage; we are invited to laugh at their outcast status and their meaningless lives, and to feel sorry for them. The tone is absurdist pathos about a make-believe lower depths that one assumes is meant to suggest a true lower depths of homosexuals and junkies; Morrissey lingers over needles going into flesh and puts a nimbus around the messiest head of hair.

Unlike the Warhol superstars, with their suggestions of forties M-G-M-personalities, *Trash* suggests the Depression films and the over-the-hills-to-the-poorhouse silents, with the limp penis substituted for the empty cupboard, and,

like the plays of recent years set in basements and rooms full of debris, it wrings humor from the general dejection. When the action moves into a different atmosphere—when the hero is caught burglarizing a modern apartment and is persuaded to remain as a guest—the listlessness that could pass for appropriate in the dirty-kitchen-sink settings is revealed as directorial ineptness. The caught-burglar situation, so familiarly Shavian and once standard in polite comedies, is treated as a wild, far-out idea, in a long, self-contained skit, but there isn't enough dramatic energy to sustain it, and it dribbles along to its contrived climax. Badly timed improvisation on camera can result in the deadest kind of movie: every pause can seem endless, the excremental language is like baby talk, and the viewer falls into a stupor. The inertia of *Trash* is almost certain to evoke comparisons with Beckett, but the inertia is what's *bad* in *Trash* and it's what Morrissey tries to fight off. The *outré* face and voice of Jane Forth as the indolent housewife in the modern apartment are a throwback to Warhol's predilection for plastic ghouls. Morrissey is at his best with weirdly unlikely animal high spirits, like those of the warm, lively go-go dancer who tries to entice the hero in the first sequence. He attempts to keep *Trash* going on the humor of degradation and the comic shocks of breaking taboos: the hero is excited by his wife's nude seven-months-pregnant sister, Holly Woodlawn fakes masturbation with a Miller High Life bottle, and so on. Yet even what may not have been done before is of too low an order of invention to be original; the shocks are without resonance. The humor in the improbable tends to be a quick, forgettable jolt, and when improbabilities become predictable, they're just tedious. The movie is filmed Off Off Broadway theatre, and its style of freakishness was old upon arrival.

Trash depends on our finding camp sordidness both true and funny, but, because of the sluggish rhythm of the picture, we are dependent, as in the Warhol films, on the vitality of the performers. Holly Woodlawn acts up a storm, and though he doesn't quite have the incredible strength of insolence with which Mick Jagger, his hair lewdly slicked down, spews out his big number in *Performance*, Woodlawn does hold you—he belts out his goofy pathos like a snaggle-toothed witch you can't take your eyes off. Like Jagger (and, for that matter, like Marilyn Monroe), Woodlawn defies normal acting categories. Jagger is horrifying, repellent, yet in a star presence, and I think we feel something new in him that draws us to him—he's surly and self-involved, and he doesn't clean up and try to ingratiate, and when that shocking power bursts forth, it seems to come out of his not being Mr. Nice Guy. The fascination of Woodlawn is that, in this quasi-Warhol ambience that is so depressing because the human spirit is

diminished, his intensity is startlingly, crazily *incongruous*. But it's not much praise to say that the high points of the movie are when people are bizarrely alive rather than just vacuous; and that limp hero is at dead center. The attractiveness of utter cool passivity has been a factor in the success of some of the homosexual-exploitation films—the ads for *Flesh* featured Dallesandro with the words "Can a boy be too pretty?"—and I guess we're supposed to find his blotchy, beat-out quality, the big muscles and the lice in the hair, both attractive and funny, but his apathy enervates this movie. He isn't just impotent; he's barely alive. That's supposed to be the point, but it isn't enough point, and the joke of watching him drag himself around while advances are made to him runs down like a stale burlesque show. What is sometimes called decadence may be just lack of energy.

Stephen Koch, "The Once-Whirling Other World of Andy Warhol," *Saturday Review* 22 (September 1973): 20-24.

I think we're a vacuum here in the Factory. It's great.

Andy Warhol's "old" Factory on Forty-seventh Street is gone now; the capital of Sixties chic has been closed down for quite some time. The five-foot plastic candy bars, the walls covered with silver paper, the crowds of glamour mingling with the street freaks: Gone. There in the Factory, Warhol presided over the decade's pop culture and made his name a synonym for celebrity; there he invented the very word *superstar*. It was to the Factory that the Lance Louds of the Sixties ran; it was in the Factory that the high chic of a low decade preened; it was in the Factory that the strangest street culture even New York could summon up from beyond the pale became famous. That vast, L-shaped room was the decade's very image.

And it was a powerful image, powerful because it touched something real, however willfully bizarre it might be. Around Warhol was an entourage of outcasts basking in the light of his fame: The speed freaks, the street geniuses, the fashion models with faces like Nefertiti's, the beautiful boys, and the slinking, whining girls—all crept out of society's secret places to suddenly find themselves "in." Above all, they were "in" the light of fame—Warhol's fame. And in that light they developed a weird power. They were an image of isolation redeemed.

At the height of the Scene, the Factory was actually well organized into a social universe made up of concentric circles. At dead center was the pale sun of Warhol himself, immediately flanked by the two men who did the Factory's

daily work. Most conspicuous was Gerard Malanga, the hyped, endlessly talkative golden boy of the art world. With his superb, arching Italian face and omnipresent, gate-crashing voice, he served as combination errand boy and superstar. For years, I'd guess, Malanga attended five parties a night, either at Warhol's side or as his alter ego ("If not Andy, at *least* Gerard"). There was also Billy Linich (who restyled himself Billy Name), another torrentially verbal young man who, after a life on the streets, actually designed the Factory (the silver idea was his) and did most of its work.

At the next remove in this little solar system—the orbit of Venus, I suppose—were the women who bathed in the light of ultrahip. Thanks to chic or money or beauty or luck, these feminine mainstays—Baby Jane Holzer in 1964, Edie Sedgwick in 1965 and 1966, Tiger Morse in 1967, Viva (Susan Hoffman) in 1968—got as close to the pale sun as any woman could before drifting into an outer darkness that was at times very black indeed (Edie Sedgwick died of a barbiturate overdoes in late 1971). Around these people revolved (in tiny epicycles) lovers, friends, connections, and sycophants. In the next circle were the superstars, art collectors, models, beautiful people, and hangers-on who, though not "*very* close" with *Andy*, were still part of the entourage, making their entrances and exits with him at the right places and at the right times. Just beyond this circle was a Van Allen belt of media—the fashion photographers, the nightly news teams, the gossip columnists, the magazine interviewers. Within this sublime circle one could hope for fame, and so admission was not easy. But outside it were Warhol's intellectual and practical allies: Jonas Mekas, Henry Geldzahler, Leo Castelli, Ivan Karp—dealers, theorists, "important" admirers. Finally, in Plutonia outer circles drifted people who'd only just got in the door: the curious, the bewildered, the amphetamine addicts looking for a drop, the homosexuals visiting a capital of homosexual glamour, the kids on the lam, the intellectuals trying to understand it all. They were not quite in outer darkness, but almost. Of course the brighter stars frequently flickered and fell. "No one can get too much power, be a star for too long," recalls one who was there. When Warhol arrived at the Factory (it was his studio; he did not live there), usually in the late afternoon, the whole house of cards might tumble if he didn't smile his "Oh, hi, as he drifted by.

For Warhol is among the great masters of passive power. Although it proclaimed its independence at every opportunity, the youth culture of the Sixties was by and large composed of very dependent people who couldn't bear to face that fact. "Oh, *Andy,* of *course* I know *Andy*. In his passive presence, security and recognition seemed to make no demands. Warhol dominated all, while

seeming merely to look on. Sweetly and shyly, in the language of a five year old, he could make or break at will. As with a monarch, proximity to the famous presence was everything. And just as Warhol could bestow that presence, he could also take it away.

Put it this way: Warhol became famous by ceasing to be a person and becoming instead a presence. He became a phenomenon; the phenomenon Andy Warhol, who in his muteness and passivity seemed to be a being without needs. One gazed at that liberation, weirdly fascinated. "I still care about people," he said, "but it would be so much easier not to care . . . It's too hard to care. I don't really believe in love."

That lays it on the line. At the center of the Factory was an innocent wickedness that didn't really believe in love. For a time, Warhol and Malanga went everywhere in black leather jackets and high boots, the whole silly rigmarole of sadomasochism. That violent look, that steady hint of unspeakable practices, was central to their chic. The phenomena of sadomasochism and chic so often occur together that the link seems almost traditional, traceable throughout the history of style for at least 100 years. Their conjunction has something to do with the nasty, exploitative games supposedly played by the rich, bored, decadent leisure class, with the frigidity of narcissism, with the notion of a Satanic elite. It combines preciosity and brutality, just as psychologically, sadomasochism so often combines cruelty with sentimentality. S-M is theatrical sex par excellence, simultaneously superficial and intense, and that is ideally suited to chic. Whatever the link, the Sixties certainly went in for it in a big way, from Warhol to the Rolling Stones.

I suspect the Factory's theatrical sex somehow struck, for many people, that nerve of fear that fascinates and awakened a shock that feels like a presentiment of things to come. The Factory played its Satanism with style, well enough to look like the decadence of the culture itself. This makes it all the more strange to chat with these dire satanists now: Ronald Travel, the playwright and scenarist, his hair tied in an Indian headband, speaking quietly in an elegantly considered, faintly academic manner; Ondine, the most brilliant and vituperative of the superstars, his volatility modified by a peculiarly impressive ethic of honesty and intensity; and Warhol himself, with his childlike charm. One wonders, Was it *all* illusion? Perhaps this society saw in the Factory nothing but itself—distorted as if seen in the curved mirror that now greets you outside the elevator in Warhol's new, elegant quarters in Union Square.

A SNAPSHOT: It is 1966: The elevator struggles to the fourth floor, and the silver door is pushed open. In the middle of the big room, Edie Sedgwick sits on a huge, quilted red couch. Her face and eyes warm but sharp, she smokes a cigarette, sips a Pepsi. People stand conspicuously in clumps around the room, and the whole place resonates with Callas in *Traviata*. In one corner two goofy-looking girls taunt a young man in blue denim, a hustler not yet sure where he is, his foursquare face bewildered. Around the turn of the L-shaped space, Warhol sits on an old trunk, watching one of his own films. Chewing his gum, he stares at the nearby unchanging image. One hand lightly lifted toward his chin, his fingers trailing on his skin, he seems utterly self-contained, at peace, "a Buddhist who has achieved the desired transcendent state," as Tavel has described Warhol watching his own films.

Caterers arrive. A rock band emerges from the elevator and begins to set up their instruments. There is to be a party. A party. During the mid-Sixties it was fashionable for the more hip art galleries to throw a newer and evermore extravagant bash for each opening. The entertainment tabs at Castelli and Pace galleries must have come close to the prices of the paintings. A huge loft space would be thronged with many hundreds of people; pop records, played at a deafening decibel level, were alternated with a live band amplified to speaker-ripping intensity. In the "environment" thus "totalized," conspicuously beautiful people preened as one had hardly even fantasized preening: they were all part of a heaving throng of flesh, dense as an orgy or the subway at rush hour. The parties at the Factory (*crème de la crème*) grew progressively grander: Baby Jane Holzer and Ethel Scull, poor lightweights, gave way to real *stars*—at last the *stars!*—mingling with the street freaks and Warhol superstars. Jonas Mekas remembers Judy Garland and Josef Von Sternberg, engulfed with Tennessee Williams in the crowd, which had eyes for none but those, with Factory glamour—Ingrid Superstar, Mario Montez, Ondine—whose faces Garland could not quite place. Montgomery Clift was leaning against one of the silver walls as the beautiful people swept by not noticing.

Absurdly enough, those irresistible and grotesque parties stick in my mind as the image of what the decade was all about. Those jangling, throbbing lofts were nothing but theaters for their own ebullience. Like Warhol himself, they were the merest images of themselves. The crush of people witnessed themselves in the blackness, dancing beneath strobe lights that made them inhabit space anew, transporting them into a flashing new medium of existence, where every twist of the hand, turn of the thigh, toss of the head seemed touched by the magical grace of a new, perfected *otherness*.

The story of Billy Linich is a little grim. Those who dislike him concede that he is "clever"; others say he is "absolutely brilliant." Coming from the streets, he was the Factory's answer man and stage manager. Perfervid with amphetamine intensity, he was forever tinkering with the silver box, making the place work, endowing it with its strange antienergy. Linich was, and is, a mystic, much concerned with Alice Bailey, Helena Blavatsky, Theosophy, and the rest. That much was standard drug cultism, but still it is striking. For at times it seemed that the Factory denizens supposed they had all been touched by a purely secular, yet transforming, grace. Almost every major Factory protagonist was a refugee from that Catholic Childhood we've heard so much about: Warhol himself (still a practicing Catholic), Linich, Malanga, Ondine, Brigid Polk, Viva, Paul Morrissey. The list could get very long.

This sheds new light on the place's libertarian style, the theatrically decadent sex, the silver-covered walls, the helium-filled silver pillows. The Factory became The Great Good Place for the children of an ideology dominated by *petit bourgeois* sexual repression, by a hypocritical *contemptus mundi*, and by a preoccupation with the miracles of grace. The Factory was a region for resolving these dilemmas, another world.

Warhol was protagonist in the social drama that tried to make the American Sixties look like another age of innocence. A childlike, gum-chewing naïveté inflects his visions of electric chairs and ripped bodies with an almost babyish, esthetic anodyne. *Oh gee!* As with the classic decadent, his esthetics are a narcotic to a sense of damnation; but unlike the decadent, he shunts aside the rarefied pleasures of connosseurship for the chintzy joys of American naïveté. In the narcissism of the Sixties, in the decade's supposed liberation of energy, and in those disastrously simple resolutions of ethical dilemmas that only innocence—call it ignorance—can propose, Warhol discovered his ethical world. In the smokey mirror of a Catholic sense of damnation, he reflected them in ways that sometimes touch the profound, where innocence and viciousness, energy and enervation, life forces and their opposites, become indistinguishable.

These are not simple matters: The hinge of redemption is death. And so is Warhol's theme finally death. He is an artist whose glamour is rooted in despair, meditation on the flesh, the murderous passage of tie, the obliteration of self, the unworkability of everyday living. As against them, he proposes the mystique of the star. Show-biz and metaphysics merge. As in the cult of James Dean or Marilyn Monroe, the obsession is underwritten by a romantic, necrophilic myth, which partly explains Warhol's interest in film. Warhol is obsessed by his own ironic sense of cinematic presence.

One of the people who invented that presence, Ondine, speaks of it now: "Your brain seems to be apparent when you're on camera. It seems as if . . . when you look at yourself on the screen . . . it seems as if your brain is working. Like to me, I can tell what people are thinking by what they look like on the screen. *Not exactly what they're thinking, but what their next moves are going to be, what they're going to do.*"

If this is a description of cinematic presence, it is also a description of something like a state of grace—illumination in which the *way* is revealed. Perhaps the Factory's concern with style, its preoccupation with beauty, glamour, lust, chic, and presence itself, are corny but absorbing modern models for the redemption of feeling chosen, for the light touch of absolute rightness in a loveless world. Ondine adds: "I know what you mean by the way the performances on the screen come in and out of focus. Sometimes it's there and other times you feel the lack of it. It's like all of a sudden there's a great presence that's missing, and then it's there again."

At its height—late '65 and early '66—the same sense of a magical presence hovered over the Factory itself. "At that point in my life," Ondine says, "in everybody's life, that was the culmination of the Sixties. What a year. Oh, it was splendid. Everything was gold, everything. Every cold was gold. It was just fabulous. It was complete freedom. Any time I went to the Factory, it was the right time. Any time I went home, it was right. Everybody was together; it was the end of an era. That was the end of the amphetamine scene; it was the last time amphetamine really was good. And we used it. We really played it."

The Sixties created the Factory, and the Sixties killed it dead. Warhol stood at the center of his time, passive and mute; he was the mirror of the decade, and his little world was its microcosm. Utterly absorbed and utterly disinterested, he had a near-Satanic power to make its casual hysteria cohere, signify, and become visible. Although he was central to that world, he stood apart from it. Between his bizarre, isolated integrity and the throng, there was a kind of space: It was the space of the mirror. Warhol's responsibilities were the mirror's responsibilities; his replies, the mirror's replies. A man had transformed himself into a phenomenon; one looked into him and saw—a scene. As the word suggests, the scene was theater—theater lived for real, though just unreal enough so the dangers of living seemed to go away. The grace of art and fame and sex and money seemed to be everywhere: A shabby world seemed redeemed, and in Warhol's mirror image and object interchanged somehow, both vanishing into the sparkling light.

But as the Sixties began to fall apart, that sparkle began to glare. For one thing, despite youth, drugs, art, beauty, chic—all of it—the precious Aquarian age of innocence turned out to be another self-flattering lie. Perhaps if people had looked closely in the mirror, they would have seen that. But most had to discover it on their own. Beyond the bubbling infantilism, the disorientation, the carelessness, there was terror and rage and despair. The media found its touchstone for this turn in youth-culture events in Altamont and the Manson murders. But how many hundreds of thousands—the youth bloom just a touch faded—discovered it in small rooms with peeling paint rather than beneath the TV lights? Was Warhol's deathly pallor once fascinating? It is less so on the faces of the shipwrecked creatures now wandering the streets of the flower children. One hears less about mind blowing these days in New York, where it is difficult to walk ten blocks without seeing somebody (usually black) who is insane, who is literally raving. Intellectual folk heroes stumble from the limelight, their theories seedy to the point of embarrassment and contempt. The drug scene has lost its glamour, to say the least. The final shock: Innocence Sixties style is expensive. The saints need cash.

Given the crises of maturity, this aspect of Sixties culture tried to defeat time by transforming it into a single all-giving, all-perfect moment: The scarcely inconsiderable forces of art, drugs, beauty, glamour, talk, youthful energy, style, and mysticism were enlisted in the effort; and for a while it seemed to work. Warhol, it seems to me, understood that effort with an intuitive profundity second to no one else's. In spite of it all Time took the hand. As usual. Even in the Factory.

It was the special destiny of the Factory to make the underground visible. When that process was completed, the show was over. Warhol himself had no place to turn, or so it seemed. Then in 1968, Valerie Solanis, one of the may wretched who had found a brief moment of self-esteem by hanging on at the Factory, walked in, pulled out a revolver, and tried to murder him. Warhol barely survived. He was hospitalized for many months; and when he emerged, the old scene was finished. Warhol stopped living in public. The wit of the old subterranean decadence gave way before the more familiar American ethic of young men in a hurry, of people rapturously impressed by how slick and ambitious and heartless they could be, thinking every minute of every day about winners and losers. Heads began to fall: Warhol had surrounded himself with brilliant and extraordinary people who seemed otherwise beyond the pale—Ondine, Tavel, Brigid Polk, Mary Woronov, Ingrid Superstar, Billy Linich—who, after 1968, defected or were eliminated one by one. "Warhol had

been told," Ondine says, "that commercialism means you can't bother with the freaks any more. You have tintypes. Whatever sound somebody did originally, well—you can duplicate it. Tavel is bewildered: "I don't know what it is, because the new films look to me inauthentic. They look like mockeries—commercializations and mockeries. Admittance to the "new" Factory began to be difficult; the gaze of the "new" people could make a stranger writhe. The entourage was replaced with reliable, presentable employees. Then the impossible happened: Malanga was fired. Only Linich remained.

Linich held out for three years, holed up in a storeroom in back of a new, sleek set of business offices called the "new" Factory, which Warhol had rented, shortly before the murder attempt, as the home office for Andy Warhol Films, Incorporated. "Billy couldn't come out with those mediocrities, "Ondine recalls. "When they moved to the new place, the only part of the Factory that was the old Factory was Billy Linich's backroom. The old world was really up there. It was painted black and silver, and Billy had tapes. He had his whole number going on. Outside was this . . .this. . ." Ondine searches for the word, "this *Juillard*."

Linich's isolation grew more and more complete. "He read continuously... Alice Bailey...He read her books in the back room in black light, so the pages jumped. He was taken to the hospital with retinal colic at one point. His eyes turned something all yellow, and all the while he was getting scabs on his face, and his fingernails were growing." Ondine pauses. "there was some kind of fire going on in Bill's brain. And Warhol's lack of interest in Billy triggered it off to such an extent that Bill couldn't come out of the back room I wouldn't say he was exactly crazy, but he was in touch with something so spiritual that most people would be frightened by it."

At last a note was found in the back room. "I am all right. Goodby." It was the definite end. Linich now lives in Los Angeles; his connection with the Factory is entirely severed, one gathers, much to Warhol's regret. "He was so loyal to that man," Ondine concludes. "Three years he waited in the back room for somebody. And nobody was there. Andy Warhol was no longer there. He had gone somewhere else."

Warhol is a major artist whose social role and art are inseparable, who for ten years diffracted the phenomena of his time into an estheticism that made him an exemplary modern antihero. Yet that role now seems invested with something almost admonitory. At the core of the passivity, the chic, the lack of affect, at the center of the extraordinarily interesting thing he did with the incapacity to love or to connect or to believe, lay a profound doubt about the very value of living. It was *that* which set him apart; from *that* the mirror of his presence acquired its

hypnotic allure. At a certain point that doubt becomes a despair profound enough to become precisely what is meant by decadence. Warhol's entire career can be understood as an attempt to redeem that despair without belying it; that was perhaps the message in the deepest regions of the mirror. But if this is so and Warhol knew it, he knew it with an intuitiveness that never threatened this astonishingly passive man's astonishing capacity to act. Knowing it, he kept silent, as always. That was the basis of his cool. It took a while—it took Time—for those who rushed in to see themselves reflected in his pale light to discover the precise massage. For Warhol himself, it took a moment when the elevator doors opened one day. He looked up to see one of the minor members of his entourage standing before him with a trembling face and crazy eyes. He said "Oh, no" just once, and then Valerie Solanis started to fire. I can't feel anything against her. When you hurt another person, you never know how much it pains. Since I was shot, everything is such a dream to me. I don't know what anything is about. Like I don't know whether I'm alive or whether I died. I wasn't afraid before. And having been dead once, I shouldn't feel fear. But I am afraid. I don't understand why.

The Great Good Place of the Sixties is gone. The remembered image—it is a false image, of course, but then the image was always false—is of a huge indoor festival of energy, innocence, and sex, of bright bodies under thirty preening over real or imagined strengths, as if they were in a state of grace. The scene I remember from seven years ago was an absorbed, disturbed, cheering audience to itself, and nobody could tell the dancer from the dance. But the cheering is over. A theatricalism has been betrayed, and it has died. The silver hall is empty.

Oswell Blakeston, "Andy Warhol," *Arts Review* **26, no. 4 (February 22, 1974): 77.** Review of exhibition at Mayor Gallery.

They say corpses are easier to identify than living people, for the living person changes from mood to mood. Andy Warhol has made certain of identification with his drawings of *Chairman Mao*. Does this mean they are lifeless? I'm afraid so. In 1973 Warhol drew some twenty photographs of Mao, all taken from the same photograph, all full-face, neck and collar. One knows the artist's habit of working in series; but it comes to us, when looking at eight of the twenty drawings which compose the present exhibition, that the process, as the artist exploits it, is no more than a mechanism for tiding over time when there's

no inspiration. The human will, although it can force the heart to be silent, cannot force it to speak; and Warhol does not communicate in these drawings, however much he may have willed himself to do so. There are minute changes in the portrait parade—as in other Warhol sequences—an eyebrow trimmed, a lip prolonged, the hair removed like a cut-price toupee, etc—but they mean no more than appeal to taste and preference at the level of choosing a photo from a batch taken at a sitting. Do you prefer the thick line or the thin? But there is no significance added or subtracted in the image. The reliance for response is on revolutionary fervor, something apart from the image as art, and the publicity surrounding the Little Thoughts of Chairman Warhol. One thinks of David crying out to his students "Let us grind enough red" when the tumbril rattled by the door but I don't believe there's any blood for China in Warhol's student-like and conventional delineations. They say that imagination is a great diagnostician and can sniff out the real; but when there's no imagination we are left with a camera pose with a lens levelled for nobility, a newspaper reproduction to accompany a laudatory article on official statistics.

Linda Frankce, "The Warhol Tapes." *Newsweek*, **April 22, 1974, p. 73.**

A New York psychotherapist leaves *Interview* in his waiting room, claiming that it is good therapy for his patients. Leo Castelli keeps *Interview* at his New York Art gallery because he says, the magazine itself is a work of art. In a burst of orgiastic enthusiasm, designer Halston even devoted a whole window at his East Side salon to *Interview*, plastering the glass with some 50 copies. "It's gossipy and in," enthuses Halston, who confesses to having stashed every single issue in his closet. "I know all the people in it."

The object of these affections is Andy Warhol's *Interview* magazine, a monthly farrago of gossip, stars, fashion and funk that is creeping onto the lacquered coffee tables of international trend followers. A showplace for the known and the soon-to-be-known, *Interview*, with its star chats and flashy photography, has changed from the precious cult magazine it was when Warhol first published it irregularly four years ago to an uptown monthly whose circulation has show from 31,000 to a claimed 74,000 in the past six months. "We are trying to revive the avant-garde without being too self-conscious about it, says Fred Hughes, *Interview's* executive vice president. "The magazine, I hope, is becoming a chic underground paper."

Couples: The technique is simple enough: either a written interview-profile or a taped Q-and-A session, the approach favored by the multimedia Warhol who is the magazine's president. "I give tape recorders to everybody now," the 45-year-old artist says in The Factory, his studio loft in lower Manhattan, "so they can tell their stories anytime." Warhol also enjoys pairing up odd couples on stories, which he says makes for more "interesting and better tapes."

Thus, Princess Lee Radziwill interviewed rock prince Mick Jagger, whose fashion-plate wife, Bianca, interviewed dress designer Yves St. Laurent. Model Lauren Hutton was interviewed by the late transvestite and and Warhol regular Candy Darling. "Is it true you had to have your nose done, your teeth capped, silicone shots and you had to lost 50 pounds? asked Candy in the October issue. "No, replied La Hutton. "All I had was my feet bobbed." Last year, Berry Berenson interviewed actor Tony Perkins—and later married him. "I'm a great movie audience," Tony confided, "I can just settle back and really laugh and cry." Replied Berry: "How wonderful. I cry like a fountain."

The quality is uneven, what with a staff of five and a free-lance budget of only $25 for each article. In the April issue, the magazine manages to misspell interviewee Jack Nicholson's name on the cover and in the interview; only the article's headline gives the actor his "h." But the story itself is lively—the first interview that Nicholson and girlfriend Angelica Houston have ever granted. Last year, in an effort to make the staff more professional, Warhol hired Rosemary Kent, 28, of *Women's Wear Daily*, to be his editor. "We try to balance freakiness with glamour," she says. "And at least we don't have to justify to a zipper manufacturer why we're doing a story on a transvestite named Silva Thin."

So far, there have been few advertisers of any kind for *Interview* to answer to, but in the past three months, ad revenues have risen from a modest $1,800 an issue to a somewhat less modest $7,000. "It's never going to be a mass-circulation magazine," says associate publisher Carole Rogers, 34, who hand-delivers each issue to some 320 newsstands. "It's very much a family affair."

Put-downs: There are some who feel it's too much a family affair. In the current issue, the movie reviews and Rosemary Kent's gossip column have been dropped. "I don't want any put-downs," explains Warhol. "Why, we put down 'Ash Wednesday' and we're friends with everybody on the film." As for the gossip column, it was interfering with Warhol's social life. "No one knew whether we were friends or gossip columnists," he complains, "and we were getting invited to less and less parties."

There is no doubt that the magazine is friendly—sometimes to a fault. It was one of the few times that no one has added little bits," costume designer Edith

Head says of her January interview. "It sounded just like me talking." Film critic Judith Christ was equally impressed. "Even the photography was good," she enthuses. "We don't want to give the whole picture," concedes Interviewer Bob Colacello. "We leave out the things we don't like." He pauses, leaning on the stuffed remains of Cecil B. DeMille's harlequin Great Dane. "We're not interested in journalism so much as taste-setting," he says dreamily. "We're the Vogue of entertainment."

David Bourdon, "Andy Warhol and the Society Icon," *Art in America* (January-February 1975): 42-45.

Who is better qualified to embalm the Beautiful People for posterity than Andy Warhol? Wherever the BP flock, from Paris to East Hampton, from the Via Veneto to Sunset Boulevard, Warhol puts in a spectral appearance and snaps their pictures with his Polaroid camera. If the subjects are as solvent as they are pretty, some of these Polaroids will metamorphose into $25,000 to $40,000 portrait commissions.

Warhol, whose own wraithlike visage increasingly resembles a memento mori, has squeegeed a number of famous faces through his silkscreen, including Brigitte Bardot, Hélène Rochas, Yves Saint Laurent, Princess Diane von Furstenberg and Nelson and Happy Rockefeller. The art dealers and collectors who have commissioned portraits would fill a museum with their likenesses: Philip Johnson, Alexander Iolas, Ivan Karp, Ileana Sonnabend, Sandy Brant, Kimiko Powers, Yoyo Bischofberger, Dominique de Menil, Lita Hornick, Attilio Codognato and Jan Cowles.

• Warhol and his ever-present camera are being taken on a tour of a 12-room apartment on Manhattan's East Side by the Halston-clad hostess. A smile alights on Warhol's face as he remarks: "Wouldn't it be great if you had a portrait of yourself in every room?"

• Twelve years ago Warhol installed Ethel Scull in an automatic snapshot booth. "Now start smiling and talking, this is costing me money," he told her, as he started dropping quarters into the machine. With and without her sunglasses, Ethel preened, mugged, clutched her hands to her chin, hair and throat. People laughed at Bob and Ethel when they actually hung what turned out to be one of Warhol's first commissioned silkscreen portraits, *Ethel Scull 36 Times*. Today that multipanel painting hangs in the Metropolitan Museum, a promised gift of the

Sculls. "It will be nice for the grandchildren," Ethel remarked, "They can say, 'There's granny.' I hope they'll be proud of me."

• When Holly Solomon saw her nine-panel portrait, painted in 1966, her first thought was "Oh, my God, this is fabulous!" She believes it to be a "sexual" and "very significant" painting. She was thrilled when Jasper Johns walked up to her at an opening and said, "Hi, Holly [kiss], how does it feel to be dead?" She understood him to mean that her portrait is a masterpiece. "Long after I'm dead," she gloats, "it will be hanging."

• Some of *Leo Castelli's* friends are concerned that his portrait (1973) is insufficiently flattering. Warhol has made him out to be as regal and cunning as Richelieu. Cornered in his gallery, Castelli smiles graciously as he comments that his portrait is "savage, quite savage."

• Brigid Polk, the roly-poly star of *Chelsea Girls* and an ace Polaroid-portraitist herself, observes: "Well, Andy, he doesn't believe in art, yet he sneaks away to Switzerland to do prints and he's the first one who will say to you, 'Oh, can't you find somebody, can't you find somebody to get me a $40,000 portrait commission? I will give you, you know, a good chunk, dear, a good chunk.'"

• At the Factory, everyone is standing around admiring a yard-high photograph of Austrian actor Helmut (*The Damned*) Berger. It is imprinted on a sheet of clear acetate (what is known in the trade as a "half-tone positive"), a preliminary stage to a silkscreened portrait. Berger is nude from his blondish hair to his blonder things; his lean torso is turned in a three-quarter profile, and he coyly holds a telephone to one ear. Undressing for Warhol's camera is one thing, but forking over the money for a portrait is quite another. Months later, the sheet of acetate is languishing on a Factory wall. Warhol stammers, "He didn't really ... We don't know whether ... I haven't even started on it because I don't know whether he's going to pay for it. He's a funny person, one of those funny people. It was his idea, I guess, but he didn't seem too eager to do it. Every portrait I have done is that way. I haven't gotten paid by anybody."

According to one source, Warhol has processed more than 75 people during the past few years. While the recently commissioned portraits may seem a new development for Warhol, portraiture as such has been a persistent theme in all of his work. The faces of specific people are ubiquitous in his art—in his Pop paintings, in his early films, even in some of his commercial art of the 1950s (when some of the faces he drew were derived from photographs).

Many of Warhol's "motionless" films of the early 1960s are essentially portraits—tightly cropped closeups of faces, only sporadically animated by the flicker of an eyelid or the tremor of a lip. One of the feature-length films of 1964

shows Henry Geldzahler sitting on a couch and smoking a cigar. According to Geldzahler: "It had a quality of portraiture that I really hadn't seen before, because within the hour and a half with nobody standing behind the camera, I'd gone through my entire gesture vocabulary, and everything about me that I knew was revealed in the film because there's no way of hiding."

Because Warhol's portraiture is essentially cosmetic, a skin-deep treatment of surfaces rather than a probing of the individual's character, it does not matter whether he knows his subjects or not. As knowable personalities go, Marilyn Monroe and Mao Tse-tung, whom he never met, are less remote to him than some of his "sitters"—such as Jermayne MacAgy, whose portrait he was commissioned to paint after she was dead.

Warhol is a maker of commemorative icons and it does not matter whether his subjects are living or dead, celebrities or nobodies. As a stylist of the human face, he can confer an alluring star presence upon even the most celebrated of faces. Barbara Rose believes that someday his commissioned portraits will appear "as grotesque as Goya's paintings of the Spanish court. Like Goya, Warhol is a reporter, not a judge, for it was not obvious to Goya's contemporaries that they were deformed either." Her comparison is striking, but somewhat subjective. Some viewers will probably read into Warhol's smudged screening and lurid colors an intentional degradation of the subject, while others will see it as thoroughly glamorizing. Since Warhol is an extremely complicated person, his intentions could cover both extremes.

In making his silkscreened portraits, Warhol has resorted to a wide range of methods and modes. His photographic sources have included publicity stills (Marilyn Monroe, Elvis Presley), newsphotos (Jackie Kennedy, some of the Elizabeth Taylors), old family snapshots (Robert Rauschenberg, Sidney Janis) and his own Polaroids (Irving Blum, Brooke Hopper). In his early Pop paintings, he frequently screened multiple heads on a single canvas (Troy Donahue, Natalie Wood), but for the past 19 years, he generally has screened only one face per panel. Not even canvas is a constant: frames from some of the film "portraits," such as Robert Indiana eating, have been silkscreened on plexiglass. He has used monochrome grounds (Ethel Scull), multicolor areas which loosely circumscribe the features (Marilyn Monroe, Holly Solomon) and arbitrarily Léger-like rectangles of color (Lita Hornick, Dominique de Menil). Along the way, he switched from flat, evenly saturated colors to modulated colors and gestural brushwork.

What distinguishes Warhol's portraits from most other artists' are the expressionist colors and the larger-than-lifesize face which fills most of the

canvas. (The individual panels in a multipanel portrait range, approximately, from a 20-inch square to a 40-inch square.) He generally selects the most complete and informative photograph, usually the full or three-quarter face, with the chin up as in a mug shot.

Since the portraits are photographically derived, one might expect them to be extremely realistic. Paradoxically, they actually give less detailed information about a face than the portraits from life, of say, Philip Pearlstein, Alice Neel or Sylvia Sleigh. As if he were a combination hairdresser, make-up man and studio photographer, Warhol transforms his "sitters" into glamorous apparitions, presenting their faces as he thinks they should be seen and remembered. His portraits are not so much documents of the present as they are icons awaiting a future.

Hair gets teased and streaked, complexions are cleared up, blemishes disappear and sometimes whole ears and noses threaten to vanish. The volume of the head is completely ignored, and the faces are as flattened out as a psychedelically colored map. Warhol does not aspire to be an accurate cartographer of anyone's physiognomy, so he emphasizes the features he considers important. These are the eyes and the mouth. The eyes are large, lustrous and luridly embellished with expressionist eyeshadow. The lips are sensuous and full, because the underlying color usually exceeds the actual contours of the lips—like the 1940s Joan Crawford whose lipstick extended halfway to her ears.

Warhol's intention, of course, is to make the portraits intensely flattering—and to give as much satisfaction to his clients as Sargent, Boldini and Kees van Donegen give to theirs. Warhol, who a few years ago feigned embarrassment at doing commissioned portraits, now exults, "I'm becoming another Vertes."

At Warhol's hefty prices, his portraits had better be flattering. "I can make ordinary people look good," he says, "but I have trouble making beautiful people look good." It is the beautiful women, he says, who usually do not like their portraits. "They're the ones that turn them down. I don't know why, because I work hardest on them and don't fluff it off as easy." Warhol considers Yoyo Bischofberger to be a great beauty but thought her large teeth looked too pronounced in the photograph he chose to screen. He finally obscured most of her teeth by exaggerating the size of the red lips.

Warhol's new portraits abound with gestural brushstrokes, swaggering this way and that in a manner that seems almost a parody of de Kooning. It used to be that the photochemical silkscreen process "distanced" the subject, placing it

behind a scrim of dots. Now it appears that the erratic, showy brushwork, some of it placed on the canvas before the image is screened and some of it superimposed on top of the image after it has been screened, has the effect of distancing the silkscreen process itself. As Warhol explained to one interviewer: "When I do the portraits, I sort of half paint them just to give it a style. It's more fun—and it's faster to do. It's faster to be sloppy than it is to be neat."

About the same time that he abandoned flat paint for vigorous brushwork, Warhol adopted a new range of offbeat hues. During the early 1960s, when he used bold primaries and metallic paints, he seemed linked coloristically to Ellsworth Kelly and Frank Stella. His current use of paler, more cosmetic hues seems to align him with the softer palettes of Walter Darby Bannard and Jules Olitski.

The range and brilliance of color are what make some portraits appear better than others. Many of the recent portraits are dappled in several radiant hues, making them light and frothy-looking. The painterly, de Kooningesque portraits of Brooke Hopper, Irving Blum and Yves Saint Laurent are among Warhol's best. Whenever he uses only a few dark or muddy colors, the portraits tend to make the sitter look listless. In the portrait of Sandy Brant, for instance, the face is imprinted on rectangles of color too muted to dispel the dullness of the uniform gray ground and the glossy maroon pigment. The portraits can also fail when the photographic image itself is inappropriate. Jan Cowles, for instance, is shown in three-quarter profile with her eyes apparently closed, which makes her appear somewhat less than vivacious. Sometimes the portraits suffer from eccentricities in the stretching. Warhol frequently likes to staple the canvas to the stretchers so that the image is deliberately askew, sliding off one edge or appearing at a sharp angle. When he does this to excess, the result looks contrived.

Many painters who do portraits from life are capable of working rapidly, turning out a good likeness in two or three sittings. In Warhol's case, the use of a photographic silkscreen is anything but a shortcut. He may spend many hours in securing the appropriate photograph, getting it converted into the proper silkscreen, tracing the color areas onto the canvas, overseeing the screening and embellishing the surface once it is screened. By the time he staples the canvas to the stretchers, he may have invested more time in producing his quasi-mechanical picture than a conventional portraitist spends on a canvas.

Warhol's usual procedure is to send his Polaroids to Chromacomp, Inc., fine-art printers located in Manhattan's flower district, where the photographs are converted into half-tone positives of the same size as the final painting. When the half-tone positives are finished, Alexander Heinrici, the young, Vienna-born vice-

president of Chromacomp, brings the acetate sheets to Warhol for his approval. Warhol selects the image he wants and, if necessary, orders some retouching. Although a normal half-tone positive is capable of a wide range of lights and darks, Warhol prefers a contrasty image. "In a face," says Heinrici, "he wants most of the middle tones to drop out and want to keep only the very dark and light ones.

Recently Warhol inspected a set of acetate sheets imprinted with different portraits of a young woman. He rejected the ones that looked too posed and selected one that showed the woman looking over her shoulder, with one arm draped over the back of a chair. Warhol requested that the drapery folds in the background be whitened and the chair eliminated altogether. When quizzed about what would happen to the woman's arm without the supporting chair, Warhol explained that he would simply put in a lot of brushy color where the chair was. He also ordered some blemishes removed from the face (these were blemishes that appeared on the Polaroid print, not on the sitter's actual face).

Once the silkscreen has been made, Warhol uses the acetate sheet as a pattern to trace the approximate features of the face. Then he paints in the background colors. Heinrici picks up the canvas panels and takes them to Chromacomp, where they are screened on one of the firm's four printing tables, the canvas simply being substituted for the customary sheet of paper. The registration of the screened image on the colored background is subject to some leeway. "Sometimes," Heinrici says, "he indicates exactly how he wants it. At other times he will say, 'Do it so it looks good.' He gets very upset if it is not what he wanted. Yo have to listen not only to what he says but be sensitive enough to understand what he really wants."

• Warhol produces mulitpanel portraits so that owners can arrange them according to their space and taste. One advantage for distressed owners is that they can be sold off unit by unit. Last year one unit of the five-panel portrait of Dennis Hopper (commissioned not by Hopper, but by a group of collectors in Ft. Worth, Tex.) appeared at auction at Sotheby Parke Bernet. "Isn't that terrible?" Warhol fretted. "They promised me, when I did those for such a small price, that they would definitely go to a museum. Now they're selling one in every country?"

• Les Levine, who enjoys analyzing other artists' marketing strategies, comments: "Andy usually finds a way to make new work appear cheaper. $40,000 may sound like a lot for a portrait, but where are you going to find a Warhol of comparable size for that price? Dealers are aware of this, which probably accounts for why so many of them have commissioned portraits.

"Warhol frequently asks $25,000 for a singe 4-foot-square painting, with additional panels $5,000 each.

• While writing this article, I was hounded by Warhol to locate potential clients, goad various dealers into securing new commissions and repeatedly asked, "Why don't you commission your own portrait?" When I explained that my fee for this article would go a very short way toward paying for a portrait, he replied: "Couldn't you put it on your expense account? Just turn in an expense account and see what happens."

In many cases the dealers and collectors who commission his portraits are people who have known Warhol for a long time and were early endorsers and/or patrons of his art. Now that he is one of the world's most famous artists, they understandably enjoy having him do their portraits. A portrait by Warhol represents one of the most satisfactory of compromises: it's fun, chic, flattering and certified art. A portrait by Philip Pearlstein or Alice Neel may have the same kind of esthetic value but will not be very flattering. A run-of-the-mill portraitist will turn out a flattering likeness but one that has little or no esthetic or market value.

Warhol obviously relishes his new role as society portraitist. Wooing the prospective clients and finagling over financial arrangements seem to give him great pleasure. For Warhol, whose life is all work and whose work is all fun, hustling the portraits becomes a pretext for being more social and having to attend even more parties than usual. Warhol's art and social life have meshed indissolubly. In the early Pop days, when he associated with underground types, he exploited the faces of film stars and celebrities in his art to attract attention to himself. Nowadays he pals around with former subjects, such as Warren Beatty and Jackie Onassis, and subtly pressures them to commission new portraits. He even became friendly with Elizabeth Taylor and plays a cameo role in one of her new films. On the face of things, it is certainly a dream come true.

Barbara Goldsmith, "The Philosophy of Andy Warhol," *New York Times Book Review,* **14 September 1975, pp. 3-5.**

Warhol speaks! High time too. No contemporary artist has had more, or more contradictory, interpreters. Prophet or observer, pernicious corrupter or satiric reformer, prescient or a put-on? Our expectation is that at last Warhol will interpret himself to us. And he does this—by not doing it.

Warhol's basic philosophical premise is "nothing": not the futility of human endeavor of Sartre and Camus, or the void beyond pain of Joan Didion, but simply—nothing added. To the observation of life, he brings no involvement, affect or emotion. He presents us with an enlarged mirror image (cool, clear, missing a dimension): he gives us surface. "If someone asks me, 'What's your problem,': says Warhol, "I'd have to say, 'Skin.'"

The title presumably refers to the dialogues between Andy (A) and another person (B). The B's, however, are interchangeable, drawn from the entourage at the Factory. "B is anybody and I'm nobody," Andy explains. B is also frequently boring, resorting to the old lexicon of Pop: repetition, tastelessness, vulgarity. The Chapter 14 monologue in which B compulsively cleans her apartment, then herself, and then masturbates with a vibrator, is so reminiscent of *The Chelsea Girls* and passages from *a*, Warhol's tedious tape recorded "novel," that it's downright old-fashioned. Warhol's long-entrenched habit of stamping his imprimatur on the work of others makes it difficult to separate B from A. It's a pity. A's a better grade.

The sections of this book that tell us about Andy's own life are fresh and illuminating. The word "autobiographical" is not used here because one can't be sure that Warhol did the actual writing. It doesn't really matter, which is his point exactly. The important message is how Warhol managed to make himself into a machine-like presence devoid of empathy. He started off inauspiciously, as human and vulnerable as the rest of us. "Andy-the-Red-Nose-Warhola" of McKeesport, Penna., a poor little kid, sick in bed with his yearly nervous breakdown, tucked in his "un-cut-out cut-out paper dolls," listening to his mother read the comics "in her thick Czechoslovakian accent."

Other scenes: Andy at 18 in New York trying to cope with the problems of his friends, feeling "left out and hurt." Then an amazing discovery—television. "I kept the TV on all the time . . . and the television I found to be just diverting enough so that the problems people told me didn't affect me anymore. It was like some kind of magic."

In 1964 Andy meets his "wife," his tape recorder. In 1968 he meets the bullet that rips through stomach, liver, lungs and spleen. "Before I was shot, I always thought . . . that I was watching TV instead of living life . . . right when I was being shot and ever since, I knew that I was watching television."

The miraculous transformation is complete. Emotion is negated, the image real, life unreal. Warhol contends that emotion is a vestigal response unsuitable to life in the seventies. As to the loss of his own emotional life, "I was glad to see it go."

Warhol has become Warhol's artistic statement. If we suffer the staggering burden of feeling in an arid androgynous society, if life cannot match the media overload of fantasy, he offers us an implicit solution: Emulate his example. Turn off. Make image reality. The logic of this plan is as impeccable as Swift's "A Modest Proposal."

The horror of such a proposal (whether it be killing children or feelings) can only be comprehended by supplying the missing element—humanity. Warhol creates a vacuum, which causes the reader to rush in with his own emotional coloration, and the grotesquerie comes clear. Because of what is not there, Warhol consistently elicits this response, but he lacks the intentional savage satire of Swift. His wide-ranging views (on such subjects as fame, work, beauty, success, love) abound with paradox and inversions of commonly held beliefs but they are essentially nothing more than pictures of our pervasive cultural alienation and topsy-turviness.

A decade ago Andy Warhol's visual images of Campbell's soup cans and Brillo boxes shoved art out into "the real world"—a world of commercialism and mediocrity. Still out there, he presents his philosophy in the readily available verbal style of movie magazines and comics. His observation, "As soon as you stop wanting something you get it" sounds straight out of a "Teen-Wise" comic strip. The tale of his "fascination" with a girl named Taxi (a thinly disguised portrait of Edie Sedgwick) who never bathes, hoards drugs, is a compulsive liar, and finally dies, is related with breathy voyeuristic banality. The form is "Modern Romance." The content, Modern Malaise. The combination keeps us off balance.

This book is chock-a-block full of celebrities and "beautiful people" names, places and events. Traditionally these people are abstracted from life, which explains why Warhol is attracted to them. "I love plastic idols," he says.

"The 60s were Clutter."

"The 70s are very empty."

Andy Warhol's mirror reflects a decade of nothing. Nothing added—we have rid ourselves of trust, ideals, patriotism, love. He shows us as disaffected and disenfranchised from our own feelings. The sense numbing repercussions of My Lai, Manson and Watergate are our legacy.

And Warhol poses the quintessential philosophical question: What is image and what is real? Can we answer? I remember reading somewhere that almost half of the people polled after a 1972 moon walk did not believe in the man on the moon. They thought they were watching a "television simulation." We have seen

too many simulations, and the emotional signposts that once marked the road to truth have been obliterated.

Is this apocalyptic vision of vacancy confined to one artist who has made of himself a machine for all seasons? The radical esthetic and social changes of the sixties were observed first in microcosm at Warhol's Factory. What's happening to the seventies? Read this book, then fill in Andy's blanks. Some people say California is the bellwether of America. I'd say Andy Warhol.

Jack Kroll, "Raggedy Andy," *Newsweek,* **15 September 1975, pp. 67-69.**

Andy Warhol. Look at the names, Andy—a kid's moniker, as befits the Peter Pan of modern art. War—the sound of our time, of Andy's time since his first one-man show in 1962. Hol—a void, an absence, as befits the artist who has been called "the Nothingness Himself." The name evokes all the paradoxes of the most legendary of pop artists—infantilism, apocalypse, negation. If a novelist wanted to create a character like Andy Warhol, he would have had to call him Andy Warhol. But Warhol was created by the pressures of reality, and until those pressures change or disappear he will still be around. As he is right now, in a show at the Baltimore Museum of Art and in his new book called *The Philosophy of Art of Andy Warhol (From A to B and Back Again)* (241 pages, Harcourt, Brace, Javonovich).

The Baltimore exhibition is an anthology of 40 of Warhol's—and our own—most representative images: the Campbell's soup cans (but not the Brillo boxes), the car crashes, race riots, suicides and electric chairs, the Day-Glo flowers, the sweet smile of success on the faces of Marilyn Monroe and Mao Tse-tung. The book is an anthology of Warholy wisdom and self-examination. Divided into sections on matters such as Love, Beauty, Fame, Work, Success and Death, it creates a kind of silk screen of words that coalesces into the ultimate Warhol image—Andy Warhol himself.

Mirror: This is as it should be, because Warhol's persona is inseparable from his work. Self-consciousness long ago was identified by T.S. Eliot as the besetting malady of the twentieth-century artist (he was speaking of Picasso), but in Warhol the malady has metabolized until it has become almost the man himself. "People are always calling me a mirror," says Warhol, "and if a mirror looks into a mirror, what is there to see?" What he does see is the image of himself that has been created by his critics, both those who admire him as a shrewd and perversely subtle image maker, and those who despise him as a

shrewd and satanically subtle manipulator of a corrupted culture that can no longer distinguish between excellence and trash.

Confronting his mirror, Warhol, now 47, sees this Byzantine icon. "It's all there," he reports. "The affectless gaze—the bored languor, the wasted pallor...the chic freakiness...the chintzy joy...the chalky, puckish mask, the slightly Slavic look...The childlike, gum-chewing naivete...the shadowy, voyeuristic vaguely sinister aura...The pinhead eyes. The banana ears..."The graying lips. The shaggy silver-white hair...It's all there...I'm everything my scrapbook says I am."

Warhol is here turning upon himself the same irony that he has turned upon the idols and artifacts of his society. In fact, he comes through like one of those superbly self-assured madmen on Gogo or Beckett. Talk about Krapp's last tape. Listen: "The acquisition of my tape recorder really finished whatever emotional life I might have had, but I was glad to see it go. Nothing was ever a problem again, because a problem just meant a good tape, and when a problem transforms itself into a good tape it's not a problem any more." And he adds: "I have no memory ... That's why I got married—to my tape recorder. That's why I seek out people with minds like tape recorders to be with. My mind is like a tape recorder with one button—Erase."

When you look at Warhol's art you see how much has indeed been erased from both art and reality in modern times. Rembrandt looked at a human face and used the most exquisite skills to body forth its meaning and his compassion. Warhol looks—not at the face itself, but at the innumerable images of that face which clutter up our eyes and minds—and uses the most "banal" of mechanical means to body forth its meaning—and his compassion. He has sinned: he has created chic icons for empty people to decorate their emptiness. But at his best he captures the pathos, the garish beauty, and something of the terror, of a society that lusts after such strange gauds.

Sage: In his book Warhol often comes on as a perversely funny sage—a pop La Rochefoucauld. "the rich have many advantages over the poor," he observes, "but the most important one ... is knowing how to talk and eat at the same time ... If for some reason the conversation demands an immediate comment in the middle of chewing, the rich know how to quickly hide the half-chewed food somewhere—under the tongue? between the teeth? halfway down the throat?—while they make their point."

The extremes of Warhol criticism—the moral outrage of his detractors and the esthetic blather of his admirers—are both off the mark. He is a terror-stricken comic moralist, much like Nathanael West, and parts of his new book sound like

West's *Miss Lonelyhearts*, such as the nightmare he describes in which he is "involved in a charity to cheer up monsters—people who were horribly disfigured, people born without noses, people who had to wear plastic across their faces because underneath there was nothing ... Then I woke up and I thought, 'Please, please let me think about anything else'..."

Funny, crazy, scared, talented Andy Warhol is a superstar and a scapegoat. The most telling image of him is probably not his own but the photograph by Richard Avedon in Avedon's current exhibition at New York's Marlborough Gallery. Avedon cuts off that Peter Pan head to show only Andy's torso, his black vinyl jacket lifted up to display the scars remaining from his near-death when he was shot in 1968 by a woman who claimed he had "too much control over my life." The shooting took place less that 48 hours before Robert Kennedy's assassination, and in this week of more such irrational violence, Avedon's icy image is transfixing. "I never fall apart because I never fall together, says Warhol. In his art and his life, both flights from emotional commitment, you hear the laughter and the cry wrenched from a man who heard something go pop in America.

Caroline Goldman, "Andy Warhol," *Arts Review* **9 (July 1976): 351.** Review of exhibition at Mayor Gallery.

Andy Warhol's latest exhibition of Cats and Dogs at the Mayor Gallery is both exciting and important. It is the first exhibition of his paintings in this country since the 1971 Tate show, and marks a powerful development in his style.

Warhol has maintained that "I'm not trying to educate people to see things or feel things in my paintings," and outwardly his choice of subjects always remained constant to this philosophy. Rather that striving for remarkable new images the objects selected were supremely familiar, be it through newspapers, magazines or supermarkets. But in this exhibition Warhol discards his role of "passive" selector of images. These works clearly testify to an involvement between artist and subject. This exhibition shows part of a series of some 40 paintings and 20 drawings, which Warhol has been working on since autumn '75. The paintings are in a mixed medium of silk-screen and paint: the silk-screen image is laid on to a primed canvas, lashings of boldly colored, thick, creamy paint are freely applied on top of this, and finally the original silk-screen image is reapplied. In certain cases, like the trio of portraits of *Broadway* the cat, the same image is used, but the completely different choice of color and treatment of

paint results in three thoroughly different paintings. The reality of Warhol's work, however forceful the image, is through its color, paint, and canvas.

A further new aspect in these latest works is the three dimensional handling of the subjects. This is to a great extent achieved by the richly varied surface quality: the brush strokes are clearly visible, and Warhol has scraped away areas of paint leaving ridges like raised enamel, used, consistently to outline and accentuate features, and the areas of silk-screen create a dapple effect which contrasts effectively with the solidity of the thick creamy paint. Warhol's use of color is quite superb.

The drawings are more stylized with precise outlines and zigzagy lines to delineate both shadow and a surface texture.

Coe Kerr, "Andy Warhol and Jamie Wyeth," *Arts Magazine* **50 (September 1976): 15.**

Since the approach to portraiture of Andy Warhol and Jamie Wyeth is totally different, there is much to be learned simply from viewing the processes and methods of these artists. Warhol took many polaroid photos of Wyeth from which he selected the final ones used for the silk-screen images which form the basis of his finished paintings. Wyeth's working method was to execute numerous small- and large-scale preparatory drawings. The finished Jamie Wyeth portrait of Andy Warhol is tightly, meticulously painted in oil on panel while Warhol's final portraits of Wyeth are in silkscreen on canvas overpainted with acrylic, the acrylic used in a stylized way to emphasize the color patches of lips, eyes and so on.

Wyeth's completed portrait of Andy is frightening although the drawings and studies leading up to it are quite marvelous. In the oil-on-panel portrait, Warhol and his dachshund Archie stare out at the viewer like Byzantine icons, frontal and unyielding. Andy's red-rimmed eyes, yellow hair, and the visceral feeling of the depicted flesh may indeed result from minute observation but Warhol looks for all the world like Lazarus raised from the dead. The bleached, whitened quality and the frailty of Warhol's physique is exactly what Wyeth has caught so perfectly in his drawings where he often uses a Chinese white for Andy's face, hands, and hair.

A most challenging aspect of Warhol's portrait process are the large-scale ink drawings of Wyeth which were not preparatory but rather executed after the final portraits were completed. They are line drawings of total assurance, the result

of an educated hand and much closer to drawings by Matisse or Picasso than to
what we think of as Pop Art. Of course Warhol's serial portraits of Wyeth here
run the risk of being dismissed with a casual glance simply because he has done
so many portraits in his familiar, repetitive image style. Yet Warhol has a strong
claim to being the leading portratist of our era if only on the basis of the number
of portraits executed, the notables included, and the development of an entirely
new type of portraiture.

Oswell Blakeston, "Andy Warhol," *Arts Review* 29, no. 6 (March 18, 1977): 174.

Pigeonhole When I heard Andy Warhol had made 10 screenprints of *Mick Jagger*, I guessed another Marilyn or Mao sequence: 10 identical images with
color change. I imagined myself writing a couple of lines and calling it a long
review because it should be read 10 times. I was dead wrong. With Jagger,
Warhol has taken exquisite trouble. Each print is a different pose, the photo
image specially short and controlled. Then sometimes, Warhol has torn colored
paper, rather a la Matisse, to contribute; but if some features are covered by
collage, there's never any doubt of the famous face or of mood: and sometimes
Warhol has added drawing with, in one case, Cocteau-like hands spiring to the
chin. Most importantly the artist has controlled the whole printing process, for
clearly so many decisions had to be made during the printing, such as over-tinting
for special blacks which may afterwards be varnished or left matt, or contriving
an odd crackling effect for an eyebrow. Astonishingly, too, the print has been
taken on hand-made paper (generally avoided because of stretch) and great use
made of texture unlike the average screenprint which can be too smooth. Maybe
this is a first-time-ever technique: certainly it's fascination with a screenprint
often like an etching. Here is the star hooded with his mouth questioning his
personality, or Jagger carried away dramatically in the slipstream of sex, or
laughing!

David S. Rubin, "Andy Warhol," *Arts Magazine* 52 (December 1978): 10.

I recently asked Andy Warhol for his own assessment of his role in the
overall development of 20th-century art (Venice, California, 9/23/78). He

seemed puzzled and, at the suggestion of his friend (and model) Wendy Stark, he replied, "It was fun."

Although the statement was casually uttered in an informal yet chaotic setting (the artist was signing exhibition posters in the back room of the Ace Gallery), it was more significant than might first appear. Warhol, quiet and cool on the exterior, undoubtedly delights in the fact that few gallery viewers will be indifferent to the subject of his new work, the Torso series. The paintings, which portray varying degrees of male or female eroticism, should amuse or offend, depending on one's personal point of view. Since a number of the poses could easily be found in pornography magazines or films, some might consider the content to be as shocking or profound as the Campbell soup cans were fifteen years ago.

The torsos were executed in the traditional Warhol mode. Photographs were shot, enlarged, transferred via silk-screen to canvas, and embellished with paint. Images were repeated in some instances, but not within a single canvas as in the past. Instead, separate canvases were joined laterally to form diptychs, triptychs, and in one case, a five-panel painting.

The idea of multiple imagery proved very effective in Warhol's work of the Sixties. The constant, driving repetition of that horrifying electric chair, for example, could cause one to literally quiver; the forceful rhythm, frame to frame and register to register, paralleled perfectly the shattering shock waves associated with an electrocution. Yet only in the five-panel painting (all the torsos are untitled) does Warhol even approach so vigorous a statement. The image is the back of a male body, seen in slight three-quarter view. The model's pose is one of tautness and tension—legs apart, back is arched, and sphincter muscles are tightly contracted. This is the most archetypically masculine image in the series, despite the fact that others focus on more explicit views of every type of male sexual anatomy. Here something *is* left to the imagination; the sexual energy is expressed by suggestion rather than description. It is not only in the pose but in the relation of each panel to the next and through manipulation of color and paint texture that there emerges a visual energy potent enough to mimic the rhythms of orgasm. Due to the lateral left-to-right organization, the dark shadows which fall over the body contours form a series of repeating pulsations in a rippling horizontal sweep. Brushwork is regulated accordingly and becomes increasingly activated, reaching a peak in the fourth panel. Within this movement are metaphorically sexual stops and starts, induced primarily by color shifts. The first four panels vary in intensity and are limited to combinations of gray, flesh, and white. The rhythms evoked by these relatively neutral hues act as a prelude

to the more explosive coloristic crescendo attained in the last panel, where the flesh-colored body is bathed in a multicolored glow of blue, green, and yellow on a gray field.

Not all of the torso paintings are orgasmic in emphasis. A triptych showing a frontal female torso remains quiet and remote—almost classical. Color again seems to play a key role, as the image is conceived in black outline on a white ground. Only in the De Kooningesque brushwork is there a hint of expressionism and a subtle reminder of the real roots of Warhol and others of the Pop milieu.

In fact another of the series, a diptych containing an up-side-down back view of a male nude, succeeds because it *does* verge on Abstract Expressionism. The non-natural positioning of the body causes it to be perceived as an almost purely formal entity. Each printing of the body is covered by a broad band of color (flesh-toned on a gray field) that leads the eye swiftly from top to bottom and off the composition. The effect of the vertical sweep recalls somewhat the successes of Newman, while the breadth of each band causes it to operate in a manner more reminiscent of Kline. In any case, there is a reasonably exciting tension created by the contrast between the rigid vertically of the band in the right panel and the bending curve of that in the left. When asked about the fact that altering a body position by rearranging the placement of the screen could yield a more abstract image, Warhol acknowledged that he thought of the shapes produced as "landscapes."

The rest of the exhibition will be remembered for the literal explicitness of its imagery—especially the triptych which features an unusually large phallus. Many of the compositions, however, are weak and exceedingly lacking in any other sort of impact. Why is this so?

I would suggest that the success or failure of Andy Warhol's art is a coincidental after effect of the artist's activities. In addition to admitting that he makes art just for the fun of it (and for the profit of it I would suspect, as well), Warhol stated that he never has any meaning in mind (both before *and* after the completion of a work). That is something which has been a continual problem for those writing about Warhol, since he will rarely confirm or deny anyone's ideas about his intent or interpretations about the content of his art. Warhol himself claims not to understand much of what has been written about him. He also approaches a series without anticipating the results.

It is interesting to note that Warhol greatly admires Rauschenberg, for although both emerged in the same place at about the same time, there is a startling difference in their attitudes. Rauschenberg seems always to be keenly aware of both the formal and conceptual problems and implications of his art.

Because he carefully plans and ponders, the level of his achievement is consistently high and ultimately one of greater sophistication. When Warhol succeeds, it is usually a matter of intuition—which is fine. But it is probably the absence of careful forethought and control (perhaps necessary components for an art that is partly conceptual) which must also account for the lows and the fact that the Torso series is, as a whole, of uneven quality.

Hilton Kramer, "Art: Whitney Shows Warhol Works," *New York Times,* **23 November 1979.**

For the second time in less than a decade, the Whitney Museum of American Art has mounted a major exhibition devoted to the work of Andy Warhol. The new show, which occupies the entire fourth floor of the museum, is called "Portraits of the 70's." It consists of a huge selection of those embellished photographic blowups—mainly silk-screened images sporting gaudy color and smeary brushwork—that instantly became the most fashionable pictures of their time. It is not exactly damaging to their renown, of course, that their subjects are drawn principally from the world of international celebrity. . . .

The style governing all these portraits follows a thin, remorsely repeated formula. Its basic elements are easily described. Commonplace photographic material is altered by an insouciant application of decorative color. Everything is made to look—quite consciously, of course—like poor-quality mechanical color printing gone slightly haywire. And the tendency of this portraiture is not to flatter—Mr. Warhol is too shrewd a judge of current taste for that—but to make every subject look ugly and a shade stoned, it not actually repulsive and grotesque.

This is a variant of the Pop Art style that won Mr. Warhol his first great fame in the 1960's, but there is this major difference: whereas the earlier work was very neat and precise in execution (the Brillo box had, after all, to look like a Brillo box), the new work has a very slapdash look. This, as they say, is no accident. In the 60's it was important for artists of the Pop school not to appear to have any affinity with Abstract Expressionism, but in the 70's—such are the vicissitudes of taste—it was O.K. again for paintings to look smeary and "unfinished." As usual, Mr. Warhol was among the first to sniff this change in the esthetic weather, and promptly gave his art a new turn.

It is probably idle to complain that the work itself is shallow and boring, and that it is the phenomenon of Mr. Warhol's media career, rather than its intrinsic quality, that endows the art with whatever interest it commands. Mr. Warhol

long ago outdistanced such criticism, and turned it to his own advantage. (Surely he would not be having his second major show at the Whitney if he were not a media hero. To paraphrase a famous quip about the Sitwells, his art belongs less to the history of painting than to the history of publicity.) What may be worth noting, however, is the debased and brutalized feeling that characterizes every element of this style. That this, too, may be deliberate does not alter the offense.

But to say this is to take a minority view, of course. In that vast cultural space where the world of art and the world of the gossip columns meet, Mr. Warhol can do no wrong. And he has likewise swept the world of the academic art historians quite off their feet, too. Thus, it comes as no surprise to find Prof. Robert Rosenblum—in his introduction to the book that accompanies the exhibition—favorably comparing Mr. Warhol with Manet, the Byzantine masters, Whistler and sundry other artists of high repute. It rather reminds one of the time—it was 1967—when another professor, Richard Poirier, then an editor of Partisan Review, avowed in the pages of that august journal that the songs of the Beatles were often superior to those of Schumann. Who said the 60's were dead? We are still paying for them on the installment plan.

"Portraits of the 70's" will, all the same, be a very popular exhibition—that, after all, is its real purpose, to be popular and talked about.

3

THE NINETEEN EIGHTIES

Charles F. Stuckey, "Andy Warhol's Painted Faces," *Art In America* **68** (May 1980): 102-111.

Bridget Berlin: Whose portrait are you doing?

Andy Warhol: Gunther Sachs.

BB: When [is] mine going to be finished? You promised me mine, I have it written.

AW: I owe you one?

BB: Yes.

AW: I didn't say when I was going to give it to you. It's in my Will.... A portrait of Bridgette [sic] Berlin goes to her when I die.

BB: How far have you got?

AW: I've got pretty far.

BB: How far?

AW: Pretty far.[1]

In essence this conversation could have taken place between Picasso and Gertrude Stein, Reynolds and Mrs. Siddons, or Raphael and Castiglione. From the outset of a commission, portraitists and sitters both accept trying interpersonal relationships: impatience, curiosity, interference, disappointment, indignation. Many artists and patrons justifiably avoid portraits, but there are many who cannot resist the special appeal of a concentrated face-off. Whatever self-images sitters may hold in imagination, posing inevitably reveals unnoticed or even studiously concealed characteristics. For the artist, no more human challenge exists than to render the presence, purpose and fantasy of a face. Van Gogh, like

his closest colleagues, was enthralled by the challenge: ". . . it is often difficult for me to imagine the painting of the future theoretically as otherwise than a new succession of powerful, simple portraitists, comprehensible to the general public."[2] Anyone who cares to may consider the brilliant portraiture painted by artists here and abroad during the 1970s as a fulfillment of van Gogh's prophecy. Warhol, whose portrait work began to emerge 20 years ago, certainly set an example for many of them. Warhol always addresses the widest public with all of his work, which is disarmingly direct and "powerfully simple." The Whitney Museum's recent exhibition, "Andy Warhol: Portraits of the 70s," attested to that, as well as to his uncanny sensitivity to sophisticated issues of pictorial representation and to the manifold possibilities of art as environment.

It was the second extensive exhibition the Whitney has devoted to Warhol's work. The first was a major retrospective in 1970. Uncomfortable with the prospect of a traditional retrospective, however, Warhol tried to convince the exhibition staff to include only recent work. For example, he proposed a show comprised exclusively of his *Flowers* (1964) paintings, up to 300 of them; and he suggested alternatively that the exhibition consist simply of his *Cow Wallpaper* (1966), applied to the walls backwards even, according to impish comments reported in the press.[3] In the end he consented to a retrospective, but nevertheless covered the gallery walls with *Cow Wallpaper*, a bold background against which (as associates assured him) the other work would be less noticeable. That retrospective confirmed Warhol's importance as a painter while simultaneously extending his longstanding interest in environmental art—or installation art, or more plainly, "decor."

Judging from "Portraits of the 70s," "decor" continues to be at least as important to Warhol as portraiture. Following plans devised by his longtime collaborator, David Whitney, Warhol checkered the gallery's walls (painted glossy brown) with 56 pairs of portraits, resulting in what 19th-century artists would have called a "decoration." According to art dictionaries of the time, the term referred to broadly painted stage scenery and by extension to interior spaces articulated with pictorial suites. For example, van Gogh painted the variations of his well-known Sunflowers as a "decoration" for his studio at Arles, and Monet devoted his final decades to "decorations" of related water-lily murals, today installed at the Orangerie in Paris [see *A.i.A.*, Jan.-Feb. 1979 and Sept. 1979]. Many of their colleagues likewise aspired to create integrated pictorial ensembles for special settings. Twentieth-century art would be the poorer had not artists such as Matisse and Rothko found clients for similar expansive projects.

Of course, Warhol disclaims lofty artistic purposes, preferring to encourage the communal participation of nonartist friends, and to make art fun (and thereby to make it more broadly and directly appealing). As a result, his installations largely express irreverence for traditional gallery and museum display that is predicated on optimal presentation of individual works. Since the start of his art career, Warhol has repeatedly suggested non-art contexts for his work. When in 1961 Bonwit Teller commissioned him to dress a display window for fashion mannequins, Warhol used the opportunity for the public debut of his comic strip paintings which he incorporated as chic backdrop. For a gallery exhibition the following year, he again limited himself to a group of related pictures, this time near-identical paintings of the 32 varieties of Campbell's canned soups. Although his decision followed installation innovations initiated a century ago by Degas and Monet, who frequently restricted their public exhibitions to variations on a single pictorial motif, Warhol extended their principle, since his ensemble systematically exhausted the possible variations of a finite theme. Warhol was delighted when Irving Blum, the gallery's director, purchased the entire group in order to preserve its total impact. Nevertheless, Warhol has been largely indifferent to whether or not closely related works remain together, even though he initially presents them grouped in provocative ensembles.

In 1964, for example, he transformed a gallery space into a stockroom when he piled it with *trompe l'oeil* sculptures representing shipping cartons for brand-name packaged goods (Campbell's, Brillo, etc.). And that same year he virtually wallpapered another gallery space with his *Flowers*, which he later claimed "were only one big painting that was cut up into small pieces."[4] These installations exemplified Warhol's outspoken disregard for conventional art contexts: "You go to a museum and they say this is art and the little squares are hanging on the wall. But everything is art."[5] Indeed Warhol's two installations at Leo Castelli's gallery in 1966 effectively extended his art to include "everything." He sprinkled one room with helium-filled silver-colored pillows, what he called "floating sculpture," the mirror surfaces of which incorporated everything present (walls, spectators) into the work. And he covered the walls in a second room with *Cow Wallpaper*, thereby relegating his work to the status of commonplace backdrop, but in the process extending art around the entirety of the space.

Warhol's experiments with decor earned him an invitation in 1968 to "12 Environments" in Bern for which he reproduced several of them. Earlier that year, when Pontus Hulten, then director of Stockholm's Moderna Museet, organized a Warhol exhibition, the artist went so far as to cover the museum's Neo-Classical exterior with *Cow Wallpaper*.

Warhol continued to create bizarre installations during the 1970s. As already mentioned, he insisted upon having an art background (*Cow Wallpaper*) for his Whitney Museum retrospective. Invited to contribute to "Art in Process" in 1972 at Finch College, Warhol vacuum-cleaned the galleries. Although his efforts were virtually unnoticeable (he displayed the vacuum cleaner's collection sack), they were to be thought of as having transformed the museum setting for art and spectators alike. For a 1973 show at the Musée Galeria in Paris, Warhol fabricated a *Mao Wallpaper* which served as background for his Mao silkscreen paintings in several formats, all based on the same frontispiece photograph to the *Quotations from Chairman Mao* Tsetung (published in English-in 1966). Installed edge to edge in uninterrupted horizontal rows, the paintings rivaled the decorative role of the wallpaper pattern. The wallpaper portraits dwarfed the smaller paintings and were themselves dwarfed by the larger ones. Altogether, 1,951 images of Mao loomed and receded as painting and decoration in tandem orchestrated the gallery space.

Warhol returned to the *Cow Wallpaper* for the premiere of his *Ladies and Gentlemen* (a portrait series of drag queens) in Frascati in 1975, this time covering even the doorways, so that spectators burst through shredded paper to enter the exhibition. And in 1978 for a retrospective in Zurich, Warhol designed a new wallpaper based upon a self-portrait.

Prior to the "Portraits of the 70s" exhibition last year, the Lone Star Foundation presented Warhol's *Shadows*, 83 large, closely-related paintings in 17 color variations which he installed just above floor level, side to side, continuously around the perimeter of the two huge rooms (formerly the Heiner Friedrich gallery). "Really it's one painting with 83 parts," he explained. Asked if the work was art, he replied in the negative, preferring the designation "disco decor."[6] This distinction notwithstanding, Warhol's seemingly abstract works (in fact based upon a photograph of a shadow) rhythmically repeated along the walls joined one another in something like a ballet in confetti colors throughout and around the enchanted space.

Warhol's concentrated investigation of portraiture began in the early 1960s when he was among several artists who decided independently of one another to use pedestrian images familiar from everyday life as the basis for pictures. Like the art of Lichtenstein, Rosenquist and Wesselmann, Warhol's responded to large, simple close-up images common to merchandized media-movies, magazines. At first Warhol made drawings after publicity photographs for stars (like Ginger Rogers) which he had collected from magazines and books. The uncomplicated pictorial qualities of publicity photographs appealed to Warhol, who ardently

admires related characteristics of popular folk art. Perhaps more important, photographs of posing stars appealed to Warhol because by temperament he ponders distinctions between what is genuine and what is counterfeit. "I don't know where the artificial stops and the real starts," he explained.[7] Of course, all representational art is concerned with where the artificial stops and the real starts, since all representational art is forgery, a substitute for some distinct counterpart in reality or imagination. But Warhol's art undermines fundamental goals of representational art, since he represents things which in themselves are tokens or containers for something else. For example, he painted money which is a certificate for precious metal, green stamps which are tokens to exchange for other goods, and soup cans whose labels only indirectly indicate their hidden contents. Warhol paints movie stars whose play-roles, like those of drag queens, hide true identities—he paints shadows removed from whatever cast them. Most often Warhol's images are literally photographs transferred to canvas with silkscreens. This is always the case with his portraits, which strictly speaking represent photographs of individuals, not the individuals themselves.

Ever since photography's invention, the use or approximation of photographic images and processes by painters has aroused debate. More than a century ago Baudelaire and his associates spoke out against art that recorded visual appearances in minute detail as if to rival the verisimilitude attainable in photographs, since for them such art was mechanical and impersonal, whereas truly great art always expressed a master's unique manner of vision. Warhol often seeks the same still unwelcome impersonal character in his art, and his work with photographs and movies must at least partially satisfy his often cited wish to be himself a machine. Yet despite Warhol's artistic inclination for repeated units arranged mechanically in grid compositions, when he uses mechanical techniques he is intentionally careless, and he apparently instructs assistants and commercial fabricators to maintain standards such as clumsy or sabotage-minded machines might be imagined to set for themselves.

The most notable example of his attitude is the characteristic misalignment in his silkscreen paintings of color and outline. Such "slippage" in his portraits displaces say, the local color of lips or hair into adjacent areas of the face and background. As a result his images are inept—smudged, broken and doubled. For over a century already, of course, sophisticated artists have added rich dimensions of meaning to works with purposeful ineptitude. Man Ray, for example, whose photographic portraits have been an inspiration for Warhol, explained that his art was "designed to amuse, bewilder, annoy or to inspire reflection, but not to arouse admiration or any technical excellence usually sought for in works of art.

The streets are full of admirable craftsmen, but so few practical dreamers." Warhol is a practical dreamer if ever there was one, and the awkward aspects of his work provoke thoughtful response.

Since, when they are uncoordinated, color and outline function independently of one another, the slippage common in Warhol's early silkscreen portraits calls attention to the component aspects of representational painting. The *Do It Yourself* pictures that Warhol undertook in 1962 similarly diagram artistic process and illustrate his unconcern for technical finesse. Based upon popularly merchandized paint-by-number kits for beginning painters anxious to obtain more advanced results, Warhol's works illustrate the fundamental relationship of color and outline taught by children's coloring books. If Warhol chooses simple-minded subject matter and disregards craftsmanship, he does so again, to emphasize the tenuous relationships between the artificial and the real, between how an artist represents and what an artist might intend to represent.

Those relationships were particularly important to the development of Warhol's portraiture. Although his first likenesses were limited to purposely fantasized subjects and media idols, Warhol almost immediately expanded his range to include friends and clients. Since in one sense his portraits glamorized non-celebrity acquaintances, they seemed to help fulfill his prediction of a future when everyone would "be world famous for 15 minutes." In another sense, however, he wanted to expose artificial glamour and realized that inept techniques made it possible to do so. Asked why as a filmmaker he disregarded professional camerawork and editing procedures, he explained, "Well, this way I can catch people being themselves . . . it's better to act naturally than act like someone else because you really get a better picture of people being themselves instead of trying to act like themselves."[8] A similar attitude presumably guided his decision to base a portrait of client Ethel Scull (1963) upon a series of snapshots taken automatically at a coin-operated booth. The 36 photographic silkscreen images of Scull arranged in a grid express a wide range of moods and expand upon traditional portraiture's unique pose convention in the interests of more complete (and consequently less artificial) representation.

Yet however "like themselves" Warhol was able to capture sitters, throughout the 1960s he tended to paint multiple, most frequently identical, portraits of a given subject and to group these decoratively in rows or grids. If the multiplication of a single portrait served to amplify a sitter's presence, it did so, however, at a cost to realism because repeating the same image diminished whatever unique true-as-life qualities any single image might seem to have in isolation.

His "Portraits of the 70s" installation was ultimately based upon his decorative composite portraits from the previous decade, such as the *Thirteen Most Wanted Men* mural for the 1964 New York World's Fair or his 1967 *Portraits of Artists* multiple. And the individual portraits included in "Portraits of the 70s," to date his largest all portrait show, are variations on the closeup format he introduced in the early '60s—what Warhol's assistant Fred Hughes termed "the icon effect of the head and shoulders."[9]

But whereas his 1960s portraits were mostly based upon media photographs or ones supplied by sitters, those in the Whitney show rely upon Warhol's own Polaroids—he claims that it is easier to take his own. Perhaps. Although a sitting might require as few as 4 snapshots (*Ileana Sonnabend*) or as many as 150 (*Jamie Wyeth*), Warhol reportedly takes an average of 50 from which he can select one for a silkscreen. This method is no different from that of portrait photographers who shoot many rolls of film to insure getting at least one usable result. As sitters and their acquaintances agree, Warhol has a remarkable sensitivity to his subjects' personalities. He most often responds to the turn of the head or the gesture of a hand, and always to the attentiveness of the eyes.

Warhol sends the chosen snapshot to a laboratory where it is enlarged in black and white and then transferred to a silkscreen, from which it can be printed onto a canvas, which will finally be mounted on a 40-inch square stretcher. Often the silkscreens are narrower than this format, so that in completed portraits the photographic image maintains a distinct identity as one part of a more complicated process. Once Warhol determines the placement of the silkscreen image on a canvas, but prior to actually printing the image, he applies unmodulated acrylic colors (sometimes expressively scumbled) by hand, to indicate the approximate local colors of areas which will correspond roughly to backgrounds, hair, costume or flesh. After setting down the colors, he silkscreens the photographic images in black; what results is an odd combination of the black and white gradations of photography and his own supporting color notations. One mechanical and the other freehand, the two systems of representation reinforce one another, but never completely coalesce.

Subsequently, Warhol puts down additional color accents, again using both stencil and hand techniques. For example, he might mask out all but one detail on the silkscreen—often the lips or eyes—and then print that area a second time with a descriptive but unmodulated local color. Or he might add highlights of color to enhance his design (to get the work "spaced right," as he puts it)[10] or to make his pictures more evocative. "I think abstract things say more because you can read more into them," he explained in 1974, at which time he expressed the desire to

give his works more "style."[11] He seems to have meant bravura brushwork, which he intentionally avoided for the most part until the early '70s.[12]

The expressive power of Warhol's portraits in a large measure depends upon the coloristic emphasis he gives to details, costumes, mouths, eyes, hair, shadows under chins. Although approximately aligned with photographically accurate appearances, the accented areas restructure faces in jarring expressionistic terms—one is reminded of Rouault's moody works, or the stylized Byzantine and Gothic portraits which he, too, admired. In a Fauvist vein, Warhol freely distorts local colors and exaggerates shadows and textures. Roughly brushed blues and reds intensify hands or eyebrows. Backgrounds in Warhol's pictures are vivid fields of color, energetically textured on occasion, like those against which van Gogh isolated his sitters. Although some of Warhol's portraits perhaps inadvertently call to mind specific images by well-known masters, (*Victor Hugo* recalls Michelangelo's *Dying Slave; Dorothy Lichtenstein* recalls Vermeer's *Lady with a Pearl Earring*), in general his adaptations of other artists' works are limited to idiosyncratic dictorial devices that increase characterization through expressive distortion. For example, the "slippage" associated with Warhol's silkscreen technique resembles the "haloes" Man Ray attained through manipulation of the Sabatier effect (sometimes referred to as "solarization"), and for both artists the imprecise secondary images suggest a supernatural glow.

Instead of "supernatural," though, Warhol would likely prefer terms such as "fake" or "artificial." In any case the shapes of color in Warhol's portraits amount to a representational system at odds with that of photography, and his portraiture as a whole relies upon the interrelationship of these alternative representational systems. Sometimes one system dominates the other. In *Dennis Hopper* (1970) a roughly square area of color brightens the presiding photographic image without distorting it, and the independence of color and outline recalls experimental attempts by Surrealist artists, such as Miro and Masson, to separate and decoratively realign the pictorial components of figurative art. Alternatively, in *Sydney Lewis* (1973) and *David Hockney* (1974) Warhol's color obliterates much of the photographic image, the remnants of which float in abstract fields of ruffle-like paint strokes indicative both of figure and background. The paradox created by the interplay of representationally real and arbitrary, artificial pictorial elements is similar to that characteristic of Cubist collages fabricated from diverse tokens of visual notation. But whereas in Cubist works different representational conventions are localized in separate details or areas, they are interfused throughout Warhol's portraits.

The shapes of color in *Ivan Karp* (1974) extend and distort the photographic likeness, yet since they do not obliterate it, real and artificial co-exist. The head's outline is obfuscated by rippling doodles, and the hand is smudged with long purplish strokes that rudely transfigure photographic representation. But given the vestigial scaffold of the photographic image, the graffiti-like paint suggests, by compensation, the textures of flesh and hair. In the lithographic portraits of *Mick Jagger* (1975) the distinct components of several simultaneously employed representational systems are arranged with decorative lyricism. Although the nonrepresentational shapes of color have jagged outlines as if they "represented" torn scraps of paper like those often used in collage, only some of them correspond to descriptive local colors, while others are entirely decorative. Line drawings traced from the photo graphic images multiply the facial features à la Picasso, and the adjacent drawn and photographic images stress the unique descriptive powers of different pictorial conventions. Warhol's exquisite lithographic portrait of Paloma Picasso relies in a wistful fashion upon a pictorial vocabulary invented by the sitter's father.

All of Warhol's portraits rely upon the degree to which the photographic and freehand terms of representation correspond to one another. In a few portraits, such as *Evelyn Kuhn* (1977), Warhol limits his palette to black and white tones, with the result that his freehand grisaille is in effect a *trompe l'oeil* of black and white photographs. But evidence of his brushwork fractures the photographic image, suggesting tears, abrasions and fading. In *Liza Minelli* (1978) his smoothly applied colors so closely follow the photographic image that real and artificial hang superimposed in another delicate balance.

Crowded with visual suggestions in resonance with one another, Warhol's portraits evoke both direct confrontation with a sitter and afterthoughts as well. Fact vibrates with fantasy, real ebbs and fake flows, representation vies with decoration. "Why do I use color and black & white?" Warhol once puzzled. "Color and black and white? That clashes.... I mean it's just so fantastic it looks like Poltergeists over Poltergeists in different colors and patterns and intricate divisions and, uhh-what was that word? I just had it on the tip of my tongue but I forgot it . . . I forgot the word. When it comes up, I'll let you know."[13] The word might still elude us all, but Warhol's "Portraits of the 70s" reminds us of the perplexing beauty located at that boundary where the artificial and the real spill over into one another.

NOTES

1. *Andy Warhol—Transcript of David Bailey's ATV Documentary*, London, a Bailey Litchfield/Matthew Miller Dunbar co-production, 1972, unpaginated.

2. *The Complete Letters of Vincent Van Gogh,* 3 vols., Boston, New York Graphic Society, 1978, 111, p. 519.

3. John Perreault, "Andy Warhola, This Is Your Life," *Art News*, May 1970, p. 80.

4. Phyllis Tuchman, "Pop-Interviews for George Segal, Andy Warhol, Roy Lichtenstein, James Rosenquist, and Robert Indiana," *Art News*, May 1974, p. 26.

5. Robert Rosenblum, "Saint Andrew," *Newsweek*, Dec. 7, 1964, p. 103.

6. Andy Warhol, "Painter Hangs Own Paintings," *New York,* Feb. 5, 1979, p. 9.

7. Gretchen Berg, "Nothing to Lose—Interview with Andy Warhol," *Cahiers du Cinema,* May 1967, p. 40.

8. *Andy Warhol's Index* (Book), New York and Toronto: Random House, 1967, unpaginated.

9. Janet Laib, "Immortality at a Price," *Cue Magazine,* Nov. 10, 1978, p. 34.

10. Andy Warhol, *The Philosophy of Andy Warhol (From A to B & Back Again)*, New York and London: Harcourt Brace Jovanovich, 1975 p. 149.

11. Tuchman, "Pop-Interviews," p. 26.

12. Gerard Malanga, "A Conversation with Andy Warhol," *The Print Collector's Newsletter*, January-February, 1971, p. 127.

13. *Andy Warhol's Index* (Book).

Carter Ratcliff, "Starlust, Andy's Photos," *Art in America* (May 1980): 120-122.

One of the standard jokes in Hollywood musicals was the egomaniacal actor who puts on his own show, giving himself not only top billing but writer's,

producer's, director's and possibly even stage manager's credits, as well. His name appears in the title of his new book, *Andy Warhol's Exposures*, twice in the bylines, and again in the publisher's credit. He is the star of his own show, the leading citizen in Andy Warhol-land, yet he hardly ever makes an appearance. It's enough for him to define the boundaries of his world and, in a cunningly rambling text, provide it with its tone (dry and reverential), its topics (those who possess a certain kind of fame), and its constitutional framework, which rests on the belief that every American has the basic right to bask in star-glow. And no one, in Warhol's eyes, is more basically American than he. Thus *Exposures* exposes first of all his lust for proximity to fame—"I have Social Disease," the text begins, "I have to go out every night."

His snapshots and anecdotes of the stars get right to the point: in our culture, celebrity is transcendent. To be famous is *to be*, to possess one's existence with a certainty denied the not-famous, though Warhol avoids fame that raises uneasy questions. Bianca Jagger's visit to the White House and Jack Ford is described; Jack's mother and father get mentioned, but Idi Amin doesn't. Muhammad Ali does and so do a couple of the Shah's minions, who appear in walk-on parts, but the Shah himself doesn't exist in Warhol's world. Of course not. To be famous and genuinely powerful (was Jerry Ford ever really the most powerful man in the world?) is to inspire dread, not a warm rush of awe. Jimmy Carter appears only when his election campaign had reached the desperate point where he asked Warhol to do some prints for him. Henry Kissinger is shown hugging Elizabeth Taylor and looking squeamish in the company of Monique Van Vooren. Then there's Warhol's conversation with the ex-Secretary on the subject of X-rated movies on Hilton Hotel room TV sets. "Do you ever watch them?" Warhol asks. "Kissinger laughed and said"—well, there's no need to retranscribe his words. (Warhol really does seem to tape everyone, everywhere.) In short, Kissinger said no. And he did it with an air of unburdened celebrity, so Andy didn't have to get upset. "It was really exciting meeting Kissinger," he says, which is no more an expression of enthusiasm than it sounds. What it means is that Warhol finds it just barely possible to acknowledge Kissinger's existence.

To be famous is *to be* in an absolutely convincing manner, to possess existence transcendentally, only if one's fame is chiefly a matter of radiating that transcendence, that glamour, that recognizability so immediate it renders any follow-up unnecessary. What tape recorders store is not conversation but images of star-talk. To have them on tape is to make play-back pointless. And everyone understands how Polaroid cameras work, so it's obvious that life, for Warhol, is just like his art: a matter of images whose importance resides in the believability

they take on even before we see them. Warhol's art-life consists of seeking out that believability, then doubling and redoubling it until it envelops him in hectic certitude. To sit speeding along a Los Angeles freeway, listening to Lorna Luft, Judy Garland's daughter and Liza Minelli's sister, talk about Raquel Welch, whom she calls "Racky," leaves Warhol immersed in glamour the way heroes of porno flicks are immersed in flesh. Heaven for Warhol is a shot of a living room that contains Lillian Gish, Lynn Redgrave, Bernadette Peters, Maureen Stapleton, Anita Loos and Paulette Goddard. Don't worry if some of these names elude you. Warhol's lust for images leads him to promiscuity, to fringe zones where quotas of fame must be inflated in order to satisfy—though of course ultimate satisfaction never arrives. The climax, the proximity to a super-star that would end all proximity to all super-stars anywhere, is never reached.

It's no exaggeration (it may be an understatement) to say that, for Warhol, fame untainted by genuine power is the quality that sanctions existence, that makes life not merely livable but imaginable—that is, graspable on the imaginative planes where the images of Warhol's art-life originate. There is no climax in art or in life, emotional, esthetic, or other, because he is not only worldly but childish—early adolescent at most. His style is geared to yearning, not consummation. He lives on the security offered by those crushes which run no risk of leading anywhere but to new crushes of new intensity. Stars are always introducing him to each other, and sometimes he gets to be the go-between. I suppose there's an Andy Warhol somewhere who lives differently, but the media Pierrot he has devised for public consumption stays endlessly chaste in his devotions—never pretentious about it, though. Sent out for a "dirty book: in Tokyo, Bob Colacello comes back with *Truckstop Jockey Shorts*. Warhol never gets to read it because wives of Canadian members of Parliament choose that moment to thump on his hotel room door. They bear a message from Margaret Trudeau.

Talking about the "sex pits" of downtown Manhattan, Warhol says he has only been to those places twice. "They're too dirty, too gay, too sexy—for me. They don't let girls in and I'm always with girls." Warhol's girls are never *too* sexy, even when they show their breasts, which they do, but not too often. Catherine Guinnes shows hers above a pair of Everlast boxing shorts, but the least threatening set belongs to Potassa de la Fayette, "Dali's favorite transvestite high fashion model from Santo Domingo." The lack of a comma in that caption makes it possible to image that Dali has favorite and equally hormone-hyped transvestite high fashion models from other Latin American cities. Anyway, Warhol approves of this one because "Potassa" is a kind of hair pomade—it's a brand-

name, just like the names of so many of Warhol's early super-stars. Warhol's unstated motto is "Make images, not love." According to him, "Truman [Capote] says he can get anyone he wants. I don't want anyone I can get." Precisely. that's the principle of the crush. Warhol has made it the foundation of his world.

He is very much a latter-day reductivist in his decision to limit the ecstasies of love to those of unfulfillment. These ecstasies, displayed in the public mode of the fan, are the content of *Exposures*, so the book cannot be dismissed on the grounds that its obsession is trivial. It isn't. Ever since the medieval beginnings of troubadour poetry, deliberately unconsummated love has been one—and of course only one—of the bases of Western culture. In fact, it is only one of troubadour poetry's bases. But it provides Andy Warhol-land with its full consignment of the actual, the real, the truly existent. The strategy of *Exposures* is to displace the fervors of hopeless yearning from 12th-century Provence and Jules Laforgue's fin-desiècle Paris to a carefully controlled milieu of contempo celebs. The result is a grainy, black-and-white light of revelation. A driving force of mass culture (the desperation of fans) is shown to be a driving force of high culture (transcendent frustration) with its power immeasurably stepped up by the camera, electronic gadgets and egalitarianism. Warhol-the-artist is far removed from the process, even as he channels it into the invention of his own world—perhaps his most important work of art to date.

His control over image-making styles and technologies gives him the power to work in high and low regions of the culture at once. It's the esthetic equivalent of out-of-the-body travel, which may explain why he looks so ghostly in the pages of this book. Ostensibly a party-goer, a sufferer from "Social Disease," he is secretly the vehicle of artistic intentions so complex he would probably cease to function if he didn't dilute them with nightly doses of the inane. As he goes about his self-invention, he endlessly implicates the seriousness of the project in the silliness of the world where his public image can survive. Andy Warhol-the-artist's Frankenstein is Andy Warhol-the-fan. Hence the irony that tints the awe he feels when he throws his heart at the feet of those whose glamor can distract him from his own, must always threaten to be painful.

Warhol feeds his high-art intentions on mass culture's denials that such intentions count. Having gerrymandered several regions of media-land and made them into a coherent work of art, his private duchy, he finds that he may only rule it if he plays its shy buffoon, wan and childish in his devotions. Within the world that owes its existence to him, he is permitted an artist's eccentric image but never an artist's stature. Nothing of that scale finds room in the Duchy of Andy Warhol, much less in the world of mass culture of which Warhol's art is the

distillate. The process of self-creation has produced a place to live for Warhol-the-fan, but only solitude for Warhol-the-artist. So the irony just won't go away. Since artist and fan are not ultimately distinguishable, Andy is always detached, even when he gazes at Paulette Goddard's diamonds.

Still, that distancing, nasal quaver of the voice is largely missing from the text of *Exposures*. And in the background of an uncredited shot of Vladimir Horowitz at Studio 54, Warhol looks positively rapturous with just being there. This book pushes Warhol-the-fan so far forward that some will assume that Warhol-the-artist has left the party for good. After all, as he mentions more than once, Warhol's lust for proximity to untainted fame has made him famous—fan turns celeb—though of course *he* is tainted, for he remains an artist. He is indeed the writer, director and producer of his own show. It's tough to wear all those hats, especially for a creative type so bashful that parties drive him into corners of the room. As he says, his "Social Disease" is all work, no play. How could there be any rest for the weary when the project is to reduce the present to its bearable essence?

The process is carried out with extraordinary precision. Warhol's world includes Dick Cavett but not Johnny Carson, John Lennon but not Paul McCartney—and yet there's no point in continuing along these lines. The sign of a fully-powered esthetic impulse is that the forms it generates cannot be summarized. Specifics must be traced, which can't be done here. Warhol's world is just too complex, with its blend of Hollywood survivors, young and old; best-selling authors; rock stars; relatives of powerful businessmen and politicians; mildly adventurous Europeans of leisure; and undistinguished youths of both sexes—"the kids from the office," who are all Republicans "except for Fred, who's from Texas." And the population contains many more varieties. The endpapers of *Exposures* bear its index, which must list about 750 people. It's quite a crowd, though every appearance is owed to fine discriminations on Warhol's part. Sue Mengers, the Hollywood agent, introduced him to Paul Newman, but, he says, "I wanted Clint Eastwood." Who, with any sense of the moment, the movies and the large-scale relations between the two, could fail to see why? The coherence of Warhol's world echoes coherences he sees in the larger world even as he flees it and its demand that one believe that there is life after fandom. Warhol's discriminations are as precise in small things as they are in large. I read somewhere that Tanya Tucker, the Nashville songbird, thinks Mick Jagger's accent on *Faraway Eyes* is fake—but only Warhol has pointed out that Jagger's English accent is fake too—fame Cockney. Of course, Warhol cites that as one of seven explanations of Jagger's "basic appeal."

The leading figures of Andy Warhol-land have been chosen for the purity of the crush that can be directed their way. Good looks help, but they aren't essential. What's important is a past or family connections whose allure can be encapsulated by a short phrase in a short anecdote. Jackie Onassis is the Ozma of Warhol's Oz. Her social clout has a troubled history in the larger world, yet that is forgiven in the moment of recognition, as the first burst of awe explodes in silence. Though, as Warhol discovered when he went to a show of Egyptian art at the Brooklyn Museum with Jackie and Lee Radziwill, some people whisper. But Jackie didn't notice all the people around her. She had blinders on. It was like she was in a trance." That is the model of public detachment which Warhol has expanded to an esthetic strategy so effective it is able to detach large molecular chains of imagery from their places in the social organism and splice them together to form the media-DNA which guides the growth of his mutant but full-function world—that seamless environment where his imagination is the most successfully adapted creature.

When Warhol says, "I'd rather be a Rothschild than a movie star," he's not being snobbish. He has no reverence for patinas of time. There is no time—much less, history—in the regions lit by star-glow. To Judge Rothschilds bigger stars than Hollywood heavyweights is to make note of a clear and obvious fact: the fame of the Rothschilds is more solidly built. It's safer. It offers more of fame's chief virtue in Warhol's eyes. He sympathizes with Margaret Trudeau, who wanted to drive her own car rather than be chauffeured everywhere. "I guess she felt trapped," he says, then adds, "I would feel secure." Warhol "really can't figure out why Margaret isn't happy just being the First Lady of Canada. I mean, what a role." He, who is more thoroughly responsible for his own role than anyone else who comes to mind, surely knows the difficulties of roles, large or small. He also knows their inevitability. Everyone has one, like it or not. More important than liking it, for Warhol, is the degree of security it affords. The brilliance with which Warhol-the-artist has created Warhol-the-fan redeems the safety of both roles by transforming ultra-refined self-consciousness into an esthetic quality. The sustaining strategies of Warhol's art-life hint at a motive behind even the riskiest adventures of self-creation—Byron's, say, or Nietzsche's. As they define themselves, these culture heroes define a realm where the meanings of their effort are certain. They too, imagine worlds where the imagination can feel safe.

Warhol requires fame to show social grace, or better yet, its parody: chic. There is no place in his world for fame touched by earnestness, doubt or missionary zeal, all of which suggest that a luminary has a purpose beyond being

famous. Thus there are a lot more politicians' wives than politicians in
Exposures. And there are lots of children, not only of politicians but of
industrialists, movie stars and counts and countesses. Of course, some of these
children are famous in their own right, and anyway, the tone of Warhol's world
is not just a matter of age. "Kids like Truman. He's like a big kid," says Andy.
"But so am I and most of my friends." Whether or not this is the whole truth
about Truman Capote (or Andy Warhol), the trouble with purposeful fame is clear
enough. Its target must always be that vast mass of citizens who perhaps share
with Warhol his addiction to certain images, and yet lack even the minimal
esthetic resources needed in order to wring from them any redemption, even the
phoniest. So fame that hints at the mere presence of this constituency is
depressing.

As for depression—its presence is punishable by permanent exile from
Warhol's world. Nearly everyone in *Exposures* is up, so totally up that they look
like emotional clones. Individual traits—the signals that announce the presence
of Liza rather than Jackie, Halston instead of Muhammad Ali—are the stuff of
which images are made, in words and pictures, but images are only helping hands
to transcendence. At the level where Warhol-the-fan turns into Warhol-the-artist,
all the famous are identical because all are objects of the same devotion. "The
one thing Truman and I disagree about is LOVE. Truman believes in it and I
don't." But Warhol does love the kind of fame that makes things seem real.
Crushes are always attended by vividness. The fame he adores (no irony
intended) is the kind that provides the feelings a safe retreat. It offers assurance
that the moment is significant and yet will not be disrupted by forces of the larger
world from which the artist has fled to create his own in all its artfully frenzied,
black-and-white realism.

Polaroids sort out the stars, and anecdotes extend their existence a bit beyond
the moment the shutter snaps. Warhol's world accumulates its intricately
connected detail. Everyone in *Exposures*, save Muhammad Ali and a couple of
the other athletes, knows about 50 percent of everybody else. So the unity of
Warhol's world is maintained. One degree of pure, bright fame blends into
another; the artist drifts hectically from one star to the next, drawn always by the
most safely adored power of all—that of like attracting like, for Warhol is a star,
too.

More importantly, he is an artist who self-consciously transforms himself into
a fan. He presents in an esthetic mode the image of awe creating its object and
so becoming identical with it. After all, fame untainted by genuine power is a
function of the endlessly unconsummated yearning that Warhol alone has learned

to live out on a plane of modernist irony. The results are startling, but no more so than those which followed on Jackson Pollock's decision to enlarge the brushstroke to a splash of paint. Process artists kept enlarging that splash, until Robert Smithson brought it up to the scale of landscape. Lord Byron made the strategies of courtly love available to anyone who could read; then Warhol invented Byron for sensibilities keyed to the jump cuts of movies and the bright, blanketing glare of TV.

Robert Hughes, *The Shock of the New* **(New York: Alfred A. Knopf, Inc., 1981), 348.** Excerpt.

Warhol's work in the early sixties was a baleful mimicry of advertising, without the gloss. It was about the way advertising promises that the same pap with different labels will give you special, unrepeatable gratifications. Advertising flatters people that they have something in common with artists; the consumer is rare, discriminating, a connoisseur of sensation. If Warhol was once subversive—and in the early sixties he was—it was because he inverted the process on which successful advertising depends, becoming a famous artist who loved nothing but banality and sameness. Nothing would be left in the sphere of art except its use as a container for celebrity, and at one stroke (although it took the art world some time to realize it) the idea of the *avantgarde* was consigned to its social parody, the world of fashion, promotion, and commercial manipulation: a new model artwork every ten minutes. *I want to be a machine*: to print, to repeat, repetitiously to bring forth novelties. This was the most cunning sort of dandyism, especially when allied to Warhol's calculatedly grungy view of reality, suggesting the smudged graininess of newsprint, the reject layout, the uneven inking. His images were less painted than registered. The silkscreen was without nuances—a surface with slips, but no adjustments. It looked coarse, ephemeral, and faintly squalid. It wanted to be glanced at like a TV screen, not scanning like a painting. And like American television in the sixties, it was morally numb, haunted by death, and disposed to treat all events as spectacle. The violence Warhol enjoyed, the dismembered wreckage of metal and flesh in his Disaster paintings, the brooding presence of the electric chair, was filtered through an indifferent medium. Thus the images had one subject in common. Not just death; rather, the condition of being an uninvolved spectator.

Charles F. Stuckey, "Warhol: Backwards and Forwards," *Flash Art* **101 (January/February 1981): 10-18.** Reprinted in *Warhol '80: Series Reversal*, exhibition catalog.

What is the proper point of view from which to experience and enjoy Andy Warhol's work? For example, how does one respond to his selection of a gruesome, emotionally-charged image—*Electric Chair*, say, or *Car Crash*—is its meaning anesthetized by inane repetition? Is Warhol irreverent to visualize it in decorator colors, which he claims clients will match to their drapes? Or, when he mismatches color and image, is it the result of his expressed inability to decide where the real stops and the artificial starts? He makes a mockery of the "petty consistencies" that Ralph Waldo Emerson called "hobgoblins of little minds." Although Warhol's art is charged with incongruity and paradox, he contends that "the less something has to say, the more perfect it is." Despite this preference, his own art has boundless scope, for whatever it has to say, it always says the reverse as well. If his art is intentionally mindless, it is nevertheless saturated with irony: if superficially it seems to be careless, it seems as well to be laced with innuendo. His art is both naive and sophisticated, deadpan and slapstick, both clumsy and lyrical, garish and ravishing, boring and provocative, trivial and profound.

The two related groups of important new paintings by Warhol that were introduced earlier this year at the Galerie Bischofberger in Zurich and Daniel Templon in Paris are both old and new, epic and banal, exasperating as only Warhol's art can be. One series is called *Reversals*, the other is called *Retrospectives*. The majority of the works belong to the *Reversals* series, which is a new departure for Warhol. Whereas since 1962 he has transferred images to canvas with silkscreens processed to print photographs, for the new paintings Warhol has silkscreens processed to print photographic negatives, with the result that areas of light and dark in the images are "reversed." For example, in Warhol's *Marilyn* paintings in 1962, based on a publicity photograph, areas corresponding to skin, hair and background are relatively light in terms of value, but these areas are opaquely dark in the dozen *Reversals* paintings based on the negative of the same photograph. And dark areas of the positive—the lips, eyes, shadows-are light in the negative. Each of the *Reversals* repeats in negative an image that Warhol used for earlier pictures: *Marilyn, Electric Chair* (1963), *Cow Wallpaper* (1966), *Mao* (1972) and *Mona Lisa* (1962). Two of the six new *Mona Lisa* paintings, curiously, are not reversed.

Leaving that seeming inconsistency aside, these new versions of former works all belong to a category of expression generally termed "art about art." Two years ago New York's Whitney Museum sponsored an exhibition of *Art about Art*, incorporating works by Johns, Lichtenstein, Rauschenberg, Rivers, Segal and other artists whose images allude to or reproduce well-known works of art. Of course, Warhol has represented in the exhibition with his Duchampian homage to Leonardo's *Mona Lisa*. But although other artists sometimes make art about art, in Warhol's case, with the exception of his portraits, virtually all of his painting and sculpture executed from 1962 until 1972 relies upon preexisting images originally created by other visual artists. These include not only Leonardo, but uncelebrated commercial designers (of postage stamps, soup labels, and so on), photo-journalists and publicity photographers. The *Reversals* series, likewise starting from already familiar visual images, therefore, marks a return to an essential premise of Warhol's pop works. But with a twist, a "reversal." Despite the fact that the famous pop images were borrowed from other artists, since their introduction into Warhol's work the images have come to be considered as "by Warhol," thanks to what Hugh Kenner described as "The Warhol Situation" (*The Counterfeiters*, 1968).

Self-indulgent to the same degree as the *Reversals*, the *Retrospectives* also include earlier images: *Campbell's Soup Can* (1963), *Car Crash* (1962), *Electric Chair, Flowers* (1964), *Self-Portrait* (1964) *Kellogg's Corn Flakes* (1964), *Cow Wallpaper, Mao* and *Marilyn* in negative (1979), but also, in a sense, 1962. The anthology of works selected for the *Retrospectives*, therefore, chronicles Warhol's career from 1962 until the present. Taking the point of view of an art historian, the *Retrospectives* call to mind Courbet's mural-scale *The Artist's Studio, a Real Allegory of Seven Years of My Artist's Life*, in which the artist brought aspects of his work together into an operatic monument to himself. One of the *Retrospectives* actually rivals Courbet's masterpiece in terms of scale, as do five of the *Reversals*. These six new paintings by Warhol are approximately seven feet high and thirty-six feet wide, the largest he has ever made.

According to Warhol, the idea for the *Retrospectives* came not from Courbet, but from Warhol's friend Larry Rivers, who was commissioned in 1978 to make a series of large works entitled *Golden Oldies '50s, Golden Oldies '60s* and so on. Each painting represents fragments copied from Rivers's earlier works. Questioned about the *Golden Oldies*, Rivers explained that they provide an opportunity to see all of his works for viewers who never had one, and he pointed out that lots of artists, Barnett Newman, for instance, are disposed to repeat components of early works in later ones. "It's like restating it once more. In a

sense it's like saying: not only did I mean it, but it's rich enough for me to take it and do something with it. For me, in a certain way, it's like stopping for a moment, but it isn't. We're so programmed to that idea that you have to go onward and upward to something new and something advanced. It's really getting boring, so you want to do something old." (*Arts Magazine*, Nov. 1978, pp. 104-106). Warhol is aware that similar issues (and others) are at stake in the *Retrospectives*.

Doing the same old thing, given Warhol's point of view, means taking an idea from Rivers to do a painting that commemorates prior paintings taken from other visual artists. Had he wished, Warhol would have been justified to take Courbet's title for this *Retrospectives*, which amount to "Real Allegories"—pictures of pictures that are not really his own, yet really are. Although unconventional in many respects, Courbet's picture illustrates the traditional assumption that art is the personal expression of an artist. Warhol, however, challenged just that aspect of past art, including abstract expressionism, and rejected the idea that art should express an artist's personal attitudes and feelings. Warhol, who wanted to be as impersonal as a machine, executed and exhibited works as if they were wallpaper. He watched TV and blasted the radio while he worked so his thoughts could not interfere with the goal to make "no comment" art. But because the *Retrospectives* and *Reversals* are comments about his own career, apparently they undermine that goal.

If so, the new pictures are the result of an important development in Warhol's art. Recall that in the past Warhol hoped to conceal information about his personal life. His date of birth, for example, was a secret until 1971. The previous year, when the Whitney Museum offer to present an exhibition of his work, he expressed disinterest in the retrospective format and preferred to emphasize the decorative, rather than the historical, aspects of the exhibition situation. In 1970, after all, a retrospective of Warhol's work was a questionable enterprise, as he had announced his retirement from painting in 1965 (repeating a gesture that Duchamp had made a half century before). According to some journalists, Warhol retired from painting in order to devote himself to movie-making and sculpture. But he himself admitted to doubts about his ability at that time to continue creatively as a painter: "I got so tired of painting. I've been trying to give it up all the time. It's so boring painting the same picture over and over."

Although more needs to be said about Warhol's notion that he always paints the same picture and about other issues related to art about art, it is best first to consider this "reversal" in Warhol's attitude towards painting. Before Warhol

ever began to exhibit paintings, he worked in two contrary styles which he discussed with friends. He remembers that he showed a painting of "a Coke bottle with Abstract Expressionist hash marks halfway up the side" along with another painting of "a stark, outlined Coke bottle in black and white" to Emile de Antonio, who told him, "one of these is a piece of shit, simply a bit of everything. The other is remarkable—it's our society, it's who we are, it's absolutely beautiful and naked, and you ought to destroy the first one and show the other." Finding himself in agreement, Warhol abandoned "lyrical painting with gestures and drips" for "the hard style without gestures" (*Popism: The Warhol 60s*, 1980, pp. 6-7). But since the early 1970s he has reintroduced gestural brushwork into his paintings. "Now I'm trying to put style back into my paintings. I'm sort of hand painting. It's more fun." (*Art News*, May 1974, p. 26). Fully integrated in the *Reversals* and *Retrospectives*, these clashing artistic ideas, one impersonal, the other personal, intensify each other.

For the past decade Warhol's art has emphasized this dialogue between fundamentally opposed systems of expression—the detailed realism of photography and the coloristic fantasies of abstract gestural art. In his portraits, for example, of the *Hammer and Sickle* series, outline (photograph) and local color (gestural brushwork) are not strictly coordinated with one another, and consequently conventional notions of pictorial space and representation are handled in a fauvist manner. Yet basic notions such as space and representation cannot be discussed logically with reference to the *Reversals*, which are ultimately decorative fabrics made of insubstantial stuff like color, memory, and inside-out photographic presences. The *Reversals* recall Warhol's rationale for choosing to exclude personal feelings and meaning in his first exhibited pictures: "Pop Art took the inside and put it outside, took the outside and put it inside." The *Reversals* express the emotional "inside" in terms of gestural brushwork, and the "inside out" in terms of image. And since the new paintings combine what amount to old and new means of expression for Warhol, time as well as space might be called collapsed.

In the *Reversals* the silkscreen images in negative, repeated in grids, form a dark armature similar to the leaded borders used to make stained glass. Color sweeps below and through Warhol's densely-dotted black patterns. The repeated dark images of the negatives structure the works like a *basso ostinato* to which the colors are descants in the keys of blue or gold, or in complex choruses. Like Rauschenberg and Stella, whose 1970s works stream with colors that the artists apparently felt compelled to avoid 20 years ago, Warhol too has reembraced the full spectrum of expressive pictorial means.

Even if the *Retrospectives* and *Reversals* celebrate a change in Warhol's attitude to painting, he still claims that all his works are essentially the same. Asked six years ago which one of his images he might choose to represent his work as a whole he replied, "I just wanted to do one. But 1 got so carried away. There should have been just one painting." (*Art News*, May 1974, p. 26). In his *Philosophy*, published a year later, he repeated the proposition: "Besides, even when the subject is different, people always paint the same painting." According to Jean Renoir, his father the painter was of the same mind: "He told me one day that he regretted not having painted the same subject all his life. In that way he would have been able to devote himself entirely to what constituted creation in painting, the relation between form and color, which can have infinite variation in a single motif, and which can better be grasped when there is no further need to concentrate on the motif." The *Retrospectives* demonstrate the primacy of form and color, as opposed to subject matter, in Warhol's art. Cows, corn flakes and car crashes co-exist in these new paintings, along with small, large, positive, negative, black and white, color, old and new. Incorporating all of this, the *Retrospectives* are quite literally the single painting that Warhol claims to paint over and over.

If the *Retrospective* are synoptic visions, however, they are also sentimental ones. The presiding mood of the new works is exuberant nostalgia, a mood no less evident in Warhol's recently-published memoirs of the 1960s. This past spring, when Attilio Codognato brought together early works and recent ones by Warhol and other pop artists at the Istituto di Cultura di Palazzo Grassi in Venice, he invoked a related dialogue between past and present. Considering this exhibition in conjunction with Rivers's *Golden Oldies* and Warhol's *Retrospective*, there seems to be a general concern now for retrospective thought about art. This sensitivity to historical development has been an aspiration for many modern artists. "What is the use of them, but altogether?" asked J . M . W. Turner, who bought back works already sold in order to give all that he could of his entire output to England's National Gallery at his death in 1851. Since that time the opportunity for artists to present, and for viewers to see, a representative selection of one's creative activity has assumed considerable importance. For artists, retrospective exhibitions and their illustrated catalogues are a measure of respect and success. And most viewers find that they can better judge, appreciate or understand individual works within the context of an artist's work taken as a whole, which can reveal enduring and therefore fundamental expressive concerns. Perhaps the retrospective has such advantages. Even so, only a few artists have

troubled to produce conglomerate art works that in themselves comprise retrospective statements.

One who did, of course, was Duchamp, whose collected written notes and works of art, reproduced under his supervision in facsimile and miniature, provided the content for the *Green Box* (1934) and *Box in Valise* (1938-1942). Besides protecting his art from being destroyed in a troubled world, the works demonstrated Duchamp's attitude that there is art even in reproductions of art. Of course, Warhol shares Duchamp's admitted "indifference" to conventional criteria for evaluating art, such as originality and hand craftsmanship. Responsive to Warhol's artistic goals, Duchamp agreed to let Warhol reproduce him on film for an entire day while he went about his life. Unfortunately never realized, the project nevertheless illustrates their differing sensibilities as visual artists. Whereas Duchamp compressed his artistic life into a portable valise, Warhol envisioned expressing a comparable concept in an epic film.

Large-scale works seem appropriate to Warhol's longstanding opinion that everything in life is art. Day-long movies and room-scale paintings are art on something like the scale of life. Moreover, large scale suits Warhol's commitment to decorative art, a modern tradition initiated by Monet and Matisse, not Duchamp. Repetition and superimposition are the principle aspects of Warhol's decorative works, including many of his films. By his own account, Warhol adapted these characteristics from Ad Reinhardt's series of "black" paintings. In terms of composition, Warhol's paintings, like Reinhardt's, are simple grids made of regular units with barely perceptible variations. Since this basically decorative format can be extended in any direction simply by adding more units, it allows Warhol to apply a single pictorial idea to any exhibition situation that presents itself.

Since the early 1960s, Warhol has tended to work in series and to present groups of closely related paintings as environments. Individual paintings removed from his exhibition installations are fragments, as a result, removed from a larger whole. Yet in itself each fragment has the essential decorative characteristics of the whole ensemble, as individual crystals have structures that interlock with other similar crystals to form lattices. When in 1964 Warhol exhibited his *Flowers* paintings, he arranged them in close files that covered every wall surface and he claimed to have painted just one picture which was cut into little pieces. Throughout the 1960s all of his installations consisted of grid alignments of regular units—a neutral, somewhat rigidly impersonal format, that extended the grid compositions of individual paintings. But during the 1970s, although he altered his pictorial style by reintroducing expressive brushwork, there has been

no corresponding development in Warhol's decorative sensibility. Indeed, during this decade most of his paintings have been single images. In the *Reversals* and *Retrospectives* Warhol has returned to decorate compositional structures. The *Retrospectives*, different motifs arranged in adjacent vertical zones (each zone a grid composition), or scattered irregularly across a rectangular format, depart from the grid scheme and suggest new possibilities for his art, taken as decoration. The *Reversals* are the same old grids, but transformed. Now freely-applied brushwork romps across the grids, filing them with improvisational complexities. In terms of decoration, the *Reversals* are Warhol's familiar song, now orchestrated for full orchestra.

Robert Hughes, "The Rise of Andy Warhol," *New York Review of Books,* **18 February 1982, pp. 6-10.**

To say that Andy Warhol is a famous artist is to utter the merest commonplace. But what kind of fame does he enjoy? If the most famous artist in America is Andrew Wyeth, and the second most famous is LeRoy Neiman (Hugh Hefner's court painter, inventor of the Playboy femlin, and drawer of football stars for CBS), then Warhol is the third. Wyeth, because his work suggests a frugal, bare-bones rectitude, glazed by nostalgia but incarnated in real objects, which millions of people look back upon as the lost marrow of American history. Neiman, because millions of people watch sports programs, read *Playboy*, and will take any amount of glib abstract-expressionist slather as long as it adorns a recognizable and pert pair of jugs. But Warhol? What size of public likes his work, or even knows it at first hand? Not as big as Wyeth's or Neiman's.

To most of the people who have hear of him, he is a name handed down from a distant museum-culture, stuck to a memorable face: a cashiered Latin teacher in a pale fiber wig, the guy who paints soup cans and knows all the movie stars. To a smaller but international public, he is the last of the truly successful social portraitists, climbing from face to face in a silent delirium of snobbery, a man so interested in elites that he has his own society magazine. But Warhol has never been a *popular* artist in the sense that Andrew Wyeth is or Sir Edwin Landseet was. That kind of popularity entails being seen as a normal (and hence, exemplary) person from whom extraordinary things emerge.

Warhol's public character for the last twenty years has been the opposite: an abnormal figure (silent, withdrawn, eminently visible but opaque, and a bit

malevolent) who praises banality. He fulfills Stuart Davis's definition of the new American artist, "a cool Spectator-Reporter at an Arena of Hot Events." But no mass public has ever felt at ease with Warhol's work. Surely, people feel, there must be something empty about a man who expresses no strong leanings, who greets everything with the same "uh, gee, great." Art's other Andy, the Wyeth, would not do that. Nor would the midcult heroes of *The Agony and the Ecstasy* and *Lust for Life*. They would discriminate between experiences, which is what artists are meant to do for us.

Warhol has long seemed to hanker after the immediate visibility and popularity that "real" stars like Liz Taylor have, and sometimes he is induced to behave as though he really had it. When he did ads endorsing Puerto Rico rum or Pioneer radios, the art world groaned with secret envy; what artist would not like to be in a position to be offered big money for endorsements, if only for the higher pleasure of refusing it? But his image sold little rum and few radios. After two decades as voyeur-in-chief to the marginal and then the rich, Warhol was still unloved by the world at large; all people saw was that weird, remote guy in the wig. Meanwhile, the gesture of actually being in an ad contradicted the base of Warhol's fame within the art world. To the extent that his work was subversive at all (and in the Sixties it was, slightly), it became so through its harsh, cold parody of ad-mass appeal—the repetition of brand images like Campbell's soup or Brillo or Marilyn Monroe (a star being a human brand image) to the point where a void is seen to yawn beneath the discourse of premotion.

The tension this set up depended on the assumption, still in force in the Sixties, that there was a qualitative difference between the perceptions of high art and the million daily instructions issued by popular culture. Since then, Warhol has probably done more than any other living artist to wear that distinction down; but while doing so, he has worn away the edge of his work. At the same time, he has difficulty moving it toward that empyrean of absolute popularity, where LeRoy Neiman sits, robed in sky-blue polyester. To do that, he must make himself accessible. But to be accessible is to lose magic.

The depth of this quandary, or perhaps its lack of relative shallowness, may be gauged from a peculiar exhibition mounted last November by the Los Angeles Institute of Contemporary Art: a show of portraits of sports stars, half by Neiman and half by Warhol, underwritten by Playboy Enterprises. It was a promotional stunt (LAICA needs money, and exhibitions of West Coast conceptualists do not make the turnstiles rattle) but to give it a veneer of respectability the Institute felt obliged to present it as a critique of art-world pecking orders. Look, it said in effect: Neiman is an arbitrarily rejected artist, whose work has much to

recommend it to the serious eye (though *what*, exactly, was left vague); we will show he is up there with Warhol.

This effort backfired, raising the unintended possibility that Warhol was down there with Neiman. The Warhol of yore would not have let himself in for a fiasco like the LAICA show. But then he was not so ostentatiously interested in being liked by a mass public. This may be why his output for his last decade or so has floundered—he had no real subjects left; why *Interview*, his magazine is less a periodical than a public relations sheet; and why books like *Exposures* and *POPism* get written. [1]

Between them *POPism: The Warhol Sixties* and *Exposures* give a fairly good picture of Warhol's concerns before and after 1968, the year he was shot. Neither book has any literary merit, and the writing is chatty with occasional flecks of *diminuendo* irony—just what the package promises. *POPism* is mostly surface chat, *Exposures* entirely so. For a man whose life is subtended by gossip, Warhol comes across as peculiarly impervious to character. "I never knew what to think of Eric, "he says of one of his circle in the Sixties, a scatterbrained lad with blond ringlets whose body, a postscript tells us, was found in the middle of Hudson Street, unceremoniously dumped there, according to "rumors," after he overdosed on heroin. "He could come out with comments that were so insightful and creative, and then the next thing out of his mouth would be something so dumb. A lot of the kids were that way, but Eric was the most fascinating to me because he was the most extreme case—you absolutely couldn't tell if he was a genius or a retard.

Of course, poor Eric Emerson—like nearly everyone else around the Factory, as Warhol's studio came to be known—was neither. They were all cultural space-debris, drifting fragments from a variety of Sixties subcultures (transvestites, drug, S&M, rock, Poor Little Rich, criminal, street, and all the permutations) orbiting in smeary ellipses around their unmoved mover. Real talent was thin and scattered in this tiny universe. It surfaced in music, with figures like Lou Reed and John Cale; various punk groups in the Seventies were, wittingly or not, the offspring of Warhol's Velvet Underground. But people who wanted to get on with their own work avoided the Factory, while the freaks and groupies and curiosity-seekers who filled it left nothing behind them.

Its silver-papered walls were a toy theater in which one aspect of the Sixties in America, the infantile hope of imposing oneself on the world by terminal self-revelation, was played out. It had a nasty edge, which forced the paranoia of marginal souls into some semblance of style; a reminiscence of art. If Warhol's "Superstars," as he called them, had possessed talent, discipline or stamina, they

would not have needed him. But then, he would not have needed them. They gave him his ghostly aura of power. If he withdrew his gaze, his carefully allotted permissions and recognitions they would cease to exist; the poor ones would melt back into the sludgy undifferentiated chaos of the street, the rich ones end up in McLean's. Valerie Solanas, who shot him, said Warhol had too much control over her life.

Those whose parents accused them of being out of their tree, who had unfulfilled desires and undesirable ambitions, and who felt guilty about it all, therefore gravitated to Warhol. He offered them absolution, the gaze of the blank mirror that refuses all judgment. In this, the camera (when he made his films) deputized for him, collecting hour upon hour of tantrum, misery, sexual spasm, campery, and nose-picking trivia. It too was an instrument of power—not over the audience, for which Warhol's films were usually boring and alienating, but over the actors. In this way the Factory resembled a sect, a parody of Catholicism enacted (not accidentally) by people who were or had been Catholic, from Warhol and Gerard Malanga on down. In it the rituals of dandyism could speed up to gibberish and show what the had become—a hunger for approval and forgiveness. These came in a familiar form, perhaps the only form American capitalism knows how to offer: publicity.

Warhol was the first American artist to whose career publicity was truly intrinsic. Publicity had not been an issue with artists in the Forties and Fifties. It might come as a bolt from the philistine blue, as when *Life* made Jackson Pollock famous; but such events were rare enough to be freakish, not merely unusual. By today's standards, the art world was virginally naive about the mass media and what they could do. Television and the press, in return, were indifferent to what could still be called the avant-garde. "Publicity" meant a notice in *The New York Times*, a paragraph or two long, followed eventually by an article in *Art News* which perhaps five thousand people would read. Anything else was regarded as extrinsic to the work—something to view with suspicion, at best an accident, at worst a gratuitous distraction. One might woo a critic, but not a fashion correspondent, a TV producer, or the editor of *Vogue*. To be one's own PR outfit was, in the eyes of the New York artists of the Forties or Fifties, nearly unthinkable—hence the contempt they felt for Salvador Dali. But in the 1960s all that began to change, as the art world gradually shed its idealist premises and its sense of outsidership and began to turn into the Art Business.

Warhol became the emblem and thus, to no small extent, the instrument of this change. Inspired by the example of Truman Capote, he went after publicity with the voracious single-mindedness of a feeding bluefish. And he got it in

abundance, because the Sixties in New York reshuffled and stacked the social deck: the press and television. In their pervasiveness, constructed a kind of parallel universe in which the hierarchical orders of American society—vestiges, it was thought, but strong ones, and based on inherited wealth—were replaced by the new tyranny of the "interesting." Its rule had to do with the rapid shift of style and image, the assumption that all civilized life was discontinuous and worth only a short attention span: better to be Baby Jane Holzer than the Duchesse de Guermantes.

To enter this turbulence, one might only need to be born—a fact noted by Warhol in his one lasting quip, "In the future, *everyone* will be famous for fifteen minutes." But to remain in it, to stay drenched in the glittering spray of promotional culture, one needed other qualities. One was an air of detachment; the dandy must not look into the lens. Another was an acute sense of nuance, an eye for the eddies and trends of fashion, which could regulate the other senses and appetites and so give detachment its point.

Diligent and frigid, Warhol had both to a striking degree. He was not a "hot" artist, a man mastered by a particular vision and anxious to impose it on the world. Jackson Pollock had declared that he wanted to be Nature. Warhol, by contrast, wished to be Culture and Culture only: "I want to be a machine." Many of the American artists who rose to fame after abstract expressionism, beginning with Jasper Johns and Robert Rauschenberg, had worked in commercial art to stay alive, and other pop artists besides Warhol, of course, drew freely on the vast reservoir of American ad-mass imagery. But Warhol was the only one who embodied a culture of promotion as such. He had enjoyed a striking success as a commercial artist, doing everything from shoe ads to recipe illustrations in a blotted, perky line derived from Saul Steinberg. He understood the tough little world, not yet an "aristocracy" but trying to become one, where the machinery of fashion, gossip, image-bending, and narcissistic chic tapped out its agile pizzicato. He knew packaging, and could teach it to others.

Warhol's social visibility thus bloomed in an art world which, during the Sixties, became more and more concerned with the desire for and pursuit of publicity. Not surprisingly, many of its figures in those days—crass social climbers like the Sculls, popinjays like Henry Geldzahler, and the legion of insubstantial careeists who leave nothing but press cuttings to mark their passage—tended to get their strategies from Warhol's example.

Above all, the working-class kid who had spent so many thousands of hours gazing into the blue, anesthetizing glare of the TV screen, like Narcissus into his pool, realized that the cultural moment of the mid-Sixties favored a walking void.

Television was producing an affectless culture. Warhol set out to become one of its affectless heroes, it was no longer necessary for an artist to act crazy, like Salvador Dali. Other people could act crazy for you: that was what Warhol's Factory was all about. By the end of the Sixties craziness was becoming normal, and half of America seemed to be immersed in some tedious and noisy form of self-expression. Craziness no longer suggested uniqueness. Warhol's bland translucency, as of frosted glass, was much more intriguing.

Like Chauncey Gardiner, the hero of Jerzy Kosinski's *Being There*, he came to be credited with sibylline wisdom because he was an absence, conspicuous by its presence—intangible, like a TV set whose switch nobody could find. Disjointed public images—the Campbell's soup cans, the Elvises and Lizzes and Marilyns, the electric chairs and car crashes and the jerky, shapeless pornography of his movies—would stutter across this screen; would pour from it in a gratuitous flood.

But the circuitry behind it, the works, remained mysterious. (Had he made a point of going to the shrink, like other New York artists, he would have seemed rather less interesting to his public.) "If you want to know all about Andy Warhol," he told an interviewer in those days, "just look at the surface of my paintings and films and me, and there I am. There's nothing behind it." This kind of coyness looked, at the time, faintly threatening. For without doubt, there was something strange about so firm an adherence to the surface. It went against the grain of high art as such. What had become of the unbelief, dear to modernism, that the power and cathartic necessity of art flowed from the unconscious, through the knotwork of dream, memory, and desire, into the realized image? No trace of it; the paintings were all superficies, no symbol. Their blankness seemed eerie.

They did not share the reforming hopes of modernism. Neither Dada's caustic anxiety, nor the utopian dreams of the Constructivists; no politics, no transcendentalism. Occasionally there would be a slender, learned spoof, as when Warhol did black-and-white paintings of dance-step diagrams in parody of Mondrian's black-and-white *Fox Trot*, 1930. But in general, his only subject was detachment, dealing hands-off with the world through the filter of photography.

Thus his paintings, roughly silk-screened, full of slips, mimicked the dissociation of gaze and empathy induced by the mass media: the banal punch of tabloid newsprint, the visual jabber and bright sleazy color of TV, the sense of glut and anesthesia caused by both. Three dozen Elvises are better than one; and one Marilyn, patched like a gaudy stamp on a ground of gold leaf (the favorite color of Byzantium, but of drag queens too) could become a sly and grotesque

parody of the Madonna-fixations of Warhol's own Catholic childhood, of the pretentious enlargement of media stars by a secular culture, and of the similarities between both. The rapid negligence of Warhol's images parodied the way mass media replace the act of reading with that of scanning, a state of affairs anticipated by Ronald Firbank's line in *The Flower Beneath the Foot*: "She reads at such a pace...and when I asked her *where* she had learnt to read so quickly she replied, 'On the screens of Cinemas.'"

Certainly, Warhol had one piercing insight about mass media. He would not have had it without his background in commercial art and his obsession with the stylish. But it was not an *apercu* that could be developed: lacking the prehensile relationship to experience of Claes Oldenburg (let alone Picasso), Warhol was left without much material. It is as though, after his near death in 1968, Warhol's lines of feeling were finally cut; he could not appropriate the world in such a way that the results meant much as art, although they became a focus of ever-increasing gossip, speculation, and promotional hoo-ha. However, his shooting reflected back on his earlier paintings—the prole death in the car crashes, the electric chair with the sign enjoining SILENCE on the nearby door, the taxidermic portraits of the dead Marilyn—lending them a fictive glamour as emblems of fate. Much breathless prose was therefore expended on Andy, the Silver Angel of Death, and similar conceits. (That all these images were suggested by friends, rather than chosen by Warhol himself, was not stressed.)

Partly because of this gratuitous aura, the idea that Warhol was a major interpreter of the American scene dies hard—at least in some quarters of the art world. "Has there ever been an artist," asked Peter Schjeldahl at the end of a panegyric on Warhol's fatuous show of society portraits at the Whitney two years ago, "who so coolly and faithfully, with such awful intimacy and candor, registered important changes in a society?" (Well, maybe a couple, starting with Goya.) Critics bring forth such borborygms when they are hypnotized by old radical credentials. Barbara Rose once compared his portraits, quite favorably, to Goya's. John Coplans, the former editor of *Artforum*, wrote that his work "almost by choice of imagery, it seems, forces us to squarely face the existential edge of our existence."

In 1971 an American Marxist named Peter Gidal, later to make films as numbing as Warhol's own, declared that "unlike Chagall, Picasso, Rauschenberg, Hamilton, Stella, most of the Cubists, Impressionists, Expressionists, Warhol never gets negatively boring"—only, it was implied, *positively* so, and in a morally bracing way. If the idea that Warhol could be the most interesting artist in modern history, as Gidal seemed to be saying, now looks a trifle *voulu*, it has

regularly been echoed on the left—especially in Germany, where, by one of those exquisite contortions of social logic in which the Bundesrepubik seems to specialize, Warhol's status as a blue chip was largely underwritten by Marxists praising his "radical" and "subversive" credentials.

Thus the critic Rainer Crone, in 1970, claimed that Warhol was "the first to create something more than traditional 'fine art' for the edification of a few." By mass producing his images of mass production, to the point where the question of who actually made most of his output in the Sixties has had to be diplomatically skirted by dealers ever since (probably half of it was run off by assistants and merely signed by Warhol), the pallid maestro had entered a permanent state of "anaesthetic revolutionary practice"—delicious phase! In this way the "elitist" forms of middle-class idealism, so obstructive to art experience yet so necessary to the ark market, had been short-circuited. Here, apparently, was something akin to the "art of five kopeks" Lunacharsky had called on the Russian avant-garde to produce after 1917. Not only that: the People could immediately see and grasp what Warhol was painting. They were used to soup cans, movie stars, and Coke bottles. To make such bottles in a factory in the South and sell them in Abu Dhabi was a capitalist evil; to paint them in a factory in New York and sell them in Dusseldorf, an act of cultural criticism.

These efforts to assimilate Warhol to a "revolutionary" aesthetic now have a musty air. The question is no longer whether such utterances were true or false—Warhol's later career made them absurd anyway. The real question is: how could otherwise informed people in the Sixties and Seventies imagine that the man who would end up running a gossip magazine and cranking out portraits of Sao Schlumberger for a living was really a cultural subversive? The answer probably lies in the change that was coming over their own milieu, the art world itself.

Warhol did his best work at a time (1962-1968) when the avant-garde, as an idea and a cultural reality, still seemed to be alive, if not well. In fact it was collapsing from within, undermined by the encroaching art market and by the total conversion of the middle-class audience; but few people could see this at the time,. The ideal of a radical, "outsider" art of wide social effect had not yet been acknowledged as fantasy. The death of the avant-garde has since become such a commonplace that the very word has an embarrassing aura. In the late Seventies, only dealers used it; today, not even they do, except in Soho. But in the late Sixties and early Seventies, avant-garde status was still thought to be a necessary part of a new work's credentials. And given the political atmosphere of the time,

it was mandatory to claim some degree of "radical" political power for any nominally avant-garde work.

Thus Warhol's silence became a Rorschach blot, onto which critics who admired the idea of political art—but would not have been seen dead within a hundred paces of a realist painting—could project their expectations. As the work of someone like Agam is abstract art for those who hate abstraction, so Warhol became realist art for those who loathed representation as "retrograde." If the artist, blinking and candid, denied that he was in any way a "revolutionary" artist, his admirers knew better; the whilly mole of Union Square was just dissimulating. If he declared that he was only interested in getting rich and famous, like everyone else, he could not be telling the truth; instead, he was parodying America's obsession with celebrity, the better to deflate it. From the recesses of this exegetical knot, anything Warhol did could be taken seriously. In a review of *Exposures*, the critic Carter Ratcliff solemnly asserted that "he is secretly the vehicle of artistic intentions so complex that he would probably cease to function if he didn't dilute them with nightly doses of the inane." But for the safety valve of Studio 54, he would presumably blow off like the plant at Three Mile Island, scattering the culture with unimagined radiations.

One wonders what these "artistic intentions" may be, since Warhol's output for the last decade has been concerned more with the smooth development of product than with any discernible insights. As Harold Rosenberg remarked, "In demonstrating that art today is a commodity of the art market, comparable to the commodities of other specialized markets, Warhol has liquidated the century-old tension between the serious artist and the majority culture." It scarcely matters what Warhol paints; for his clientele, only the signature is fully visible. The factory runs, its stream of products is not interrupted, the market dictates its logic. What the clients want is *a* Warhol, a recognizable product bearing his stamp. Hence any marked deviation from the norm, such as an imaginative connection with the world might produce, would in fact seem freakish and unpleasant: a renunciation of earlier products. Warhol's sales pitch is to soothe the client by repetition while preserving the fiction of uniqueness. Style, considered as the authentic residue of experience, becomes its commercial-art cousin, styling.

Warhol has never deceived himself about this: "It's so boring painting the same picture over and over," he complained in the late Sixties. So he must introduce small variations into the package, to render the last product a little obsolete (and to limit its proliferation, thus assuring its rarity), for if all Warhols were exactly the same there would be no market for new ones. Such is his

parody of invention, which now looks normal in a market-dominated art world. Its industrial nature requires an equally industrial kind of *facture*: this consists of making silk-screens from photos, usually Polaroids, bleeding out a good deal of the information from the image by reducing it to monochrome, and them printing it over a fudgy background of decorative color, applied with a wide loaded brush to give the impression of verve. Only rarely is there even the least formal relationship between the image and its background.

This formula gave Warhol several advantages, particularly as a portraitist. He could always flatter the client by selecting the nicest photo. The lady in Texas or Paris would not be subjected to the fatigue of long scrutiny; in fact she would feel rather like a *Vogue* model, whether she looked like one or not, while Andy did his stuff with the Polaroid. As social amenity, it was an adroit solution; and it still left room for people who should know better, like the art historian Robert Rosenblum in his catalogue essay to Warhol's portrait show at the Whitney in 1979, to embrace it: "If it is instantly clear that Warhol has revived the visual crackle, glitter, and chic of older traditions of society portraiture, it may be less obvious that despite his legendary indifference to human facts, he has also captured an incredible range of psychological insights among his sitters." Legendary, incredible, glitter, insight: stuffing to match the turkey.

The perfunctory and industrial nature of Warhol's peculiar talent and the robotic character of the praise awarded it, appears most baldly of all around his prints, which were recently given a retrospective at Castelli graphics in New York and a *catalogue raisonnée* by Hermann Wünsche. "More than any other artist of our age," one of its texts declares, "Andy Warhol is intensively preoccupied with concepts of time"; quite the little Proust, in fact. "His prints above all reveal Andy Warhol as a universal artist whose works show him to be thoroughly aware of the great European traditions and who is a particular admirer of the glorious French Dixneuvicme, which inspired him to experience and to apply the immanent qualities of 'pure' peinture." No doubt something was lost in translation, but it is difficult to believe that Hans Gerd Tucheh, the author, has looked at the prints he speaks of. Nothing could be flatter or more perfunctory, or have less to do with those "immanent qualities of pure peinture," than Warhol's recent prints. Their most discernible quality is their transparent cynicism and their Franklin Mint approach to subject matter. What other "serious" artist, for instance, would contemplate doing a series called "Ten Portraits of Jews of the Twentieth Century,"[2] featuring Kafka, Buber, Einstein, Gertrude Stein, and Sarah Berhardt? But then, in the moral climate of today's art world, why not treat Jews as a special-interest subject like any other? There is

a big market for bird prints, dog prints, racing prints, hunting prints, yachting prints; why not Jew Prints?

Yet whatever merits these mementos may lack, nobody could rebuke their author for inconsistency. The Jew as Celebrity: it is of a piece with the ruling passion of Warhol's career, the object of his fixated attention—the state of being well known for well-knownness. This is all *Exposures* was about—a photograph album of film stars, rock idols, politicians' wives, 'cocottes, catamites, and assorted bits of International White Trash baring their teeth to the socially emulgent glare of the flashbulb: I am flashed, therefore I am. It is also the sole subject of Warhol's house organ, *Interview*.

Interview began as a poor relative of *Photoplay*, subtitled "Andy Warhol's Movie Magazine." But by the mid-Seventies it had purged itself of the residues of the "old" Factory and become a punkish *feuilleton* aimed largely at the fashion trade—a natural step, considering Warhol's background. With the opening of Studio 54 in 1977, the magazine found its "new" Factory, its spiritual home. It then became a kind of marionette theater in print: the same figures, month after month, would cavort in its tiny proscenium, do a few twirls, suck or snort something, and tittup off again—Marisa, Bianca, Margaret Trudeau, and the rest of the fictive stars who replaced the discarded Superstars of the Factory days.

Because the magazine is primarily a social-climbing device for its owner and staff, its actual gossip content is quite bland. Many stones lie unturned but no breech is left unkissed. As a rule the interviews, taped and transcribed, sound as though a valet were asking the questions, especially when the subject is a regular advertiser in the magazine. Sometimes the level of gush exceeds the wildest inventions of S.J. Perelman. "I have felt since I first met you," one interviewer exclaims to Diane von Furstenberg, "that there was something extraordinary about you, that you have the mystic sense and quality of a pagan soul. And here you are about to introduce a new perfume, calling it by an instinctive, but perfect name." And later:

Q. I have always known of your wonderful relationship with your children. By this, I think you symbolize a kind of fidelity. Why did you bring back these geese from Bali?
A. I don't know.
Q. You did it instinctively.
A. Yes, it just seemed right. One thing after the other....It's wild.
Q. There's something about you that reminds me of Aphrodite.
A. Well, she had a good time.

Later, Aphrodite declares that "I don't want to be pretentious," but that "I was just in Java and it has about 350 active volcanoes. I'll end up throwing myself into one. I think that would be very glamorous."

In politics, *Interview* has one main object of veneration: the Reagans, around whose elderly flame the magazine flutters like a moth, waggling its little thorax at Jerry Zipkin, hoping for invitations to White House dinners or, even better, an official portrait commission for Warhol. Moving toward that day, it is careful to run flattering exchanges with White House functionaries like Muffie Brandon. It even went so far as to appoint Doria Reagan, the daughter-in-law, as a "contributing editor." To its editor, Reagan is *Caesar Augustus Americanus* and Nancy a blend of Evita and the Virgin Mary, though in red. Warhol seems to share this view, though he did not always do so. For most of the Seventies he was in some nominal way a liberal Democrat, like the rest of the art world—doing campaign posters for McGovern, trying to get near Teddy Kennedy, Nixon, who thought culture was for Jews, would never have let him near the White House. When Warhol declared that Gerald Ford's son Jack was the only Republican he knew, he was telling some kind of truth. However, two things changed this in the Seventies: the Shah, and the Carter administration.

One of the odder aspects of the late Shah's regime was its wish to buy modern Western art, so as to seem "liberal" and "advanced." Seurat in the parlor, SAVAK in the basement. The former Shahbanou, Farah Diba, spent millions of dollars exercising this fantasy. Nothing pulls the art world into line faster than he sight of an imperial checkbook, and the conversion of the remnants of the American avant-garde into ardent fans of the Pahlavis was one of the richer social absurdities of the period. Dealers started learning Farsi, Iranian fine-arts exchange students acquired a sudden cachet as research assistants, and invitations to the Iranian embassy—not the hottest tickets in town before 1972—were now much coveted.

The main beneficiary of this was Warhol, who became the semi-official portraitist to the Peacock Throne. When the *Interview* crowd were not at the tub of caviar in the consulate like pigeons around a birdbath, they were on an Air Iran jet somewhere between Kennedy Airport and Tehran. All power is delightful, as Kenneth Tynan once observed, and absolute power is absolutely delightful. The fall of the Shah left a hole in *Interview's* world: to whom could it toady now? Certainly the Carter administration was no substitute. Those Southern Baptists in polycotton suits lacked the finesse to know when they were being flattered. They had the social grace of car salesman, drinking Amaretto and making coarse jests about pyramids. They gave dull parties and talked about human rights. The

landslide election of Reagan was therefore providential. The familiar combination of private opulence and public squalor was back in the saddle; there would be no end of parties and patrons and portraits. The wounded Horseman might allot $90 million for brass bands while slashing the cultural endowments of the nation to ribbons and threads; who cared? Not Warhol, certainly, whose work never ceases to prove its merits in the only place where merit really shows, the market.

Great leaders, it is said, bring forth the praise of great artists. How can one doubt that Warhol was delivered by Fate to be the Rubens of this administration, to play Bernini to Reagan's Urban VIII? On the one hand, the shrewd old movie actor, void of ideas but expert at manipulation, projected into high office by the insuperable power of mass imagery and secondhand perception. On the other, the shallow painter who understood more about the mechanisms of celebrity than any of his colleagues, whose entire sense of reality was shaped, like Reagan's sense of power, by the television tube. Each, in his way, coming on like Huck Finn; both obsessed with serving the interests of privilege. Together, they signify a new moment: the age of supply-side aesthetics.

NOTES

1. *Andy Warhol's Exposures*, by Andy Warhol (Grosset and Dunlap, 1979); *POPism: The Warhol Sixties*, by Andy Warhol and Pat Hackett (Harcourt Brace Jovanovich, 1980).

2. The Jewish Museum, September 17, 1981 to January 4, 1981.

John Richardson, "Andy on the Move: The Factory Factor," *House and Garden* **155 (July 1983): 90-97.**

Andy Warhol's moves from "Factory" to "Factory," as he calls his studios, have been reflected in abrupt changes of style and subject. In this respect, if no other, he reminds me of Picasso, whose successive "periods" were likewise triggered by domestic change. True, a change of mistress as opposed to studio, but then the former usually involved the latter.

Warhol's famous shoe advertisements for I. Miller conjure up memories of the Lexington Avenue brownstone that the artist shared with his mother in the late 1950s. Later (1962), when he started painting his breakthrough Coke bottles, Warhol moved (his studio, never his sacrosanct living quarters) to an old firehouse on East 87th Street. Within two years, however, the lease expired, and the artist was once more obliged to relocate, this time to a grimy industrial

building—hence the "Factory" nickname—at 231 East 47th Street. This was the loft that became the launching pad for Pop art. According to Warhol's memoirs (*Popism: The Warhol Sixties*), his silver décor—so symptomatic of the sleazy sixties—was the idea of a spaced-out hermit, Billy Name, who later opted for a life of solitary confinement in the Factory's darkroom: [Billy] covered the crumbling walls and the pipes in different grades of silver foil . . . He bought cans of silver paint and sprayed everything with it, right down to the toilet bowl . . . [silver] must have been an amphetamine thing . . . But . . . it was the perfect time to think silver. Silver was the future, it was spacy—the astronauts And silver was also the past—The Silver Screen Andy maybe more than anything, silver was narcissism—mirrors were backed with silver.

Andy's silver walls and silver hair, silver Marilyns and silver Presleys, are what I most remember about the 47th Street Factory in its heyday. That and the din: *Turanodot* at full blast drowning out "She wore blue velvet"; and the "Superstars": Ultra Violet, Viva, and Joe Dallesandro; and the Speedfreaks: Rotten Rita and, saddest of them all, poor hell-bent Edie Sedgwick decked out in spandex, velvet, and bits of broken mirror. No wonder the attrition rate was astronomical: within three or four years virtually everyone except Andy had burnt him or herself out. And no wonder Paul Morrissey, the man most responsible for Andy's involvement in movies, decided that the factory should be cleaned up and divided into cubicles so that the burgeoning Warhol empire could be administered with a modicum of propriety and efficiency. As Andy foresaw, the cubicles were used for everything but business.

Toward the end of 1967, the landlord of the 47th Street building announced that it was due for demolition. A new Factory with more space had to be found, but what form should it take? According to Andy, "the biggest fights at the Factory were *always* over decorating." Hence row after row when the ideal space, the sixth floor of 33 Union Square West, materialized. Morrissey wanted a movie mogul's office with projection rooms, filing cabinets, and stacks of *Variety*. Andy, on the other hand, envisaged an all-purpose loft ("I wanted to do *everything*"), where, besides making movies, he could paint, photograph, experiment with video, sponsor a pop group, hold court—you name it. In the end a young Texan called Fred Hughes, whom Andy had recently put in charge of the Factory, transformed the new premises into a functional combination of studios and offices. "The Silver Period," Andy later wrote, "was definitely over, we were into white now . . . it wasn't all just hanging around anymore."

Thirty-three Union Square West was a landmark to the extent that it is mentioned in Scott Fitzgerald's story "May Day"; its eighth floor had been the

headquarters of the U.S. Communist party for many years, while its top floor provided Saul Steinberg with a studio. As soon as Andy moved in, his lifestyle and circle of friends changed drastically, so did his work. Rowdy Rod La Rod was replaced as Factory favorite by wholesome Jed Johnson. Likewise the speed freaks and the transvestites, such as Jackie Curtins and Candy Darling, gave way to High Bohemia: collectors and dealers and people in "showbiz" or café society who were lured to the Factory by sociable Fred Hughes. But the most significant development was Andy's rejection of the flat, mechanical *facture* of Pop art for de Kooning-like painterliness, as witness the hundreds of portraits of Chairman Mao in which Andy deftly defused—censorious critics said trivialized—one of the most revered and reviled images in twentieth-century history. No question about it, there was more to Andy than silkscreens of electric chairs and Brillo boxes: the artist had an unsuspected feeling for rich impasto and shrill atonal color. Skeptics who had announced that Andy was mere flash in the Pop pan were obliged to look and reconsider.

In their plush new quarters the Warhol enterprises attract celebrities to the new premises. Thanks to Colacello and Hughes, Andy now presided day after day over what amounted to the only salon in Manhattan. Boardroom luncheons of excellent cold cuts were—indeed still are—a bizarre mishmash: artists from O'Keeffe to Schnabel, writers from Mailer to Burroughs, sacred monsters from Swanson to Divine rubbed shoulders with royal personages, various Kennedys, tennis champions, tycoons, journalists, and bevies of beautiful star-struck kids of every class and race, nationality and sex, out for the instant fame that, to believe Andy, is within everybody's reach.

And the work? To quote Robert Rosenblum, "The Beautiful People had replaced the dreams and nightmares of Middle America" as subjects. Andy's disingenuous snobbery was reflected in numerous society portraits that gave a new lease on life to the bravura tradition of Boldini and Sargent, a tradition that had fizzled out around World War II. True, many of the sitters were involved in the arts: collectors, dealers, curators, as well as the writer of this article. But by and large Andy concentrated on café society and the fashion world: people like Saint Laurent, Halston, Diane Von Furstenberg, Hélène Rochas, who were in a position to pay a substantial sum for anything from one to twenty likenesses of themselves.

And since these portraits were trendy and eye-catching, flattering yet resembling (were they not based on photographs?), and since they generated considerable publicity for sitter and artist alike, they had a well-deserved success with narcissists desperate for an alternative to Portraits, Inc.: not, however, with some of Andy's former followers, who denounced the pope of Pop for selling out.

This was to miss the point. These posterlike portraits are quintessentially Pop, for they provide the sitter with images that, besides being labels (like the famous soup cans), are in Norman Mailer's words, advertisements for himself.

At the same time Andy took on a succession of more challenging themes: hammers and sickles, Puerto Rican transvestites, shadows and sexual parts; and more recently he has reverted to the subjects on which his early reputation was based—women's shoes and flowers—as well as endangered species and, that ultimate challenge, the cross. In each case the artist has demonstrated that the Warhol conjuring tricks still work and that his cool–no, cold-blooded—way if defiantly teetering on the brink of schlock has not lost its power to titillate or, better still, vex.

And now Andy has had to move once again. How, one wonders, will Factory IV—a rehabilitated Con Edison subway generator station located on East 33rd Street—differ from the old one, and its products—paintings, video programs, *Interview's* interviews—from all that came before? My own guess is that Andy is due for a go at sculpture—the one field he has not as yet tackled—and that technology will play a greater part in his activities. And let us hope, albeit vainly, that he will get around to exploiting his incomparably rich archives. For, make no mistake, one of Andy's greatest claims to fame is that he is the principal recording angel of our time—always on the job whether in the White House or a star's dressing room, dining with Beautiful People or the likes of you and me. Besides his portraits, tens of thousands of photographs depict virtually anyone he has ever met. and since his tape recorders are seldom turned off, he has accumulated an oral archive that includes enough material to provide friends like Diana Vreeland or Paulette Goddard with ready-made autobiographies. Likewise his extensive diaries record his perceptions of a vast circle of acquaintances, and his magazine, *Interview*, publishes their on-the-whole vacuous chatter, and chronicles their no-less-vacuous activities. Only the F.B.I. has more comprehensive archives, but then Andy has a lot in common with J. Edgar Hoover. Despite the mask of ditsy innocence ("Gee! Gosh! Wow!") the artist is no less addicted to power, no less ruthless, no less, in the last resort, reticent. How else could this silver wraith have survived? How else sustain twenty years of notoriety and stardom?

Ronald Jones, "Andy Warhol/Jean Michel Basquiat," *Arts Magazine* **60
(February 1986): 110.** Review of exhibition at Tony Shafraji Gallery.

It has all the charm of a Roy Orbison/Billy Idol concert. It promises to make
history, but at everyone else's expense. Like much of the art produced nowadays
this exhibition swells with revivalism, but with the difference that Andy Warhol
and Jean Michel Basquiat recall those occasions, instead of styles, when art
history was charged with a particular kind of significance. In the yellow
advertisement for this exhibition the two artists stare out at us, dressed in boxing
trunks and gloves, appropriately attired for this larger than life occasion. The ad
implies that the two are at odds, ready to do battle along the lines of Ingres and
Delacroix jousting in that well-known cartoon. Inside the gallery a different tone
prevails.

The canvases were traded back and forth between the two artists over a
period of time (perhaps to recapitulate the gentle relationship of Homer's Mentor
and Telemachus?). This is not quite the rapport between the artistically deflated
Verrocchio and his startling pupil Leonardo. These and other art-historical
caricatures waft through these paintings so casually that they relinquish any
pretensions to seriousness. Of all the pantomimes the most melancholy portrays
Modernism as a contender, vital and fit. Its spent energy, originality, and its
agent, the avant-garde, have been propped up as witnesses to this May-December
marriage of artistic generations. Ironically, it is a gesture that counters its own
best interests because the result pictures Modernism as hopelessly compromised,
chasing its own tail.

At first, these paintings vacillate between amplifying the generational
differences that naturally occur between artists and animating a version of the
Surrealist *Cadavre Exquis*. They come to rest, slumping at the end of the
tradition of great teachers and promising students, as a version of the
"Grandfather Theory." Like Ingres' *Troubadour* pictures which permitted him
to disavow his debt to David by falling for the virtues of Raphael, Basquiat
cancels (graffitis over) Warhol's influence with an expressionist tag. These
paintings indiscriminately footnote artistic collaboration and generational
differences to valorize their investments in the stuff art history is made of: *they
build in greatness*.

Typical is the large canvas picturing two red steaks Warhol has quoted from
the generic supermarket ad. Necessarily, the older artist has worked on the
canvas first: the means to prepare the monument for his successor to efface with
exaggeration; the maneuver, one imagines, to set the Wölffinian pendulum in

motion. The painting gives no suggestion that Warhol returned to it after this initial contribution. Basquiat then was permitted free play to conjure yet another art-historical episode: turning Rauschenberg's *Erased de Kooning* inside out. Basquiat reinvents one steak as a dog and the other as a ski slope. An alligator superimposes, binding the K-9 and K-2 steaks together, thus mixing art-historical metaphors to make canceling and claiming history the same expression.

At the bottom of the painting Basquiat has scrawled two labels: "MUY FAO" and "HYBRID." The claim is for a third meaning, a third thing. Basquiat proclaims a faithfulness to the "progress of art" and the heterogeneous result of mixed origins, of different species. His is the ambition to make something yet unthinkable, something that may first appear unfamiliar, even unlovely. Basquiat's ambition is to revive the anthem of the avant-garde. It is the familiar cadence that taps out the rhythm meant to rally Modernism's faithful by staging something of a Mystery Play around the corpse of the avant-garde and the spirit of originality.

All in all, these pictures are attempts to infuse anemic Modernism with the vigor and radicality it once could boast. Their effect is to etch Warhol's profile alongside those of de Kooning and David in the Pantheon of great masters where, art history tells us, significance is measured by the degree of a legacy's repudiation. These pictures, then, are reduced to soap operas of art history whose mission is to quell the rumors about Modernism. From this vantage the Warhol-Basquiat exhibition is little more than an anthology of picture perfect, textbook models for "the significant moment in art history." That is to say, these paintings seem to be more about making the proper appearance than about making paintings. They are, in fact, a merger, a managed consolidation of two parties' best interests. The streamlining effect allows them to work together toward a common end, feigning traitorousness at the proper cues.

History repeats itself, again. Whenever stale and anachronistic art-historical models are used indiscriminately, stylistic relativity is suspended and distinctions diffused. These paintings recite the gestures of "collaboration" and "cancel" so that their meanings collide; and in turn, art-historical metaphors, types, cycles, and personalities collapse into one another. The result wilfully admits that Basquiat's expressionism is simply another way of saying Warhol's commercialism while the effect is a highly stylized but all-too-familiar veneer that resonates with a shrill stylistic falseheartedness.

Jim Hoberman, "Andy Warhol: Top Gun and Brancusi," *Artforum* 25
 (December 1986): 70-77.

In principle, the artist has always been identifiable by a trademark. It took
Andy Warhol to make the two identical. By calling his studios a factory, Warhol
blatantly identified his output with that of an assembly line. He used mechanical
reproduction not only as a source of ready-made imagery but, just as important,
as a means to rationalize esthetic production by adjusting supply to demand. Any
Warhol has become the brand name given a certain recording device—and a
means of distribution. The mechanical stare of the camera underscores all
Warhol enterprises turned back on itself to photography; it's remarkable how
transfixing that gaze can be.

 In a previously unseen selection of Warhol's photographs, taken during the
'70s and '80s, each work stitches together four prints, usually identical to multiply
the image. This design produces a modified kaleidoscope effect, a bludgeoning
symmetry of unexpected if overdetermined rhymes. Thanks to the blunt
repetition, random details take on heightened authority, and chance juxtapositions
seem inevitable. In the obviously candid portrait of Truman Capote, twisting
around on his deck chair in joyless acknowledgement of the camera, a stray foot
and a beach boy slugging down a can of soda achieve the allegorist weight of two
angles in a Renaissance annunciation. Repetition turns even the most causal photo
opportunity into an icon—it's as if seeing the same snapshot four times at once
makes it as familiar and official as a block of postage stamps or as one of
Warhol's silk-screen superstars.

 As much as they're about anything, these photographs are about the nature
of repetition. They travesty Minimalist geometry no less than they parody the
unique quality of the individual image. Warhol's repetitions can be winsomely
harmonious or violently contrapuntal. A molded plastic chair against a curtain (it
might almost be the setup for an impoverished TV talk show) is transformed into
a figure of bruised and elongated oval forms, while a shelf full of canned goods
becomes as thunderous a vista as any photographed by Ansel Adams. Strong
patterns, like the tip of an airplane wing bisecting a cloud, hover on the brink of
self-parody. There's an overhead shot of a telephone and its sinuously unfurled
wire that Warhol is said to be considering as the successor to his cow and flower
wallpapers.

 Many images are of trademarks or icons, which is to say they are
transparently "Warhols": a torso wearing a James Dean T-shirt, the Empire State
Building, a statue of Mao Zedong, cartons of Coca-Cola labeled in Chinese, the

front page of the *New York Post*, various celebs (Brooke Shields, her mother, Muhammad Ali, Senator Barry Goldwater). Of course, Warhol's development lends itself to repackaging—a large traveling exhibition organized by the Pasadena Art Museum in 1970 was limited to variations on five themes (soup cans, Brillo boxes, portraits, flowers, and catastrophes). Reworking familiar Warhol iconography, some of these new photographs have the look of classics. (Austerely monochromatic versions of the paintings and silkscreens from the mid '60s, they've been printed, and stitched, with such evident attention they seem a kind of artisanal throwback.) Other photographs are ostentatiously empty—just ephemeral junk on a worn piece of pavement, three birds and a shadow on a city street or blurs that can't be read. A few are also political—the exterior of the Ramrod Club in New York, or a Park Avenue address. Still others offer a mind-boggling art-historical plentitude, like the plates of apples that seem to cascade out of one photograph and into the next, or the radiant vortex of a flushing toilet shot from above against the Vienna Secession checkerboard of the tile floor. Decomposing language at its most inertly functional, as on a 42nd Street movie marquee or the sign for a parking lot, and at its most brazenly opaque, as in Chinese characters or convoluted graffiti, is another Warhol strategy.

It is impossible to judge how these images would work as individual photographs—we're taking about Warhol, after all. A few, like the portrait of a Chinese bellhop glamorously poised on the brink of making a phone call, are already resonant and majestically amplified: in most cases, though, the original scarcely matters. No matter how hackneyed the composition, no matter how grossly sentimental or boldly hideous the content, the grid acts as a sort of subliminal crucifixion ennobling the subject. But these images literally have no center—it's all or nothing. There's a photograph of a window filled with Chinese calligraphy (the artist's reflection glimpsed on the glass) that can't be resolved. Your eye skitters up and down, lost in the planes.

Like many epic photographic enterprises, this one has a cumulative impact, yet Warhol's selection of images is as disconcertingly random as it is rigorously controlled. The photographs appear found rather than taken (it would be easy to appropriate this cornucopia of people, places, and things by superimposing a theme over Warhol's vague interest, indeed, it's already been done, first by the Factory hands who chose which images to print, then by the Robert Miller Gallery, which selected the prints which they'll exhibit, and now by me in this magazine. Warhol defeats the intentional fallacy). These images give the impression that Warhol has looked at every photograph that's ever been. There's the old fashioned Weegee flash, the Diane Arbur direct hit, the Modernist Paul

Strand interiors (a chevron of shadows slating across an old wooden door), the Lee Friedlander panorama, the Walker Evans billboard, the '80s appropriation, not to mention all manner of postcards and snapshots. As in his earliest films Warhol has invented a ready-made style which can incorporate anything.

In his essay "The Work of Art in the Age of Mechanical Reproduction" (1936), Walter Benjamin remarked that the "futile" debate on whether photographs could be art obscured the primary fact that photographs had already and irrevocably transformed the nature of art. The impact of photographs on 19th century artists has been well documented. They were, after all, among the early victims of automation. Forced to compete with a mechanical rival, painters studied and imitated it, copied even its "mistakes" (blurs, double exposures, distortions). Photographs set virtually the entire Modernist agenda. Marcel Duchamp exhibiting a urinal—that is to say, reducing the "creative act" to a combination of a choice and context—is Duchamp the photographer. When Duchamp drew a mustache on a cheap print of the Mona Lisa then recently pilfered, he wittingly recapitulated art history from Leonardo (the birth of perspective, the invention of the idea of "genius") to photograph (the birth of mechanical reproduction, the license of stupidity).

Warhol's new photographs bring photographs full circle. If Duchamp is the photographer literalized, Warhol is the camera anthropomorphized. These sutured images do not simply gather the randomness of the camera impressions, they magnify the photograph's leveling power—its ability to obliterate scale, to dispense with the labor of making art, and to estheticize every sort of subject matter, no matter how clichéd or appalling. An anonymous Chinese bellhop becomes for an instant as vivid a personality as Phyllis Diller. An actual airplane is identical with a model, the museum relic with the actual tourist site. Multiplied by four, a pile of dirty New York snow archives the pure symmetry of a formal garden.

The post-Modern can be partially defined as the point in Western civilization at which art finds itself identified within and against mass culture. Television is the greatest equalizer, transforming everything (our attention spans not the least) into a commodity. So Warhol ups the ante, offering a new, improved, extra-strength photography that jumbles up the Eastern bloc and the West, high culture and low, right wing and left, *Top Gun* and Brancusi, and once again, painting and photography. The multiple image flaunts the photographs "phototones" even as it defines its spontaneity. No longer windows, snapshops are turned into (eminently collectible) objects. The desire, noted by Benjamin, to possess an object through its likeness has been superseded by the desire to possess the not-

even-unique representation itself. Reproduced, these photographs look like paintings. They are, in some ways, painting's revenge.

Pierre Nahon, "America's Most Famous Artist," *Cimaise* **35 (September-October 1987): 89-92.**

In the same way that the wine rack became a work of art when placed in an artistic context, Warhol became pop art. In itself, the wine rack had no intrinsic interest whatsoever, and Warhol himself did not do much to deserve his celebrity, other than becoming famous and passively remaining so.

Warhol always succeeded because he never tried. Like tycoons, failure was a word that did not exist in his vocabulary. He was the king of passiveness, the last dandy.

Impassively chewing gum, he made obvious the vanity of our world and the cruelty of its psychological destiny, which, when considered in personal terms, is almost nightmarish.

I am convinced that Warhol's most important works all have a same fundamental theme. The theme of death. Is this capital truth enough to make the spectacle cease? No. Because death, in Warhol's mind, was terribly metaphorical.

For Warhol, death was both a theme and a process. This is particularly evident in the series of silk-screens on "Death and Disaster" and in those of the *Electric Chair* with the word "Silence" over the massive steel door in all its ghastliness. But the art dealer is wandering astray. Andy Warhol, "America's most famous artist," died recently. He was 58.

In 1962 the Stable Gallery exhibited the "Campbell's Soup" series, thirty-two paintings at 100 dollars each. These same paintings have just been placed in the new gallery of the Museum in Washington, lent by the collector Irving Blum, and insured for 2 1/2 million dollars.

"In the market, prices are now (March 1987) three times what they were two weeks ago," says Martin Blinder, President of the Galleries of Los Angeles.

The New York dealer Ronald Feldman confirms this: "My problem is to maintain reasonable prices. Compared with Jasper Johns or even Hockney, Warhol's prices were low. They're going up now, and may even become higher than their's for a simple reason: Andy won't be doing any more. The *One Dollar Bills* painted in 1962 and which went for 385,000 dollars at Sotheby's last fall are now 500,000 dollars.

"His death took us by surprise," says Patterson Sims, curator of the permanent collection of the Whitney Museum. "He produced an extraordinary variety of works and all his work reminds us of his essential contribution to American Art since 1961." For a while now the early works, and those considered important, such as the "disaster paintings," have gone up in price. A few were able to acquire them. Two or three years ago we sold a *Car Crash* to the Musée de Dunkerque, thanks to the tenacity of its driving force, Gilbert Delaine, for 35,000 dollars. A large painting from the same series was just sold in New York (May 1987) for 660,000 dollars.

Dealers and auctioneers think it will take 6 to 12 months to stabilize the market, and also think that not all of Warhol's prices will necessarily go up.

At the bottom end are certain works like *Dollar Signs*, the *Hammers and Sickles*, etc.; not all of Warhol's work has the same historical importance, hence important variations in price on the market.

What did Warhol think in seeing the price of his works go up? "Andy always thought that his prices should have been higher," says Feldman.

We ourselves have always thought his work was undervalued, and will perhaps remain so a while longer.

Bradford R. Collins, "The Metaphysical Nosejob: The Remaking of Warhola, 1960-1968," *Arts Magazine* **62 (February 1988): 47-55.**

I'd been hurt a lot to the degree you can only be hurt if you care a lot. So I guess I did care a lot, in the days before ..."pop art"....
 —Andy Warhol

The Pop Art movement of the 1960s, in which Andy Warhol played a leading part, effectively separates contemporary art from the Modernist system of beliefs and practices that had dominated the art world for nearly a century. Whereas Modernist artists, such as the Abstract Expressionists, had imagined themselves working in a "pure space" *outside* capitalist culture—one which they disdained—the Pop artists were the first to understand that their art is produced and consumed *within* it. For at least one Pop participant, Claes Oldenburg, this did not mean that one was therefore *for* "bourgeois" culture.[1]

But the precise nature of Warhol's relationship to prevailing cultural values has proven more difficult to determine. There are two fundamental schools of thought on the matter: 1) those who maintain that Warhol, like Oldenburg,

offered an ingenious, sometimes brilliant social critique and 2) those who insist that he was little more than a pathetic, albeit fascinating, *manifestation* of mainstream America—a man who used art simply as a vehicle to gain attention, and thus fame and fortune.[2] This failure to resolve the question of Warhol's relationship to culture is a function of the professional unwillingness to consider the all-too-ample evidence of his life. Most scholars consider the facts of Warhol's titillating private and professional existence, as well as his intellectually shallow philosophical pronouncements, material suitable only for gossip columnists and low-brow biographers.[3] When taken seriously, however, these materials offer a new picture of the man and his work.

Warhol's art was basically self-serving, as many have argued, but not in a narrow sense. In fact, two distinct personal agendas generated Warhol's first Pop production: ostensibly, it was designed to satisfy his social ambitions; less apparently, it was intended to cope with a nexus of psychological problems. Moreover, his work was a celebration of popular American culture, albeit a most peculiar one. What is impressive in Warhol's work of the 1960s is the way these three separate functions dovetailed, the way Warhol's clever merchandising and self-promotion techniques served to spotlight the America he loved and to relieve his emotional problems.

Warhol's initial Pop art was conceived to satisfy his social ambitions, first of all, as the facts surrounding his sudden professional transformation in 1960 attest. Warhol had two separate careers: one as a commercial illustrator (1949-ca. 1964) and one as a Pop artist (1960-1987). The shift, a true metamorphosis, was characterized by the absence of apparent continuity. The cool, industrial character of his 1960s art was completely different from the warmly personal quality of both his advertising and artistic production of the preceding years. Warhol's commercial trademark in the 1950s was a simple, graceless blotted line which, in conjunction with his preference for cheerful subjects, gave his work a sweet, childlike appeal. The descriptions of Warhol given by his friends at that time— "sweet," "gentle," "uncomplicated"—suggest the work was a faily direct expression of the young man.[4] His paintings, drawings, and art-book illustrations in this period were consistent with his commercial output. Even the homosexual elements were charmingly phrased, as in his illustrations for in *The Bottom of My Garden* (1956). And the cock drawings (done in the late 1950s in preparation for a book) were frequently decorated with little hearts or ribbons.[5]

Although Warhol's personal style was enormously successful in the commercial arena, it was not well received as art. The few exhibitions he was able to arrange met with either indifference or sarcasm. *ArtNews'* mini-review of

his 1956 exhibition of shoes dedicated to individual stars, for example, archly dismissed the work by noting that "Warhol is a very young artist who may be said to be addicted rather than dedicated."[6] The nature of the artworld's hostility to Warhol's earliest art also is evident in an incident that marked the end of Warhol's close friendship with Philip Pearlstein. In 1955 or 1956 Warhol submitted a series of beautiful boy drawings to the Tanager Gallery, the cooperative to which Pearlstein belonged. The submission was refused. In the context of the conservative social attitudes of the decade and the masculine atmosphere of Abstract Expressionism, his subject matter was unacceptable—a fact Pearlstein tried to point out to him.[7]

This incident at the Tanager suggests that by the mid-1950s Warhol aspired to be more than a commercial illustrator who dabbled in art for a narrow audience. These ambitions were galvanized and given shape at the end of the decade by the examples of Robert Rauschenberg and Jasper Johns, artists whom Warhol knew casually and apparently identified with because of their occasional commercial work and homosexual preferences. What impressed Warhol most, however, was their emerging "star" status, a social standing unattainable to commercial artists.[8] Determined to achieve a similar standing, Warhol refocused his career goals. At the time of his decision to devote the bulk of his energy to fine art, a friend asked him if he wanted to be a great artist. "No," he replied, "I'd rather be famous."[9]

Knowing his "personal" art could not serve his ambitions, Warhol decided to scrap it. In 1960, he abandoned work on the cock book and canceled plans to exhibit a series of drawings devoted to celebrities' feet.[10] Shortly thereafter, he and Henry Geldzahler (a curator at the Metropolitan Museum of Art) destroyed dozens of drawings and paintings based on his blotted-line technique.[11] For the archetypal modern artist, the realization that his art was incompatible with prevailing taste would be disheartening, but it would not cause him to reform it. Warhol, partly because of his commercial background, had a different set of values—one that placed success above the commitment to personal expression. Warhol's importance for the history of art may depend less on his art than on his decisive rejection of Modernist notions of the artist as priest or prophet. His conception of the artist as a businessman offering a product clearly opened a way for the following generation. Warhol's heretical conception of the modern artist is perhaps nowhere more evident than in the advice given Charles Lisanby in 1962. Sounding more like a stockbroker than an artist, he advised, "There's something new we're starting. It's called Pop Art, and you better get in on it because you can do it, too."[12]

In the success of Rauschenberg and Johns, Warhol recognized not only the fame he coveted but also the means to attain it: the rejection of the autobiographical for the world of common culture. Warhol may have understood then that their success signaled a general shift in sensibility away from the aesthetics of the New York School. He perceived it in retrospect, at least. In 1980 he wrote: "Abstract Expressionism had already become an institution and then...Jasper Johns and Robert Rauschenberg...had begun to bring art back from abstraction and introspective stuff. Then Pop Art took the inside and put it outside, took the outside and put it inside."[13] The combined influences of Johns and Rauschenberg are evident in *Saturday's Popeye*, (1960), one of the paintings that inaugurated Warhol's new phase. While the vernacular subject and restrained use of a crude, drippy paint handling derived from Rauschenberg,[14] the work's wry commentary on what Warhol later described as the aggressive, "macho" character of the New York School's painterly tradition depends on works by Johns, such as *Painting with Two Balls* (1960)."[15]

Unlike Johns' work in this vein, *Saturday's Popeye* is not devoid of a personal dimension. The identification of Popeye with Pollock, de Kooning, Kline, and others in the orbit of the Cedar Street Tavern is demeaning; it suggests the caustic tone of one who has been injured by their type of "manly" intolerance. Furthermore, and on an entirely different plane, this work and others, such as *Dick Tracy* (1960), seem to embody cherished childhood memories. Warhol said that his mother often would read comic books to him "in her thick Czechoslovakian accent as best she could and I would always say, 'Thanks Mom,' after she finished Dick Tracy, even if I hadn't understood a word."[16] Because of its blurred, indecipherable text, *Dick Tracy* appears to be a fair record of such experiences.

The nostalgia and revenge masked by the matter-of-fact veneer of these two paintings suggest more than simple opportunism was involved in the artist's decision to follow the lead of Rauschenberg and Johns. In effect, Warhol sought to align his personal concerns with his commercial inclinations. That he ardently and openly pursued a vulgar success through his art should not blind us to the fact of his very real interest in its topography.

When Warhol discovered, in 1961, that Roy Lichtenstein, too, was working with comic-book imagery, he discontinued the theme in favor of the other subject area suggested by the works of Rauschenberg and Johns: ordinary consumer products such as televisions, water heaters, typewriters, telephones, storm windows, corn plasters, and soda pops.[17] These objects not only were mundane and unglamorous (including the 11-inch television); they were drawn from the

most banal realm of advertising: daily newspapers. The inky, black-and-white handling only reasserts that fact. Warhol himself had done much of his commercial work for newspapers, but his work (for I. Miller shoes, for example) had emphasized originality and creativity.

Because of the unpleasing form in which these unlovely objects are presented, one might easily read these paintings as critical commentaries on American consumerism. Such an interpretation does not square with Warhol's stated views, however. In a statement that reveals more about his art than about that of Oldenburg and Lichtenstein, Warhol insisted:

> The Pop artists did images that anybody walking down Broadway could recognize in a split second—comics, picnic tables, men's trousers, celebrities, shower curtains, refrigerators, Coke bottles—all the great modern things that the Abstract Expressionists tried so hard not to notice at all.[18]

Warhol's embrace of that which his avant-garde predecessors had scorned may reflect, in part, the ideas of John Cage. The musician-philosopher was a close friend of, and a major influence on, many American artists around 1960, including not only Rauschenberg and Johns but Emile de Antonio, Warhol's chief art adviser at the time. Warhol claimed de Antonio was "the person I got my art training from."[29] Cage's ideas undoubtedly were a part of that training. In his famous interview with G.R. Swenson in 1963, Warhol said, "I think John Cage has been very influential."[20] The essence of Cage's novel philosophy was an uncritical acceptance of life *as it is*. On the "purposeless play" of his compositions, Cage noted:

> This play, however, is an affirmation of life—not an attempt to bring order out of chaos nor to suggest improvements in creation, but simply a way of waking up to the very life we're living, which is so excellent once one gets one's mind and desires out of its way and lets it act of its own accord.[21]

Warhol was impressed with such ideas but chiefly, I suspect, as they confirmed and supported convictions quite different from those of Cage. Whereas Cage was concerned with the issue of man's relationship to nature, Warhol was absorbed by his personal relationship to American culture. Cage was a philosopher committed to improved experience; Warhol was a chauvinist preoccupied by issues of the marketplace. With the exception of "celebrities," everything mentioned on Warhol's list of "great modern things" and included in his paintings ca. 1961 were consumer goods.

Moreover, the objects Warhol painted appear to inventory the old working-class notion of the American dream. That Warhol came from such a background seems relevant here. Born in 1928, the year before the Crash, to an immigrant coal miner, Warhol experienced the worst of the Depression. That is, he grew up in a time and to a class where water heaters and storm doors were neither taken for granted nor disdained; rather, they were considered the very essence of the American promise. Geldzahler, who knew Warhol as well as anyone in the early 1960s, claimed that "the aching poverty early on" provided "the armature of his view of the world."[22] What is perhaps so surprising about Warhol is that he never seemed to relinquish his ghetto perspective. Even though he eventually rose far above his modest beginnings, he often sounded like an enthusiastic immigrant fresh off the boat. His opinions on Coca Cola, one of his favorite subjects in the 1960s, are indicative: "What's great about this country is that America started the tradition where the richest consumers buy essentially the same things as the poorest...you know that the President drinks Coke. Liz Taylor drinks Coke, and just think, you can drink Coke, too."[23] His hymnal to this country, America (1985), beings with the pronouncement: "America really is the Beautiful."[24]

Missing from the product paintings of the early 1960s, of course, is that note of enthusiasm—the formal equivalent for the adjective great. If we are to believe that Warhol shared something of the Rotarians' view of "this great country," how are we to understand the absence from these paintings of any positive sign of it? The answer, I believe, is that Warhol was in the process of depersonalizing his art. Just as he masked the personal content of *Dick Tracy*, he muted his personal views on television and Coke. Although the artist had convictions about his subjects, he did not want to demonstrate them. The commitment to an old-fashioned chauvinism is *contained* in the choice of subjects, although it is not *revealed* in the handling. Like Duchamp earlier, Warhol wanted to avoid the purely subjective in both feeling and taste. (For a man who had been so fond of charming and beautiful graphic effects, the paintings based on unrefined newspaper ads must have been a tortuous exercise in self-denial.) Unlike Duchamp, who eliminated subjectivity in favor of the intellect, Warhol did so in favor of the objective. His paintings do not tease the mind; they confront it with blunt facts.

That Warhol was in the process of eliminating all signs of the subjective from his work is evident in his use of, and attitude toward, the painterly brush stroke that characterizes roughly half the works in the series based on newspaper ads. This flaccid brush work was inspired by Johns' simulation of the passionate

markings of the Gesturalists. But whereas Johns used his mechanical strokes to raise intellectual issues about the nature of Abstract Expressionist art, Warhol employed his as a compromise, as a way of suggesting both the physical presence of the artist in the work and his emotional absence from it. Warhol wanted to eliminate all record of the self but was hesitant to do so. Thus he asked his friends' and associates' advice about the two styles he was using. He was particularly fond, for example, of showing two versions of the Coca Cola theme: one painterly, "high-art" version and the other derived entirely from advertising.

> I liked to show both to people to goad them into commenting on the differences, because I still wasn't sure if you could completely remove all the hand gestures from art and become noncommittal, anonymous. I know that I definitely wanted to take away the commentary of the gestures.[25]

Ivan Karp told Warhol he

> preferred the works without the splashes and splatterings, that if one were to work in a...style like this..., one might as well go all the way. He said that he felt the same way,...he would prefer to reject them if he felt an audience could be responsive to work as cold and brutal....[26]

De Antonio's response to the two versions was more direct, as Warhol recalled: "'One of these is a piece of shit, simply a little bit of everything. The other is remarkable—it's our society, it's who we are, it's absolutely beautiful and naked...' That afternoon was an important one for me."[27] These accounts reveal Warhol conducting a kind of market research to determine which product the art experts preferred. They also indicate the artist's fondness for the impersonal or, more accurately perhaps, his desire to evolve an impersonal art. "The works I was most satisfied with," he stated, "were the cold 'no comment' paintings."[28]

In order to achieve that goal, Warhol had to empty himself of the old "insides." One method he used was

> the routine of painting with rock and roll blasting the same song, a 45 rpm, over and over all day long...The music blasting cleared my head out and left me working on instinct alone. In fact, it wasn't only rock and roll that I used that way—I'd also have the radio blasting opera, and the TV picture on (but not the sound)—and if that didn't clear enough out of my mind, I'd open a magazine, put it beside me, and half read an article while I painted.[29]

Perhaps the most important technique Warhol adopted around 1962 to change the basis and nature of his art was to encourage others to suggest his subjects. His habit of "asking everyone I was with what I should do"[30] was neither an indication that "Andy was desperate for ideas"[31] nor simply a shrewd marketing device: it was another way to shift attention from the inside self to the outside world. Warhol said that he "was never embarrassed about asking someone, literally, 'What should I paint?' because Pop comes from the outside, and how is asking someone for ideas any different from looking for them in a magazine?"[32]

The Campbell's Soup can theme, suggested by art dealer Muriel Latow,[33] is the best known result of this procedure. Warhol told Swenson that he chose the subject "because I used to drink it. I used to have the same lunch every day, for twenty years, I guess, the same thing over and over again."[34] Although this is an exaggeration, friends have confirmed that the soup was, indeed, a staple of Warhol's diet in the 1950s and early 1960s.[35] The soupcan paintings, prints, and sculptures therefore had for their maker a personal dimension; but the superficiality of this connection differed markedly from the kind of biographical content hidden in the 11 earliest Pop work. Of the supermarket themes from 1962 and after, only *S & H Green Stamps* (1962) seems to have had any degree of personal meaning. (Mrs. Warhola avidly collected the stamps and often enlisted Andy and his friends in her cause.)[36] Furthermore, the other shopping-cart works—the Brillo, Kellogg's, Mott's, Heinz, and Del Monte boxes—were devoid of any private associations: Warhol simply sent his commercial-art assistant, Nathan Gluck, to the grocery store to buy an assortment of unspecified boxed items.[37] On one level this series represents the successful culmination of Warhol's attempts to empty the subjective self from his art. That the boxes all were hollow and many of the soup cans drained of their contents seems significant.

Part of what Warhol was doing in these rigorously objective supermarket works was calculated to intrigue the art world, to provoke its curiosity and interest—much as Johns' target and flags had done in 1959[38] Gestural expressionism still was the dominant art form in the early 1960s. To an art audience raised on a passionately personal art, Warhol's soup cans seemed "really interesting," as Irving Blum, the Los Angeles dealer who first showed (and bought) them, admitted: "I was absolutely mystified by them, coming from an orientation of first and second generation Abstract Expressionism and being involved with that style. These seemed to me...oh...very strange..."[39]

The soup cans were even more fascinating because their lowly nature and anti-artistic presentation smacked distinctly of Marcel Duchamp, the Dada conceptualist who was then in the process of being resurrected and canonized by

a whole generation of artists, critics, and art historians. Duchamp himself legitimized the connection by noting that what was interesting about Warhol was not the Campbell's soup cans but the kind of mind that would decide to paint them.[40]

Warhol's attitude to the subject of his work does not appear in these mute and indifferent products, but they can be discerned in the way they were produced and distributed. Warhol claimed at the time, "I want to be a machine."[41] He acted out that desire by producing hundreds of these facsimiles in an assembly line technique at his studio, "the Factory".[42] The objects were then displayed them for sale in piled abundance, as in a supermarket or discount outlet. That he sold them, instead, in a fine-art gallery is itself testimony to his commitment to the business ethic of maximizing profits through intelligent merchandising. As he later said, "To be successful as an artist you have to have your work shown in a good gallery for the same reason that, say, Dior never sold his originals from a counter at Woolworth's. It's a matter of marketing."[43] Such remarks effectively refute the arguments of those who claim that Warhol's mimicry of American business methods was a form of parody.[44] It was, instead, a form of embrace. As de Antonio said, "Andy is essentially a phenomenon of capitalism..."[45] Or, as another colleague insisted, "Andy was the first artist to understand the corporation. He became Andycorp."[46] Warhol affirmed capitalism not by commenting on it in his art but by engaging in it. Warhol's use of business methods in the promotion of his art and himself was not peripheral to that art, nor simply an opportunistic device to gain fame: it was essential to its meaning. Warhol was a businessman artist dedicated to the theme of American business.

More precisely, Warhol's art was committed to the promotional arm of American business, that segment of the American economy that keeps the products of industry moving from hand to hand—just that sector for which he had worked in the 1950s. With very few exceptions, Warhol's 1960's art deals with merchandising. *$199 Television*, for example, presents an ad for a television, not a television itself. The Campbell's soup works never deal with soup; they deal only with its packaging. Warhol's death-and-disaster series treat the subject via the photographs used to market tabloids such as *The National Enquirer*. Even Warhol's movie stars do not refer us to the individuals themselves, but to the glossies and stills used to promote them and their films.

As this list suggests, Warhol never actually produced anything. He was not a creator in either the usual artistic or capitalist senses. Nothing essentially new entered the world via his art. Warhol was a re-creator. He merely reproduced the products of others, products and by-products, moreover, which were not

represented for reconsideration but repackaged as art for reconsumption. Warhol was the archetypal middleman. He recycled:

> You can take it and make it good or at least interesting...You're recycling work and you're recycling people, and you're running your business as a by-product of other businesses. Of other *directly competitive* businesses, as a matter of fact. So that's a very economical operating procedure.[47]

Warhol was not a mirror for our post-industrialist service culture but its microcosm. [48]

Warhol's desire to integrate himself into the central fabric of American life, to become, as he said, "a part...of my culture, as much a part as rockets and televisions,"[49] may be understood to some degree as a function of his background. The general pattern among American immigrants and their children is common enough: the newcomer to America attempts to shed his unattractive old-world persona and find himself reborn in the mold of mainstream culture. The most conspicuous sign of this phenomenon, of course, is the Americanization of surnames, an action Warhol himself took in the 1950s when he dropped the a from Warhola.

The psychological urge to fit into one's new culture may be easily understood, but the form this took in Warhol's case needs further explication. Warhol's inclination to disappear, to erase himself in favor of American icons like Campbell's soup cans suggests he was responding to other, more idiosyncratic impulses. A wealth of evidence suggests that Warhol was deeply unhappy about himself and his life. Rather than wallow in self pity, Warhol sought remedies for his pain. His identification with unfeeling things was part of this effort to deaden the sensitive self. Andrew Kagan was first to suggest that the emotional emptiness of Warhol's mature art may best be understood as a kind of haven from the difficulties of human interaction,[50] difficulties which had been most acute for Warhol since childhood. As one acquaintance explained: "he had St. Vitus Dance as a child and he lost his hair and couldn't hold his hand steady; he couldn't write on the blackboard. The other kids would beat him up, which made him terrified of socializing.[51] Warhol actually had three "nervous breakdowns" between the ages of 8 and 10.[52] As an adolescent, and later in New York, he was disappointed repeatedly in his quest for a true friend:

> I lived with seventeen different people in a basement apartment on 103rd Street...and not one person out of the seventeen ever shared a real problem with me.[53] I still wanted to be close with people. I kept living with roommates

thinking we could become good friends and share problems, but I'd always find out they were just interested in another person sharing the rent...I worked very hard in those days, so I guess I wouldn't have had time to listen to any of their problems...but still I felt left out and hurt.[54]

"I'd been hurt a lot," he later confessed, "to the degree you can only be hurt if you care a lot."[55] When Warhol said he wanted to be a machine, he was expressing not only his commitment to American industry, he was also revealing what had given that commitment its singular shape: the honest desire to be freed from the troublesome baggage of the human heart.

Warhol dealt with his suffering through an extraordinary act of will:

A person can cry or laugh. Always when you're crying you could be laughing, you have the choice. Crazy people know how to do this best because their minds are loose. So you can take the flexibility your mind is capable of and make it work for you. You decide what you want to do and how you want to spend your time.[56]

Warhol spent his time learning to feel indifferent:

Sometimes people let the same problem make them miserable for years when they could just say, "So what." That's one of my favorite things to say, "So what."
"My mother didn't love me." So what.
"My husband won't ball me." So what. "I'm a success but I'm still alone." So what.
I don't know how I made it through all the years before I learned how to do that trick. It took a long time for me to learn it, but once you do, you never forget.[57]

As Warhol admitted, the trick was not easy to master. The first step in accomplishing the goal was to keep his friends and associates at an emotional distance. Thus he preferred to deal with people through the medium of some mechanical device, such as a telephone or a camera.[58] Eventually he transferred his affections to such instruments, because they could not hurt him. His late 1950s "affair" with his television was the prelude to his "marriage" to his tape recorder.

When I got my first TV set, I stopped caring so much about having close relationships with other people...I started an affair with my television which has continued to the present, when I play around with as many as four at a time. But

> I didn't get married until 1964 when I got my first tape recorder. My wife...The
> acquisition of my tape recorder really finished whatever emotional life I might
> have had, but I was glad to see it go.[59]

His "love" for his recorder seems to have been based on its capacity to transform all problems into fiction: "Nothing was ever a problem again, because a problem just meant a good tape...An interesting problem was an interesting tape. Everybody knew that and performed for the tape. You couldn't tell which problems were real and which problems were exaggerated for the tape."[60]

Evidence of Warhol's success in mastering the trick of indifference is plentiful. Among the many anecdotes that document his hard-won inhumanity, the classic is perhaps Danny Fields' account, as recounted to Warhol himself, of his introduction to life at the Factory:

> You were sitting there reading my paper and Gerard was talking to Denis and
> Arthur was kicking the beautiful French model in the face with his good leg. She
> got upset and ran for a window that was open from the top and climbed up onto
> the ledge...You just glanced up from the newspaper and said so calmly, "Ooo.
> Do you think she'll really jump?" and went back to reading.[61]

Warhol's failure to find a deeply satisfying relationship was only one factor in his decision to commit emotional suicide. Another, apprehensions about his own mortality, is evident in the death-and-disaster series. Geldzahler, whose suggestion to paint *129 Die* (1962) initiated the series, said that Warhol was unusually afraid of death: "Sometimes he would say that he was scared of dying if he went to sleep. So he'd lie in bed and listen to his heart beat. And finally he'd call me...That was it—a cry for help of some kind."[62] The works Warhol produced on the subject were a way of coping with those fears, of anesthetizing them. The shocking gap between the horrible events depicted in the source photographs and the wallpaperlike treatment of them has led some observers to conclude that Warhol was parodying the processes of desensitization in modern life, laying bare "the effect of ubiquitous reproduction on the genuine experience of emotion."[63] Warhol, who claimed to be missing some "responsibility chemicals,[64] flatly stated, "It confuses me that people expect Pop art to make a comment."[65] The series was not a prolonged sermon on anesthetization but an exercise in it. Warhol chose the serial device because he knew that "(w)hen you see a gruesome picture over and over again, it doesn't really have any effect."[66] Warhol was convinced that "the more you look at the same exact thing, the more the meaning goes away, and the better and emptier you feel."[67]

The mechanical repetition of dreaded events drained them of meaning at the same time the artist's manipulation of the material gave him a sense of emotional mastery over it. Furthermore, the translation of gruesome imagery into pretty pastel colors, as in *Lavender Disaster* (1964), transforms their horrible essence into tasteful decor—"just like a dress fabric," according to the artist.[68] Finally, the translation of the photos into the sphere of aesthetics not only distances the spectator from the original event, but undercuts its claims of unmediated veracity. In effect, Warhol twisted a terrible reality into a pleasing fiction—just as his tape recorder did.

Ironically, the failure of these devices fully to counteract the content of their source materials only makes them seem more compelling. I suspect that the peculiar power of these works resides in the tension between the fears these powerful photographs inspire and Warhol's unsuccessful efforts to neutralize them.

Another, more problematic psychological cross Warhol had to bear during these years was his profound unhappiness concerning his appearance, which he dealt with via the celebrity series. In order to appreciate properly what was at stake in his works on Marilyn, Liz, and Elvis, it is necessary first to understand that Warhol not only participated in the American love affair with its stars but to a profound degree. One dealer who visited Warhol's studio ca. 1960 recalls: "What really made an impression was that the floor...was...covered wall to wall with every sort of pulp movie magazine, fan magazine, and trade sheet having to do with popular stars from the movies or rock 'n' roll. Warhol wallowed in it."[69] Warhol's obsession with the principals of Hollywood films developed early. Chuck Wein, who recounted the artist's unfortunate experiences with St. Vitus dance, reported that he therefore "retreated into movie magazines—the glossy pictures not the printed words."[70] The trauma of temporary hair loss coupled with his near-absence of pigmentation left Warhol more susceptible than most to the Hollywood myth of perfect beauty.[71]

Warhol's fascination with these actors and actresses was based on their appearances, not their lives. This may help us to understand why he did not outgrow his need to identify with them. During his twenties, Warhol's appearance deteriorated further: he began to bald and his nose became increasingly red-veined and bulbous, to the extent that he thought of himself as "Andy the Red-Nosed Warhola."[72] In fact, in order to hide his face, Warhol often greeted studio visitors wearing elaborate masks, "like at the 'bal masque' of the eighteenth century."[73]

In the late 1950s Warhol had a nosejob, an event he documented in his unique deadpan manner in *Before and After* (1961).[74] The operation was not meant

simply to improve his looks but to transform them, and his social life as well. Warhol's traveling companion, Lisanby, insisted:

> He had very definitely the idea that if he had an operation on his nose...then suddenly, that would change his life...that he would become an adonis and that I and other people would suddenly think that he is as physically attractive as many of the people that he admired because of their attractiveness. And when that didn't happen...he became...very upset, and...even angry.[75]

In the star series, Warhol dealt with that grave disappointment. The issue on which the series turns is neither fame nor glamour but the kind of good looks on which such intangibles often depend—the kind of good looks that he had hoped to purchase from medical science. That his series of works dedicated to actors and actresses began with portraits of *Troy Donahue* and *Warren Beatty*, just the type of pretty young men Warhol yearned to resemble, only confirms this fact. Warhol's preoccupation with the lovely faces of Hollywood was not a simple matter of adolescent idolatry. Instead, the series represents what we might call a mediated or rationalized embrace, an exercise in both celebration and denial, as an analysis of the works that form its core—those devoted to Marilyn Monroe—demonstrates.

Warhol learned of Marilyn's death while working on the Troy and Warren portraits, which is what gave him "the idea to make screens of her beautiful face."[76] Between 1962 and 1964 he dedicated about thirty silkscreen editions to that face. Although the time and energy spent on the theme bespeaks an obvious and profound involvement, his handling of it took the form of a disclaimer. First, Warhol often repeated her face as if it had no more importance than a soup-can label or a green stamp. Second, he sometimes smeared, smudged, or faded it—an action meant not to evoke the vandal or scorned lover but the indifferent technician, or someone who wished to achieve that state of mind.

This distancing process is completed by the artist's emphasis not on her "beautiful face" but on her cosmetic mask: her eye shadow, hair dye, and lipstick. Rather than heightening her facial features, here makeup elements actually conceal them, becoming a barrier between us and her. The veneer of color, not the person beneath it, is the subject here. Warhol advised us to "look at the surface of my paintings...There's nothing behind it."[77]

There are two ways to interpret that gloss of color, of course: as cosmetics or as technicolor. Whichever reading you prefer, however, the issue is the same: artifice. Both the exaggerated emphasis on makeup and the reminder of the two-dimensional world of film wherein Marilyn was enshrined argue the fictive,

illusory quality of her beauty. Warhol was quite clear on the synthetic nature of Hollywood perfection:

> Someone once asked me to state once and for all the most beautiful person I'd ever met. Well, the only person I can ever pick out as unequivocal beauties are from the movies, and then when you meet them, they're not really beauties either...In life, the movie stars can't even come up to the standards they set on film.[78]

The remark suggests Warhol was not celebrating Marilyn's beauty but the technicolor myth of it. Warhol said as much when he admitted: "I love plastic idols."[79] For Warhol, Marilyn was a kind of deity, as he acknowledged in those works on her wherein he used the kind of gold ground found in Byzantine icons. Like those New Testament figures, Marilyn belonged to a distant, infinitely better sphere.

Warhol cherished the beauty of Hollywood stars not *in spite of* its being fabricated but because it was so. The issue of beauty, so problematic for Warhol, was thereby removed to a safe realm outside reality. By way of his works on Marilyn, Liz, and the rest, Warhol transformed ideal beauty into a fiction. He could continue to embrace the pleasant illusion of the screen without being hurt by it.

Looking back on the 1960s, Warhol said, "I always thought I was more half-there than all-there. I always suspected I was watching TV instead of living life."[80] His three major series of that era (those on ordinary products, death, and movie stars) document the process of desensitization which stood behind this dispassionate perspective. What is sad is that Warhol should have consciously chosen such a perspective. His decision to ground his existence in the avoidance of pain bespeaks a profound pessimism.[81]

Warhol was not a nihilist, however; the one good he continued to believe in was fame. This he pursued relentlessly, if not passionately. His passive, indifferent stance towards it was, in his own mind, essential to any chance he might have of attaining it. One gauge of his pessimism was his conviction that people never get what they actively want: "As soon as you stop wanting something you get it. I've found that to be absolutely axiomatic."[82] In his own case, he was right, but not for the reasons he owned.

Much of Warhol's critical success and therefore fame was a function of the cool, indifferent phrasing of his art. One result of the systematic retreat from the themes of his own works was to open these themes to others. In the context of the Dada revival of the early 1960s, Warhol's matter-of-fact presentation of subjects

from common culture seemed to invite the thoughtful participation of the spectator. But because of what one art historian has called "the suspension of the authorial voice,"[83] his art was amenable to all serious interpretations. Because it offered no significant resistance, everyone could find in Warhol's art exactly what he or she wanted. Critics did not discover Warhol in the depths of his work; they discovered themselves or, more accurately, what they had brought to the work. In effect, Warhol's art became a series of "open" signs, all-purpose illustrations. His iconic *Marilyn,* for example, was equally capable of embodying Tom Crow's pro-feminist investigations on the "Marilyn phenomenon," Patrick Smith's research on the "death of glamour," or Mary Josephson's emotional identification with her sad life and tragic death.[84]

Warhol's status as a kind of do-it-yourself Duchamp was partly self-conscious. Having discovered how eager the audience was to participate in his work, Warhol actively sought to encourage it. He liked the silkscreen medium not simply because of its mechanical nature and more prolific (i.e., profitable) results, but also because its unpredicability produced a greater range of "provocative" images. According to David Bourdon, Warhol's critic and friend, "that was an important consideration. He would always try to second guess audience reaction."[85] That is, the decision to offer many versions of a theme was consciously a marketing one. Warhol's general approach to his thematic material was grounded in a significant personal agenda, as I have demonstrated, but the motive behind any given formulation of a theme was often purely commercial. In short, Warhol hoped to *interest* the consumer/viewer, not in the pejorative sense of mildly stimulating him or her, but in the original sense of the term "interesse," which means "to be in the midst of," or "to be put in the midst of." For example, the suggestive contrast in the *Marilyn Diptych* (1962) between the uniformly colored faces in the left panel and the uneven black-and-white faces on the right was not meant to reveal anything of Warhol's thoughts or feelings; it was simply meant to enmesh the spectator in his own responses to aspects of the Marilyn story. Thus, to insist that "this painting is a moving meditation on the contradictory themes of beauty and ugliness; fame and obscurity; public adulation and lonely, pathetic death..."[86] while misrepresenting Warhol's achievement, nonetheless fulfills his intention.

Warhol's attempts to interest critics and collectors were only rarely successful, however. His reputation depends on a handful of brilliant successes. Warhol's early Pop oeuvre is, in fact, a series of hits and misses in which the latter far outnumber the former. His *Del Monte* boxes (1964), *Cow Wallpaper* (1966), *Do-it-yourself* series (1962), *Troy Donahue* (1962), *Baseball (Roger*

Maris) (1962), and *Most Wanted Men* (1963) are just a few of his works that failed to generate significant response. In his later Pop work, Warhol was even less effective. There is nothing from the late 1960s or after comparable to the Marilyns, death-and-disaster series, or even the Campbell's soup cans.

Warhol's near-murder in June of 1968 usually is used to mark the end of his early Pop phase.[87] I believe the actual watershed was the forced move out of the old Factory earlier that year. Warhol's new downtown studio, with its formal office spaces and reception area, had nothing of the free-wheeling informality of the first Factory. The move offered Warhol and his associates the opportunity to reflect on the status of the Warhol organization. What they decided, as their new corporate space suggests, was that they had "arrived" and that the future would belong more to consolidation than to experimentation and innovation. The move also completed Warhol's journey away from his old self. The original Factory had been a haven for all the odd fringe types with whom Warhol identified. The new Factory, run by Warhol's "business associates," excluded his old crowd and represented the final victory of his aspirations to a kind of respectability.

The shooting incident was a major factor in Warhol's decision to disassociate himself from his former mates.

> Everyone around the Factory was more protective of me...they could see I still had a lot of fear, so they turned anybody away who was acting at all peculiar...Before, I'd always loved being with people who looked weird and seemed crazy—I'd thrived on it, really—but now I was terrified that they'd take out a gun and shoot me.[88]

Warhol had doubts about the wisdom of this isolationist policy, however: "I was afraid that without the crazy, druggy people around jabbering away and doing their insane things, I would lose my creativity. After all, they'd been my total inspiration since '64, and I didn't know if I could make it without them."[89] Judging from the work he produced after 1968, perhaps he was right to worry.

Frankly, I doubt whether the later ouevre would have been much different had Warhol remained in contact with people like Ondine and Billy Name. The existential edge that marked his best art and films seems to have disappeared before the shooting. Others have argued that by 1968 Warhol had said what he wanted to say.[90] I would rephrase that: by that date he had *accomplished* what he had needed to accomplish. For one thing, he had completely solved the problem of emotional susceptibility. In a remark from the early 1970s that says more about its author than it does about the era, Warhol admitted: "During the sixties, I think people forgot what emotions were supposed to be. And I don't think they've ever

remembered. I think once you see the emotions from a certain angle, you never can think of them as real again."[91] Although Warhol's brush with death may have helped him overcome his fear of it, his unusually detached response to being shot twice through six major organs suggests that he had already taken care of the matter:

> Then suddenly Billy was leaning over me. He hadn't been there during the shooting, he'd just come in. I looked up and I thought he was laughing, and that made me start to laugh, too, I can't explain why. But it hurt so much, and I told him, "Don't laugh, oh, please don't make me laugh."[92]

He also reminisced, remarking on the incident, that "the movies make emotions look so strong and real, whereas when things really happen to you, it's like watching television—you don't feel anything."[93]

More important, Warhol had become famous. The attempt on his life made the headlines of both the *New York Post* and the *Daily News*, but Warhol hardly needed those tabloids to confirm his star status. Among many testaments to the fact, in 1965 (8/27) *Time* featured Warhol and Edie Sedgwick in its "Modern Living" section. When the pair turned up for Warhol's 1965 retrospective at the ICA in Philadelphia, they were greeted by so many jostling, screaming fans that the gallery director removed the art from the walls while the pair signed autographs.[94] Warhol's new status meant financial security, of course, and it meant acceptance and integration into the mainstream culture. Even more, it did for Warhol what the nosejob was meant to do: it transformed his coarse Slavic face into the beautiful visage of an American deity. Fame, in our culture at least, changes appearance because it alters how others see us. Fame, like love or beauty, is in the eye of the beholder. To his fans at the ICA opening, for example, Warhol was as beautiful as Edie. Warhol's blatant pursuit of popular adulation must be understood in this light: it was not the manifestation of an immature, adolescent mind but of a deeply unhappy man who, as Truman Capote observed, "would like to have been a charming, well-born debutante from Boston...anybody except Andy Warhol."[95] Warhol understood perfectly, if unconsciously, that fame literally would remake him.

Having resolved the major issues of his life, Warhol had little to do in the 1970s and 1980s except maintain his fame—which he did in an efficient, businesslike manner—and enjoy it, which he did as well as anyone could who'd "forgot what emotions were."[96]

NOTES

1. See B. Rose, Oldenburg, Greenwich, CT, 1970, Pt. 1.

2. For the first view see H. Smagula, *Currents: Contemporary Directions in the Visual Arts*, Englewood Cliffs, 1983, 41-52; D. Lurrie, "Andy Warhol/Disaster Paintings," *Arts Magazine*, Summer 1986, 117-118; and A. Huyssen, "The Cultural Politics of Pop," *After the Great Divide*, Bloomington, 1986, 141-148. For the second view, see C. Tomkins, "Raggedy Andy," *The Scene: Reports on Post-Modern Art*, New York, 1976, 35-53. Some critics and historians have insisted that his earliest Pop art was critical but that he very quickly (and mysteriously) relinquished that agenda for a more selfish one. See, for example: T. Crow, "Saturday Disasters: Trace and Reference in Early Warhol, *Art in America*, May 1987, 129-136 and R. Hughes, "The Rise of Andy Warhol," *New York Review*, Feb. 18, 1982, 6-10.

3. An exception is P. Smith, *Andy Warhol's Art and Film,* Ann Arbor, 1986.

4. Warhol's closest friend in the 1950s, Charles Lisanby, insisted that he was both "sweet and gentle." In *ibid.*, 380. Eugene Moore, for whom Warhol designed window displays at Bonwit Teller, agreed: "...he always seemed so nice and uncomplicated. He had a sweet, fey, little-boy quality, which he used, but it was pleasant even so..." In Tomkins (as in n. 2), 39.

5. Smith (as in n. 3), 260 and 317-318.

6. P. Tyler, "Andy Warhol," *Art News*, Dec. 1956, 59.

7. Conversation with Pearlstein 7 March 1987 in Tallahassee, FL.

8. Ted Carey, the friend who promoted Warhol's interest in collecting contemporary art, said that "Andy was definitely influenced by Johns and Rauschenberg, not so much by their produced work but by...their success and their glamour and the fact that they were in the Castelli Gallery...that they were 'stars'..." In Smith (as in n. 3), 263. Another friend, Emile de Antonio, recalled Warhol's wistful comment, "Jasper is such a star." In Tomkins (as in n. 2), 44. Warhol continued doing commercial work until about 1964 when the sales of his art permitted him to quit it, but he understood that knowledge of it would hurt his reputation as a legitimate artist and so he kept the fact from his dealers and art fiends. A. Warhol and P. Hackett, *Popism: The Warhol '60s*, New York, 1980, 17.

9. In Smith (as in n. 3), 367. Warhol's friends and associates are unanimous on the issue of his overriding ambition to be famous. See *ibid.* 264, 294, 308, and 386. De Antonio claimed that "Andy was blindingly ambitious." In Tomkins (as in n. 2), 44.

10. Smith (as in n. 3), 97.

11. In his text, Smith dates the event to 1960. *Ibid.* Geldzahler, in his interview with Smith, however, said it occurred "around 1962." *Ibid.* 307.

12. In Tomkins (as in n. 2) r 44.

13. Warhol and Hackett (as in n. 8), 3.

14. See, for example, *Charlene* (1954) where such a paint handling is used in conjunction with comic-book imagery. The second version of the Popeye subject, from 1961, is in Rauschenberg's collection.

15. "The world of the Abstract Expressionists was very macho," he correctly noted in Warhol and Hackett (as in n. 8), 13.

16. A. Warhol, *The Philosophy of Andy Warhol,* New York and London, 1975, 21-22.

17. Although Geldzahler and others advised him to continue working with such sources, Warhol decided there was not enough room in the New York market for two comic-book painters. Geldzahler later admitted to Warhol, "From the point of view of strategy...you were of course correct. That territory had been preempted." In Warhol and Hackett (as in n. 8), 18

18. *Ibid.*, 3. The idea that all Pop art was a celebration of American consumerism was popular in the 1960s. See, for example, J. Rublowsky, *Pop Art,* New York, 1965.

19. Warhol and Hackett (as in n. 8), 3.

20. In *Art News*, November 1963. Reprinted in J. Russell and S. Gablik, *pop art redefined*, New York and Washington, 1969, 118.

21. J. Cage, *Silence*, Middletown, CT, 1961, 12.

22. In Smith (as in n. 3), 308.

23. Warhol (as in n. 16), 100-101. Although such remarks may sound facetious when taken out of context, they are not. A quick perusal of any of Warhol's books reveals the special innocence and sincerity of his tone.

24. Warhol's observations on mainstream American culture are illustrated with his own photographs.

25. Warhol and Hackett (as in n. 8), 7.

26. In J. Stein and G. Plimpton, *Edie: An American Biography*, New York, 1982, 195.

27. Warhol and Hackett (as in n. 8), 6.

28. *Ibid.,* 7.

29. *Ibid.* Dealer Ivan Karp remembers that during his first visit Warhol played one rock 'n' roll song over and over again "at an incredible pitch." Stein and Plimpton (as in n. 26), 195.

30. Warhol and Hackett (as in n. 8), 17.

31. Tomkins (as in n. 2), 46.

32. Warhol and Hackett (as in n. 8), 16.

33. For the well-known story, see Tomkins (as in n. 2), 46-47.

34. In Russell and Gablik (as in n. 20), 117.

35. Pearlstein interview (as in n. 7). And see Smith (as in n. 3), 377 and 401.

36. *Ibid.,* 132.

37. Although Gluck misunderstood Warhol's instructions and brought back fruit crates beating pretty labels, which meant that Warhol had to do the shopping himself, Warhol's intentions to avoid personal taste and associations are clear. Smith (as in n. 3), 169.

38. See L. Steinberg, "Contemporary Art and the Plight of its Public," *Harper's Magazine,* 1962. Reprinted in G. Battcock, ed., *The New Art,* New York, 1966, 27-47.

39. In Smith (as in n. 3), 218.

40. J. Perrault, "Andy Warhol, This is Your Life," Art News, May 1970, 52.

41. In Russell and Gablik (as in n. 20), 117.

42. In the following decade, he liked to be called "the boss." G. O'Brien, "Andy," *Parkett*, 12, 1987, 62.

43. Warhol and Hackett (as in n. 8), 20-21.

44. See, for example, S. Morgan, "Andy & Andy, the Warhol Twins: A Theme and Variations," *Parkett*, 12, 1987, 35.

45. In Smith (as in n. 3), 294.

46. In O'Brien (as in n. 42), 64.

47. Warhol (as in n. 16), 93.

48. One of the clichés of the Warhol literature is that his work provided a mirror for American culture. See, for example, Tomkins (as in n. 2), 51 and C. Ratcliff, *Andy Warhol*, New York, 1970, 29.

49. Tomkins (as in n. 2), 48.

50. A. Kagan, "Most Wanted Men: Andy Warhol and the Anti-Culture of Punk," *Arts Magazine*, Sept. 1978, 121.

51. Chuck Wein, one of Warhol's assistants at the Factory, in Stein and Plimpton (as in n. 26), 185.

52. Warhol (as in n. 16), 21.

53. *Ibid.*, 22.

54. S. Koch, *Stargazer: Andy Warhol's World and His Films*, 2nd ed., New York and London, 1985, ix.

55. Warhol (as in n. 16), 26.

56. *Ibid.*, 112

57. *Ibid.*

58. Smith (as in n. 3), 140.

59. Warhol (as in n. 16), 26.

60. *Ibid.*

61. Warhol and Hackett, (as in n. 8), 97. For similar incidents, see ibid., 60 and 289.

62. In Stein and Plimpton (as in n. 26), 201.

63. M.R. Daniel, "The Object of Pop Art and Assemblage," in S. Hunter, ed., *An American Renaissance: Paintina and Sculpture Since 1940*, New York 1986, 102.

64. Warhol (as in n. 16), 111.

65. In Russell and Gablik (as in n. 20), 119.

66. *Ibid.*

67. Warhol and Hackett (as in n. 8), 50.

68. Interview with P. Tuchman, *Art News*, May 1974, 26.

69. In Stein and Plimpton (as in n. 26), 192. See also the remarks of de Antonio and Truman Capote in *ibid.*, 196.

70. Tomkins (as in n. 2), 48.

71. "I lost all my pigmentation when I was eight years old...people used to call me...'Spot.'" Warhol (as in n. 16), 64.

72. *Ibid.*, 63.

73. According to one visitor, Ivan Karp, in Stein and Plimpton (as in n. 26), 195.

74. *Ibid.*, 195-96. The three works he did on the subject 196-1961 were based on a newspaper ad that ran regularly in *The National Enquirer* (Fig. 14), which Warhol regularly read at this time.

75. In Smith (as in n. 3), 379-380.

76. Warhol and Hackett (as in n. 8), 22.

77. *Andy Warhol*, Moderna Museet, Stockholm, 1968, n.p.

78. Warhol (as in n. 16), 68.

79. *Ibid.*, 53.

80. Koch (as in n. 54), iii.

81. The strongest manifestation of his pessimism are the depressing films of the late 1960s based on the lives of those in his circle. See, for example, *The Chelsea Girls* (1966) and *Trash* (1970).

82. Koch (as in n. 54), vii.

83. Crow (as in n. 2), 130.

84. See *ibid.*, 132-134 and Smith (as in n. 3), 123-124. Josephson found Warhol's *Marilyn* (1962) to be "an image of heartbreaking power" whose "peculiar anguish lies in the fact that, since there was nothing behind Marilyn's face...the anguish is experienced on the surface, that is uncomprehendingly." M. Josephson, "Warhol: The Medium as Cultural Artifact," *Art in America,* May-June 1971, 43.

85. In Smith (as in n. 3), 229.

86. Smagula (as in n. 2), 47.

87. One of the fringe members of Warhol's circle at the Factory, Valerie Solanas (sometimes spelled Solanis), shot him twice in the body on June 3rd, explaining to the police later, "He had too much control over my life." For a full account of the incident see D. Bourdon, *Warhol*, New York, 1989, 284-287.

88. Warhol and Hackett (as in n. 8), 285).

89. *Ibid.*

90. See, for example, Koch (as in n. 54), iii-vi.

91. *Ibid.*, i-ii.

92. Warhol and Hackett (as in n. 8), 273.

93. Warhol (as in n. 16), 91.

94. Ratcliff (as in n. 48), 55.

95. In Stein and Plimpton (as in n. 26), 183.

96. Warhol spent the last years of his life "being seen" at parties and restaurants, and shopping. He accumulated so much on the daily shopping sprees of his later years that it took Sotheby's ten days to auction off over 10,000 of these items. Proceeds of the sale amounted to 25.3 million dollars.

John Updike, "Fast Art," *New Republic* **200 (March 27, 1989): 26-28.** Review of MoMA retrospective.

The Andy Warhol retrospective at New York's Museum of Modern Art is the perfect show for time-pressed Manhattanties. They can breeze through it at the clip of a fast walk, take it in through the corners of their eyes without ever breaking stride, and be able to talk about it afterward entirely in terms of what they got out of it. Indeed, you can honorably discuss the show without attending it at all, if you've ever seen a Brillo box, a Campbell's soup can, a photograph of Marilyn Monroe, and a silver balloon. Here they are again, the dear old Warhol icons, full of empty content, or contented emptiness. Their vacuity gains through muchness, since if you miss one wall of silk-screened caps or Marilyns or dollar bills, another wall will deliver the same message, and we can absorb this art as we absorb reality—while trying to ignore it. Not only does, say, a duplicated and garishly paint-smeared image of Liza Minnelli or Truman Capote not invite close attention, it sends it skidding the other way. Busy power people should love this show; it repels lingering, and can be cruised for its high spots, which are all but indistinguishable from its low spots.

This is not denigration, but an attempt at description. Warhol's art has the powerful effect of making nothing seem important. He was a considerable philosopher, and in his testament, *The Philosophy of Andy Warhol*, as extracted by Pat Hackett, we read: "Some critic called me the Nothingness Himself and that didn't help my sense of existence any. Then I realized that existence itself is nothing and I felt better." His great unfulfilled ambition (he couldn't have had too many) was a regular TV show: he was going to call it "Nothing Special." He came to maturity in the postwar, early cold war era of existentialism and angst, and found himself greatly soothed by the spread of television and the tape recorder.

In this *Philosophy* he speaks this parable: "A whole day of life is like a whole day of television. TV never goes off the air once it starts for the day, and I don't either. At the end of the day the whole day will be a movie. A movie made for TV." The tape recorder completes his deliverance from direct, emotional involvement in his own life: "The acquisition of my tape recorder really finished whatever emotional life I might have had, but I was glad to see it go. Nothing was ever a problem again, because a problem just meant a good tape, and when a problem transforms itself into a good tape it's not a problem any more." Like the pidgin pronouncements of Gertrude Stein, Warhol's harbor amid their deadpan tumble of egocentric prattle an intermittent clairvoyance, a shameless gift for seeing what is there and saying it. The political turbulences and colorful noise of the 1960s did not hide from him the decade's essential revolution. "During the '60s, I think, people forgot what emotions were supposed to be. And I don't think once you see emotions from a certain angle you can never think of them as real again."

What remains real, it would seem, is the semiotic shell, the mass of images with which a society economically bent on keeping us stirred up appeals to our oversolicited, overanalyzed, overdramatized, overliberated, and over-the-hill emotions. Warhol on sex, our great social lubricant and sales incentive, is especially withering: "After being alive, the next hardest work is having sex." Sex is not only work. "Sex is nostalgia for when you used to want it, sometimes. Sex is nostalgia for sex." Or: "Frigid people really make out." His obsessive silk-screening of *Marilyn Monroe* (of one particular face that she presented the camera, her eyelids half-lowered and her lips parted in a smile somewhat like a growl, a '50s drive-in waitress's tired sizing-up of one more coarse but not totally uninteresting come-on) turns her into a Day-Glo-tinted, tarted-up mask, the gaudy sad skull left when she is viewed without desire.

The repetition that was one of Warhol's key devices—two Liza Minnellis, ten Elizabeth Taylors, 36 Elvises, 102 Troy Donahues—has a mocking effect. In one of the many essays that introduce the tribute-laden, 478-page catalog, John Cage is quoted as saying, "Andy has fought by repetition to show us that there is no repetition really, that everything we look at is worthy of our attention." To me the message seems the exact opposite: that everything is repeated, that everything is emptied and rendered meaningless by repetition. Warhol himself stated, "When you see a gruesome picture over and over again, it doesn't really have any effect."

Born Andrew Warhola in 1928, the son of an immigrant Czech coal miner, he came from Pittsburgh to New York in 1949, freshly graduated from Carnegie

Tech. In *Pre-Pop Warhol*, an album of his commercial art published last year by Panache Press at Random House, Tina S. Fredericks, who gave Warhol his professional start at *Glamour* magazine, writes, "I greeted a pale, blotchy boy, diffident almost to the point of disappearance but somehow immediately and immensely appealing. He seemed all one color: pale chinos, pale wispy hair, pale eyes, a strange beige birthmark over the side of his face (almost like a Helen Frankenthaler wash)." He was not only appealing and blotchy but persistent and resourceful: by the mid-50s he had become a very successful commercial artist. His drawing of shoes for I. Miller, done in the Ben Shahn-like blotted-line look that he had developed, were especially celebrated in the advertising world.

He was industrious and quick, and never overdid his assignments, providing a light, artist-effacing touch. In *Pre-Pop Warhol* can be found a number of devices directly transferred to the "serious" art he began to produce in 1960: repetition, gold-leaf, a wallpaper flatness, monochrome washes across the outlines, and appropriation of "ready-outlines, and appropriation of 'ready-made elements like embossed paper decorations. These early years also saw, in the hiring of his first assistant, Nathan Gluck, in 1955, the beginning of his famous "Factory" and (to quote Rupert Jasen Smith)"his art-by-committee philosophy."

Warhol's first art sales were of shoe drawings rejected by I. Miller, displayed on the walls of the Serendipity restaurant in 1954. His first exhibit, containing paintings of Superman and a Pepsi-Cola advertisement and a before-and-after nose job all present in MoMA'S retrospective, appeared behind mannequins in a window of Bonwit Teller in 1961. As late as 1963 he was still accepting more commercial commissions than he rejected. He saw, however, that the gallery and the museum were the path to true wealth and fame. He went, in his words, from the art business to business art. I started as a commercial artist, and I want to finish as a business artist...I wanted to be an Art Businessman or a Business Artist. Being good in business is the most fascinating kind of art."

"American money is very well-designed, really," Warhol said in one of the few aesthetic judgments offering in his *Philosophy*. "I like it better than any other kind of money." He drew dollar bills freehand, he silkscreened sheets of them, he became rich. He had an untroubled tabloid mentality: his eye naturally went to what interests most of us: money, advertisement, packages, lurid headlines, pictures of movie starts, photographs of electric chairs and gory automobile accidents. His early-60's pencilled and painted copies of screaming front pages from the *News*, the *Post*, and the *Mirror*, with Sinatra and Princess Margaret, Liz and Eddie carefully but not mechanically reproduced, make us smile, because these are familiar images we thought too lowly to be passed through the eye and

hand and mind of an artist. They, and the soup cans and Coke bottles, are Pop comedy, our world brought home to us with that kiss of surprise that realism bestows.

We like to think of art as lying on the frontier between reality and our awareness. The multiple silk screens possess, in the inevitable irregularities of the process and the overlay of colors, qualities we can call painterly, and this reassures us. But when we arrive, on the lower floor of his exhibition, at the blown-up and monochromed photos of car wrecks and electric chairs and race riots, a whiff of '60s sulphur offends our nostrils in these odorless '80s. Something too extreme and bleak is afoot. We wonder how much of our interest can be credited to Warhol, and how much to the inherent fascination of the original photographs. Where is the artist in all this? Is he working hard enough, or just peddling gruesome photos? We find ourselves getting indignant and hostile. Warhol in his lifetime inspired a great deal of hostile criticism, even in times when almost anything went, and the hostility relates, I think, to the truly radical notion his works embody: the erasure of the artist from modern life, his total surrender to mechanism and accident. Such a notion makes art critics uneasy, for if artists self-erase, art critics must be next in line, and it distresses the art viewer with the suspicion that he is being swindled—being sold, as it were, a silk of the Brooklyn Bridge.

No sweat, the saying goes, and Warhol perfected sweatless art: movies without cutting, books without editing, painting without brushing. Up from blue-collar origins, he became the manager of the Factory. His lightest touch on the prayer wheel there produced a new billowing of replicated images, of Maos and cows and Mick Jaggers, of dollar signs and shoes, of mock ads and packages, of helium-filled silver pillows. When each idea had its scandalous and impudent little run, he came up with another, and although some, like the oxidization paintings produced by urinating on canvases covered with copper metallic paint, will never replace Pollock in the hearts of museum curators, it must be said that for all the '60s and much of the '70s Warhol maintained quality controls. Almost everything produced was perfect in its way, with a commercial artist's clean precision and automatic tact. In the anarchic realm of the disappearing artist, the artist's ghost-wispy and powdery. Warhol came to look more and more ghostlike-exercised taste. Not until the last rooms of this show do any of the canvases seem too much, like the visually noisy camouflage series, or too little, like the epochal religious paintings of Raphael and Leonardo reduced to color-book outlines and disfigured with manufacturers' logos.

In the realm of social behavior, too, a certain control kept Warhol productive and inventive. Though lesser members of his Factory descended into stoned orgies and ruinous addictions, he remained wrapped in a prophylactic innocence, going home every night (until 1971) to his mother—that same mother, who, he remember in his brief memoir of his childhood, used to read Dick Tracy to him in "her thick Czechoslovakian accent" and who would reward him with a Hershey bar "every time I finished a page in my coloring book." How much, really, of his mature work can be described as "coloring"! In one of his first self-abnegations he induced her to sign his works, and write his captions, in her own clumsy but clear handwriting. Julia Warhola presents a perspective on her son quite different from that of the critic who called him Nothingness Himself: Fredericks quotes her as saying, "He represents at the same time the American and European fused together, and he's very keen and sensitive to everything that goes on everyday and he registered it like...you know...a photographic plate... He has this terrific energy and he goes out and he registers everything and he does that everything and he becomes everything. The everything man."

Everything and nothing. Warhol might have pointed out, are close to identical. He evidently did not quite discard the Roman Catholicism in which he was raised, paying daily visits to the church of St. Vincent Ferrer on 66th Street and anonymously performing good works for the homeless. The closing paragraphs of the catalog essay by Robert Rosenblum persuasively link Warhol's Catholicism with his sense of the iconic, his altarpiece-like diptychs, his fondness for gift and memento mori. But surely, also, the profound hollowness, we feel behind the canvases is a Catholic negativity, the abyss of lost faith. Protestantism, when it fades, leaves behind a fuzzy idealism: Catholicism, a crystalline cynicism.

In the *Philosophy*, some of his remarks have the penetrating desolation we associate with maximists like La Rochefoucauld and Chamfort. "I think that just being alive is so much work at something you don't always want to do. Being born is like being kidnapped. And then sold into slavery." The equation of being born with being kidnapped takes one's breath away, and the Warhol "works" on display in New York assume a new light when seen as the fruits of a kind of cosmic slavery. Work he did, while pretending to do nothing. If the show in its early rooms has the gaiety of a department store, it takes on downstairs the somber, claustral mood of a catacomb. Negatived skulls and Mona Lisas suggest the inversions of a black mass. The glamorized women, we notice, are almost all of them dead or grazed by death—Marilyn, Jackie, Natalie, Liz. And Warhol himself, unexpectedly dead in a hospital when not yet 60, a victim perhaps of the

distracted medical attention that celebrities risk receiving from the awed staff, has joined the Pop martyrs, the mummified media saints.

There was an efficient churchly atmosphere to his show, of duty discharged and superstition placated. Visitors, I noticed, kept glancing slyly at one another, as if to ask, "How foolish do *you* feel?" One woman, with a seemly irreverence, combed her hair in from of a Warhol self-portrait whose framing glass reflected back from that dead opaque face. It might have been an act of oblation. Andy has become—what he must have wanted all along—an icon.

Bradley W. Block, "On Art, Where Warhol Failed," *The New Leader* **72, no. 6 (March 20, 1989): 22-23.** Review of MoMA retrospective

Andy Warhol: A Retrospective, on view at the Museum of Modern Art (MoMA) until May 2, is every bit the blockbuster show its planners hoped it would be. Unending streams of visitors dine in a museum café, covered with Warhol paper, crowd a screening room to view a documentary about Warhol's life, and stop at the museum gift shop to purchase Warhol posters, lapel pins and stationery, carried away in Warhol shopping bags.

But then there's the art. Dealing with Warhol's *oeuvre*—making sense of the avant-garde work he produced—raises so many complex issues, it is perhaps not surprising to find the task largely avoided. Since everything he did has been called art almost from the start, to many people, that is what it must be. In the eyes of a vocal minority, however, he has been an avatar of the cheap appeal to fashion now pervading our cultural life. In both cases Warhol is transformed from artist to symbol; indeed, his name conjures up a complete sex, drugs and rock 'n' roll world view during a turbulent period of American social history. This is understandable, yet it obscures what he accomplished, as well as an assessment of the damage he left behind.

After graduating from the Carnegie Institute of Technology in 1949, Andrew Warhola came to New York with the hope of establishing himself as a painter. He supported himself at the outset by working for magazines and department stores. It was common then for an artist to lead the life of commercial illustrator by day and Expressionist painter by night, but Warhol's artistic interests flowed directly from the window displays and newspaper advertisements he did for the shops that lined Fifth Avenue. It is not difficult to see why. He came of age during the Golden Era of American Consumerism. The '50s were not merely a time of perfected mass production; they marked the beginning of mass marketing.

The American visual landscape was being flooded with a new and vast array of images.

It was the esthetic potential of these images that Warhol's early work explored. In 1955, he sent art directors a fanciful lithograph of a woman covered with tattoos of supermarket products and corporate logos. Among his first paintings to receive attention were a 1960 series based on advertisements for electric drills, vacuum cleaners and televisions. The individual elements of these paintings were faithfully copied from their source, then scrambled on the canvas in collage-like fashion, with an occasional paint drip as a nod to Abstract Expressionism. The result of this toying with context was a heightened awareness of the line, space and texture of the everyday, akin to Stuart Davis' well-known compositions of cigarette packages.

By 1962 Warhol had taken the approach to its logical terminus, removing the brush marks and other signs of painterly intrusion from his work. Using intense, vivid hues to flatten the image, he gave us matchbook covers and soup cans that were simultaneously ultra-real and parodies of their subjects. Confronted with 32 such renderings of a Campbell's soup can, a viewer at the MoMA experiences in an immediate way the conflict between creation and mechanical reproduction as it was played out at the dawn of mass marketing. It is often said Warhol blurred the line between high art and commercial art. Actually, that boundary was blurred long before when graphic designers began packaging products in a visually interesting way. Warhol did not invent the paradox; his achievement was bringing it into sharper focus than anybody else.

The main impediment to an appreciation of Warhol's early period is virtually everything he did afterward. Around the same time that Warhol was eliminating brush strokes from his paintings, he was also experimenting with silk-screening, henceforth his favored technique. Warhol simply had to choose the image he wanted to reproduce, photochemically transfer it to a screen, and then press ink through the screen to a canvas on the other side. It might be suspected that heavy reliance on such a mechanical method leaves little room for personal development, and that suspicion is borne out at the MoMA retrospective. After viewing a wall of silkscreened Jackies, a room of silkscreened Marilyns, one is numb and has lost all hope of glimpsing a developing esthetic vision. The source of the problem is that any vision Warhol had was dwarfed by his desire to be liked, to be the lovable eccentric of the art world. As Warhol churned out ever more likable art, he made the small yet crucial shift from art inspired by painless consumerism to art that was painlessly consumable.

Warhol's defenders claim he was working in the tradition of Conceptualism, but underneath that slick notion there is nothing except chronic cleverness—which is, in fact, the basis of Warhol's continuing popularity. We line in a time when few things deft stroke of incongruity. Here Warhol was the undisputed master, turning out wallpaper decorated with the repeating likeness of Mao Zedong, or a silkscreen of the Statute of Liberty superimposed on a camouflage pattern. Different artists appeal to different emotions within us; Warhol appealed to our sense of hip. It is fitting that one of his last works, *Moonwalk (History of TV Series)*, looks like nothing so much as a still from MTV.

While offerings upon the altar of cleverness need to be substantial, they must be frequent, a requirement that left Warhol grasping at straws during his last decade. This is illustrated with almost pathetic clarity by a 1979 piece (not in the show but included in the catalogue), *Big Retrospective Painting (Reversal Series)*, consisting of parallel rows of his previous flowers, electric chairs and cows. He even returned to newspaper advertisements for inspiration, producing paintings of light bulbs and girdles. Unfortunately, compared with similar work he did 25 years earlier, the later versions are lifeless and stale.

Andy Warhol began his career with an intriguing insight that was quickly either exhausted or abandoned, and then spent the rest of his years producing enjoyable yet uninspired, second-rate art. In more sane circumstances, he would have won a secure if decidedly minor niche in the annals of art history. That is not, of course, what happened.

Quite to the contrary, the art world has been unable to move past Warhol. It would not be an overstatement to say that as a consequence virtually the entire avant-garde art movement has withered. Warhol's immense popularity taught artists everywhere the false lesson that cleverness is enough. It is difficult to imagine the trivial efforts of Julian Schnabel or Barbara Kruger, to name only two established lights, being taken seriously without Warhol having broken the ground for them. A tour through the galleries of SoHo, move over, leaves one with the unpleasant feeling that change will be long time in coming. Emerging painters and sculptors, working with the fervor of admen, continue to concentrate on thinking up gimmicks that will shock just enough to make their work desirable.

No art exists in a vacuum, but avant-garde art in particular requires a dialogue among the curators, critics and audiences who, with the artists themselves, makeup the "art world." Avant-garde art is by definition experimentation, and the cruel reality is that in any endeavor most experiments are destined to fail. Therefore, the first responsibility of those within the art world must be to distinguish between what is worthy of consideration and what

is not. With Warhol, regrettably, this responsibility was shunted aside. The near-universal acceptance of his work has meant that art is whatever the artist says it is. Because of this, the most foolish artists—and the past decade has seen many—are taken to be important by critics and curators struggling to offer high-sounding explanations of works that would be better dismissed.

It is peculiar that Warhol precipitated such a situation. For at the very least, the bulk of his work—the formulatic portraits, the predictable repetition of shock images, and so on—should have forced us toward some understanding, of what it is we expect from art. Where Warhol is concerned, for example, it could be argued that he successfully captured and chronicled his times. But is this sufficient, or should art also transcend its time? What role should we assign to the artist's intention in evaluating his creation? These questions should stand at the core of any discussion of the avant-garde, not be discarded as irrelevant.

The art world will not be able to put Warhol in proper perspective—and move past him to more significant creation—until the realization begins to take hold that avant-garde art existed long before the first silkscreened Marilyn. But Warhol's influence has been so strong that Picasso and even Pollock today appear to be distant, chthonic gods. Perhaps, then, it is a hopeful if ironic sign that his retrospective is being held at the MoMA, home to one of the greatest collections of 20th century avant-garde art in the world.

Arthur C. Danto, "Art," *Nation* 248, no. 155 (April 3, 1989): 458-461.

It is possible—I would argue that it is necessary—to explain the history of art through the past century as a collective investigation by artists into the philosophical nature of art. The significant art of this extraordinary period accordingly has to be assessed as much on grounds of speculative theory as on those of aesthetic discrimination. "Beginning with van Gogh," Picasso said to Francoise Gilot, "however great we may be, we are all, in a measure, autodidacts—you might almost say primitive painters." It was as if each artist was at the beginning of a new era opened up by his own theories. Picasso had supposed that he and Braque had done something more important in Cubism than to have made some works of art: He believed they had created a style of art that would compose a new canon, sparing those who followed them the need to define the essence of art. For a time, neither of them even signed their works—one does not sign a theory—and when Cubism failed to bring back the sense of order, Picasso tried one thing after another, inventing whole art-historical periods that

he alone occupied. I recall when Abstract Expressionism was deemed the new paradigm, destined to last for as long at least as the tradition which came to its end in Impressionism. It was the collapse of that faith with the advent of Pop, rather than the irreverence and brashness of Pop Art itself, that disillusioned so many artists in the early 1960s who believed that they knew what art was. Pop violated every component of their theory and somehow remained art. And so the quest went on.

"Art?" Warhol once asked in response to the inevitable question, "Isn't that a man's name?" Well, suppose we think of the century as Art's heroic-comic quest for his own identity, his true self, as it were, and the artworks of the century as Art's discarded theories, which may have had coincidentally some redeeming aesthetic merit. (Art's peradventurous history would resemble that of his second cousin Geist, as comically narrated in Hegel's side-splitting *Bildungsroman, Phanomenologie des Geistes.*) That would mean that no artist could be taken seriously who did not, as part of whatever he or she made by way of negotiable works, play a role in Art's stumbling search. So the history of Art proceeds on two levels: as a sequence of objects and as a sequence of enfranchising theories for those objects.

The story has its high and low moments, but it would not be easy to tell, always, from an inspection of the objects alone, without reference to the theories through which they must be interpreted, whether they marked high moments or low. Thus, the objects might be pretty unprepossing and yet specify important stages in Art's coming to philosophical terms with himself. Few aesthetes would be stopped dead in their tracks by certain of Duchamp's blank ready-mades—his grooming comb, his snow shovel—but they are climatic moments in the epic. And few would expect from the crashing tautologies of the 1950s—"Painting is painting, the action of spreading paint"—the opulent glory of the Abstract Expressionist objects they so inadequately characterize. Clement Greenberg's identification of painting with the flatness of their surfaces went perfectly well with the canonical works this theory championed (and in some cases generated). But except by denouncing as "not really art" everything that failed this austere and reductive definition, Greenburg was unable to characterize anything *except* the canonical work.

Bitter as the truth may be to those who dismissed him as a shallow opportunist and glamour fiend, the greatest contribution to this history was made by Andy Warhol, to my mind the nearest thing to a philosophical genius the history of art has produced. It was Warhol himself who revealed as merely accidental most of the things his predecessors supposed essential to art, and who

carried the discussion as far as it could go without passing over into pure philosophy. He brought the history to an end by demonstrating that no visual criterion could serve the purpose of defining art, and hence that Art, confined to visual criteria, could not solve his personal problem through art-making alone. Warhol achieved this, I think, with the celebrated Brillo boxes he exhibited a quarter-century ago at Eleanor Ward's Stable Gallery in New York.

A great deal more was achieved through the Brillo boxes that this, to be sure, but what was most striking about them was that they looked sufficiently like their counterparts in supermarket stockrooms that the differences between them could hardly be of a kind to explain why they were art and their counterparts merely cheap containers for scouring pads. It was not necessary to fool anyone. It was altogether easy to tell those boxes turned out by Warhol's Factory from those manufactured by whatever factory it was that turned out corrugated cardboard cartons. Warhol did not himself make the boxes, nor did he paint them. But when they were displayed, stacked up in the back room of the gallery, two questions were inevitable: What was it in the history of art that made this gesture not only possible at this time but inevitable? And, closely connected with this, Why were *these* boxes art when their originals were just boxes? With these two questions posed, a century of deflected philosophical investigation came to an end, and artists were liberated to enter the post-philosophical phase of modernism free from the obligation of self-scrutiny.

Warhol was, appropriately, the first to set foot in this free moral space. There followed a period of giddy self-indulgence and absolute pluralism in which pretty much anything went. In an interview in 1963, Warhol said, "How can you say one style is better than another? You ought to be able to be an Abstract Expressionist next week, or a Pop artist, or a realist, without feeling you've given up something." Who can fail to believe that, in art at least, the stage had been attained that Marx forecast for history as a whole, in which we can "do one thing today and another tomorrow, to hunt in the morning, fish in the afternoon, rear cattle in the evening, criticize after dinner, just as I have a mind, without ever becoming hunter, fisherman, shepherd or critic." Its social correlate was the Yellow Submarine of Warhol's silver-lined loft, where one could be straight in the morning, gay in the afternoon, a transsexual superstar in the evening and a polymorphic rock singer after taking drugs.

It was at times been urged as an argument against Warhol's extreme originality that Duchamp did it before, inasmuch as there also is little to distinguish one of his ready-mades from the mere object he transfigured by appropriation. But it is the shallowest order of art criticism to say that something

has been done before. Two historical moments can resemble each other outwardly while being internally as different as the snow shovel that is a work of art is from one that is a mere tool for clearing sidewalks.

In the early days of Pop, artists were taking over images wherever they found them. Roy Lichtenstein was sued for using a diagram from a famous book on Cézanne. Warhol was sued by the photographer whose image he used and modified in his marvelous flower paintings of 1967. (An I think a suit was threatened by the artist, in fact an Abstract Expressionist, who designed the Brillo carton.) The flower paintings mark a later phase, but in the classic moment of Pop, it was essential to the enterprise that the images be so familiar that "stealing" them was impossible: They belonged to the iconography of everyday life, like the American flag, the dollar sign, the soup label, the before-and-after shots of transformed faces and physiques. these were wrenched out of their locus in the universal language of signs and given the power of art while retaining their own native power as symbols. Duchamp's objects were often arcane and chosen for their aesthetic blandness. Warhol's were chosen for their absolute familiarity and semiotic potency. It was not merely that Brillo pads were part of every household, as the Campbell's Soup can was part of every kitchen—the one item likely to be found in the barest cupboard, by contrast, say, with a can of artichoke hearts or of pickled quail's eggs—but beyond that, the cardboard container was ubiquitous, disposable and part of American's itinerant mode of life. It was the container of choice for shipping and storing books, dishes, clothing, or for bringing kittens home in. It was what everyone threw away.

Duchamp's gestures of 1913-17 were jokes. They were evidence that Art had evolved to a point where Anti-Art was his own doppelgänger. As part of Dada, the ready-made was a kind of thumbed nose at the pretentiousness of art in the scheme of exalted values that just happened to be responsible for World War I. But artistically, really, it was a snigger from the margins. With Warhol, the gesture was maintstream: This was what Art had evolved into by 1964, when his search reached its end. Moreover, it was a celebration rather than a criticism of contemporary life, which is partly why Warhol was so instantly popular. Everyone had been saying how awful contemporary culture was, and here was the most advanced artist of the time saying it was rally wonderful—saying, as Warhol in effect did, "Hey, I like it here." Finally, it can be argued that the two moments of Duchamp and Warhol reverse the in-any-case Marxian order—a farce the first time around, something deeper and more tragic the second.

There is a contingent of Brillo boxes at the great Warhol retrospective at the Museum of Modern Art in New York city (until May 2), and it was a joy to see

them again after so many years. But I could not help but reflect, as I stood for a moment in contemplation (Aristotle is shown contemplating the bust of Homer, but Danto...), how different it was to seem then as part of an achieved corpus from what it had been to see them in 1964, when they defined the living edge of art history. I have the most vivid recollection of that show, and of the feeling of lightheartedness and delight people evinced as they marveled at the piles of boxes, laughing as they bought a few and carried them out in clear plastic bags. They didn't cost very much, and I believe it was part of Warhol's intention that it should be possible for people to own the art that so perfectly embodied the life it reflected. I bought one of the flower prints for $5 or $10 from a stack of them at Castelli's. (The opening night crowd at the retrospective evidently felt moved by his intention when they sought to walk away with some of the silver pillows that decorated MoMA's ceiling, to the consternation of the museum guards.)

Fascinated as he was by money, it must have shocked Warhol that his work became so pricey: The thought of a painting of coca-Cola bottles going for $1.43 million at auction is a real-life cartoon, something that would have aroused some mild amusement had it been drawn for *The New Yorker* twenty years ago. Warhol was fairly tight, as might be expected of a Depression child, but he was not, like Dali, avid for dollars ("Salvador Dali = Avida Dollars" was the famous anagram). Arne Ekstrom once told me that he commissioned some art made with hat forms from a number of artists, and afterward decided to purchase some of the works. One artist quite famous, wanted $5,000, a lot of money at the time. Warhol said he could have his for 2 cents, which he raised to 3 cents because of the arithmetic involved in paying his dealer a commission. (He cashed the check.)

For many of us, the excitement of the current Warhol shows is in part the memory of the excitement of seeing the artist's amazing career unfold from exhibit to exhibit through the 1960s and 1970s. In compensation, seeing it all spread before us, synchronically, as it were, one has available the priceless gift of retrospection, through which we can see where Warhol was heading—invisible, of course, until he got there. I particularly cherish, for example, the fascinating transitional pieces from the early 1960s, such as the *Dick Tracy* paintings, in which there is a powerful tension between style and subject. There are unmistakable comic-strip personages, down to the word-balloons, but the hard commercial-style drawing wars with the Expressionist art. Everyone is familiar with the story about Warhol showing Emile de Antonio two Coca-Cola bottles, one done in the flat laconic manner of the newspaper graphic, the other in the flamboyant brushy style, and asking which road he should follow when he had

already, by presenting that choice, taken the road to Pop. Dick Tracy, like Warhol's Popeye or Nancy or Superman, belongs to that wonderful period of 1957-64, in which Art was putting aside his romantic phase and entering his minimalist-conceptual-philosophical phase. The Dick Tracy paintings belonged to a future no one could know about when they were shown, and experiencing them today is something like walking through one of those late Romanesque churches, like St. Severin in Paris—that church the Cubists so loved—built at a time when architects were evolving a still-not-well-understood Gothic style.

There is a further compensation. At the opening I had a moment's conversation with a young critic, Deborah Solomon. She expressed the view that Warhol had peaked in the early 1960s, precisely in the Dick Tracy paintings and their peers. I responded that Warhol always peaked, but on reflection it occurred to me that she was privileged in a way I was not, to be able to see Dick Tracy as a painting rather than as a transitional document, and hence aesthetically rather than historically. This show gives us perhaps our first glimpse of Warhol as an artist, and for the first time a perspective on his work is opened up from the standpoint of the future, so that we can see it as we see, for example, the work of the Impressionists or the Sienese masters. The organizers of this exhibition are displaying Warhol as if he had already passed the test of time, as he must have to the sensibility of young people who address his work simply as work.

In truth, I am not certain that I know what it is to view Warhol's creations disinterestedly and from across an aesthetic distance. Nor do I know to what degree an artist so vehemently part of the consciousness of his own time can be detached from that consciousness and held up for critical scrutiny. Lately, art historians have been seeking to restore the Impressionists to their own temporal situation, as if they have so completely stood the test of time that we can no longer see the life to which they were responsive and are blind to the deep human content of their work. The question for me is to what degree it is even possible to see Warhol now in the tenseless light of pure art. And this raises the further question of whether, when there is no longer an audience that shares beforehand the images that compose these works from the 1960s, that is in effect a community *because* it shares those images as part of itself, there really will be much left of the power of the work.

What Warhol had not computed into his fifteen minutes of fame was the curatorial obligation to regard artworks as eternal objects, subject to a timeless delectation. Warhol enjoyed making "time capsules," sweeping up into cardboard cartons the ephemeral and detritus of common life. But really, this whole output is a kind of time capsule precisely because of those features that set it apart from

the impulses of Dada, especially the celebration of the commonplace. How will all this be perceived when the commonplace is no longer commonplace—when the Brillo people, as they are certain to do, change the design of the packaging? Suppose the old familiar Brillo cartons get to be collector's items and a market emerges for unopened cartons with their original scouring pads intact. Or that corrugated paper becomes a camp item in its own right, like bakelite, the technology of packing having moved on to generalized bubble wraps with little stickers to identify content.

Warhol said, "The Pop artist did images that anybody walking down Broadway could recognize in a split second...all the great modern things that the Abstract Expressionists tried so hard not to notice at all." But privileging the commonplace depends upon its being ubiquitous, so that only an absolute stranger would not know that, if an image, it is an image of. All Warhol's images in the early works were of this order, and part of the pleasure of his art is in having these utterly banal forms lifted out of the plane of daily intercourse and elevated to the status of art, a kind of revolutionary reversal. The thought of the Brillo box in the art gallery connects with the American ideal of people in high places being still just folks (cf. Barbara Bush). But not only are these images instantly identified: They condense the whole emotional tome of life, of the consciousness in which whose who know them participate. A person who has to have Marilyn—or Jackie or Elvis or Liz or Superman—identified is an outsider. These faces belong with the Campbell's Soup label, the S&H Green Stamps, or Mona Lisa, since everyone knows her. But what happens when there is not this split-second recognition? Was Troy Donahue really the kind of icon *Marilyn Monroe* was? One panics in front of one of Warhol's iterated portraits of a man nobody knows, thinking one should know him when he was in fact selected for his anonymity. And how many, really, recognize Ethel Scull on sight? I think eventually people competed to be portrayed by Warhol because that appeared to give them instant immortality, of the sort usually enjoyed only by the greatest of stars or the most celebrated products, as if they were also part of the common consciousness of the time.

The work from the 1980s is less complex from this point of view. It really does become, more or less, just art, connected to the culture only through being done by Warhol, who had by then become as much an icon or superstar as anyone he ever portrayed. When his *Last Supper* was displayed in Milan, in a kind of citywide two-man show with Leonardo, 30,000 people flocked to see it, hardly any of whom went on to see the "other" *Last Supper*. Perhaps, then, these late works can be viewed, even now, merely as art. But Warhol's greatest works

come from the time when the boundaries between art and life were being
exploded, everything was being redrawn and we were all living in history instead
of looking backward at what had been history. The late work escapes me, but
here is a prediction: When the final multivolume *Popular History of Art* is
published, ours will be the Age of Warhol—an unlikely giant, but a giant
nonetheless.

Jack Bankowsky, "Words Around Warhol," *Artforum* **(April 1989): 142-
143.**

Galled by Andy Warhol's sycophantic courtship of the rich and powerful,
Robert Hughes published a smug 1982 rebuke in the *New York Review of Books*
that aimed to depose the "King of Pop" in the name of high culture and common
sense. Disputing Warhol's general cultural relevance, and particularly the
credentials bestowed upon him by left sympathizers, Hughes' article gave voice
to a welter of widely held parochialisms and exerted a substantial measure of
undeserved influence. At the same time, precisely because his intent was
defamatory, Hughes cut through the pieties that frequently occlude more
congenial appraisals. In dubbing Warhol's solicitous a deux with the Reagan
presidency "the age of supply-side aesthetics," Hughes singled out as evidence of
Warhol's artistic fraudulence precisely those inversions—the conflation of
business and art, and the confusion of expedient conformity and subversive
intent—that lend Warhol's sociocultural prestidigitations a singular adequacy as
a mirror on our contemporary condition.

In the half-dozen years since Hughes penned his protests, Warhol's stature
has grown more secure. The seemingly endless litany of Warhol quirks and
collectibles that glutted the press since his untimely death two years ago has only
given way to a new wave of coverage occasioned by Warhol's current MoMA
retrospective. The museum has mounted one of the most ambitious tributes to a
single contemporary artist in recent memory, replete with a 500 page catalogue,
setting the tone for a generally feverish validation of Warhol's controversial
production. By seeming consensus, the biggest obstacle impeding Warhol's
canonization is the confusion of the famous personality and his artistic
achievement.

A near cousin of the futile efforts to retrieve the autonomy of the art object
from Warhol's extra-artistic enterprises is the equally farcical mania to separate

the "valid" early work from the presumably vapid late repetitions. This impulse is neatly encapsulated in the catalogue in Ivan Karp's call to arms:

> It is incumbent upon those members of the fine-arts community who possess the requisite perceptual ability to sort out and identify what part of. . . [Warhol's] production should enter the visual-arts culture.

If Karp's comically pious dedication to defending the culture of Warhol's Soup Cans from the incursions of his latter presumably "decadent" Vesuviuses or Renaissance remakes reflects the intrinsically self-validating motivations of institutional connoisseurship, it also points to the contradictions inherent in the application of conventional modes of valuation to the work of an artist credited with challenging our very understanding of art and its place in the larger world. When Warhol remarked that "Pop art is a way of liking things," and, by extension, a stance in relationship to the world as opposed to an artistic style, he opened his project, in a single affirmative embrace, on all those extra artistic contents that an essentially proto-Romantic American Modernist tradition repressed.

If diligent attempts to ferret out the "art" oppose the Hughes-style impulse to call the "Warhol bluff," they have an equally deforming effect on the understanding of his project. The standard guises these domesticating efforts take seem as endemic to the untutored museum-goer as to the art professional; they are common to Warhol defenders and detractors alike. The symptoms range from wanton a historical comparisons (Manet's *The Execution of the Emperor Maximilian, 1867,* is a favorite, but the analogies can get as farfetched as curator and catalogue essayist Kynaston McShine's likening of a late Warhol camouflage painting to Monet's "Water Lilies") to the overemphasis of formal qualities at the expense of iconographic particulars (again McShine states that "for their exhibition in Paris in 1974, Warhol installed a large number of [Maos] on a specially created Mao wallpaper, which added a boldness and dramatic tension...startling in its symphonic complexity"). As equally strained is the attribution of psychological insight to society portraits, in which the glossy affectless unreality a sitter gets back for a price is more to the point. Finally, the over valuation of the role played by technical innovation in the work thickens the fog. After all, Warhol employed silkscreen to tell us of the ubiquitous effects of photomechanical reproduction, not to dazzle us with new technology.

As an artist who spent his career enthralled by the power of the mass media, Warhol would undoubtedly have greeted his own contradiction laden

apotheosis—as it reflects history's inevitable inequities—with his famous pop equanimity. Indeed, Warhol anticipated this ultimate spectacle in his 1979 *Big Retrospective Painting* (Reversal Series), a single canvas screened with a selection of his signature icons.

Though Warhol complained that he would rather have worked on films, publishing projects, anything but painting, he knew better than anyone, as Benjamin Buchloh suggests in his catalogue essay, that both the strictures of pictorialism and the institution of the museum were his closest allies. Intuiting the fact that even his status as an outsider depended on this institutional "contract," though he announced his retirement from painting in 1965, Warhol redeemed the gesture on a grand scale when he retook up the brush. The "institution of art" was his lifeline, not only because his artwork literally brought home the bacon, but because his place in the pantheon of culture depended on his maintaining proximity to the pictorial. Buchloh quotes Duchamp very suggestively on this count: "What interests us is the *concept* that wants to put fifty Campbell's Soup cans on a canvas." Buchloh explains that what Duchamp is proposing here is that by adhering to the support of the canvas, Warhol's gesture differs from, and in a way exceeds, his own absolute departure from the frame. After all, Warhol was playing the culture game—even as he examined the reciprocity of art and the mechanisms of publicity and business that had previously constituted an unspeakable underside. Perhaps it not all that ironic that Warhol truest Karp—the same Karp with the quaint anxiety about dating the "important period of Warhol's production," one of those insiders who knew what would "play" in the highbrow world. It was Karp, we remember, along with Emile De Antonio, who advised Warhol in the early '60s to leave behind the expressionist brushwork and go with the plain graphic Coke bottle that ushered Pop into swing.

Warhol inhabits a very particular place in the history of the avant-garde. Though it is tempting to suggest as McShine does at the conclusion of his catalogue essay, that "Warhol eliminated, almost by himself, the venerable distinctions between the 'avant-garde' artist and the general public, between the commercial; graphic world and the world of fine art," nothing could be further from the truth. In the first place, your every man will still find Oliver Stone's 1987 film *Wall Street* and the white collar version of the American dream on which it depends more in sync with his sense of the zeitgeist than the schizophrenic extremes represented by a Warholia jaunt from Mortimer's to the late demimonde hot spot. In the second place, the legacy of the avant-garde that Warhol inherited is one that already understood "art" as an "institution," and then proposed the immolation of that institution. Warhol, in fact, violated this legacy

in an exemplary way when he revealed the tautology inherent in the fact that those privileged avant-garde tropes—the "end of the institution of art" or the denigration of the boundaries between art and life—become meaningless once the designation "art" is abolished or subsumed by "life." Warhol made it plain that the utopic conflation of art and life is just that utopia. There are better chess players than Duchamp, but we're not to make room for them in the pantheon of modern masters; by the same token, the Trumps dwarf Warhol both as business people and publicity mongers, yet still MoMA demurs. When Warhol said that the best kind of art was business art, he meant it, but his "genius" rests in his realization that the business/art equation only works when both signs are operative. If Warhol had permanently abandoned painting that he claimed he found so drudgerous, we would not be numbering him with a retrospective at the Modern, and indeed his career should have suffered, as Buchloh suggests again, the same kind of radical marginalization that has rendered the Fluxus experiments virtually invisible. On the other hand, if Warhol had bequeathed us *only* his canvases—if it were possible or desirable, as McShine avows, to separate Warhol's extrapictorial endeavors from the artifacts left behind (McShine proposes that without his own dramatic and stylish presence, Andy Warhol's work remains great art, "a monument impossible to ignore")—Warhol would not tug our imaginations so persistently. The real Warhol "trick" was that he as able to maintain under the sign of art a whole sphere of activity that traditionally defied that designation. So, while his famous Marilyns and Jackies will inhabit pride of place in art history as iconic registers of the tyranny of the mass media, a tyranny Warhol subjected to the disarming gaze of Pop, the phenomenon of *Interview* magazine, to pick an extreme example, remains its ephemeral but equally significant counterpart, the ultimate monitor of the regime he cagily marketed as art. If, as Ivan Karp suggests, we have a "responsibility," it is not, as he proposes, "to sort out and identify what part of [Warhol's] production should enter the visual-arts culture." That will take care of its self. Rather it is to write into history those parts of his endeavor—all the instruments and strategies of his self-promotional enterprise—that museum culture inevitably obscures.

Martin Amis, "'Ugly People Are Just as Hard to Get as Pretty People': *The Andy Warhol Diaries,"* ***New York Times Book Review,*** **25 June 1989: 9.**

Despite their virtuoso triviality, their naïve snobbery and their incredible length, the diaries of Andy Warhol are not without a certain charm. Of course,

they aren't even diaries: they are the "Collected Cassettes" or the "Collected Wiretaps." On most mornings Andy Warhol called his former secretary, Pat Hackett, and rambled on for a while about what he did the day before. She made "extensive notes," she explains, and typed them up "while Andy's intonations were fresh in my mind." So that's what we are looking at here: 800 pages—half a million words—of Andy's intonations.

But it works, somehow. "Peter Boyle and his new I think wife were there." "Princess Marina of I guess Greece came to lunch." "Nell took her clothes sort of off." "Raymond [is] out there posing for David Hockney—Raymond takes planes just to go pose." Ms. Hackett's editing, one feels, is affectionate and scrupulous, yet correctly unprotective. And after a while you start to trust the voice—Andy's voice, this wavering mumble, this ruined slur. It would seem that *The Andy Warhol Diaries* thrives on the banal; for in the daily grind of citizenship and dwindling mortality, the nobody and the somebody are at one.

Meanwhile, here comes everybody—or at least everybody who is somebody. "We went over to Studio 54 and just everybody was there." "You go to places where people are sort of nobodies." "Everybody was somebody . . . just everybody came after the awards. Faye Dunaway and Raquel Welch and just everybody." But who *is* everybody? Or who is everybody *else*? Everybody is Loulou de la Falaise and Monique Van Vooren and Issey Miyake, Peppo Vanini and Yoyo Bischofberger, Sâo Schlumberger and Suzie Frankfurt and Rocky Converse, Alice Ghostley, Dawn Mello and Way Bandy and Esme, Viva, Ultra and Tinkerbelle and Teri Toye, Dianne Brill, Billy Name, Joe Papp, Bo Polk, Jim Dine, Marc Rich, Nick Love and John Sex.

Similarly Andy went everyplace, or everyplace that was anyplace—or not even. He goes to the opening of an escalator at Bergdorf Goodman, to Régine's for Julio Inglesias' birthday, to an ice-cream shop unveiling in Palm Beach, to Tavern on the Green for a "thing" (this is a word that Andy has a lot of time for) to announce that Don King is taking over the management of the Jacksons, to the Waldorf-Astoria for the Barbie doll bash, someplace else to judge a Madonna look-alike contest and someplace else to judge a naked-breast tournament. It strains you to imagine the kind of invitation Andy might turn down. To the refurbishment of a fire exit at the Chase Manhattan Bank? To early heats of a wet-leotard competition in Long Island City.

Some days, of course, nothing much happens. "Had to go close on the building and we had to drink some champagne with the people," for instance, listlessly accounts for Oct. 19, 1981. Or take this eventful interlude in September 1980: "I tried to watch TV but nothing good was on." Ah, such striving. If you

try, you can make Andy's life sound almost ghoulishly varied: "I had tickets...
to the rock kid who ate the heads off bats"; "Lewis Allen came down with the
dummy-makers who're making a robot of me for his play." But really every day
was the same old round. Occasionally he stayed in and dyed his eyebrows, or
read the memoirs of some old movie queen, or met with success in front of the
television (*The Thorn Birds* or *I Love Lucy*; this is the man who saw *Grease II*
three times in one week). And every now and then a mention in the news media
proves to be as good, or as bad, as the real thing: "There was a party at the Statue
of Liberty, but I'd already read publicity of me going to it so I felt it was done
already."

During the years covered by the diaries (from 1976 until Warhol's death in
1987), the planet was spinning, as it always spins, but Andy's self-absorption
remained immovable. Events of world-historical significance are simply given
a quick sentence here and there, before being engulfed by the usual gossip and
grumbling. This isn't to say that Andy remains untouched by current affairs.
The 1986 American raid on Libya seriously disrupts a live television show he's
doing. The Achille Lauro hijacking in 1985 causes concern, because now
"everybody won't be watching 'The Love Boat' . . . with my episode on it." The
fall of the Shah of Iran spells a lost commission ("At dinner the Iranians told me
that when I paint the Shah to go easy on the eye shadow and lipstick"). For
Andy, history is a nightmare during which he is trying to get a good night's sleep:
"Some creep asked us what I thought about the torture in Iran and Paulette said,
'Listen, Valerian Rybar is torturing me here in New York.' He's still decorating
her apartment, she was complaining that it's been a year."

Manners change too, though, and Andy is better placed, and better equipped,
to reflect the general retreat, the increasing social distrust, of his final decade.
In 1977 he can say of a woman dress designer: "She acts like a
businesswoman—she doesn't take much coke in the day." But by 1987 it isn't just
Andy who is drinking Perrier water and then curling up with a quarter of a
Valium pill. AIDS makes its first appearance halfway through the book, in
February 1982, where it is called "gay cancer" (in contradistinction to "regular
cancer"). By June 1985 it is referred to as "you-know-what." The diaries show
very clearly how the transcendentalism of the counterculture eventually turned in
on the self, on the human body. If the 1970's was the Me decade, then the 90's
will be the ME decade. Andy, already a fervent hypochondriac (he was shot in
1968 by a woman who had once appeared in one of his underground movies),
moves on from beauty classes and pedicure into nutrition, collagen, shiatsu

treatments, crystals, kinesiology and other desperate quackeries. By December 1986, AIDS itself is weirdly called "the magic disease."

It would be hard work, and a waste of energy, to do much disapproving of Andy Warhol. He doesn't take himself seriously enough for that—or for anything else. It is worth remarking that at no point does he say anything interesting (or even nonridiculous) about art. He'll mention having "a good art idea" or attending "an art party"; he'll mention that "art is big now." "We talked art," he says, and the reader leans forward attentively, into this: "Thomas told the story of the Picasso he bought from Paulette Goddard, it cost $60,000 and he brought it to one of the Picasso kids and they said it was a fake, and he said Paulette gave him a hard time, that she was 'difficult,' but she did give him his money back."

It's all on that level. Andy's agent tells him "not to take the wrinkles out too much on these old people." There is a conference about Dolly Parton's beauty mark: is it in or out? "I'd taken it out and they want it in, so I called Rupert (Smith, Andy's silk-screener) and told him it was in again." Pia Zadora wants a painting and she'll "take it with her if it fits into her husband's jet, so they were measuring it." For the rest, it's desultory reports on how much his Marlons and Marilyns and Lizzes and Elvises are currently fetching. The Warholian apotheosis is duly reached when Andy does a commission for Campbell's soup. It troubles him—"Me standing there twenty years later and still with a Campbell's soup thing"—but he doesn't quite appreciate the asymmetry. Once the artist urging us to reexamine the ordinary, now the commercial portraitist celebrating the vendible. "And for all the work and publicity, I should've charged them like $250,000."

Plainly, Andy was funny about money. Throughout the diaries he dutifully records the cost of everything—everything claimable, anyway. These bracketed price tags look odd at first—on page 1: "phone call for directions (phone $.10)—but we soon get used to them. Andy's crab soap cost $6, and his bulletproof vest cost $270. "She said Matt didn't relate to her (dinner $600 including tip)." "Drank and talked and looked out of the window ($180)." Money has a habit of making people seem lopsided. Andy pays for Grace Jones's dinner, despite the wad of hundreds she produces. And yet: "Went to church and while I was kneeling and praying for money a shopping-bag lady came in and asked me for some. She asked for $5 and then upped it to $10. It was like Viva. I gave her a nickel." Well, it could have been worse. It could have said, "I gave her a nickel ($.05)."

Warhol was a fame snob, a looks snob, a weight snob, a height snob and an age snob. But he got older, and iller, and was obliged to wander the biological

desert of middle-aged gaydom. Childish himself, he became a frustrated parent. His chaste crushes never seemed to work out: "Looking back now, I guess I wasn't seeing what I didn't want to see. Again. Does it ever end? Do you ever get smart? Toward the close, the invitations dry up, the photographers pass him by, the calls go unreturned. "I like ugly people. I *do*. And anyway, ugly people are just as hard to get as pretty people—they don't want you either."

His most thoroughly sympathetic moments come in his dealings with animals. Even here he is habitually wounded and touchy: "I took all my old bread to the park and tried to give it to the birds but they didn't come around and I just hated them for that." Or with his dachshunds, Amos and Archie: when he returns home from work on a rainy day and finds that one of them has wet his bed, "I beat him up. Amos." Or most appropriately, most comically, most hopelessly, when the Walt Disney film crew arrives and asks him who his favorite Disney character is, "and I said, 'Minnie Mouse,' because she can get me close to Mickey.'"

Carter Ratcliff, "Master of Modern Paradox," *Art International* **(Summer 1989): 74-83.** Review of MoMA retrospective.

Early in the 1960s, Andy Warhol asked an art-world insider named Emile de Antonio for advice about a pair of paintings. "One of them," the artist wrote in POPism, "was a Coke bottle with Abstract Expressionist hash marks halfway up the side. The second one was just a stark, outlined Coke bottle in black and white." After a moment or two, De Antonio dismissed the first one, then said, "The other one is remarkable—it's our society, it's who we are, it's absolutely beautiful and naked, and you ought to destroy the other." But Warhol destroyed nothing that came from or into his hands, not even shopping bags or postcards. So the Warhol retrospective that recently opened at the Museum of Modern art in New York includes both Coke bottle paintings, the "Abstract Expressionist" one with its "hash marks" and the "stark, outline" version of the motif which De Antonio and the rest of Western civilization either preferred or took the trouble to detest with vehemence.

Presented two years after Warhol's seemingly accidental death in the aftermath of gall bladder surgery, the Modern's immense exhibition of his paintings, drawings and sculptures—the Brillo, Heinz and Del Monte boxes—serves as a memorial. The earliest works on view are pre-Pop drawings from the 1950s; among the latest are examples of Warhol's Camouflage Self-Portraits from 1986. Organized by Kynaston McShine, Senior Curator of the

museum's Department of Painting and Sculpture, the Warhol retrospective is absorbing throughout and especially in its treatment of the early 1960s. Not only did McShine track down and include the two old Coke bottle paintings, he also dug up other paintings from this period to show how Warhol moved step by step, cautiously but nonetheless quickly, toward the glamorously abraded style of his Marilyns and Elvises.

Roy Lichtenstein, who had begun to make paintings from comic-book imagery in 1961, had his first show at the Castelli Gallery in early 1962. Though Warhol made his first Pop—or Pop-ish—paintings in 1960, he couldn't persuade a gallery to show his work until 1962, and then only at Ferus in Los Angeles and at the Stable Gallery in New York. After what must have seemed an unbearable wait, Castelli decided that, after all, he could show two Pop artists, and exhibited Warhol's "Flowers" late in 1964. By then Warhol had worked his way through supermarket items, movie stars and Race Riots to the Disasters he showed earlier in the season at the Sonnabend Gallery in Paris. In 1966, Warhol covered the walls of one room at Castelli with Cow Wallpaper and let silverish, helium-filled plastic pillows float through the gallery's second room. McShine's installation at the Modern recalls that show with a corridor similarly papered. Against its ceiling hovers a flock of Silver Clouds, as the artist called them.

At the opening of his second exhibition at Sonnabend's Paris gallery, in 1965, Warhol announced that he would soon abandon painting in favor of movies. Earlier that year he designed a cover for *Time* magazine, having learned to count on this and other general-circulation magazines to treat him as a minor but always noteworthy celebrity. His rock band and light show, the Exploding Plastic Inevitable, spent the mid-sixties touring the East Coast of the United States. Warhol's activities drew much attention and many tattered scraps of meaning into an empty and undefined center somewhere near his public persona. The Plastic Inevitable was loud but not explosive—implosive, rather—yet the word "inevitable" still sounds almost right. In New York's mid-1960s, the artist, his work and his entourage (three not entirely distinct entities) had an aura not of necessity but of in ineradicability. His presence was in the weave of things, like a stain. Like a mood, it permeated the air.

One could escape the Warhol mood by looking away from the harsh, giggly lighting in his movies or on his dance floor, away from the dandified inelegance of his silk-screened canvases, toward a primly squared and lacquered Minimalist box, for example. Or one could look away from all art to the peculiar, by now almost forgotten blandness of the American spectacle in the years after Kennedy's assassination. But the Warhol mood was always available. It offered the urgency

of glamour without promising that glamour held any redemption. Thus Warholism seduced with a mixture of lie and truth, for glamour is neither urgent nor does it redeem. Warhol's art and persona obscured the first point, as glamorous things always do, yet made glamour's unredemptive nature difficult to miss.

Few artists have supplied a time with a mood. It requires, among other things, a show of overweening certainty, and that is why it is so helpful to see the paintings from 1960, 1961 and early 1962 at the Modern's retrospective. They all display strength of ambition, some are charming, and none looks certain about theme or style. Each confirms what one might have assumed without such evidence: the mood Warhol generated with his fully achieved Pop style was not an urban equivalent to a large fact of Nature, as those who felt its power of course took it to be. That mood was an artifact, the elusive upshot of experiment's power to defeat hesitation. The air of caution drifting through the Pop-ish paintings Warhol made in 1960-62 surprises now because the uncertainty he felt in those years registered so faintly on the art world's attention. Some of these canvases—*Saturday's Popeye, Before and After*—and *Superman* among them—were seen in New York only as backdrops for a window display at Bonwit Teller's in 1961. Understood as precursors of his Marilyns and Campbell's Soup Cans, these early, uncertain works were assimilated without fuss into Warhol's *oeuvre*, their doubts obscured by the shimmer of offhand certainty that illuminated Warhol and his art from the mid-sixties until his death.

In 1960 Warhol understood only one thing well: if he was to succeed as a fine artist, a real *gallery* artist, he would have to abandon the illustrator's sheet of paper for the large canvas that New York painters had made standard more than a decade earlier. Nearly all the tentative paintings from 1960-62 are biggish or simply big. Their ambitious dimensions read as tactically right, but no analysis of tactics or even of strategy accounts for their borrowings from comic strips and cheap ads. The imagery that Roy Lichtenstein chose in 1961 is similarly resistant. It is tempting to ask, simply, how did he and Warhol know that Pop motifs would glitter so brightly under such intensities of love and hatred and empty-headed adoration of the kind that is closer to hatred than usually supposed? Of course they didn't know. The question needs rephrasing.

First, it is necessary to formulate one question for Lichtenstein and another for Warhol, because they did not take up Pop motifs at the same moment, in the same manner, nor in the same forms. During the 1950s, Lichtenstein could not prevent comic-strip characters and banal Americana from appearing in the routinely agitated depths of the Abstract Expressionist canvases he painted in that decade. In 1961, he let those themes lead him from the mire of painterly paint to

the shockingly neat new style he has elaborated ever since. The crisp patterns and immediately recognizable motifs of his first Pop paintings signal a definite, if still elusive, intention. So the question to Lichtenstein ought to be, not how did he know that Pop Art would be so widely effective, but why did he pursue this innovation in the face of so many reasons to believe that it would be dismissed or would flare up and fade with the speed of so many other avant-gardist shocks to received taste? What made him—or at least his art—look so assured in 1961?

One would like to ask Warhol what made him so skittish in 1960. The canvases he showed in Bonwit's window are coy about their brashness. Though Pepsi-Cola's logo and Popeye's roundhouse punch are easily recognized in these canvases, Warhol's whitish brush work obscures the rococo curves of one and the baroque sweep of the other. Warhol exposes portions of consumer culture through a fog of high-art mannerisms, his prim parodies of Abstract-Expressionist abandon, sometimes dense, more often thin. Reworking the Little King (a comic-strip hero popular thirty years ago but long faded), Warhol pushed the cartoonist's simplicities almost to the point of flat geometric abstraction. Yet indecisive as he had never been in his commercial-art career and, after 1962, would never be again, he chose not to reach that clearly-marked point. The Little King remains easily identifiable. In the 1970s and 1980s Warhol was often bored, and the Modern's retrospective neglects much of his work from those years. However, the thinness that signals boredom ought not to be mistaken for the panicky voids created by the uncertainty Warhol felt in 1960-61 and early 1962.

Beside the Bonwit-window paintings and the two early Coke bottles, McShine included two versions of *Storm Door*, 1960 and 1962, the earlier version brushy around the edges and the latter in sharp focus throughout. A pair of *Dick Tracy* paintings from 1960 show the same variation. In the second version, Warhol hides evidence of the hand that, in the first one, he hesitantly allows to appear. In 1962 he experimented with rubber stamps and other mechanical methods of replicating an image. Then, in August of that year, he discovered photographic silk-screening, which allowed him to make paintings without having to paint them—that is, without having to touch his hand to a brush or a brush to canvas. Putting that simple technology to work in his Factory, he got over a two-year spell of uncertainty. But why had he suffered it even for a moment? During the 1950s, he had employed mechanical devices to turn out commercial work, and sometimes employed others to execute his designs. These methods had made him the most successful commercial artist in New York. Why, then, did an interlude of hesitation separate that success from his success as a Pop artist?

His memoirs suggest that he felt intimidated in 1960 by what he knew of the high-art zones occupied by his friends Jasper Johns and Robert Rauschenberg. Moreover, he was new to the difficulties of working on canvas and seems to have been reluctant simply to set them aside, as the veteran Abstract Expressionist Lichtenstein did in 1961. Warhol wanted his canvases to count as fine art and yet he found convincing precedents in none of the high styles of painting available to him. As his half-hearted brush work of 1960-62 suggests, he had little inclination toward the agitated, De Kooningesque textures that for so many signalled the seriousness of the New York painter. Nor was he attracted to the hard-edged impersonality of Ad Reinhardt's or Barnett Newman's abstractions. I believe Warhol's fully realized Pop manner appeared in late 1962 with a double purpose. It rejected the argument for personal, possibly confessional brush work that De Kooning (and Johns) had made with painterly Paintings, and it rejected too Reinhardt's and Newman's hard-edged arguments that surfaces lacking a personal touch should also lack images of recognizable things.

By rejecting New York painting's major possibilities, Warhol advanced the cause of an art that refers to familiar objects and images in a hands-off manner—Pop Art, in short. But artists' innovations are not merely arguments for new styles. They support certain meanings. But which ones, in the instance of Warhol's brand of Pop? A clue lies in his ambivalent paintings from 1960-62. They are painterly, but do not pretend to the sustained passion of De Kooning's canvases or the sustained irony of Johns' painterly paintings. They are hard-edged but do not strive for the purity of Newman's or Reinhardt's abstractions. Thus they do not display the virtue painterly and anti-painterly New Yorkers sought in common: integrity. Nor do they claim virtue for a lack of integrity. They merely betray it, along with ambiguity, uncertainty, ambivalence. Only when Warhol began to imprint his canvases with silkscreen images did he go from betraying ambivalence to exemplifying it. When his Pop style came into focus, he was no longer oppressed by his own contradictions. In command of silk-screening's quick efficiencies, he deliberately cultivated contradiction. He became the maestro of on-the-one-hand-this and on-the-other-that, the virtuoso of preventing any satisfactory resolution of contraries.

The Modern's Warhol retrospective canonizes him as a Modernist master, yet the works in this show were made by commercial methods and display illustrative devices that high Modernism has long opposed. Commentators dance around this contradiction to the familiar melodies of formalism, art history and Marxism, yet the contradiction remains. There is a similarly persistent clash between Warhol's crudity and his finesse. In his art, these traits are inextricable, yet neither absorbs

the other. His *Disaster* paintings are grossly horrible and they are delicate. His *Race Riot* series expresses concern and indifference. His *Most Wanted Men* convey his bitter jealousy—for Warhol wanted most of all to be the most wanted man—and his compassionate contempt (a most-wanted poster conveys notoriety on the least desirable terms).

Contradictions like these carried Warhol into the 1970s, when he became a portraitist. Imprinting Polaroid blow-ups of his sitters on passages of painterly painting, he abrogated an early policy, for these canvases are in part homages to De Kooning. He also showed that churing brushwork can be as numbly blank as a late canvas by Ad Reinhardt or a Warhol *Soup Can* silkscrren in 1962. Throughout the 1980s, Warhol made variations on the seventies portraits, among them a four-panelled work called *Philip's Skull*. In the upper-left-hand quadrant of this painting from 1985, the artist's palette is lively and bright. It verges on pastel. The upper-right-hand panel is funereal, a frank memento mori in black and white. One of the remaining panels gives the skull a melodramatic tinge of gold; the other sets its image afloat an a smoothly applied field of harsh red, yellow and blue (an allusion to Barnett Newman's *Who's Afraid of Red, Yellow, Blue?*). This painting's lively hues suggest, if not life, then at least an optimistic view of death. Or do they? Pondered for a time, the cheery yellows and blues of *Philip's Skull* look as deathly as the work's somber colors, and its dark shades seem no less happy than its passages of brightness, an ambiguity encouraged by the motif, for this is not a picture of a death's head, as in Warhol's Skull series of 1976.

Derived from an X-ray image of a living head, *Philip's Skull* is a picture of bone showing the still-vital flesh. As the original X-ray mixes the presence of life with the promise of death, so Warhol's canvas gives each hue and nuance of texture the same double weight of meaning. Further, because X-rays bring depths up to the surface, as Modernist painting often does, a smear of pink or mottled crust of gold reads not only as a bearer of an ambiguous attitude toward death but also as a means to a formal virtue flatness, the quality of serious painting that Warhol mastered early and mocked throughout his career. So the writhing web of contrary, unresolved feelings that permeate this image of life and death is entangled in the rigid formalist structures that put flatness in contrast to depth. In *Philip's Skull*, a wide swath of color reads as an assertion of the picture plane and as an emblem of modern melancholy. Here as elsewhere, each term of a Warholian opposition belongs to another set of clashing terms. His images are patterns of contradiction deliberately snarled. Of course analysis can resolve any

conflict. When it resolves Warhol's clashes of style and tone and motif, it denies his meanings.

Among the valuable features of the retrospective's superb catalogue is a collection of art-world comments on the artist. The collector and literary patron Lita Hornick recalls that "in 1966 he did my portrait, first taking me down to a photo booth on Forty Second Street and taking five dollars' worth of three-for-a-quarter photos. From these he selected one image," and made an eight-panelled painting. In 1981 Hornick asked Warhol "if he had chosen the photograph for psychological or purely visual reasons. He replied, 'It was just the right photograph.' I asked, 'Just visually right or also psychologically right?' Rather reluctantly he said, 'Well, both.'"

Ask which of these two opposed interpretations of Warhol's art is correct, and that will always be the answer: Well, both. Is Warhol present or absent in the *Camouflage Self-Portrait* he made in 1986? Does the *Rorschach Series* of two seasons earlier mean everything or nothing? Well, both. His silkscreen method allowed his images to be distinctively his, yet let him produce them from a distance. He was at once intimately engaged with his art and detached from it. So one can't account for the importance of the paintings he made with a brush in 1960-62 by calling them transitional. They do not show an intention being refined or a vague impulse growing stronger under pressure of clarification. Warhol never refined or clarified anything. Nonetheless, he exchanged hesitation for astonishing resolve. His paintings from the early 1960s are important because they nearly sank Warhol in a dilemma of irresolution which he escaped only by turning irresolution into his abiding topic. Toward the end of 1962, Warhol became decisive about his ambivalence, certain that his uncertainties would be the theme and even the method of his art. His career justified his certainty, and that makes his art terrifying.

All the objections to Warhol on grounds of vulgarity or lack of affect or moral irresponsibility and all the praise for Warhol on grounds of elegance or insight into the contemporary psyche or good works on the plane of cultural politics are distractions from the ambivalence that gives his art its point. We usually understand ambivalence as a negative quality, a lack. Warhol's art presents it as a quality, perhaps a force, as positive as the firmest determination. With his photo-mechanical techniques and his mass-produced themes, he suggests that we must understand industrialized modernity as the agent that gave ambivalence its positive presence in the world. Or are we to understand that the ambivalence of thought and belief led to the secular, mechanized world we call modern? Which is cause and which is effect? Well, both. For every factor in the

modern situation can be taken as a cause or an effect, depending on the style of analysis brought to bear. Likewise, a modern style of painting can posit form as content and content as form, and either can count as causal or as the product of a cause.

These ambiguities are well-known and effectively obscured by works of art that make claims to formal integrity, emotional sincerity, spiritual purity and so on. Many in the art world of the 1980s have turned cynical about such things, but their cynicism only inverts the ideal of integrity, a tactic that suppresses ambiguity with all the force of a starry-eyed devotion to a single virtue. None of Warhol's detractors and few of his admirers are willing to look with him into the abyss of modern ambiguity. He not only looked into it, he brought images back from it. He lived in the abyss, willfully and consciously, a choice so dreadful it is almost unimaginable.

Sanford Schwartz, "Andy Warhol the Painter," *The Atlantic Monthly,* **264, no. 2 (August 1989): 73-77.** Review of MoMA retrospective.

Andy Warhol was an enormous personality during his life, and since his death, in 1987, at fifty-eight, he has become an even larger figure. His place in American art and culture is so enormous and fuzzy—there are so many claims made for what he did, or failed to do, or symbolized—that he's like a din in your head.

Yet if you see the large retrospective of his work that was put together at the Museum of Modern Art last spring and that is now at the Art Institute of Chicago, and can block out what you know about Warhol the celebrity, personality, and problem, I think you'll be amused and touched by his paintings and, even more, come away admiring his sheer artistic—his formal—intelligence. Warhol wasn't a titan; he didn't go from one kind of picture to another, absorbing new styles and transforming them as he went. But he was consistently open to new techniques, and his lack of caution makes him seem like more than a minor master. Seeing a lot of his best work is an expansive experience. His pictures don't draw you into the sensibility of a particular individual; they're mostly about style itself, and they prompt unexpected connections with the art of his contemporaries and of other periods.

The quality of Warhol's work hasn't been a secret; his Pop Art pictures—the movie stars, labels of products, and grisly tabloid shots—have hung in museums and distinguished collections for years, and there are plenty of publications

devoted to this or that aspect of his work. Yet the scope, and particular nature, of his achievement may be a revelation for many. The show goes from Warhol's work as a commercial illustrator in the fifties—he arrived in New York in 1949, when he was in his early twenties—to the paintings he did the year he died. The majority of the pictures, though, are from 1962 through 1964, and they're far and away his finest. Warhol said that if he died by 1970 his reputation would be secure, and he was right. Warhol wasn't a passionate or warm artist; he was a virtuoso of precise placements done at top speed. His finest pictures give something of the same immediate and intense pleasure that watching an Olympic competition does.

When Warhol's images are taken together, they present a sort of ho-hum, everyday American world. We seem to be only a step away from Depression America. We go from pictures of dollar bills and S&H Green Stamps to Campbell's soup cans, from pictures of Elvis Presley and Natalie Wood to newspaper images of an electric chair and freakish disasters. It's like being in a supermarket. We might be at the checkout counter, flipping through a *National Enquirer* while folks at the head of the line fumble with their coupons. What's compelling about Warhol's work, though, is the distinctive soft presence of his canvases, and the obvious speed, assurance, and high spirits with which he worked.

Warhol's best works are his "serial" paintings, in which the same image is repeated on a single canvas. (He didn't invent serial painting, but he used it to an extent that nobody else has.) We see, sitting right next to one another, or sometimes overlapping on another, two or five or a dozen or an uncountable number of something. It might be Coke bottles, Marilyn Monroe's face (or lips), or Jackie Kennedy at the President's funeral. In reproduction these paintings can appear facetious, even brutal. But the actual pictures have a powdery and breathing surface; you want to get close to the canvas itself. Warhol took his images from photos in magazines and newspapers. He had a silk-screen print made of the image, and then he ran colors through the screen directly on the canvas. When he wasn't printing in black on colorless canvas, he'd paint the canvas a single color first and then print on it in black, and he produced a large number of surprising color harmonies. He still seems audacious in his use of silver and turquoise, lavender, orange, and brown.

If Warhol wanted to print with different colors—if he wanted, say, to make Monroe's lips red—he'd use the same silk screen, but he'd cover every part except the lips and then go over that exposed section with red paint. The result is an echo of nineteenth-century folk art. The colored *Marilyn Monroes* are like

theorems, or mourning pictures—scenes with urns and weeping willows, where the stenciled application of one colored section next to another is so stiffly mechanical and awkward that it conveys more of a sense of the hand that made the work than an average watercolor does.

Essentially, Warhol was a printer on canvas who appears to have done everything in a hurry. He clearly didn't care about smudges, dribbles, or inconsistencies in color and intensity, yet he didn't strive for sloppiness, either. The smudges and dribbles don't seem willed, and that's a key element in his success. Looking at a Warhol, your eyes search out—you savor—the mistakes. In a picture made up of many images of the electric chair, the animating detail is the way, when Warhol was printing his silk screen again and again, he didn't quite cover the entire canvas. (If he had printed his electric chairs, or any of his images, neatly, or "correctly," it wouldn't have been a Warhol.)

Going from work to work at the exhibition, you watch someone playing with a picture-making device. You're also made aware, in each case, of the canvas itself, which is as much the "picture" as the various images that are silk-screened onto it. I kept thinking of the abstract painters who were at work at the same time as Warhol; they were sometimes called stain painters, because their pictures were made by staining acrylic colors directly into unprimed canvases. The figure who most came to mind was Morris Louis. Pouring acrylic medium onto big pieces or raw white, canvas and then bunching and shifting the canvas (his working methods are something of a mystery), Louis produced images of, as it were, paint on the move. In a typical Louis Veil painting (there is a large series of Veils) a mass of overlapping colors whooshes up from the bottom of the canvas—you might be standing before the mouth of a cave.

Warhol's Pop pictures and Louis' Veils have nothing in common simply as images, and the two artists are rarely mentioned in the same breath. In the way they've been written about (and shown and collected), they might come from different planets. Louis' art is invariably described in purely aesthetic and technical ways—he's presented as an anonymous genius at an art-school think tank—and Warhol's work is described in terms of, among many other things, his transformation of Liz, Elvis, and Campbell's soup cans into icons. Yet their best pictures have an amazingly similar presence: it is of a bolt of canvas suddenly stamped, or suffused, with an identity. Although their individual paintings are very much framed things—you're conscious of the four edges—their pictures, in spirit, are more like banners than paintings. Ideally, they'd hang outside a big public building, flapping in the wind.

And in the way they worked and in their ambition, Warhol and Louis might have been brothers. Warhol's pictures were, in part, developments of Jasper Johns's and Robert Rauschenberg's use of pop images, and Louis' pictures were, in part, developments of Jackson Pollock's "dripping" and pouring techniques. And both Warhol and Louis seemed to be saying to their predecessors, "Speed it up! You've made art too fussy!" Louis was some sixteen years older than Warhol, but he took a relatively long time to find a right path, and he didn't come into his own until the late fifties; when Warhol was getting under way. Louis died of cancer in 1962, and that was the year that Warhol took off. They were the sons of immigrants (they both changed their names, from Andrew Warhola and Morris Louis Bernstein), and although it's a cliché to say it, they worked with a mighty need to prove themselves Americans. They were single-minded. Louis dedicated himself to the history of abstract painting; he wanted to make a picture that would mark the necessary next step in the evolution of modern art. Warhol's dream was fame in itself.

The most absorbing photos in the documentary section of the Modern's gigantic Warhol catalogue are pictures of Warhol in his early twenties, posing the way Greta Garbo posed in Steinchen's portrait, with her hands cradling her face, and the way Truman Capote posed in a picture where he lunges on a sofa. Fame, and its representations, were Warhol's meat. It's fascinating to think of him as a young man, both doting on fame and thinking of how to use it professionally. He's simultaneously in the grip of something larger than himself—he's the quintessential raving fan—and the astute delineator and entrepreneur of fandom. Other documentary photos show that his preoccupation with appearance was personal and long-standing. He was troubled by what he believed was his unromantically lank hair and large nose, and he doctored photographs (and he eventually had himself doctored) to alter the situation.

Warhol and Louis had exalted and monumentally simplified goals, and they perfected picture-making methods that mirrored those all-or-nothing goals. Each was able to make a new kind of picture because of fairly recent technical developments: the silk-screen process and, in Louis's case, fast-drying acrylic paints. Each man created a sort of one-note painting, in which there was little room for fixing or improving. The chief option in their respective techniques was editing, or cropping, the canvas. Once each man found his method, he went into mass production. That both artists produced so many similar works doesn't mean that it's enough to see only a handful. Warhol and Louis look best when you're surrounded by their paintings. Half the thrill is registering the many variations on a theme.

Warhol's finest pictures are funny, grotesque, sentimental, grand, beautiful, and blasé all at once. Many of his images are of frightening or sad events or people or things. In addition to electric chairs and the Kennedy assassination, there are suicides, car crashes, race riots, atom bombs. And when these pictures are seen along with the Hollywood stars, a viewer can believe that Warhol was eulogizing the stars. You may want to think of him as an elegiac artist, a chronicler of national violence and loss—it makes him easier to like, less aggressive, more serious, nobler. You may also think that he was licking his lips over the national nightmare.

Warhol was a mourner; he did the Marilyns right after she died, and he said he started on Liz "when she was so sick." He had to have been a bit of a Weegee, too. Mostly, though, he was indifferent to subject matter in itself. His point, it seems, was that the less likely, or acceptable, the image he slapped down on canvas, the greater his chance of aesthetic success. His dancelike and seemingly spontaneous way of placing his silk screens is felt to the degree that he's taking a liberty in using the image in a flip way. And image alone doesn't guarantee that the painting will be good. When he silk-screens a single photo onto a canvas there's no snap; the work is dormant. Warhol is better when his canvas sizes are bigger too; when his paintings are too small, they're often souvenirlike.

After 1964 Warhol's finest work has to do with size itself. In 1966 he covered the walls of a gallery with wallpaper of a repeating image of a photo of a cow's head, done in amusingly tart and tacky color combinations and when the wallpaper covers, say, a long corridor, it recalls some of Christo's "wrappings." It has the same sheathlike and cutting-through-space quality, and the same passive but riveting power, as Christo's *Running Fence*, where a seemingly endless white sheet ran over hill after hill, down to the Pacific.

Warhol's other superlative decorative work concerns his use of the official photo of Chairman Mao. In this "piece" different-sized Warhol paintings of Mao (and, as the Modern showed it, drawings, too) are hung on wallpaper Warhol designed that's made up of repeating images of the same photo of Mao. The eye takes in various framed Maos and the Mao wallpaper simultaneously, and the effect is of one big, pulsing, very optical picture. Your second response is probably that the paintings are being toyed with; aren't paintings more important than wallpaper? Yet are Warhol's Mao "paintings" any more his own, or more serious, than his wallpaper? It's as though he were enlarging the scope of his indifference to rigid categories.

But in most of Warhol's later work the indifference—the lovely superficiality—is gone. The effect of his Mick Jagger portraits (and other pictures

from the late sixties on) is that he's artifying photographs. He put jazzy lines and sloshed units of paint on top of photos, and it's airless; there's no feeling of an underlying canvas breathing through. What we see is a photo trapped in a lot of artistry.

He certainly continued to experiment. There are recyclings, in attractively pale or disco-hot colors, of his Marilyns, Maos, and other borrowings, and he did striking graphic rearrangements of work by Raphael, da Vinci, Munch, and de Chirico. It could be said that Warhol pursued kinds of touchlessness—that he kept making "Warhols" from images that weren't his own—and in time his works from the seventies and eighties may become resonant. But now they're merely dexterous and pleasant. They suffer from being seen alongside his work from the early sixties. Nothing is rash or tense.

Thinking about all of Warhol's work, and Warhol the person, or character, you're taken into an intricately layered—and intangible, hall-of-mirrors—world. Warhol is one of the most un-pin-downable figures in American art. The strands of irony and naiveté in him are inseparable. When Warhol talked about making his pictures on an assembly line, and called his studio "the Factory," it was hard to know if he was a con man or if he genuinely saw himself as an aspiring captain of industry in the art line. One of his goals apparently was to make his very person an instrument for selling: he seemed to want to turn "Andy Warhol" into an all-purpose brand label, like "Walt Disney." It's possible to see him as a commercial artist all his life. He moved easily back and forth between paintings created for art galleries and works commissioned by this or that bank or corporation, between a thriving business of making portraits of the famous and pure commercial work—ad campaigns for companies.

For some, Warhol's journeying between the art and business worlds had to be one big arch joke. But for artists coming into their own in the eighties, in a period when art, as never before, seemed to be a sheer commodity, Warhol could be seen as someone who had prophesied this situation, and kidded about it, for years.

You could believe, too, that Warhol wanted most to question, or reinvent, the idea of art. Making a career out of consistently borrowing his material, of never "inventing" anything, he helped create the idea that reproductions in themselves, like the press photos he used, could be a subject, or a takeoff point, for an artist. In the eighties artists have used reproductions (or ads, or posters) the way nineteenth-century painters used waterfalls and mountains—as both a subject of great moment and mere given. And certainly Warhol was a forerunner of the idea, which has had much currency lately, of the artist as gesture-maker, where

the artist's overall intent is what we're concerned with. Warhol's lifelong gesture might be called the making of a sham body of work. Since his paintings were literally pieces of canvas with a photo of something dashed onto them, a "Warhol" could be seen as an ultimate fake, like the "masterpiece" you'd win at Coney Island.

In another light, though, Warhol wasn't an isolated phenomenon; he was, on the contrary, one of many related voices of his period. His best-known statements concern the shallowness and superficiality of his tastes and his work. He said that if you wanted to understand what he was doing, all you needed to do was look at the surfaces of his pictures—that there was nothing behind the surfaces. These sayings have been taken as brilliant, gnomic, subversive utterances. But Warhol's emphasis on shallowness and sheer surface is no different from what contemporaries and near-contemporaries of his such as Johns and Christo and Alex Katz and Minimalist sculptors such as Donald Judd and Dan Flavin, and stain painters such as Helen Frankenthaler, Larry Poons, and Louis (and others) might have said.

The generation that came to maturity in the fifties and early sixties was romantic about a formal, physical flatness and an emotional blankness. Coming in the wake of the myth-bearing Abstract Expressionists, their challenge was to see how many associations could be pulled out of art. Johns takes images we know are flat and, in a let's-try-this-but-it-could-be-something-else spirit, gives them a sumptuous—a brooding or an ecstatic—texture. Katz revisits every convention in art—the portrait, the still life, the landscape, the group scene—and, with a tense blandness, refuses to put in the expected emotion. Warhol in his person may have been the hippest of the hip, but when his pictures are seen along with the works of his contemporaries, he's one of a number of talented hipsters.

Warhol was very much in harness all his life. Beginning in the middle sixties, he made (or participated in the making of) countless movies, and he had a rock band, the Velvet Underground. Around 1972 he became involved with painting again, and in addition to exhibiting regular new series of pictures from then on, he did between fifty and a hundred commissioned portraits a year. He began the magazine *Interview*, and he put out different compilations of his photographs. He published a novel, a hefty collection of sayings, and, with Pat Hackett, an account of the sixties Pop scene. After his death it was learned that he had assembled an awesomely large collection of art and objects. Yet the biggest impression was made by the man himself. His obsession with his face and his fame could be seen as a freakish passion play of a martyrdom to consumer culture; at times it seemed a spooky, perhaps helpless display of vanity.

There is very little of the personality or the cultural figure "Andy Warhol" to think about when you stand before his best work, though. The finest serial pictures are like pieces of magically airy cake. In the catalogue, in a section of notes on Warhol by artists and friends, he's referred to in the same breath as Picasso, but for me he's more like our Chagall or our Raoul Dufy. Like Chagall, he found a way to make an exquisitely physical and lyrical art out of folklore. (What are Chagall's scenes of Eastern European village life but another culture's pop imagery?) And like Dufy, Warhol was stimulated by the thought of effortlessness. Like the Frenchman, he gave new life to the idea of a light touch.

Stuart Klawans, "The Corpse in the Mirror: The Warhol Wake," *Grand Street* **8 (Winter 1989): 176-187.**

Andy Warhol, draftsman of shoes, is dead, and the people viewing his remains are mostly wearing scuffed white sneakers. It is April 16, 1988, the first day the public can see his much-hyped relics in Sotheby's showrooms: about 10,000 objects, which have nothing in common except for having been stored for a few years in Warhol's townhouse on East 66th Street. Published reports have portrayed Warhol as a compulsive shopper, who piled never-to-be-opened boxes of flea-market junk on top of never-to-be-opened antique furniture in rooms he never visited. Some of his furnishings were in fact bought for him by his associates; rumor has it that he disliked many of the pieces. Yet, through his death, these odds and ends have become The Warhol Collection, to be auctioned over the course of eleven days at Sotheby's in one of the best-publicized funerary rites of recent times. They will fetch $25.3 millon, nearly twice their estimate; but that is not the concern of today's scuffed-sneaker crowd.

There are dozens of aerobics, tennis, and jogging shoes crossing the showroom floors; a few flamboyant variations, such as the pair of canvas Caribbean-print Keds worn by a wandering twelve-year-old; and a goodly number of black Reeboks, this year's office-quality sneaker. There are no basketball shoes. I do spot one pair of high-tops, laced only halfway up, on an elegant young woman; but in general Air Jordan does not come to Sotheby's.

This mild evidence of racism does not lesson one's conviction that the viewing is a people's holiday. The Saturday crowd is cheerful and curious, and Sotheby's employees are friendly in return, even though they have the unmistakable look of people called up for an all-hands operation. There is none of the solemnity one finds in a museum, and very little of the hearty scoffing that

usually serves as its antidote. The visitors all seem comfortable, as if the things on display were as much their property as Warhol's. In life, he had given himself wholly to the mundane. Now, at his death, the common world has claimed him as its own, even though, among all the shoes at this wake, only one pair might have entertained him back when he was drawing ads for I. Miller: a pair of high-heeled, light-green pumps with gold tips on the toes, which Lana Turner might have worn in a Douglas Sirk movie, except for their being slightly baggy from wear on the streets, slightly homey in their glamour.

Warhol's relics are more than merely comfortable to the public; if you accept his way of thinking, the objects and people are transubstantial. Sotheby's has added a symbolism of its own that reinforces this idea: everything, objects and people alike, is labeled. The objects bear stickers, color-coded according to auction session, marked with the lot number, a small picture of Warhol, and the words "The Warhol Collection." The people, too, have Warhol-faced stickers, only theirs are marked not with a lot number but a time of day. Sotheby's has allotted the general public an hour and a half to view the collection. Thus, entering at noon, I get a sticker with 1:30 printed in bold letters as my expiration time. It seems a bit more sinister than the legendary fifteen minutes of fame, though surely consistent with the day's funerary theme. And, of course, it is democratic, as democratic as death itself.

"Can I see 2121?" asks a man standing near me. We are at a square of display cases which hold Warhol's watches and jewelry. The man is wearing brown penny loafers. After sneakers, penny loafers and Topsiders are the most frequently encountered shoes at the viewing. The security guard, wearing heavy black security-guard shoes, brings out the watch. Suddenly, the man is delighted. "Hey," he cries, "it works!"

Of course it works. This watch belonged to Andy Warhol, who earned his place in history by running mimesis smack into the wall. His supporters sometimes claimed that Warhol made mass-produced reality come alive before the viewer's eyes, that he turned the mundane into the aesthetic, as artists should. His distinction, in this account, lay in his having worked the trick so invisibly. But now, standing at the counter in Sotheby's, I decide this is exactly wrong. Warhol didn't turn a Brillo box into art; he turned art into a Brillo box. That was the achievement of his life. The achievement of his death lies in turning a cheap watch into art. Yes, this watch is part of The Warhol Collection, celebrated in magazine and newspaper articles, numbered and tagged and destined to sell for a lot more than similar watches found in any pawn shop. And yet it works—just

like a real watch! The wonder of it proves death to be more traditional an artist than Warhol.

All around Sotheby's, commoners in sneakers are enjoying themselves precisely because these things—these cookie jars and stacks of Fiesta ware and old sticks of furniture—are objects from the realm of art. And yet they don't have to be treated with the delicacy due to museum pieces. They are for sale to anyone who has enough money to buy them, and the management invites your inspection. A young man in deep-blue sneakers with very white laces settles into an ornate throne chair. "Comfortable?" asks his companion. She is wearing suede boots. "Yeah," he says. "Nice imperial feel." Nearby, acting without hesitation, a man in moccasins picks up a globed lantern and moves it to a chest of drawers, the better to examine a table on which the lantern had stood. A woman in blue-gray cloth slip-ons calls to her friend, "Hey, Pat! Someone's ceremonial bowl!"

Somebody's, indeed. Sotheby's would have us believe that Warhol, by choosing the bowl, revealed something about its aesthetic qualities. But, even if he bought it himself—not always a certainty, as I've mentioned— there is an anonymity to the bowl and to everything else on display. As lots destined for the auction, these things are in fact anybody's, and they look it.

More and more it seems to me that if there is a unifying element to this hodgepodge, it is not an individual's taste—much less an artist's—but rather the taste of a subculture. These are the furnishings one expects to find in the homes of many gay men of a certain age and class. The only difference is that there are not *many* of them. Instead of one piece of bloody Catholic statuary, there are a dozen. Instead of a single tin tray painted with an ad for Coca-Cola, there's a whole display case full. There are naïve paintings of the sort one finds in furnished summer cottages; a wall of tribal masks; pieces of homoerotic kitsch, such as a framed engraving of a classical nude with fig leaf. The furniture that Sotheby's calls "important" merely completes the setting. Suddenly, my thoughts fly back almost twenty years, to the first time I entered the apartment of a gay man. It was all there, the same mixture of religious melodrama, popular-culture detritus, high-art novelties, and deliberately out-of-date elegance. What if this were not The Warhol Collection but rather the contents of that apartment and the apartments of two dozen other men? Could anybody tell the difference?

Even the artworks by Warhol's peers don't identify their owner. There are drawings by Cy Twombly and Tom Wesselman dedicated to Warhol and a drawing of Warhol himself by David Hockney. But there are also drawings dedicated to other people, which seem to be neither more nor less Warhol's than the ones done especially for him. Was he that interchangeable with everyone

else? He sometimes claimed to be. "I think everybody should be a machine," Warhol once said in an interview. "Someone said that Brecht wanted everybody to think alike. I want everybody to think alike. But Brecht wanted to do it through Communism, in a way. Russia is doing it under government. It's happening here all by itself. . . . Everybody looks alike and acts alike, and we're getting more and more that way."

Standing behind a stanchion, looking at Warhol's canopied bed, I note the approach of a woman who is escorted by Sotheby's officials and several bulky men who clearly are bodyguards. She, too, stands by the stanchion and nods at the bed, then leaves with her entourage. Somebody says she's the Queen of Sweden. If so, she must be unlike the scuffed-sneaker crowd in material ways and probably is unlike us in her thoughts as well. But here, at the wake, she's one more gawker, staring at Warhol's heaped-up proofs of anonymity. I don't get a glimpse of the Queen's shoes. But when Lily Auchincloss goes by, I notice she's wearing black pumps with half-inch heels and ornamental gold buckles. In the spirit of generic identities, on the class level at least, I decide the Queen must be wearing shoes just like those.

Near the counter where Sotheby's employees sell catalogs, a young woman with the New England prep-school look of all auction-house underlings speaks to a black security guard. "Three more hours," she says, impressed with her own weariness. The guard nods, not looking at her: "Yeah, I know." The visitors—those who have not yet expired—check estimated prices in the catalogs, which hang from the walls on strings that resemble black shoelaces.

April 23, 1988: Under an acoustical-tiled ceiling, beneath incandescent bulbs set back in chrome sleeves, one thousand folding chairs sit on a carpet the color of eight-year-old lint. It is 10:00 A.M., and the chairs— graffiti-artist gold with red seats—already are filled, except for the reserved rows at the front. In fifteen minutes, the first auction session will begin.

Movable grey partitions close off the sides of the auction pit. By the left wall, which is hung with Native American blankets, seven video and film crews stand in a row, with a gang of still photographers heading the line. By the right wall, a single photographer, no doubt Sotheby's own, has set up two tripods in front of a large print by Toulouse-Lautrec. Above us, on the third floor, horizontal banks of windows look down on the scene. Curtains are drawn across all of them except for one at the right side, which is flooded with light. These windows, I learn, are like boxes at the opera. For now, though, they are vacant.

On my lap lies a green plastic paddle shaped like a vanity mirror. It bears the legend "SOTHEBY'S FOUNDED 1744" and, in very large white figures, the

number 335. Like many of the people here, I have never before attended an auction and feel nervous about holding the paddle. Urban mythology has many tales of incautious people who, visiting an auction, scratched their noses at the wrong moment and thus bought an egg cup for three zillion dollars. Having laid my paddle across my lap, then take the further precaution of covering it with the *Times*. I would gladly get rid of it altogether, but Sotheby's will not let me.

When I arrived at 9:45, having both phoned and written the press office in advance, I discovered my credentials were nonexistent. For all Sotheby's cared, I could have been some purple-nosed guy in a houndstooth jacket with a police press pass slung around his neck. Would it be possible for me to get into the auction with the general public? "I don't know," the man at the press table told me. To my left, a security guard was admitting a line of people from the street. Was that the line for public admissions?" "I don't know," the press officer said.

I reverted to the empirical method. Forty-five seconds later, the security guard ushered me in and pointed downstairs, where seven young prep-school graduates sat behind a long table. One of them took my name, my address, and the numbers of my credit card and driver's license. That done, she issued me a paddle, a second guard tagged me with yet another Warhol-face sticker, and I went up to the auction pit to take a seat. Members of the press, I understand, do not sit at auctions. They stand at the side, so they can get a full view of the bidding. It seems strange, then, that Sotheby's would insist on my taking a chair that might well have gone to a real bidder. But then I realize the logic of it. They will go to any length to get that paddle into your hand. I, too, am a bidder now. I take off my jacket and dump it over the *Times*.

A few people are still milling in the center aisle, looking for places to sit. They are wearing beige pumps with medium heels, grey suede calf-boots; black patent-leather pumps, black moccasins with tassels; and lots of imitation reptile. To my left is a woman with grey, tasseled slip-ons; to my right, a man with pointy-toe leather laceups much in need of polish. In the hope of looking respectable, I am wearing tan oxfords instead of my usual New Balance hiking boots. There are, by my count, four black people in the room; a young couple in the back, a young woman sitting at the left, and a press photographer amid the tripods. Behind us, the Sotheby's prep-schoolers have taken up their positions. At the front of the room, the price board suddenly clicks. A moment ago, it had read "Estate of Belle Linsky." Now, in preparation, it goes blank, except for the permanent headings—British pound, Swiss franc, French franc, yen, lira, and mark—and the apparent motto of the auction house, "All Conversions Approximate."

By 10:15, the stage is set. The centerpiece is a turntable draped with a tan curtain. Objects will appear and disappear on it, while behind its flimsy partitions a couple of black men take away the previous lot and position the lot to come. To the left of the turntable stand two Art Nouveau pieces from The Warhol Collection. A Sotheby's official, a bespectacled black man in a grey three-piece suit, has taken his place in front of this furniture. He will call out the telephone bids. To the right of the turntable stands the auctioneer's cathedra. It is massive, wooden, canopied—a true seat of power. At 10:20, the auctioneer, John L. Marion, mounts the cathedra, attended by his assistants. The show begins.

Marion, who is the chairman of Sotheby's North America, is a sleek man with a straight brown hair and the genial expression of someone who is about to make a lot of money. Fill the jowls and turn the hair white, and he could double as Edwin Meese. "I am pleased to welcome for your competition this morning and continuing for the next ten days The Andy Warhol Collection," he begins. Many of the bidders are new to auctions, he says, and he graciously predicts that he and the audience will get to know each other better. But Marion must be overestimating the number of newcomers, since there is general applause at his next announcement: that the auctions benefit the Andy Warhol Foundation for the Visual Arts, and Sotheby's therefore will not have to collect sales tax. Bear in mind: Somebody at Sotheby's will eventually pay $23,000 for two cookie jars and a set of salt and pepper shakers. I assume you have to be used to auctions to throw that kind of money around and yet protest against a sales tax.

But now, the turntable revolves, a silver plate appears, and bidding begins on Lot 1. In his strong baritone, Marion announces the bidding will start at $500. Twenty seconds later, the plate goes for $950.

Lot 2: $2,600, 35 seconds.

Lot 3: $2,400, 30 seconds.

Lot 4: $1,000, 45 seconds.

Lot 5: $7,000, 45 seconds.

I begin to get the idea. This is going to be as boring as bad opera. The next two hours will give me ample time to reflect on the justice of the comparison.

The minor coincidences are easiest to remark. For example: estate auctions and bad opera alike have a turntable as the central element of the set. Both require the performance of mechanical, seemingly endless oral repetition—of the score in the case of opera, of numbers at an auction. Indeed, at either event, the most impressive feature is the performer's sheer endurance. As the auction wears on, I gain great respect for John Marion, who never pauses in his patter and never takes so much as a sip of water. At the 91-minute mark, his voice breaks; at 96

minutes, he swallows in mid-chant. Otherwise, he talks steadily for 132 minutes, a feat as doughty as that of any Wagnerian tenor. And, as at a bad opera, the audience gets most of its thrill from seeing how his performance varies from the score. The score-readers in Sotheby's are everywhere, following the estimates in their catalogs. When something goes for much more than was foreseen, there is applause. In this sense, Saturday morning's great aria is the calling of Lot 56, a French silver and aventurine tureen and a cover made by Jean Puiforcat, circa 1930-40. The estimate was $10,000-$15,000; the bidding stops at $50,000, and the crowd goes wild. Yet there are many people here, as at the opera, who are deaf to such music. They are attending out of a sense of duty but don't quite know why. Throughout the morning, one sees a steady stream of them walking out, signs of stupefaction on their faces.

But all these are surface resemblances. At the deeper level of purpose, the coincidence of opera with auction is still more telling: both are rituals of death. In opera—indeed, in all classical music—the performers subject themselves to strictly prescribed rigors so they may call up the spirits of the dead. Sometimes it works, too. At a good opera, Mozart once more dwells among the living. At a bad one, the necromancy having failed. the audience sits through three hours of meaningless yammer. Consider auctions, then, to be like operas that are always bad. They are so bad because the dead are meant to stay that way. Spirit is out of the question. The gravediggers have taken care of one part of the corpse, and the auctioneer is there to dispose of the rest. In this sense, the Warhol auction really is the greatest of its kind. It celebrates the obsequies of the artist who wanted people to be like machines, who was indifferent to distinctions between living beings and merchandise. No eulogy for Warhol could be more fitting than this endless repetition of prices.

Above us, at the banks of windows, the Sotheby's employees have abandoned their boxes. Even they do not want to watch any longer. It is 12:25, and all the film crews have gone. Although new viewers have entered periodically as seats became available, the auction pit is emptying rapidly. John Marion sings on. Earlier, when the bidding sometimes went sluggish, he had enlivened the audience with a touch of humor, jovially urging us to raise the price. Now he calls out the numbers singlemindedly. At 12:32, he lowers the gavel for the last time, one hundred forty-three lots have been sold.

I direct my tan oxfords out of the room. The Sotheby's preppies have set up a table here on the second floor where they collect my paddle. Though many shoes are passing—some on bidders, some on the crowd viewing the collection—I

no longer pay attention. Dispirited and weary, I walk out to the damp, chilly street. It always rains at funerals.

May 1, 1988: The women are wearing high-heeled pumps in soft shades of satin. The men are in black patent leather, sometimes with velvet bows. It is evening, and Sotheby's is deserted except for these patrons of the American Academy in Rome. They are holding a formal-dress benefit, with Warhol's collection of contemporary art as one of the main attractions.

Though dressed in nothing better than a dark suit and a pair of shiny Florsheims, I have wangled an invitation to the earlier part of this event, when the Academy patrons wander among contemporary painting and sculpture. The Warhol auctions have wound down to their last days, so his collection, though still the centerpiece, now has company in Sotheby's. The showrooms are filled with other collections, scheduled for auction to benefit the American Academy in Rome and the AIDS unit at St. Vincent's Hospital. Whatever the provenance of the works, though, the art barely attracts the gaze of the Academy patrons. They are mostly interested in seeing each other.

Lily Auchincloss, with Kirk Varnedoe in attendance, stands near the bar, wearing shoes like the ones she shared with the Queen of Sweden, though with higher heels. To her right hangs a picture Warhol had owned, a drawing by Jasper Johns of a man's shoe. A costumed trio plays Renaissance music on period instruments; their outfits are faithful enough, except for the brown walkers on one of the men. The music is pleasant, and the bar is well stocked; but The Warhol Collection has grown familiar to me, so I depart for the ground floor. And there, finally, I see the element that was missing from The Warhol Collection: pictures by Warhol himself.

The earliest is a drawing from the 1950s, done with considerable charm, of an ice cream cone sailing through the skies, festooned like a hot-air balloon. Warhol signed the drawing with his full name, using an ornate, old-fashioned script, much like Saul Steinberg's. And that's the problem with this drawing. It's entertaining, but it plainly resembles two Steinberg pieces from the same period, hung above and below. There is something mysterious about the Steinbergs, some complexity to their arrangements of line and color that hints at hidden meanings. The Warhol, though similar, has the one-time appeal of the average magazine illustration.

But the ice cream cone, whatever its shortcomings, is better than a later Warhol hung nearby: a small, jeeringly ugly silkscreen of a dollar sign. By calling the cone *better*, I refer of course to its visual appeal, not its economic

value. In fact, the dollar sign will cost much more. This seems puzzling at first, but it becomes logical once the artist's identity is figured into the price. Warhol's cone was imitative. With the dollar sign, though, he had come into his own. He had learned to show us the corpse in the mirror.

For a very long time, art had been the mirror of life. Then, at the turn of this century, painters stopped reflecting the world. They no longer made representations; they created images, which were meant to be understood as real in themselves, on the same level of existence as anything else. When, in the 1950s, representation began to creep back, artists still did not depict the world at large. They painted representations of things that were already images: the American flag, a comic-book panel, Marilyn Monroe's poster face.

It was Warhol's contribution to turn these images-reflecting-images into art in the older sense, a mirror of the world. All it took was the assumption that the world was dead. Why not? Images already had been granted equal status with living beings. For most people, that claim was based on the logic of art history. Warhol, though, seemed to rely on a more compelling argument. Artworks had become more valuable than people; and the century that had learned to mass-produce images was also the century of mass-produced death. Why not decide that the world was as inanimate as the art—that the figure in the mirror was a corpse? That way the art, at least, could retain its integrity. Even though we are nothing more than cheap commodities aspiring to the condition of machines, the art that reflects us can stay true to the principles of modernism—a small triumph, though nobody's left to enjoy it.

It makes no sense to argue with this point of view. Warhol was persuasive enough to make himself part of history, a much greater part than most artists; no one can dispute him out of existence. But those who still imagine themselves to be alive might recall a different vision of art and of the world. There is no evidence today that would favor this vision; but then, there was none two centuries ago, when William Blake spoke up for it. All he had was the crazy conviction that the spirit of John Milton had entered him through his left foot. We don't know why Milton chose the foot, rather than some other part of the body, and it's hard to say why he should have come in through the left one instead of the right. Nevertheless, Blake saw it happen, and that was enough to inspire in him the greatest shoe-poetry in the English language:

And all this Vegetable World appeared on my left Foot,
As a bright sandal formed immortal of precious stones & gold:
I stooped down & bound it on to walk forward thro' Eternity.

We who live in the Vegetable World still can bind it to ourselves, however shriveled and decayed it might seem, not as matter paired with our own doomed matter but as a shoe, which eases the imagination's steps. I. Miller cannot sell this shoe. Andy Warhol could not draw it. But it's there, ready to be used. All we need to do is step out.

In a corner of the ground-floor showroom, I find a painting by someone who seems to want to do just that. It is a recent nude by Philip Pearlstein, whose work was never all that fashionable even during its fifteen minutes of fame. Now, Pearlstein is suffering the sort of hanging that in nineteenth-century salons used to incite secessions and manifestos. His painting is tucked next to a doorway, out of the light. Even if one should notice the picture, there is no backing-up space; one can't take in the painting as a whole. Yet, despite this disadvantage, the Pearlstein nude stands out in this company like a Bach fugure interrupting *The Monkee's Greatest Hits*. It is unquestionably a modernist painting—a textbook example of flattened space, tilted perspective, photographic composition, and all the rest of the image-making apparatus. It is also a painting about light and flesh and physical tension and the personality of a particular woman. A friend, looking at the Pearlstein with me, remarks that its estimate seems very low. I agree. "The estimate for that Warhol," I say, pointing to *210 Coca-Cola Bottles*, " is around $800,000."

"Is that with or without the deposits?" says my friend.

Upstairs, amid The Warhol Collection, Philip Pearlstein is standing in a quiet corner of the room, chatting with one of the other guests. He is a diminutive man, wearing an ancient-looking dinner jacket and a red vest. His shoes, for those who care to notice, are just like the clunkers on the security guards.

4

THE NINETEEN NINETIES

Bob Colacello, *Holy Terror: Andy Warhol Close Up* **(New York: Harper Perennial, 1990), 118.** Excerpt.

We had visited the great Mexican artist Siqueiros at his studio the day before, and as we spoke, Andy flipped through the catalogue of a recent exhibition that Siqueiros had signed to him. He stopped at a reproduction of a late abstract painting. "Anybody could do this," he said. "I mean, he could turn out hundreds of paintings a day like this. He just puts on the base. Then takes it off. Then goes crazy a little. It's just action paintings. Anyway, Pollock was much better. Pollock was a great painter. I wish I had a Pollock. This is nothing. But his wife was funny wasn't she? Do you think she's a lesbian? She could be a lesbian, right? She's tough."

I wasn't surprised in the least by Andy's off-the-wall sexual speculation. That was typical, everyday Andy. But I was almost shocked to hear him say what he really thought about another artist's work, especially something so negative and analytical and, in my opinion, right. Andy didn't talk about art; it wasn't cool. If asked, he said everything was great, or mocked the questioner, as he did with Barbara Rose.

That afternoon Andy also told me, "I think American Indian art is the greatest art. It's so simple and beautiful. And it doesn't matter who made it."

Kirk Varnedoe and Adam Gopnik, *High and Low* **(New York: The Museum of Modern Art, distributed by Harry Abrams, 1990), 193.** Excerpt.

What makes Warhol original is the isolation of his comic images: the detective and the little girl and the superhero are not fragments shifting within the kaleidoscope of mass culture but icons, fixed and staring. What's original in Warhol is not that he painted Dick Tracy, but that he *just* painted Dick Tracy.

Warhol's comic paintings are formally much closer to the floor-to-ceiling assertions of Abstract Expressionism than they are to the palimpsests of fifties neo-Dada. For Johns and Rauschenberg, the inclusion of comic-book imagery in the midst of a painterly rhetoric borrowed with genuine reverence from de Kooning and Pollock still had about it an air of muted protest and debunking. They share a sense, as strong as Schwitters's of the world breaking in on the studio, insistently and surely, and share also an infinite hesitation to choose only one or the other. It was Warhol's wicked and demoralizing intuition to see that the choice was in any case unnecessary, that the very highest and very lowest visual elements in the culture—Mondrian and a crossword, a Newman zip and comicbook panels—had already a punning similarity. Part of the joke in Warhol's *Dick Tracy* lies in its deflation of the old, transcendent pretensions of American abstraction, but part of the joke also lies in its translation of pictorial absolutism into the vernacular.

Yet Warhol's real genius was for the off-register print, for the lag moments in culture, for the thing just on its way out: the tabloid headline in the age of television, the movie star in the age of rock. He had an unerring instinct for those occasions when the iconic image was just beginning to disconnect from its audience.

Alan Pratt, "Andy Warhol at the Movies: The Critical Response."

Andy Warhol purchased his first movie camera in 1963 and in the next fourteen years produced hundreds of silent shorts and thirty-five feature length films. The most controversial films were made between 1963 and 1968, and though much discussed, only a few have actually seen them. The criticism of Warhol's films, as with his art, runs the gamut, from vehement (and often hilarious) condemnation to hyperbolic praise. Detractors argue that Warhol's movies are deadening, an abuse of the camera too stupid to even be called

cinema; supporters celebrate them as revolutionary, films that reshaped the medium's syntax and represent the artist's most creative accomplishment.

As yet no definitive catalog of the films exists,[1] and there are only three books in English devoted to them: Peter Gidal's *Andy Warhol* (1971) which identifies a voyeuristic theme in the films; Stephen Koch's *Stargazer* (1973; Second Edition, 1985) which also discusses Warhol's voyeurism and includes a discussion of the films' formal elements that influenced much of the criticism that followed; and a collection of essays and excerpted material edited by Michael O'Pray, *Andy Warhol: Film Factory* (1989).

Warhol's film career can be divided into three periods.[2] The first focuses on the photographic process, the effects of being photographed, and the qualities of cinematic time. The second period introduces crude sound tracks, "superstars," minimal scripting, and parodies of Hollywood films. The third period is dominated by Warhol's assistant Paul Morrissey who abandons Warhol's methods for more conventional techniques.

Time, Motion and Technique (c. 1963-1966)

These first films are marked by limited action, interior shooting, a fixed camera, and the absence of editing and sound, though off-screen sound and noise were later added. When he began making films, Warhol knew little about cinematography which, it's been argued, accounts for the low production values. Warhol's aesthetic—make it easier, quicker, and cheaper—has also been identified as a significant influence, that his primitivism was deliberate, reflecting an ostensible goal of a new back-to-basics film making.

Many of the first films are portraits. Using a stationary camera and without cues, Warhol filmed hundreds of silent three-minute reels of the people who visited the Factory. These "100 footers" are deceptively simple, according to David James, because they do not simply document personalities but record the individual's response to being photographed and constitute, in effect, "being as performance" (139). *The Thirteen Most Beautiful Women*, *The Thirteen Most Beautiful Boys* and *Fifty Fantastics* are compilations of these 100 footers.

Kiss, *Sleep* and *Empire* are typical of other experimental films of the first period. None of them have credits and all are shot with a fixed camera in high-contrast black and white. The fifty-minute *Kiss*, a collection of embracing couples, was inspired by either Thomas Edison's first short of 1874 (Rayns 164, Dick 155) or an old Hayes Office rule forbidding actors to kiss for more than three seconds (Colacello 29). The six-hour *Sleep*, Warhol's first film, consists of selected, sometimes repeated, reels of John Giorno sleeping shown to the

accompanying sound of two radios tuned to different stations. *Empire* is an eight-hour shot of the Empire State Building. Warhol explained that films like *Kiss, Sleep,* and *Empire* were intended "to help the audiences get more acquainted with themselves.... They're experimental films; I call them that because I don't know what I'm doing. I'm interested in audience reaction to my films, testing their reactions" (qtd. in Berg 58). For these early films Warhol received the 1964 Independent Film Award from *Film Culture* magazine.

Those who approve of Warhol's minimalist approach discuss these films as radically new explorations of cinematic time and space, in retrospect, perhaps the artist's most creative, provocative, and influential work. From their criticism three themes emerge: the revolutionary treatment of time, the fundamental reevaluation of the film medium, and the paradoxical Duchampian features of the films.

Empire (1964) is the last and most frequently referenced "purified" film of the first phase, and discussions about it can be applied to virtually all the early films. Because the intellectual premise carries nearly all of the meaning, *Empire* appears to have been designed to be discussed rather than seen (Rayns 165). By fixing the camera on a single object for an extended period, filming at 24 frames-per-second, and then projecting the results at 16 frames-per-second[3] an unusual transformation occurs. Focus is shifted from movement, event, and entertainment to the experience of time (Bragin 223).

While Warhol commented on the artificiality of the early films, critics who liked these uninterrupted concentrations on the insignificant claimed to have been struck by the powerful "new realism" of the approach (Battcock 237). Cinematic time, conventionally elliptic, becomes a literal record of unchanging "real time." The critics of New Cinema, as the underground dubbed itself, were ecstatic. Parker Tyler's classic 1967 essay, "Dragtime and Drugtime," enthusiastically describes the effect as "psychedelic time," where a perceived transformation in the object actually originates in the observer (94). Ken Kelman was amazed by the existential implications of unabridged recordings of eating, sleeping, and observing. Because the films dissolve the perceptual hierarchy, distinctions between background and foreground fade, revealing "life in its infinite richness and poverty, with all its surprise and dullness" (102). In contrast, Tony Rayns was excited by the sensation of time stopped, a temporal quiescence similar to the "absolute stillness" conveyed in Warhol's paintings (169). Koch was struck by the experience of duration, as well, but because it requires "a massive, absurd act of attention" which only a machine could be capable of, films like *Empire* dehumanize the cinema (60).

In addition to the perceived time warps created by the films, much has been made of Warhol's idea to reconsider motion picture mechanics. In addition to the almost imperceptible slow motion of 16fps, Warhol reintroduced the leader at the beginning and end of each reel, a technical feature generally eliminated, and uses the strobe cut to interrupt shots. (" Strobe cut" is a misnomer, though. Warhol simply turned the camera on and off arbitrarily, leaving several unexposed frames.) By interrupting the recording or "action," "killing cinematic life with the flick of a switch," Gene Youngblood, notes, Warhol creates a sort of "Brechtian-Godardian play" which distances the viewer (8). Rainer Crone is also remined of the alienating techniques of Brecht and Godard, arguing that Warhol's express purpose in these early films was to make audiences conscious of the powerfully manipulative nature of the medium (89). By calling attention to otherwise ignored or deliberately obscured characteristics, the films compel audiences to reconsider the nature of the medium (Battcock 245).

Accordingly, Warhol's "style" serves to remind audiences of the artificiality of the medium, that it is not a picture of reality, that filming anything changes it and our perception of it. Several writers have made this point, suggesting that the "functional boredom" in films like *Empire* is actually a sophisticated manipulation which breaks down the motion picture illusion (Rees 127). The back-to-basics filmmaking is often related to similar techniques Warhol employed in other media. Just as the simplifying, repeating, and enlarging which characterizes his painting highlight what was previously unseen and taken for granted, Warhol's emphasis on the purely structural features of film creates a similar transforming aesthetic.

Much has been made of the influence of Duchamp on Warhol, and it's frequently suggested that the early films rely on and expand Duchamp's aesthetic ironies. Just as Duchamp transformed the perception of everyday objects with his ready-mades, Warhol's "flickering wall-paper" transforms the movie experience (James 149). One who watches a film of The Empire State Building for an extended period, Koch observes, is "likely to be made peculiarly aware of the process of looking, itself, conscious not merely of the object, but also the feel, the nature, the very matrix and interplay of...perception" (22).

The Hollywood Treatment (c. 1965-1968)

In 1965, Warhol announced his retirement from painting at an exhibition of his work at the Galerie Ilenna Sonnabend in Paris. From 1965 to 1972, he focused his attention of filmmaking, significantly modifying his technique. When the shift from plotless, actionless films occurred, however, is problematic. Was *Harlot* the

bridge between the old and the new? (Koch 34), or was it *Kitchen*? (Battcock 240). Was it *My Hustler,* when Paul Morrissey insisted on moving the camera (Rayns 165) or *Nude Restaurant* in which Warhol initiated a series of activities? (Smith 142).

At some point, anyway, Warhol gravitated to making films based on "incidents" or loosely structured "playscripts." His direction still remained minimal, and he would still often leave the room during shooting, but occasionally he began encouraging performers with such cues as "Say something dirty" or "Get personal" (Mead 435). And though still devoted to the fixed camera, Warhol began to expand his cinematographic repertoire with simple camera movement, color, and sound. The results, still crude and uneven by Hollywood standards, have been compared to a cinematic happening. In *Screen Test #2* and *Harlot*, for instance, the premise is established, but the dialogue is improvised, blurring any distinction between acting and acting-out (Battcock 238). Also appearing in 1965 is Warhol's interest in imitating or parodying the Hollywood movie business, beginning with characters who were loosely based on Hollywood stars and culminating in his later films with remakes of several Hollywood films[4]. Warhol's Superstars, the exhibitionistic personalities who according to the artist had a magical screen presence, made their appearance at this point, and not surprisingly, they're often connected to Warhol's life-long fascination with Hollywood glamour and decadence (Smith 144).

The Chelsea Girls (1966) is the best-known film of the second period and the first to receive national media attention. New Cinema critic Amos Vogel is convinced that its popularity is directly attributable to the wide-spread publicity the film received as a supposed transcription of sexual decadence (135). This was no surprise since Warhol's voyeuristic interests were already notorious from earlier work such as *Blow Job* and *Couch*. During the second period, however, erotic sexuality becomes more conspicuous, and Warhol was frequently embroiled in legal battles involving censorship, battles which, depending on one's point of view, ultimately had a liberating or corrupting effect on American cinema.

The Chelsea Girls is a loosely structured affair done in Warhol's typically flat style. An unedited serial of sorts, the camera movement is limited to shaking and infrequent zooms which have no relationship to the events being photographed. The film consists of one outlandish scene after another—of sadists, addicts, pederasts, and transvestites—set in the rooms of the Hotel Chelsea. Referred to as Warhol's home-made *La Dolca Vita* (Tyler 102), *The Chelsea Girls* is discussed for its ambiguous place as documentary—is it existential realism or cinema verité? The "actors" appear to be themselves, but the decision as to

where, what, and how to shoot the scenes is the artist's. The "performance" of *The Chelsea Girls* involves two reels projected simultaneously, or sometimes overlapped, in no particular order, with various color gels placed over the projector lens. The dialogue, generally muddled or unintelligible, is shifted from one scene to the other. Because each showing is unique, it's a technique which places new emphasis on the role and personality of the projectionist, and as Battcock notes, raises new questions about the nature of cinematic display (249).

Koch identifies *The Chelsea Girls* as Warhol's last experimental film because, like earlier films, it "disintegrates" the sense of time by repeatedly interrupting the viewer's perceptual focus (88). David Ehrenstem's lavish praise centered on Warhol's decision to refrain from manipulating the film's content thus making it

> one of the most human pieces of cinema ever created.... No excuses are made, no incidents avoided.... Warhol knows that every cut would be a lie.... The people are all that is necessary; what drama need be created? (37)

As usual, there were plenty of detractors. John Simon, for example, accused Warhol of being a birdbrained idiot, the film a "testimonial of what happens when a camera falls into the hands of an aesthetic, moral, and intellectual bankrupt." And Warhol's sensational manipulation of time? It's nothing more than boredom with a vengeance leading him to the conclusion that "because a minute of Warhol's brand of boredom is easily the equivalent of an hour of the Hollywood kind, the actual duration [of *The Chelsea Girls*] is 17 1/2 days" (261).

After *The Chelsea Girls*, Warhol began to experiment more freely with the grammar of commercial cinema with films such as *Bike Boy, Lonesome Cowboys, Nude Restaurant* and the last film of the second period, the suppressed *Fuck* (released as *Blue Movie*). While these low low-budget films are generally dismissed as cheesy pornographic movies at best or, more likely, just undiluted failures, others have praised them as Warhol's best work, "...more vibrant, intellectually challenging, and visually more satisfying" than any of the others (Bourdon 53).

The Influence of Paul Morrissey (c. 1968-1976)

After he was nearly killed in 1968, Warhol's direct involvement in filmmaking gradually diminished, and actual control went to his long-time assistant and collaborator, Paul Morrissey. It was during Warhol's convalescence that Morrissey directed *Flesh* with Warhol credited as producer. Although it retains the limited camera movement, long uninterrupted takes, and the "strobe

cutting," characterizing Warhol's previous films, *Flesh* is a bit more structured and coherent than the previous films. Morrissey's improvisational style of direction, however, was certainly influenced by Warhol's own hands-off approach to filmmaking. Subsequent films by the Morrissey-Warhol "collaboration" rely on conventional film techniques. Though why Warhol gave his assistant free reign remains controversial, Morrissey's ideas and methods dominate the films of the third period. Films such as *Trash*, *Heat*, and later *Frankenstein* and *Dracula*, were surprisingly successful but abandoned much of Warhol's early style.[5] The last film Warhol produced, the black comedy *Bad* (1976), directed by Morrissey's assistant and Warhol's housemate Jed Johnson, was a box office failure that cost Warhol over $400,000.

The films of the third period are the Warhol films most moviegoers have seen, yet critics agree that they are almost exclusively the work of Morrissey, "their factual director, their creator, their energy" (Koch 33). Critic David James, however, views these last films differently. Warhol's role as executive producer of Andy Warhol Films, Inc. during this phase puts him in the position of controlling the entire process of making and publicizing a film, of making those involved "either famous or non-existent." As a producer, then, Warhol succeeded in redefining the author as well as the *auteur* (James 144). An *auteur*? When asked if he thought Warhol was an *auteur*, Morrissey was thoroughly amused. "Andy an *auteur*? You must be joking. Andy's idea of making a movie is going to the première" (Colacello 34).

Warhol's Mark on the Medium

Warhol referred to his early films as "art movies" (Koch 19) and made a distinction between a "period where we made movies just to make them" and a period of "feature-length movies that regular theaters would want to show" (qtd. in James 136). It was with these later films, after *The Chelsea Girls*, that Warhol's perceived significance as a film maker eroded.

Writing in 1973, Koch speculated that if any of Warhol's artistic contributions would stand the test of time, selected early films would be among the survivors, evidence of the artist's resourcefulness and originality (25). Whether Warhol's early films were made "just to make them" or were intended to purify and thereby clarify the medium is unclear. Showing little and suppressing nothing can be boring. And even though an audience may be versed in the aesthetics of "functional boredom," boring is boring.

Not surprisingly, the Warhol films often considered of most consequence have been excoriated by the critics who argue that regardless of the artist's

theoretical premises, the films are failures, unendurably tedious experiments in non-technique, experiments that never went beyond a gratuitous negation of the medium. Like the emperor's new clothes, the profound qualities attributed to the films never existed; sloppy thinking, indifference, and careless execution are boring. According to Dwight MacDonald, Warhol is a marvelously successful huckster, "the Ponzi of the movie-world," manipulating a public "afraid to be laughed at if it didn't respond" (68).

However, his non-interventionist technique does significantly reduce the role of the artist and the audience. Also, viewing simple images recorded in the simplest manner for extended periods does potentially alter accustomed patterns of experiencing and provides a new way to understand film. And despite a wealth of negative criticism, Warhol's early films are classics of avant-garde cinema. Historically, O'Pray identifies them as an important link in the evolution in an aesthetic of diminishing content, first by the Impressionists, later by Duchamp's ready-mades, continuing with Minimalism (172), a point also made by James and Bourdon (135; 48). Koch situates these films within the non-narrative "poetic" avant-garde and related to the work of Cocteau and Bunuel, transplanting into film the high-modernist sensibility prevalent in the painting of the time (19). Jonas Mekas, who first wrote about them, sees Warhol's early films as a unique contribution to the medium; no one, he notes, has approached form, subject, and technique in quite the same way (28).

It may well be that Warhol was one of the most influential filmmakers of the 1960s, that his films ultimately expanded the mechanics of the medium, creating new ideas about how the camera could be used, what could occur before it, how the results were shown, and what the function of the artist and his audience might be in all of this. It may be. But as with his painting, all of his work really, the question remains: Is he the creative genius who forever changed the way we think about film or a hip, opportunistic hack? The answer has always depended on whom you believe.

NOTES

1. There is still controversy about the Warhol filmography, and much remains to be done. Some films are damaged, unavailable or missing; others were seized by the police. Questions remain about the length of the films, the reel sequence, and the dates. Some titles found in one filmography are not included in another. While the filmographies of Koch (1973) and O'Pray (1989) are the best available, the Whitney Museum of American Art is developing a definitive catalog.

2. These three periods, incidentally, recapitulate the history of filmmaking in general as the films progress from unscripted, silent black and white shorts to elaborate, full-length commercial features, and Warhol himself moves from photographer, to director, to producer (Arthur 149).

3. Warhol insisted that many of the films be projected at 16 frames-per-second, resulting in a barely perceptible slow motion (Mussman 154).

4. David James identifies a threefold process in Warhol's appropriation of the Hollywood experience. They include 1) a selective use of names, roles and gestures from Hollywood's golden age, 2) deliberately crude generic imitations, and 3) remakes of specific films (141).

5. Tony Rayns specifically addresses the Morrissey/Warhol relationship in his essay, "Death at Work"; and though he does not answer the question of why the two "collaborated," his profile of Morrissey and his films illuminates the sharp differences between Warhol and his assistant.

WORKS CITED

Arthur, Paul. "Flesh of Absence" in *Andy Warhol: Film Factory*. Ed. Michael O'Pray. London: British Film Institute, 1989, 146-153.

Battcock, Gregory. "Four Films by Andy Warhol" in *The New American Cinema*. Ed. Gregory Battcock. E. P. Dutton, 1967, 233-252.

Berg, Gretchen. "Nothing to Lose: An Interview with Andy Warhol." *Cahiers du Cinema in English*, no. 10, 1967. Rpt. in *Andy Warhol: Film Factory*. Ed. Michael O'Pray. London: British Film Institute, 1989, 54-61.

Bragin, John. "The Work of Bruce Baillie" in *The New American Cinema*. Ed. Gregory Battcock. New York: E. P. Dutton, 1967, 226-232.

Bourdon, David. "Warhol as Film Maker." *Art in America* (May-June 1971): 48-53.

Colacello, Bob. *Holy Terror*. New York: Harper Perennial, 1990.

Crone, Rainer. "Form and Ideology: Warhol's Techniques from Blotted Line to Film" in *The Work of Andy Warhol*. Ed. Gary Garrels. Seattle: Bay Press, 1989, 70-92.

Dick, Vivienne. "Warhol: Won't Wrinkle Ever" in *Andy Warhol: Film Factory*. Ed. Michael O'Pray. London: British Film Institute 1989, 154-159.

Ehrenstein, David. "No Story to Tell" in *The New American Cinema*. Ed. Gregory Battcock. New York: E. P. Dutton, 1967, 33-38.

Gidal, Peter. *Andy Warhol: Films and Paintings*. London: Studio Vista, 1971.

Indiana, Gary. "I'll Be Your Mirror." *Village Voice,* 5 May 1987. Rpt. in *Andy Warhol: Film Factory*. Ed. Michael O'Pray. London: British Film Institute, 1989, 182-185.

James, David. "The Producer as Author." *Wide Angle* 7, no. 3, 1985. Rpt. in *Andy Warhol: Film Factory*. Ed. Michael O'Pray. London: British Film Institute, 1989, 136-145.

Kelman, Ken. "The Reality of New Cinema" in *The New American Cinema*. Ed. Gregory Battcock. New York: E. P. Dutton, 1967, 102-104.

Koch, Stephen. *Stargazer: Andy Warhol's World and His Films*. New York: Praeger, 1973. Second Edition, New York: M. Boyars, 1985.

MacDonald, Dwight. *Dwight MacDonald on Movies*. Englewood Cliffs, New Jersey: Prentice-Hall, 1969.

Mekas, Jonas. "Notes After Reseeing the Movies of Andy Warhol" in *Andy Warhol*. Ed. John Copland. New York: New York Graphic Society, 1970. Rpt. in *Andy Warhol: Film Factory*. Ed. Michael O'Pray. London: British Film Institute, 1989, 28-41.

Mussman, Toby. "The Images of Robert Whitman" in *The New American Cinema*. Ed. Gregory Battcock. New York: E. P. Dutton, 1967, 155-159.

O'Pray, Michael. "Warhol's Early Films" in *Andy Warhol: Film Factory*. Ed. Michael O'Pray London: British Film Institute, 1989, 170-177.

Rayns, Tony. "Death at Work" in *Andy Warhol: Film Factory*. Ed. Michael O'Pray. London: British Film Institute, 1989, 160-169.

Rees, A. L. "Warhol Waves" in *Andy Warhol: Film Factory*. Ed. Michael O'Pray. London: British Film Institute, 1989, 124-135.

Simon, John. *Private Screenings*. New York: Macmillan, 1967, 261-262.

Smith, Patrick S. *Andy Warhol's Art and Film*. Ann Arbor, Michigan: UMI Research Press, 1981, 1986.

Tyler, Parker. "Dragtime and Drugtime." *Evergreen Review* 11, no. 4 (1967). Rpt. in *Andy Warhol: Film Factory*. Ed. Michael O'Pray. London: British Film Institute, 1989, 94-103.

Vogel, Amos. "Thirteen Confusions" in *The New American Cinema*. Ed. Gregory Battcock. New York: E. P. Dutton, 1967, 124-137.

Youngblood, Gene. "Andy Warhol." *Los Angeles Free Press*, Feb. 16, 1968.

Steven Kurtz, "Uneasy Flirtations: The Critical Reaction to Warhol's Concepts of the Celebrity and of Glamour."

Was Andy Warhol a social critic? Did his work have a socio-critical dimension? These two simple questions summarize one of the painful conundrums of contemporary art history. While few would disagree at this late date that Warhol was and is emblematic of 60's aesthetics, it is hard to defend the notion that Warhol also represents the more critical political opinions of the generation that embraced him. For the most part, Warhol's critics have tried to keep the social questions at a distance. And who can blame them? For a critic to take a stand in an area so fraught with ambiguity is difficult enough, but add to this problem the (nostalgic) cultural hope that Warhol fit the 60s mold of contestation, liberation, and authenticity, and engaging this critical territory becomes positively frightening. No critic or historian really wants to say that this influential rorschach test of an artist had particular politics.

Flash back for a moment to Lucy Lippard's 1966 essay on New York Pop.[1] In this essay—one that all art history students must read at some point in their budding careers—Lippard never mentions whether or not she thinks Warhol is a social critic. Rather, statements such as these are typical: "Warhol's films and his art mean either nothing or a great deal. The choice is the viewer's...."[2] Unlike the other artists mentioned in the essay for whom Lippard offers clear interpretations (Lichtenstein's criticality or Saul's humanism), the silent Warhol is left in a realm of ambiguity. While part of the explanation for the lack of ideological analysis can be blamed on the domination of formalism, which would not sully itself with such a study, most of Lippard's silence seems to come from a "wait and see" attitude.

Flash forward more than twenty years to a discussion about Warhol by key curators and art historians of the day, sponsored by the Dia Art Foundation.[3] How little things change. The critical dimension of Warhol's work is still perceived to be as ambiguous as ever. Either Warhol is politically provocative yet neutral,[4] or

his political statements are facetious yet serious.[5] Warhol is the ultimate and/both conundrum. The problem remains the same—no one seems able (or perhaps no one is willing) to identify a socio-political metanarrative in Warhol's work. Formal and thematic metanarratives abound, but the ideological content of Warhol's practice never seems to jell. The ambiguity hypothesis is consistent due less to a lack of material from which ideological metanarratives could be constructed, than to the fact that many potential constructions would place Warhol's political practice at odds with his aesthetic practice. In turn, Warhol would not fit comfortably within the mythic pantheon of the 60's demigods. What greater cultural catastrophe could there be than to remake Warhol's image, especially if his claim to greatness can no longer be constructed as that of the artist most representative of his time and his generation?

One common rhetorical theme that permeated the critique of representation in the 60's was the notion of authenticity. The concept itself was rather liquid in definition, emerging as it did from various intellectual paths such as the radical sociology of Etzione, the ethical systems of Sartre's version of existentialism, the theories of alienation from Marcuse and the Frankfurt School, or from the new French political critique of the Situationists. Whatever the blend might be, a curious worry slowly turned into a fear. Not that people were consuming images, but that images were consuming people. Life was becoming artificial, alienating, and inauthentic. As Debord warned:

> In societies where modern conditions of production prevail, all of life presents itself as mass accumulation of spectacles. Everything that was once directly lived has moved away into a representation.[6]

Key in this passage is the loss of what "was once directly lived." The directly lived is the authentic, and this is what rational economy had taken, replacing life with the enriched privation of the commodity and the terror of enforced labor. The fulcrum of reality itself was shifting from the material to the ideational, as modern experience became the experience of experience. All products and all processes were being reduced to a representation, to simple sign forms that could in turn be exchanged within the market-economy. One did not go to church to explore a relationship with mystical forces, but to have the appearance of piety. This sign contributed to one's image-capital, making one more desirable in the marketplace of signs. One did not get an education, but collected the signs of education. A person could exchange the signs of a college education (a diploma, transcripts, class ring, etc.) in the marketplace, but actual knowledge without

these signs meant nothing in the realm of exchange. Much of 60s activism and resistance was a last-ditch attempt to at least expose—and at best collapse—the empire of signs, and to thereby also close the gap between being and representing. This desire manifested itself in various ways. For hippies, the strategy was to retreat back to the land in an attempt to reinstall a simple division of labor in order to side-step the apparatus of the image, whether electronic media, mass produced graphics, or advanced urban architecture. For Yippies, the Black Power Movement, and other radical contingents, the strategy was to turn the spectacle against itself, by producing counter-spectacles of such horror to "the establishment" that its authoritarian underpinning would become obvious in a reactionary and oppressive spasm of law and order. Whatever facet of the counter-culture or the underground is examined, the common current was resistance to the ascendancy of the sign as real, and against the hypocrisy that rested in the schism between the represented and the lived. As to be expected, the spectacle (ever hungry for more images) embraced the counterspectacle, and manufactured revolution for profit. Everything from peace symbols to popular entertainment (a film such as *The Graduate)* were manufactured in an effort to capitalize on the yearning for authentic experience.

The art world also did its part to manufacture products—sometimes with the best of intentions, other times not. Kaprow's happenings were an attempt to re-examine the tenuous connection between life and representation. By refusing to accept passive spectatorship, Kaprow forced, conned, or seduced his audience (co-producers) into actively participating in the generation and dissipation of representation, in an attempt to keep it tied to life; that is to say, the happening was an attempt to create art that was directly lived; it was action painting gone democratic. In these efforts, Kaprow annulled the dreaded separation caused by specialization through the instantaneous creation of wholistic experience. The final hope of much 60's avant-garde art was to implode art and life, or the representational and the lived back into a single experience as a means to regain authenticity. The real life dramas of The Living Theater, the mundane dance works of The Judson Church Group, and the everyday life noise/music of Harry Partch or John Cage are examples of this same agenda working in other media.

Then there is Warhol. In hindsight he makes these artists (and the hippies as well) look quite naive, as he was among the first to realize that spectacle cannot be sidestepped, and neither he nor his work indicates that there can be a return to originary experience. Such notions have inspired later artists, particularly the critical postmodernists, to accept spectacle as a given, as well as to view the loss of the originary as liberating, and as a foundation for constructing temporary

paths of resistance. While Warhol and his work may have been an inspiration for radical thinking, this thinking itself is not contained in his work, as open-ended as it may be. Rather, Warhol is the ultimate passive conduit of representation. Images passed through him freely, shaping him to the needs of the market. Indeed he achieved his wish and became man as machine in a way that Stelarc never will. While the 60's avant-garde was working for authenticity, Warhol saw the world as having no real meaning beyond the exchange of the sign. While the avant-garde was fighting the commodification of the world, Warhol was busy becoming the commodity. Warhol was Greenbergian prophecy gone nova. Instead of painting evolving toward the two dimensional, for Warhol, all of life would be two dimensional, with the flesh existing only as a mere redundancy to the perfection of the mirrored flesh of representation.

Really life is so unreal....the unreal has become real—the accepted.[7]

Jean Baudrillard's cynical affection for Warhol is well directed.[8] Warhol is an artist standing on the border of second order simulation, about to take the plunge into the abyss of the third order. He seems to understand that industrial economy requires simulation in order for it to function. All images, which is to say products, must exist under the sign of equivalence. When an image is produced in an extreme serial form, one image must be able to stand in for another. One image of a Campbell's soup can must be the equivalent of the image of all other Campbell's soup cans. Image consistency is as important as product consistency. Through this strategy of desire, products may be endlessly replaced without any feeling of loss or deprivation. Campbell's soup flows in an endless stream that has no beginning or end. Unlike a fine wine, which is marked by finitude since it is irreplaceable when the stock is depleted, Campbell's soup flows in the realm of infinity—the soup I ate, and Andy ate as a child, is the soup I eat today. Andy's experience and my experience are equal in the realm of simulation. There is no original.

While most of the avant-garde panicked about this aspect of industrial life, Warhol cherished the moment, bringing us grids of soup cans and Coca-Cola bottles, and stacks of Brillo boxes. Warhol pushed the principle of equivalence to its limits by changing, manipulating, darkening, lightening, and smudging, and still a Campbell's soup can image was a Campbell's soup can image, and an image of a Coca-Cola bottle was still an image of a Coca-Cola bottle. No matter how many of these icons were produced in his art factory, the commodity/image remained unchanged. From this situation emerged the perception of Warhol as

con man. His work was not art, but the equivalent of what is seen in the grocery store every day, and no grid or smudge was able to change that perception. Or even worse, he was a philistine who was going to destroy art by denying the originality of the art object and the individual contribution of the aesthetic genius. (In a manner of speaking, if Warhol and the Pop artists in general could have completely undermined the myths of originality and genius, art—that is, the art market—would have been destroyed. The luxury market requires a principle of exclusion to inflate price and thereby reduce the need for volume sales. This principle seems to have suffered little from Pop or its progeny.)

With his success assured in the realm of second order simulacra, Warhol took the big plunge and dived into the third order, producing the most ambiguous works of all—*The Death and Disaster Series*. In this series, life is refracted by its mediation through images. One of the most famous images from the series, *Electric Chair* (1965) happily embraces any political interpretation, and can rest comfortably within any ideological environment. The chair simultaneously reads as the means to punish those who radically transgress the natural moral order, or as a medieval instrument of torture that monumentalizes the cruelty of a corrupt justice system. The chair itself is so steeped in cultural representation, as layer upon layer of meaning rest upon it, that any association with a material referent dissolves in a frenzied exchange of signs. Here Lucy Lippard is correct—the work means everything and nothing—but it is also here that we find what is so seductive about Warhol's work: The seeming ease with which such a piece offers a home for any set of prejudices the viewer might hold. Each participant is asked to take part in a poll that marches forever onward. Read the meaning of the image and decide if you are for it or against it. Are you for or against capital punishment? Are you for punishment or rehabilitation? Are you for the liberals or the conservatives? This piece only asks to be read. It is a textual cell that conforms to its environment, and reinforces the ideological conditions of the environment. If the environment is liberal, the meaning of the piece is liberal; if the setting is conservative the meaning of the piece is conservative. Electric Chair challenges nothing and no one. It is difficult to see any work as critical that tends, in the extreme, toward the reinforcement of the status quo of a given situation. Perhaps the best that can be said for this work is that it forces into the open the question of whether art can have a subversive function.

While the commodity-object had a certain charm, Warhol was equally, if not more, attracted to the celebrity. This variety of sign exchange was not just limited to traditional reproduction, but was the center of the performative matrix as well. The intentional fallacy collapses into its own contradictions in the realm of

simulation. "We should talk about the work itself, and how it reads, and sidestep the problem of Warhol's intentions." This is all well and good when discussing his prints or films, but what about Warhol's life-actions as a performance art work? How do we separate Warhol from Warhol? What was acting and what was authentic? Warhol and Warhol's life process turn into art. As his audience, we do not know where the image stops and Warhol begins. In criticism the tendency has been to focus on the objects as a means to sidestep this metaphysical problem. For this reason, Warhol's acts—painting paper dresses on Nico, helping found the Exploding Plastic Inevitable, and making countless public appearances marked by gestural and vocal monotony—are typically ignored. At the same time, how can we unlock the riddle of the celebrity in the work of Warhol without examining his manipulation of (and his surrender to) star status?

Let us recall the prevailing critical opinion about the celebrity of the 60s and early 70s. Consider the following by Guy Debord, writing in 1968:

> Being a star means specializing in the seemingly lived; the star is the object of identification with the shallow seeming life that has to compensate for the fragmented productive specializations which are actually lived. Celebrities exist to act out various styles of living and viewing society—unfettered, free to express themselves globally.[9]

Celebrities signify the bizarre nature of contemporary intersubjectivity. In spite of the fact that celebrities are for the most part known only as images, viewers still identify with them. Celebrities' bodies, although flattened and sometimes shrunk to tiny proportions, or expanded to mammoth size, still retain a likeness that elicits identification. Combine that with a perfect social image that is forever reproducible, and the celebrity becomes the ultimate form of image seduction. While at one moment the celebrities evoke empathy, at the next moment they are objects of jealousy—representing the perfection that flesh, with all its imperfections, its decay, and its mortality, will never attain. Either way, once identification is made, since the viewer cannot be a global image, s/he can only emulate the perfection by surrounding him/herself with the commodities that are associated with the celebrity. While this process is never actually fulfilling, it can be validated. This happens when the celebrity appears in the flesh—a truly magic moment. At this moment, the paradox of artificiality can be felt in the extreme—flesh is image and image is flesh. In the case of the celebrity, flesh and image (electronic or otherwise) may be exchanged as image equivalents. The flesh itself no longer has the privilege of originality, and is in fact consumed by the image of itself.

Warhol again mercilessly cashes in on the mechanical reproduction of celebrity images by churning out endless streams of celebrity grids. Celebrity images are the hard cash of sign exchange—Warhol recognized this. He chose celebrity images that were tried and true, the best of the best, because not only could these images sell themselves, they could also sell other images. This wild appropriation of image-capital by Warhol is amazing. (Such a thing could never happen now, when images are recognized for the value they have. Now if you want to use the Elvis image you'd better have permission from the Elvis Presley Estate). Warhol, by surrounding himself with celebrities (flesh or image), became one. To return to the problem first introduced in this section, Warhol at some indefinable moment became an image himself, and like all celebrities, was swallowed whole by it. In a sense, Warhol himself is his greatest masterpiece. The rest of his work was a lead into that moment where he could only be perceived as representation.

In 1977 Warhol's destiny is revealed with the release of *Interview*. This magazine was a line of flight for stars who had gone nova. The audience had already been prepared for this development by decades of spectacle and, of course, by Warhol's personal contribution of the celebrity series. Whether it was Jackie, Elvis, Troy, Marilyn, or Mao, these superstars only existed in the light of their sign exchange value. Each signified liquid structures of sociality which the viewer could vote on. Was it Mao the beneficent father or Mao the evil dictator? Either way the superstar had come to stand in for the structure of political economy itself. Marilyn was both the decadence and the glamour of the Hollywood system ("Hollywood" being the code word for a global image producing apparatus). *Interview* is a magazine dedicated to the rule of the empire of the signs. Any figurative image can be on the cover as long as it is the image of a superstar (one who has had his or her flesh consumed by image, and essentialized by recognition). Nancy Reagan, Imelda Marcos, it really doesn't matter. There is nothing satirical, ironic, or jocular about it. It is just another manifestation of global image. The only element that may be funny about the appearance of Nancy or Imelda on the cover of *Interview* is whether or not these internationally recognized images are well known for their glamour or for their lack thereof.

So what became of Andy after his being was burnt into nonexistence by the fires of public image? He seems to have fared much better than Elvis or Marilyn. His body did not die. Warhol understood that his flesh could help sell the products; his flesh could help to spread his image into a host of other products. Most obvious is his collaboration with Paul Morrissey on the later film projects.

The following sums up the situation quite well in spite of the fact Warhol may have actually been trying to joke:

> When asked what he does, since Morrissey receives credit as writer-director on their films, Warhol says, "I go to the parties."[10]

Warhol then goes on to say that everyone at The Factory contributed ideas, but the truth is in the joke, not in the "serious" comment. Warhol was the promotional vehicle for the films. His was the signature and the face that launched the perfect ad campaign to attract the underground, the avant-garde, and the alternative sets.

Dead flesh/live image. Warhol understood cyberpunk before the genre existed, and was already researching life as cyborg. The options which Warhol discovered were twofold: One was to have one's flesh enveloped by one's own electronic image—what Bradford Collins called a "metaphysical nose job"[11]—or work as a drone with technology functioning as an extension of the organic base. The former was his party persona, the latter was his studio persona. Warhol seemed to live the cyborg class division to its fullest. The former Warhol persona reflected the perfect rationality of consumption in the society of late capital, while the latter reflected the perfect rationality of production in late capital. Warhol as drone cyborg could produce at a factory rate, while Warhol as glamour cyborg could motivate others' participation in the excess consumption of these products. The full array of cyborg possibility imploded Warhol into an organic interface with spectacle and mechanical reproduction.

Why Warhol modified himself to such an extreme is a mystery for psychoanalists to decide. Although we may not know why, we can be sure that Warhol was no friend of the flesh. Consider the following:

> If someone asks me "What's your problem?" I'd have to say "skin." [12]

This hardly sounds like a person speaking in the mid-seventies (after the pill and before HIV). Instead, within the present context, such a statement seems to emerge from adolescent hacker fantasies of escaping the confines of the body and living the autonomous life as down-loaded consciousness. Or perhaps it is actually quite the opposite, and is more reminiscent of the church fathers' call to deny the flesh, and escape sinful temptation. Either way, Warhol expresses through his image and through his work (remembering the extreme overlap between the two) an unsympathetic feeling for the body. Beyond the simple appearance of the body,

actual flesh can only be recognized as meat—a point well demonstrated by *Ambulance Disaster* (1963). Warhol was the perfect example of the new world order work force. A neutralized persona living a life of mechanical gesture for the sake of the market. He found intimacy only in other machines: first his tape recorder, then his television.

Such an ideology has long been encouraged by right wing contingents, and with good reason. A cyborg workforce is the preferred workforce. As the sociologist Max Weber explained, bureaucracies can only run at maximum efficiency if nonrational elements of existence are deleted from the workplace. Employees standing around the water cooler swapping stories about their weekend cannot be tolerated, nor can co-worker flirtations, nor any other kind of activity unrelated to work. While strict prohibitive rules have been the norm in stopping inefficient behavior, such as expressions of desire, a new method is becoming increasingly popular—electronic surveillance of employees. This new surveillance is not defined in terms of traditional panoptics, but in terms of attaching surveillance/work technology, such as the wearable computers, to employees. With such attachable technology, the body becomes a work station. Like Warhol, we can also marry our commodities, and our jobs, thus neutralizing desire and subordinating our flesh to machine.

To be sure, Warhol never got much beyond television in his flirtation with technology, nor did he get to see how far body modification would progress; however, much to the chagrin of the 60s counterculture that embraced Warhol, he helped to pave the way for cyborg culture. Warhol was the docile recipient of the corporate dream—a laborer force who denied himself, and who begged to be like the images produced by rational economy. Warhol's dislike of the flesh, of its pains, of its limitations, and of the simplicity of its destruction hardly make him a child of the free love, "sexual revolution" generation. The flesh and the sexual revolution only belonged on the screen or in magazines, much as it does to this day. In other words, it should exist only as representation in trashy movies and celebrity magazines. In denying the body the opportunity to live, Warhol made the experience of experience become the only option. This situation of offering food without nourishment is the perfect corporate environment: no matter how much is consumed, the public is never satisfied and is always hungry for more. This is the situation for which Warhol was emblematic, and not as voice of contestation.

> Since I was shot, everything is such a dream to me. I don't know what anything
> is about. Like I don't even know whether or not I'm alive or—whether I died.
> It's sad. Like I can't say hello or good-bye to people.[13]

Warhol was the first artist of simulation. He seemed to desire an existence of
representation tenuously connected to being as cyborg. Now that his body is gone,
he can reach even higher planes of achievement, as did Elvis or Marilyn after
their respective bodies disappeared from the realm of the living. Warhol was a
futurologist more compelling and longer lived than his contemporary Marshall
McLuhan. He saw, as clearly as any science fiction writer or media theorist, the
great expanse that spectacle would cover, and sought to establish a place in this
artificial empire. Authenticity and liberation were empty signs that were dead on
arrival in the 60's "revolution," and Warhol was careful to avoid such traps with
his strategy of total surrender. And in spite of all the underground trappings with
which he surrounded himself, Warhol became its very antithesis. If Warhol was
a social critic of any kind, it emerged incidentally, yet like all chaotic systems,
quite deterministically. Like his celebrity colleagues Elvis and Marilyn, Warhol
demonstrated, perhaps by martyrdom, that being consumed by one's own
image(s) is pathetic. I have to agree with Warhol on this final quote; not being
able to say hello or good-bye to people is quite sad. At the same time, perhaps
such thoughts are only more nostalgia for a reinstatement of originality and
authenticity, and what Warhol really prepared us for was the condition of cyni-
cism as the center of lived experience

NOTES

1. Lippard, Lucy. *Pop Art*. New York: Oxford University Press, 1966.

2. Ibid, 99.

3. A transcript of this panel is provided in *The Work of Andy Warhol*. Gary Garrels, ed.
Seattle: Bay Press, 1989, 124-39.

4. Ibid, 136.

5. Ibid, 137.

6. Debord, Guy. *Society of the Spectacle*. Detroit: Black and Red Press, 1977 (revised
edition).

7. Warhol, Andy. Quoted in "Public Views Warhol Under Glass," Anita Buie Lamont. *St. Louis Globe Democrat,* Oct. 1, 1975, 15A.

8. Baudrillard, Jean. *For a Critique of the Political Economy of the Sign.* St. Louis: Telos Press, 108-9; *Simulations.* New York: Semiotext(e), 1983, 151.

9. Debord, 60.

10. Warhol, Andy. Quoted in "Warhol-From Kinky Sex to Creepy Gothic," Paul Gardener. *New York Times* (July 14, 1974), D-11.

11. Collins, Bradford R. "The Metaphysical Nosejob: The Remaking of Warhola." *Arts Magazine* (Feb. 1988): 47-55.

12. Warhol, Andy. Quoted in "Affectless but Effective: The Philosophy of Andy Warhol," Barbara Goldsmith. *New York Times* (Sept. 14, 1974): Sec 7, p. 4.

13. Warhol, Andy. Quoted in "The Return of Andy Warhol," John Leonard. *New York Times Review of Books* (Nov. 10, 1968): 32.

Jonathan Crane, "Sadism and Seriality: The Disaster Prints."

> what is in the colors is easily
> washed away
> —Gregory the Theologian

In 1962, opting for new grist and moving beyond Campbell's Soup cans, airmail and trading stamps for serial subject matter, Andy Warhol inaugurated his voluminous Death and Disaster line.[1] The first effort in the program of new appropriation was *129 Die in Jet (Plane Crash)*, 1962. It was among the last pictures he created brush in hand prior to adopting mechanical painting via the silkscreen. *129 Die* was also the first entry, in a lengthy chronicle, to document Warhol's obsession with the infinite procession of images that circulate through the media depicting death and carnage.[2]

The big black and white painting, measuring 100 x 72 inches, is a rough enlargement of the front page of *The New York Mirror*, a tabloid daily, for June 4, 1962. The picture offers a very close approximation of the *Mirror's* standard features, ears, flag, and folio line are all true to the original, although the inset photograph of the crash site is far less realistically rendered. It appears to have

been painted by a diffident and untried Franz Kline pursuing a career as a sketch artist for the dailies (Honnef 50). In this regard, however, the central focus of *129 Die*, the reworked photo of the plane wreck, is truer in execution to the initial image, as it carries more of the original site's dark detail than most, if not all, of Warhol's other hand painted exercises. This is not, it must be stressed, to claim a resolute commitment, on Warhol's part, to the power of the brush. *129 Die* still has the anxious look of a rush job common to Warhol's earlier comic and advertisement paintings. Like *Wigs*, 1960, *Saturday's Popeye*, 1960 and *Little King*, 1961, all of which also came out of the newspaper, albeit the funny pages or the classifieds, *129 Die* did not represent a new turn to verisimilitude.

Unlike the paintings of media shards requisitioned from pieces of comic strips and banal clip art, *129 Die* also came with a well-known cover story. The numbered dead were on a Paris to New York flight, in a Boeing 707, that went down on takeoff. Most of the 129 were art patrons (actually 130 as the paper and Warhol got the corpse count wrong), touring Europe on a trip sponsored by the High Museum of Atlanta. When the plane crashed, their elevated status in the community guaranteed that the stories of the hapless passengers, their singular histories as loyal spouses, good friends, distinguished colleagues, and intellectual elite, were eulogized in the *Mirror* and other newspapers across the country. Even if Warhol had taken a moment to excise the massive headline framing the mishap, and struck out any other icon that denoted daily news, the picture would have been easily placed. Just a glance at the broken tail fin and attending police, topped with the unmistakable box chapeaux of Gallic law enforcement, would have immediately recalled to the viewer the terrible story of the Air France crash. Electing to raise the painting on a massive body of exhaustively disseminated and widely scanned press clippings assured an informed audience for *129 Die*.[3]

Another pair of early efforts in the Death and Disaster Series, sharing the title *Tunafish Disaster*, 1963, would have been similarly confronted. The tunafish calamity paintings feature silkscreen reproductions of head shots drawn from newspaper accounts detailing the unfortunate end of two Detroit housewives: Margaret McCarthy and Colette Brown. McCarthy and Brown died from botulism after opening a contaminated can of A & P Chunk Light Tuna, preparing sandwiches, and sharing a simple meal between friends.[4] They had been knitting booties for a neighbor. Thankfully, their kids wanted peanut butter and jelly sandwiches for lunch.

Alongside the pictures of the dead diners are reproductions of seized tins of contaminated tuna and some lines of reportage documenting the untimely demise of the unknowing consumers. Although most contemporary viewers are unlikely

to have memories of signal episodes of food poisoning going back to the 1960s, most viewers from thirty years ago would have known the industrial mishap that engendered the picture.[5] And even reasonably close viewers of today will share the inspiration for the paintings, unlike the genesis for *129 Die* which has fallen out of public memory, as the writing appropriated from the print media carries the gist of the story behind the sad portraits of Mrs. Brown and Mrs. McCarthy.

These initial works, to invoke a term that carried great force in the exegesis of Western "history painting," freeze "the *peripateia*—that instant in the course of an action when all hangs in the balance" (Burgin 144). History painting, the received style for two hundred years beginning around 1550, since succeeded by the verity of the photographic record, as painting has long abandoned the documentary mode, underscores the consequence of irrevocable human action, by capturing, with exquisite clarity the decisive moment when lives are forever altered (Burgin 144).[6] History painting is now, in current parlance, the province of the perfectly timed snapshot. The ideal snap, particularly those composed by photo-journalists, appears to fix with ineluctable certitude the truth of any human endeavor. Apparently worth much more than ten thousand carefully chosen words, the documentary photograph assumes the burden of narrative by allowing the model slice of life, to speak, with concentrated force, for the entire event. In so doing, the photograph of the downed airliner, transferred to the canvas and restoring authority to painting, captures the spectacular cost of modern death when mass transit fails. The black and white portraits of Brown and McCarthy, when juxtaposed with the photographs of lethal cans of fish, creating a super-photograph, speak, with awful poignancy, to the sometime failure of the commodity to deliver even the most elemental degree of consumer satisfaction.

Outside of a conspicuous exception—paintings based on photographs taken at an Alabama race riot, the later works in the series come to the museum wall and collector's trove with something less than the fertile narrative legacy that accompanies *129 Die* and *Tunafish Disaster*.[7] Some works only feature instruments of death: the electric chair or, fittingly enough, in the last work in the series, the mushroom cloud of a detonated atomic bomb. Even in the absence of human subjects, these works are richly connotative. We can spin all sorts of motivated associations from the images of punitive death chair and toxic cloud, but we cannot create narratives the equal of those tales that are grounded in the lives and deaths of real protagonists. That is, the images without people must, because they represent pain and suffering apart from tangible flesh, remain more abstract presentations of death and disaster. The terrible presence of battered

flesh, made all the more palpable as part of a photographic record, compels us, at least initially, to limit our consideration of the manifold aesthetic issues that normally attend a gallery crawl. More concretely, the wired seat Warhol appropriated for the electric chair paintings remains, at least on canvas, forever unoccupied. While, in the case of the metonymic burst, the image could just as easily have come, especially as the painting is by Warhol, from a promotional still for a low-budget sci-fi flick or news photo of a Bikini Island test drop.

In the other paintings which contain human figures, images of anonymous death far outnumber images siphoned off from specific accounts of individuated catastrophe. In these studies of anonymous loss, the spectacularly deadly car wreck, with unknown bodies cruelly and impossibly broken, is the rule. *White Burning Car III*, 1963, for example, features a doubly unlucky victim impaled on the rung of a telephone pole as his crashed car burns. *Foot and Tire*, 1963 showcases, none too surprisingly, a shoe securely wedged under two large truck tires. Given the title, the owner of the footwear is also under the tires or, maybe worse, both the tightly fit shoe and foot have been severed from their bearer. Along similar lines, Warhol also appropriates images of suicidal leapers, in flight and upon impact, as well as photos of mourners at a gangland funeral, hospital trauma, and weary rescuers carrying a nameless corpse to light.

The small number of paintings in the series featuring real protagonists, of whom we have some background knowledge, the doomed flight to New York, poisoned Michigan homemakers, and embattled protestors, are then, exceptions in the Death and Disaster program; as these works allow us to feel as if we have a substantial purchase on the short lives of those brought to ruin. Our connection to the shots of suicides, traffic deaths, and other unidentified casualties remains far more tenuous. For this reason, paintings based on the imagery of rote death are also less capable of bearing, despite the presence of actual unfortunates, the heavy narrative weight borne by *129 Die* and *Tunafish Disaster*. These immaterial fatalities have been repeatedly over-exposed; no one can total the countless photographs of routine accidents with lethal injuries that have run in the dailies. For these victims, familiarity breeds, not contempt, but indifference. Their individual histories, the details that matter, were lost the moment they meet the criteria for a daily photo feature.[8]

In an empty afterlife, such protagonists are conscripted into a peculiar class of documentary photograph that is an everyday favorite of photo editors and news directors. This sort of photograph highlights the individual cost of human imperfection, capturing inept drivers and the deeply depressed at the height of error, while erasing almost every vestige of that which is specifically unique

about each tragic event. In lieu of the perfect moment, an epiphanic insight of terrible clarity, these pictures demote the dead to the status of props.[9] They will end their lives headlining with redundant captions, "Don't Drink and Drive," or as the subject of macabre diversions, "In a freak twist...." As a class, these photographs ceaselessly mine exchange value from people for whom gainful employment is otherwise not an option. The animating spirit of the body is, in this genre, consumed twice: once in the event itself, and again, in the admonition cribbed from the handy corpse.

Outside of the hand-painted *129 Die*, as the first in the series it should be considered a tentative opening gambit, the rest of the Death and Disaster paintings all share most of the same formal features. They are all monumental, billboards for the gallery and expansive living room, they are all drawn from photographs of a sort we have seen time and again, they are all generally monochromatic, in that the black silkscreened photos are printed against one color, they all ostensibly foreground pain, and they are all organized in grids.

The use of the grid, as established by Rosalind E. Krauss, is the most common and successful organizing principle employed, in this century, by Western artists. The supremacy of the grid can be measured in terms of quantity, the considerable number of artists charting the same coordinates, in quality, the number of major works produced along x and y axes, and in terms of its authority as the premier hallmark of the aesthetic new (12). The triumph of grid, given its unquestionable omnipresence, lies in its unparalleled ability to effectively fence off the practice of art from all other human endeavor and establish the freedom of artistic praxis outside the purview of all but home rule.

> The grid announces, among other things, modern art's will to silence, its hostility to literature, to narrative, to discourse....The grid states the autonomy of the realm of art. Flattened, geometricized, ordered, it is antinatural, antimimetic, antireal. It is what art looks like when it turns its back on nature.... It is the result not of imitation, but of aesthetic decree.... The grid is a way of abrogating the claims of natural objects to have an order particular to themselves. (Krauss 9)

In finding the grid a suitable staging ground for running his appropriations through their paces, Warhol is, following Krauss, just another in a crowd of artists who have also annexed the same territory. He may have adopted imagery new to the fine arts, reaching lower than most, but the manner in which he deployed his appropriations is neither particularly original nor especially innovative.

While the use of the grid is a formalized power play, as conventional a gesture as any in contemporary art, Warhol did subject his found photographs, when mapping them onto the grid, to exceptionally harsh treatment. First, Warhol's grid is not well-ruled. The pictures are haphazardly screened in messy, oftentimes overlapping, rows and columns that do not share any part of the glacial, mathematic precision common to many other gridworks. Warhol's grids, unlike those of Mondrian, LeWitt, or Martin, are themselves wrecks. As if the confusion of vertical and horizontal line is not enough, Warhol also inked the base photographs without regularly cleaning the silkscreens. Thus, the images are indiscriminately sited *and* erratically printed. With these desultory production values, the photographs are so degraded that it often takes a considerable degree of concentration to make out the depicted catastrophe in the abstract mess printed on the canvas.[10] In addition, plain titles like *Mustard Race Riot*, *White Car Crash Nineteen Times*, *Lavender Disaster*, *Red Race Riot*, *Blue Electric Chair*, *Orange Car Crash Nineteen Times*, manifestly establish the rule of color and proclaim the primacy of form over content.[11] Taken together these manipulations attest to the power of the artist to consume anything. As Ivan Karp proudly observes in an early paean to pop, "The worthy subject is struck down once and for all" (26).

Yet, the bodies may still matter. The violence of pop craft cannot entirely bear them away. Through the multiple mediation of lens and shutter, beyond the brief life of the throwaway daily, against the order of the grid and the awful washes of color, they continue to voice a mute appeal. The dim call of the dead is not, however, a result, as John Coplans would have it, of "finally [being] made to seem real" (52). As a leading architect in the society of the spectacle it is ludicrous to so diminish Warhol's accomplishments. In running well before the trajectory of contemporary media practice, Warhol has not returned the image to life. He has, all too effectively, provided a model demonstration of the power of the image to subsume and void all human experience. The Death and Disaster Series sentence the dead to a lasting extinction by negating the possibility of making an affective commitment to the world in and beyond the image. If the dead continue to speak, it is as fossilized tracks expressing the presence of absent beasts. For what once was—empty space.

NOTES

1. Warhol began these paintings at the suggestion of friend and curator Henry Geldzahler, who gave Warhol a newspaper account of a plane wreck at Orly and told him, "It's enough affirmation of soup and Coke bottles. Maybe everything isn't always so fabulous in America. It's time for some death" (Bockris, 126).

2. Warhol would return to death many times over the course of his career. A small sample of his work explicitly concerned with extinction includes his widow Jackie paintings, 1963, the memento mori *Skull* series, 1976, the paintings of guns and knives done in 1981, the endangered species portraits of 1983, and the reversal paintings, produced from 1979 to 1986. In the reversals, Warhol screened the negative image of his most notable appropriations. These pictures are particularly arresting in that they depict Warhol's successes as if they too have been fatally stricken.

3. This is not to say that all who encountered the painting near the time of the accident would draw the same moral from the common tale of the dead. To some the plane crash was a civic catastrophe, "a tragic loss for Atlanta; the lives of their most active and influential cultural leaders had been snuffed out in an instant," to others, notably Malcolm X, the disaster was a miracle as "He [God] dropped an airplane out of the sky with over 120 white people on it" (Nash, 9-10).

4. If the Campbell's Soup can paintings represent the bliss of serial consumption, as consumers we are secure in our freedom to make the same satisfying purchase time and again, then the tuna fish paintings suggest that by stepping into the supermarket we have, unwittingly, begun a round of alimentary Russian Roulette.

5. Cases of botulism were, and remain, exceptionally rare occurrences. Between 1925 and 1972 there were only three outbreaks of botulism arising from tainted commercial food products. Botulism was also, until recently, nearly always fatal. Today, this is no longer the case as antibiotics are now available that will save most people who contract botulism. The disease is however so virulent that one case is considered an outbreak by toxicologists (Painter & Kilgore, 564). As with the Ebola virus today, the infectious agent we are all talking about, botulism outbreaks marked yesterday's hot zone.

6. In typical laconic style, Warhol felt that his subjects needed some extra assistance, beyond that provided by the news media, securing their place in history: "it's just that people go by and it doesn't really matter to them that someone unknown was killed so I thought it would be nice for those unknown people to be remembered" (Shanes, 24).

7. The Race Riot paintings are based on photographs of black civil-rights protestors in Birmingham, Alabama beset by snapping German Shepherds and baton-wielding, white police. The source photographs, taken by Charles Moore, ran in *Life* magazine in May of 1963. Their original appearance in *Life*, a titular guarantee of transparent authenticity, bolstered by the blanket coverage given to similar clashes, assured Warhol that his audience would, once again, have heard and seen the news.

8. A particularly egregious use of the body can be found in the penultimate image of the woman who made her final appearance in *1947—White*, 1963. The source photo for this

work ran as part of an article on the history of the Empire State Building (Bourdon, 154). The record of the deceased, and her use of the building as a springboard into eternity, now belongs to the story of the skyscraper and the allure prominent architecture holds for even the clinically depressed.

9. Compare this class of photography to Andreas Serrano's "Morgue" portraits. In Serrano's work the end of life does not mean the dead are no longer human.

10. For this reason, in an inadvertent homage to Warhol's ability to make any image truly abstract, surveys of the artist's career by Carter Ratcliff and Eric Shanes include Death and Disaster paintings that are printed upside-down or reversed.

11. This rainbow of colors also calls to mind, given Warhol's start in commercial art, the multiple editions of the same painting, done in a variety of tones, available at starving artist sales. For all patrons and interiors, a painting to match.

WORKS CITED

Bockris, Victor. *The Life and Death of Andy Warhol*. New York: Bantam, 1989.

Bourdon, David. *Warhol*. New York: Abrams, 1989.

Burgin, Victor. *The End of Art Theory: Criticism and Postmodernity*. Atlantic Highlands, NJ: Humanities Press International, 1986.

Coplans, John. *Andy Warhol*. Greenwich, CT: New York Graphic Society, 1970

Honnef, Klaus. *Andy Warhol 1928-1987: Commerce into Art*. Trans. Carole Fahy and I. Burns. Kohn, Germany: Benedikt Taschen, 1993.

Karp, Ivan. "Anti-Sensibility Painting." *Artforum* (Sept. 1963): 26-27.

Krauss, Rosalind E. *The Originality of the Avant-Garde and Other Modernist Myths*. Cambridge, MA: MIT, 1986.

Nash, Jay Robert. *Darkest Hours*. Chicago, IL: Nelson-Hall, 1976.

Painter, Ruth Robbin, and Wendell W. Kilgore. "Food Additives" in *Toxicology: The Basic Science of Poisons*. Eds. Louis J. Casarett and John Doull. New York: Macmillan, 1975, 555-569.

Ratcliff, Carter. *Andy Warhol*. New York: Abbeville, 1983. Vol. 4 of *Modern Masters*, Ed. Nancy Grubb.

Shanes, Eric. *Warhol: The Masterworks*. New York: Portland House, 1991.

Faiyaz Kara, "**Pop Prose: The Critical Response to Warhol Literature.**"

For Andy Warhol, the book was a natural progression of his art. Though his foray into the world of literature failed to achieve the popularity and success of his pop-art renditions and experimental films, his impersonal hands-off approach was, nevertheless perpetuated in his literary efforts.

Warhol's "books," published in a 22 year span from 1967 to 1989, were greeted with mixed criticism ranging from high praise to sheer contempt. Some argued his books were ingenious constructions revealing the colorful world of the underground art scene, while others merely saw them as fodder for the addlebrained.

The prevailing themes in Warhol's art and films—that of unending boredom, gossipy diatribes and perverse schlock—recur in his literature, with each work depicting Warhol's professional and social life in all its loquacity, mockery and artistry. Warhol's books ran the gamut, from novels and pseudo-autobiographies to multimedia creations and photobooks. Like Warhol's early films, his first two books, *Andy Warhol's Index (Book)* (1967) and *a* (1968) prompted heated intellectual discourse. His later books, like his later films, became increasingly racy and celebrity-centred and, with the exception of *Popism: The Warhol '60s* (1980), punching bags for pugnacious critics.

Pop Book

Andy Warhol's Index (Book) (1967), a clever little pasticcio of lift-outs, pop-ups, and tear-outs, follows the traditional Warhol ethic of maintaining a put-on quality. *Index* resembles one of Rauschenburg's "combines" more than it does a book. Its pages feature an interview of Warhol, a pop-up castle and airplane, a squeaking accordion, a tear-out vinyl record, labels that disappear when immersed in warm water, photographs of Factory denizens, and notes and phrases replete with grammatical errors. The intentional inclusion of these errors reveals Warhol's ingenuity in capturing snippets of life in its most complete and unabridged form. Remarked Warhol acolyte Christopher Cerf, "The book is full of mistakes but Andy liked them and wanted them left in" (Glaser 12).

Index aroused debate as to the very nature of the print medium itself at times taking dead aim at the publishing industry. Some critics felt that it destroyed publishing doing a book like this, arguing it deliberately mocked the very industry that helped create it—biting the hand that fed it so to speak. Then there was the question of whether in fact *Index* was a book at all. One *New York Times* critic, unimpressed by the book's originality, referred to *Index* as a "costly put-on book, and a very wary one at that" (35).

Others lauded Warhol's "collage book" praising its "in your face" attitude finding it an artistic and intellectual *chef d'oeuvre*. One proponent, namely critic Phoebe Adams, found *Index* to be "marvellously amusing," describing it as a "nonbook" as a sort of caution to readers that *Index* wasn't a book to be read (119).

The controversy generated around the prototypical *Index* may be construed as yet another crafty marketing ploy by the adroit artist but perhaps Ms. Adams put it best when she noted, "art is what an artist does, and discussion of it is irrelevant" (19).

Picture Perfect

In any case, Warhol wasn't one to let any adverse criticism stop him from resuming his career as a pop-penman. In a sense, *Index,* with its countless photographs and pop art concoctions, prefigured a host of picture books Warhol would publish in his famed career. Like *Index*, *Exposures* (1979), *America* (1985), and *Andy Warhol's Party Book* (1988) all featured paparazzi-style photographs with pages laced with Warhol's transparent, often cheeky, commentary on American society. Far from the critical controversy aroused by *Index,* these publications were met with surprisingly favourable reviews.

As Warhol laid bare his bluff slant on contemporary America, critics were struck by the candid photos and observations as well as the earnest manner with which he treated the subject matter. Unlike the paparazzi, Warhol's socialite status afforded him the privilege of photographing the jet-set from the inside. In *America,* the end result, notes Marjorie Miller, "tells us something about contemporary America beyond the familiar picture-magazine view" (176). The photos are augmented by the simple and honest text that Ms. Miller describes as "unabashedly jingoistic, with a truth-telling oratory style not unlike that of Will Rogers, with echoes of Mark Twain" (176).

Warhol once stated that his notion of a good photograph was "one that's in focus and of a famous person doing something unfamous" (qtd. in Tomkins 118).

His *Exposures* is chock full of such photos (360 to be precise) from Muhammad Ali to an armpit shaving Bianca Jagger, all accompanied by his usual chatty text. Some critics, such as Calvin Tomkins, contrasted *Exposures* and Warhol's silkscreens remarking the principle difference seemed to be that "the *Exposures* are not retouched" (118).

More of the same can be seen in *Andy Warhol's Party Book*. Co-authored by Pat Hackett, Warhol delves deep into the world of the fete, interviewing everyone from party-givers to valets. Says Brain Wallis, "Warhol takes seriously the institution of partying" and even goes as far as to call Warhol a "sociologist" (31).

a Novel Idea

Warhol's experimental films of the early 1960's examined the relationship between art and life through what Robert Mazzocco deemed "an experiment in duration" (34). Films such as *Empire* (1964) and *Sleep* (1963) forced the viewer to endure through painstakingly lengthy films that dwelled in the mundane. Twenty-four hours of the Empire State Building or 8 or so hours of a sleeping John Giornio introduced a novel concept to the cinematic medium; however, as a number of critics pointed out, the idea was far more fascinating than its concrete representation.

In his tape recorded novel *a* (1968), Warhol parlays this concept into 451 pages of text. The result, to the dismay of a majority of critics, was an absurdly vapid, unreadable piece of work. *a* essentially transcribes, from cassette tape, a day in the life of the Warhol toady, Ondine—a loquacious, homosexual speed freak. The text highlights the tedium of life itself, of what the *American Poetry Review* called "the life of aimless conversation and waiting around" (45). Perhaps the most frustrating aspect of the book is that any expectation for action is left unfulfilled leaving behind a "backlash of sheer coruscating boredom" (Beauman 32). Not surprisingly, criticisms for *a* were unreservedly harsh. In a comparison to Warhol's films, Ms. Beauman noted that on film, "Warhol's people live; they evoke responses; pruned down to a transcript they lose all identity, they all sound alike, they evoke nothing, not even compassion" (32). She further added, "For $10 you can find realism pilloried more effectively and more entertainingly practically anyplace else" (32). Mr. Mazzocco called the book "art, without morals or manners and completely without sentiment" (36), while the New Yorker referred to it as "a totally boring jumble" (82).

Yet *a* isn't totally devoid of merit. In its effort to purify the art of the boring, "the objectification of the random and the everyday" (35) as Mr. Mazzocco put it, *a* succeeded swimmingly. If life really is this tedious, then

Warhol made us aware that, in a sense, art cheated—it made life interesting (Beauman 4).

Philosophy

Continuing in the tradition of his tape recorded novel *a*, *The Philosophy of Andy Warhol: From A to B and Back Again* (1975) is neither the excessively chatty nor unrelentingly boring book its predecessor was. The title alludes to the dialogues between Warhol (A) and various other people (B). His "philosophy," comprised of a mishmash of thoughts, opinions and reflections on everything from love and beauty to death and underwear, is presented in a manner that reveals to us his vacuous personality.

There seemed to be a refusal among critics to accept the book as a serious work of literature. The tabloid nature of *Philosophy*, with its countless references to celebrities, created the popular sentiment that *Philosophy* made for light, easy reading. Edit deAk went a step further refusing to acknowledge *Philosophy* as a book but rather as "a mixed-media production (fame mixed with consumerism)" (23). Even so, Ms. deAk found Warhol's philosophy to be "cheerful, light-hearted advice" (23). Similarly, Frank Wilson concluded the book was "off-beat, light reading" and felt Warhol himself was "harmless" and "modestly entertaining" (216).

Warhol, as seen by a number of critics, was the very reflection of nothing (Goldsmith 5). The affectless reviews may be the direct result of an affectless man creating, in the minds of critics, an immaterial piece of work. Warhol's complete negation of his emotional self may explain the disinterested stance taken by his critics. "The 70's are very empty," remarked Warhol and *Philosophy*, accordingly, mirrored the decade. Adele Silver's harsh critique of *Philosophy* supports this view that:

> As a symbol of the affectless machine-dependent life most Americans are **supposed** to live, this is as good as any, and Warhol has made himself the best current symbolic image of nothingness (63).

A Look Back

The 1980's saw Warhol collaborate with long time associate Pat Hackett on three books: *Popism: The Warhol '60s* (1980), *Andy Warhol's Party Book* (1988) and *The Andy Warhol Diaries* (1989), the latter two being published posthumously after Warhol's death in 1987.

Popism: The Warhol '60s recounts the burgeoning pop art movement, the Factory years, the private lives of celebrities and the tragic tales of Warhol's Factory members. To the delight of many critics, the book was not a tape recorded account of the turbulent decade, but rather a concerted effort on the part of Warhol and Hackett to bring to light the goings-on of those productive/destructive years. *Popism* chronicles Warhol's rapid ascent to the pinnacle of the pop-art mount, his popularity as an underground filmmaker and fashion guru, as well as his days as a rock impresario.

Of all the books Warhol had published to date, no other received the critical acclamation as *Popism*. Calvin Tomkins attributed the book's success to its conversational excellence saying, *"Popism* does not read like an edited tape... It reads like a novel. The dialogue is terrific, and the violent subplot creates suspense... It is arguably the best piece of work that Warhol has given us, in any medium" (114).

Perhaps the most telling aspect of *Popism* was its conclusion as Warhol listed members of his freaky entourage who had died of overdoses or suicides. Warhol, taking no responsibility for their misfortune, claims his innocence in a rare display of emotion. Critics, such as Fred Schruers, intrigued by the defensive Warhol, regarded the book as being "much more candid and informative than Warhol's enigmatic reputation would lead one to expect" (714). He adds further that *Popism's* sobering conclusion provided "a cautionary—and instructive—look at a clique that revolutionized the art world" (714).

Detractors of the book were indeed few and far between. Joyce Carol Oates in a scathing review of the book focused her fury, it seemed, on Warhol rather that the book itself. Even so, Ms. Oates couldn't help but praise *Popism* for its "gossipy qualities" (33).

If Warhol was a social historian of the "rarest kind" (114), as Mr. Tomkins claimed, then *Popism*, in all its pop-profundity, was the textbook of the times.

Warhol's Log

The love-hate relationship Warhol and his critics shared for the past twenty odd years reached its acrimonious conclusion with the posthumous publication of *The Andy Warhol Diaries*.

Reduced to 807 pages from 20,000 by Warhol telephonic amanuensis, the *Diaries* were initially dictated to Pat Hackett, from 1976 to 1987, to record financial details for tax purposes. John Brosnahan amusingly remarked that "For taxi fans, Warhol provides an explicit and detailed account of cab rides and fares throughout Manhattan—fascinating stuff for the right audience" (1740). The bulk

of criticisms, unfortunately, didn't treat the *Diaries* in such a light-headed fashion. In fact, the volume was one of the most critically degraded pieces of work since Warhol's novel *a*. *Diaries* was repeatedly lambasted for its gossip overload and "bitchy tone." David Sexton argued, "Nothing of interest is said about art...Most people will only read this to find Warhol bitching about particular individuals" (36). Reminiscent of the critical response to *a*, a critic for *The Listener* wrote "[*Diaries*] is impertinently unreadable, flagrant, despairingly unstoppable. As a monument, it is utterly rude" (31).

What the *Diaries* does offer, though, is Warhol's invaluable knack at capturing the eccentricities of high society. Whether it be Jerry Hall's philosophy of "How to keep a Man" (give him a blow job), Jackie O's disgust of Warren Beatty's penis or Arnold Schwarzenegger's adoration of Kurt Waldheim, *Diaries,* says an *Economist* critic, "reads like a tabloid headline-writer's fantasy" (74).

Sadly, the nefarious ways of the jet-set seemed to be the only point of interest in *Diaries*. In commenting on the 20,000 pages *Diaries* was distilled from, Don Gillmor writes, "she could have edited them down to six pages and little would have been lost" (77). Lou Reed, whom Warhol managed in the days of The Velvet Underground, fittingly stated in a song to Warhol, "Your Diaries are not a worthy epitaph." Warhol would've probably agreed.

Warhol's Im-Print

It may be argued that Warhol had a minimal role in the publication of these books. Commenting on *Popism* in her expose *Famous For 15 Minutes,* Ultra Violet noted:

> I tell him I've enjoyed reading his book but, I've noticed many inaccuracies in
> it. He replies, "Not my fault. I never wrote it, never read it." (214).

One can't be sure whether or not Warhol did the actual writing, after all the same can be said about his art and films. The point Warhol makes is that it doesn't matter. What's important is how Warhol transformed himself into the wealthy, vacuous pop icon that has come to epitomize the Warhol name.

Literature is but one of many diversions Warhol chose to attach his moniker to. The result, though, has been far from perfect. Whether his books were published to popularize the Warhol name or to steer the medium in a new direction is not known. The variety of criticisms that have greeted his works is a testament to this belief. Were Warhol's works brainchilds of a pop mastermind

or were they the direct results of an exploited class of bizarre flunkies? The
question may be, does it really matter?

NOTE

 1 The quote is taken from the song "Style It Takes" from the album *Songs for
Drella* by Lou Reed and John Cale (1990 Sire Records).

WORKS CITED

"a." *The New Yorker.* 4 January 1969, 82.

Adams, Phoebe. "Potpourri." *Atlantic Monthly*, March 1978. 119.

"The Andy Warhol Diaries." *The Listener*, 29 June 1989, 31

"Andy Warhol's *a."* *American Poetry Review* (March-April 1978): 45.

Beauman, Sally. *"a*, A Novel." *New York Times Book Review*, 12 January 1969, 4.

"Breaking the Icons." *The Economist*, 29 July 1989, 74.

Brosnahan, John. "The Andy Warhol Diaries." *Booklist*, 15 June 1989, 1740.

deAk, Edit. "The Philosophy of Andy Warhol." *Art in America*, November 1975, 21.

Gillmor, Don. "Painted by Numbers." *Saturday Night*, October 1989, 76.

Glaser, Alice. "Send-up of a Put-on." *Book World*, 14 January 1968, 12.

Goldsmith, Barbara. "Affectless but Effective." *New York Times Book Review*, 14
September 1975, 4.

Mazzocco, Robert. "aaaaaa..." *The New York Review of Books*, 24 April 1969. 34.

Miller, Marjorie. "America." *Library Journal*, 15 February 1986, 176.

Oates, Joyce Carol. "Popism: The Warhol 60's." *The New Republic*, 2 February 1980, 31.

Schruers, Fred. "Popism: the Warhol '60s." *Library Journal*, 15 March 1980, 714.

Sexton, David. "The Blonde Who Preferred Fame." *The Spectator*, 24 June 1989, 34.

Silver, Adele. "The Philosophy of Andy Warhol." *Museum News*, March 1976, 63.

Tomkins, Calvin. "The Art Incarnate." *The New Yorker*, 5 May 1980, 114.

Ultra Violet. *Famous For 15 Minutes: My Years with Andy Warhol*, New York: Harcourt Brace Jovanovich, 1988.

Wallis, Brian. "Absolute Warhol." *Art in America*, March 1989, 31.

"Warhol Banal-Traditional." *New York Times*, 18 November 1967, 35.

Wilson, Frank. "The Philosophy of Andy Warhol." *Best Sellers*, October, 1975, 216.

Steve Jones, "Andy Warhol's Allegorical Icons."

On the whole, both Andy Warhol's work and life present a series of artfully constructed antitheses. He was able to permeate cultural barriers segregating advertising from the fine arts, the fine arts from American cinema, and the social function of the artist from the role of the media personality. The apparent simplicity and limitedness of his iconography mask a subtly monumental body of work that is "a virtual history" of his day.[1] Despite his announced intention of creating an anonymous art that could have been produced by anyone, he "never surrendered the human element, accepting the disjunction between the machinelike perfection toward which he was striving and the human fallibility to which the process inevitably gave rise."[2] His relentless drive for recognition and talent for self-promotion contrast with an egalitarianism that celebrated the fact that "a Coke is a Coke and no amount of money can get you a better Coke than the one the bum on the corner is drinking."[3]

From this nexus of contradictions emerges a corpus that has a long history of generating uncertainty concerning Warhol's sincerity of intention, legitimacy of technique, and significance of content. Early reviews tend to puzzle over Warhol's public persona, which did little to dispel doubts about the legitimacy of soup cans and Coca Cola bottles as subjects of the fine arts. At a well-attended meeting of the Society of Illustrators in 1965, Warhol said little other than "no" to the questions posed, tacitly delegating Ivan Karp to speak for him. The reporter of this event concluded that the "icy portraits of tomato-soup cans rouse strong and sometimes hostile emotions," and complained that Warhol's "sincerity remained his own mysterious business."[4] This early uncertainty was exacerbated

by Warhol's mercurial utterances, which complicate rather than resolve difficulties of explication by cloaking poignant insight within Warhol's Pop idiom. His cultivation of language and public image were cited as an example of how "in contemporary America the artist, rather than the art, has become the commodity."[5] Paradox surrounded the reception of his work. In 1962, William Seitz, despite buying a *Marilyn* for the Museum of Modern Art, responded affirmatively to a colleague's query, "Isn't it the most ghastly thing you've ever seen in your life?"[6] In 1966, Warhol's work was praised for being "simultaneously mechanical and autographic."[7] Another essay of the mid sixties asserts that although Warhol's "work raises important theoretical questions," they remain unanswered because "fact, not theory, is his interest."[8]

With the passage of time these tendencies appear less contradictory, not so much because they have been resolved but because the social order has changed. It is still possible to view Warhol as a "contrary," an adversary whose function was that of a devil's advocate whose "dedicated pursuit of surface values held up a mirror to the art world that it found either irritating beyond measure or seductive."[9] On the whole, however, his desacralizing commodifications no longer seem shameless in an intellectual climate that tirelessly theorizes commerce; his Factory persona seems harmless compared to the realities of Basquiat and Mapplethorpe; his sincerity little troubles a society capable of blandly accepting the concept of disinformation. In this context Warhol's images from the sixties are not threats; they have become canonical exemplars of Pop art. Nevertheless, his images seem familiar rather than outmoded, classicizing rather than incipient, contemporary rather than historical.[10]

Warhol's silkscreen paintings of 1962-1967 present four categories of subjects: variations of the still life and landscape; portraits of individuals whose fame or stardom has transformed their images and personalities into objects of consumption; scenes of disaster or impending death, usually gleaned from newspaper images; and the serial reproductions of basic consumer goods that appear by the millions in the modern marketplace.[11] The last group, the icons of mass production comprising the Coca Cola bottles, Campbell's soup cans, Brillo boxes, and other consumer goods, augmented by images of rows of shoes and the hammer and sickle and in the next two decades, constitute a thematic center of Warhol's work. Within them it is possible to locate a position for the viewing subject within the interstices between the self and the other, between the born and the fabricated, between the consumer and the consumed. It is these mediating icons of mass production, depicting "both the entrepreneurial world-view of the late twentieth century and the phlegmatic vision of the victims of that world view,

that of the consumers," which allow Warhol's work to bridge the gap between late modernism and the emergence of a postmodern ethos.[12] Warhol's images of consumer products, conducted in the language of the icon, articulate a treatise on the self.

In 1966 Nicolas Calas described Pop icons as "pictures of reality or of dreams that have crucial cultural impact," further stipulating that the "icon is for use, when warm for prayer, when cool for companionship."[13] Under this rubric Warhol's images are tautologically iconic, as he mined his subject matter directly from the reality-defining agencies of commercial culture. They are so, however, to different degrees and in different ways. In addition to being reproducible objects with a value of their own, icons are reifications of memory, whether living or historical. To be efficacious, they must function both as object and as text. In the context of the Pop movement, Warhol made objecthood itself the content of his iconic images, as was early commented upon:

> Warhol's work makes us aware again of objects which have lost their visual recognition through constant exposure. We take a fresh look at things familiar to us, yet uprooted from their ordinary contexts, and reflect upon the meaning of contemporary life.[14]

The relentless probing of the nature of objecthood has been taken as the central meaning of his work:

> Whether consciously or not, Warhol and other image duplicators are making a comment on the monstrous repetition our machines have bred: millions of the same car, the same dress, the same soup can....[15]

What differentiates Warhol's work from other Pop artists, and indeed what is thematically unique about his work, is the extent to which he exploits the means of iconic representation in order to present iconic texts. This textuality has two primary dimensions: an external reference to the history of the object or person depicted, and an internal focusing of the viewing subject's relationship to the icon over the history of his or her lifetime.

Externally, icons engage in a dialogue of present significance with a culturally determined, canonical past, which is modified by the moment at which the subject contacts the icon. After its inceptionary cultural moment has passed, an icon becomes not only the reflection of a cultural moment, but also the progenitor of cultural memory. Some of Warhol's images are directly concerned

with this interaction of canonical past and dynamically subjective, transformative present.

One of the central tenets of Warhol's iconic presentations of objects is precisely to note or promote the gap between their original functions and their potentialities for resignification. Not only are icons subject to redefinition due to circumstances surrounding their textuality, they are also affected by the erasure of memory at the level of subjective perception. One of the primary functions of an icon is to locate for the subject a particular mode of perception, emotion, or locative context that has been obscured by time. Talismanic gifts, transportive melodies, or Proustian scents nostalgically and partially reinvigorate memories which provide the individual with internal continuity; the image of the crucifix or of the crescent sutures the forgotten ubiquitous with the momentous. If an icon ceases to provide access to this Heraclitan flow of memory, it is either relegated to storage or discarded as a definitive agent of the self, retaining only its value as object. Icons always flirt with the danger of lapsing into mere commodity. In 1962 Michael Fried lamented that "an art like Warhol's is necessarily parasitic upon the myths of its time, and indirectly therefore upon the machinery of fame and publicity that market these myths; and it is not at all unlikely that these myths that move us will be unintelligible (or at best starkly dated) to generations that follow."[16] More recently, it has been suggested that "it is not the dependence of Warhol's images on mass-culture myths but participation in mass-culture experience that animates the work."[17] However, both dimensions operate simultaneously, for the canonical, mythic dimension, a function of the past, can exist apart from present participation in the life of the icon. Fried lamented the vulnerability of Warhol's work to "the advent of a generation that will not be as moved by Warhol's beautiful, vulgar, heart-breaking icons of Marilyn Monroe as I am."[18] However, the images of *Marilyn* remain vital precisely because they have bridged the gap separating the participatory present from the past, and are located in the memories they have themselves created.[19] The potency of Warhol's icons lies very much in their ability to become a part of the mythology of their subject matter.

Warhol studied the relationship of mythic past to reception in the present in his *Hammer and Sickle* paintings and prints of 1977, which appropriate the "once-feared Communist emblem....and re-create it as a still life," marking the exhaustion of the icon's political ideology by transforming it into an object of consumption.[20] These works demonstrate the consequences of an aporia between the canonical mythic content of the icon and its designified reference to common commodities, reifying the mutability of iconic representation.

In iconic representation, the canonical, mythic past and collective cultural present confront the individuality of the viewing subject. Reception thus engages the subject in a dialogue of the self with the other, an interaction critical to the maintenance of the vitality of the icon. Warhol's *Diamond Dust Shoes* of 1980 present very personal objects in a fashion that deprives them of their subjectivity, rendering them

> a random collection of dead objects hanging together on the canvas like so many turnips, as shorn of their earlier life world as the pile of shoes left over from Auschwitz or the reminders and tokens of some incomprehensible and tragic fire in a packed dance hall.[21]

Shoes have a clearly subjective dimension, which allows personal access; they also have an art historical dimension, exemplified by the images of shoes produced by van Gogh and Magritte. Iconic representations always stage a confrontation between the desire of the viewing subject to locate the self within an icon and the exclusionary properties of the icon, the corporate power and irrecoverable history which render it an other. The *Diamond Dust Shoes* series thus complement the *Hammer and Sickle* paintings, which enact the neutralization of externalized, public, and highly mythologized icons. The cultivated, highly subjective image is depicted such that the "hermeneutical gesture" necessary to animate the shoes through both external and internal memory is rendered impossible.[22]

If Warhol's later work focuses on an examination of iconic neutralization, his work of the sixties is more concerned with the formation of iconic resonances. One series addressed the concerted attempts of the media to create specific personae through its fetishizing of images of movie stars; another was driven by the press' insistence that news is essentially constituted by the presentation of disaster and death. In these works

> Warhol grouped together the photographic conventions that regulate social practices of looking: looking at the Other (in envy at fame and fortune, and in sadistic secrecy at catastrophe), and at the disappearing Self (in futile substitutes).[23]

These images confront the viewer with the very process of iconic fabrication, offering not so much a commentary as a record of how images become icons.

Warhol's analysis of the iconic process extends back into his career as a commercial artist, during which he learned how to select "overdetermined

symbolism" which allowed him "to condense into his images an overload of meanings far in excess of anything the fine artist is obliged to deal with."[24] The Coca Cola bottles and Campbell's soup cans, whether in their easel-painted versions of the early sixties or in the silkscreen versions produced from 1965 on, are especially revelatory of this characteristic.[25]

Warhol's method of finding fine art subject matter is encapsulated in the celebrated story he recorded in *Popism*. In 1962 he showed Emile de Antonio two paintings of Coca Cola bottles, one an Abstract Expressionist version, which was dismissed, the other "just a stark, outlined Coke bottle in black and white," which elicited from de Antonio the remark "it's our society, it's who we are, it's absolutely beautiful and naked...."[26] Given Warhol's casual regard for accuracy of reportage, the primary worth of this testimony is as a critical statement of his desire, in 1980, to be regarded as the forger of a cultural icon.

Warhol's icons transform the artifacts of mass production by enshrining them and endowing them with a complex referential dimension.[27] His conversation of December 1961 with art dealer Marie Latow prompted him to produce images of dollar bills in response to her suggestion that he paint what he liked. Latow likewise inspired his Campbell's soup cans by stating that he "should paint something that everybody sees every day, that everybody recognizes...like a can of soup."[28] These anecdotes are especially revelatory of Warhol's willingness to encode both himself and popular desires in his iconography, and to allow his individual experiences and desires to interact with those of others.

These anecdotes also illustrate the sort of difficulties that always surround any reading of Warhol's art, the possibility that he "came to be credited with sibylline wisdom because he was an absence, conspicuous by its presence--intangible, like a TV set whose switch nobody could find" whose paintings were "all superficies, no symbol."[29] Ivan Karp addressed this issue at the Society of Illustrators interview of 1965, asserting that Warhol had,

> by taking a can of Campbell's tomato soup out of its context in a supermarket,
> by blowing it up, putting it on canvas, and adding something ineffable of his
> own--and what Mr. Warhol added is very subtle--transfigured that can of soup
> and raised it to the level of spiritual importance. By his act of transmutation he
> created beauty and meaning.[30]

More than twenty years later David Bourdon praised the "eloquent and tragic" torn soup cans as "intimations of mortality...far more effective than the artist's 1976 series of silkscreened paintings of human skulls."[31]

The soup cans themselves present a complex field of involvement. First, there is a dimension of memory, involving both the history of a culture and that of each individual within that culture. The iconic representation elicits the relationship of the self's personal, familial involvement with Campbell's soup and the ambiguous relationship of the self to the impersonal, commercial culture which both enables and disables. The iconic self is augmented by an allegorical dimension, a narrative of the life process told by a series of cans produced in 1962. Finally, by altering the presentation of the cans through the course of the decade, Warhol endows them with a history of their own.

Warhol's remarks provide a few clues as to how the cans might be considered, though they are as always couched in "a field of blague" which is best interpreted as Pop literature rather than earnest critical statement.[32] When asked why he chose the *Campbell's Soup Can* as a subject, Warhol responded, "I used to drink it. I used to have the same lunch everyday, for twenty years, I guess, the same thing over and over again."[33] He stated that "many an afternoon at lunchtime Mom would open a can of Campbell's tomato soup for me....I love it to this day."[34] With some amusement Hancock reports that at the Illustrators luncheon Warhol's reticence vanished when he was asked about Campbell's actual product:

Then and only then did Mr. Warhol speak freely. "I love it," he said.[35]

A degree of genuine attachment, an association with life processes, underlies these remarks. Through them Warhol licenses the viewer to identify, directly and individually, with the cans and what is in them directly and individually.

The iconography of the cans further indicates. that they are to be taken as iconic sites within which the viewing subject can be located. Actual Campbell's soup cans are decorated with an image of the gold medallion the product won at the Paris International Exposition in 1900. Two reclining allegorical figures appear on the medallion, one male and one female, and the date of the award.[36] The various images of the cans produced from 1961-1963 reveal Warhol's deliberations about the role of the medallion in his iconography. A drawing from 1962, which appears to be a preparatory study, depicts a can whose flavor has not been indicated but whose medallion is sketched completely.[37] However, the medallions of the numerous cans painted in 1962 arc all left blank, despite the thoughtful attention to detail manifest in the inclusion of the banners proclaiming

"NEW" and "GREAT AS A SAUCE TOO!" on "Cheddar Cheese" from the series of thirty-two paintings of *Campbell's Soup Cans* and the inventive meticulousness with which Warhol produced the appearance of corrosion on some of the cans.[38] In assessing this alteration, which seems purposeful rather than economical, it seems wise to follow Arthur Danto's maxim: "I take it as categorical with Warhol that there are no accidents."[39]

The removal of the two human figure and the historicizing date produce two distinct advantages. The differentiation of the commercial product from the iconic image becomes a point around which the conservative function of memory and the transformative forces of historical process can coalesce. Additionally, the evacuated medallion becomes a locus which the viewer can inhabit as a site of the self.

Warhol was careful to modulate this identification, creating resonance between self and other, icon and object, art and mass production. The manner in which he displayed the soup cans reveals his desire to balance empathetic iconic identification with the perception of the image as an external other, especially of forces concentrated at the sites of commerce. This is evident in his presentation in 1962 of thirty-two silkscreens of *Campbell's Soup Cans*, one representation for each flavor then available, at the Ferus Gallery in Los Angeles. The paintings were displayed on small horizontal shelves running along the gallery wall, suggesting the displays of actual soup cans, but they were also framed and hung from the wall to insist on their identity as works of art.[40] Warhol thus locates reception between the polarities of the examination of the self and the act of consumption.

The soup cans exist in a striking range, varying from a monumental scale of six feet to portable pencil sketches. They appear both in majestic isolation and in crowded serial grids; some are provided with varying colors and exist in different states of being. They can be seen as emblems of the other which drives the commercial order or as icons of the self encased within that order, projections of "both the entrepreneurial world-view of the late twentieth century and the phlegmatic vision of the victims of that world view, that of the consumers."[41] The soup cans share the Coca Cola bottles' egalitarian qualities; they recognize neither wealth nor status. Since the sixties, the received history and the mythology of Campbell's has changed, but the presence of the product on the shelves of virtually every American supermarket guarantees the renewal of individual contact.[42] Indeed, much of the current effectiveness of Warhol's images lies in their ability to establish a dialogue with the past at the site of this iconic shift, which complements the dynamic polarities established within the works.

In *Campbell's Soup Cans (Chicken with Rice, Bean with Bacon)* of 1962, consisting of paired panels suggesting a contrastive diptych, the can on the left fills the canvas' twenty inches of height, while the can on the right is presented on a scale which is about one third of that of its partner. The contrast of proportion, coupled with the embedded discontinuity inherent within diptych structure, can either commemorate the equivalence of selves of different magnitudes or insist on the discontinuity of status, the diptych emphasizing the new feudal order that underlies the theoretical egalitarianism of a consumer society. The "fauve" colors, made possible by the use of new industrial materials, of two works of 1965, both titled *Campbell's Soup Can*, perhaps suggest the possibility of change and redefinition created by new technologies. However, the garish color is equally suggestive of the harlequin puppetry of created desires, especially as it necessarily alters the monumental dignity established by the earlier cans.[43] Viewed as an other, these cans illuminate the contrivance of the identity of the self, which is at the disposal of the manipulators of mass production, whether these create celebrities, news items, or products. Significantly, Warhol painted about two dozed cans in the original colors during the mid sixties, one on commission from the Campbell's Soup Company.[44] As always with Warhol, the novel and the traditional were subject to the same iconic scrutiny; art and commerce remained relentlessly undifferentiated.

The serial compositions develop a more extensive analysis of the individual in society. Used with slight variations in the Coca Cola bottle paintings or with essential identity in the grids of dollar bills, labels, and stamps, the serial technique expands the thematic potential of the soup cans, which are identical in form but differentiated by their flavor labels. The modernist idealism of the self projected by the monumentalizing of a most humble icon of the self is complemented by the depiction of diversity within unity in *Two Hundred Campbell's Soup Cans* of 1962. The various kinds of soups, some isolated from their fellow flavors, some grouped in vertical or horizontal pairs, others placed in "neighborhoods" dominated by certain brands, become a kind of map of the social order, one which depicts a harmonious integration. This idealism is counterbalanced by the suggestion of the deindividualizing effects of commercialized society in *One Hundred Cans* of the same year. All of these cans are "Beef Noodle"; the round number further emphasizes the anonymity and replaceability of each individual item.

This mild pessimism is further elaborated in a series presenting damaged or used cans. One *Soup Can*, a drawing of 1961, has been deprived of its identity through the loss of its label; the "mute anonymity" of its passive and forlorn

grayness contrasts with the confidence of the early paintings.[45] Less abject are *Big Torn Campbell's Soup Can (Black Bean)* and *Big Torn Campbell's Soup Can (Pepper Pot)* of 1962. Both nearly six feet tall, their torn labels suggest the disintegration of even the strong in a society of mass consumption. As usual with Warhol, balance is maintained. Several drawings depict cans as mutilated trash, fit only for disposal; others show cans stuffed with money.[46]

These images suggest a theme central to much of Warhol's work of the period, the terrifying balance of benefice and destruction created by a social order which offers nurturing soup in the same location as the lethally treasonous cans depicted in *Tunafish Disaster* of 1963. Likewise, the media which can produce movie stars whose public fame is said to be stored "in the can" also create the fame of the *Most Wanted Men*, several of whom are destined for another sort of container. Warhol emphasizes this ambivalence by replacing substantive titles such as *Blue Electric Chair* with formulaic titles such as *Silver Disaster* or *Lavender Disaster*. The deaths of innocents are located within another sort of container, the automobile. The sense of the containment of the individual is always strong.

Warhol's treatment of the cans has a further dimension, one that projects onto the iconically generated metaphor of memory an archetypal narrative of the self as everyman.[47] It is a narrative that displays several of the allegorical tactics of contemporary art.[48]

Allegory is at base a palimpsest, the appropriation of imagery in order to supplant antecedent meaning.[49] The narrative often has a concern with "the ephemerality of all phenomena."[50] It is possible to arrange a group of Warhol's cans as a sequence, one endowed with a history, one that presents an allegory of the contained individual.[51] Any one of the he thirty-two cans exhibited at the Ferus Gallery can serve as the moment of conception, the beginning of the cycle of life. *Campbell's Soup with Can Opener* portrays the unlocking of potential, showing a can in the process of being opened by a mysterious and somewhat sinister force, the manual opener performing its function while suspended in space. Next, *Big Campbell's Soup Can, 19 c(ents)* shows a can at the apex of its existence, its top hinged back in its moment of full maturity. Finally, *Crushed Campbell's Soup Can (Beef Noodle)* shows a can emptied of its contents and ready for disposal.

Warhol's cans especially exhibit the "reciprocity which allegory proposes between the visual and the verbal."[52] The quiet tensions within his serial compositions, juxtaposing the sameness and anonymity of the individual represented by the form of the can with the carefully depicted script which

differentiates one flavor from another, rely on this principle. A concern with "image as hieroglyph" is especially evident in his restoration of the medallion, left blank in the earlier cans, to the fauve cans of 1965 and to the series of prints of the cans produced in 1968.[53] The empty zone which provided the viewer a space in which to locate the self has yielded to the mark of the other, the culture of mass production that contains the self. The process was completed in 1985 when Warhol painted images of Campbell's boxes of dried soup mixture as a purely commercial art venture.[54] With this act, the allegory is closed.

In enacting the antithetical forces generated by a society of mass production, Warhol's icons establish a new sort of classicism, creating an irresolvable tension between celebration and despair that, by calculatingly refusing to take an evaluative stance, forces the viewer to examine the processes of the formation of the self. What renders his art contemporary is the relentlessness with which he constructs a site for the subject, a present, and a history, and the effortlessness with which he erases these dimensions, replacing them with the history and the presence of mass commerce, which can then oscillate with the memory of the self in never-ending alternation. The iconic allegory of the self, rendered inert by the restoration of the commercial emblem, is immediately supplanted by the past of the iconic itself, which in turn recalls the subject's memory of the actual product iconized. In the many paradoxes of his personal behavior, Warhol seems involved in the same maneuvers he demands of those willing to ponder his icons. Perhaps the ultimate paradox is the complexity of the apparently simple surface.

The cans exhibit a complex layering of dimensions of involvement. They present a text that can be read, but they provide no clear point of view from which to establish a meaning. They are in no sense inert, however, for they stage the social condition in which "the drive towards differentiation and the drive towards monological organization operate simultaneously, or at least oscillate so rapidly as to create the impression of simultaneity."[55] Given these conditions, neither meaning nor being determine the subject to the extent that becoming does. This is what allows Warhol's work to satisfy both late modern and early postmodern paradigms. He creates a place for the viewing subject, and allows involved participation. It is, however, an involvement that is hermetically sealed within itself, in an endlessly self-reflexive movement. Early criticism recognized the significance of subjective participation in Warhol's work.[56] A paper of 1962 creates sixteen hypothetical readings of Warhol's work, characterized by their laughable latitude.[57] But this late modernist parody of relativism has yielded to postmodernist reader response. Warhol's seemingly simplistic icons address contemporary expectations of complex subjectivity.

NOTES

1. Robert Rosenblum, "Warhol as Art History," in *Andy Warhol: A Retrospective*, ed. Kynaston McShine (New York: Museum of Modern Art, 1989), 27.

2. Marco Livingstone, "Do It Yourself: Notes on Warhol's Techniques," in *Andy Warhol: A Retrospective*, ed. Kynaston McShine (New York: Museum of Modern Art, 1989), 70.

3. Andy Warhol, *The Philosophy of Andy Warhol (From A to B and Back Again)* (San Diego: Harcourt Brace Jovanovich, 1975), 101; see also Benjamin H. D. Buchloh, "Andy Warhol's One-Dimensional Art: 1956-1966," in *Andy Warhol: A Retrospective*, ed. Kynaston McShine (New York: Museum of Modern Art, 1989), 39.

4. Marianne Hancock, "Soup's On," *Arts Magazine* 39 (May-June 1965): 16.

5. Paul Bergin, "Andy Warhol: The Artist as Machine," *Art Journal* 26 (Summer 1967): 362.

6. Victor Bockris, *The Life and Death of Andy Warhol* (New York: Bantam Books, 1989), 116-117; for other early reactions to Warhol's work see David Bourdon, *Warhol* (New York: Harry N. Abrams, 1989), 86-87.

7. Bourdon, 130.

8. Samuel Adams Green, "Andy Warhol," in *The New Art,* ed. Gregory Battcock (New York: Dutton, 1966), 233-234.

9. Roger Lipsey, *An Art of Our Own: The Spiritual in Twentieth-Century Art* (Boston: Shambhala, 1988), 405. Robert Hughes remains the most eloquent of Warhol's detractors; see "The Rise of Andy Warhol," in *Art After Modernism: Rethinking Representation*, ed. Brian Wallis (Boston: David R. Godine, 1984), 45-57.

10. Fredrick Jameson, for example, finds in Warhol's *Diamond Dust Shoes* a paradigm of postmodernism; see Fredrick Jameson, *Postmodernism, or, the Cultural Logic of Late Capitalism* (Durham: Duke University Press, 1991), 8-10.

11. Bergin, 360-362.

12. Buchloh, 57.

13. Nicolas Calas, "Pop Icons," in *Pop Art*, ed. Lucy R. Lippard (New York: Oxford University Press, 1966), 164, 170.

14. Green, 234.

15. Ellen H. Johnson, *Modern Art and the Object* (New York: Harper and Row, 1976), 190.

16. Michael Fried, "New York Letter," *Art International* vol. 6, no. 10 (December 20, 1962), 57; cited in Bourdon, 134.

17. Buchloh, 60 n. 49.

18. Fried cited in Bourdon, 134.

19. Unless otherwise indicated, all works of Warhol referred to are illustrated in Kynaston McShine, ed., *Andy Warhol: A Retrospective* (New York: Museum of Modern Art, 1989).

20. Arthur C. Danto, *Beyond the Brillo Box: The Visual Arts in Post-Historical Perspective* (New York: Farrar, Straus & Giroux, 1992), 136.

21. Jameson, 8.

22. Jameson, 8-9.

23. Buchloh, 53.

24. Danto, 134.

25. For a discussion of the development Warhol's technique in fashioning these images see Livingstone, 67-70.

26. Andy Warhol and Pat Hackett, *Popism: The Warhol Sixties* (San Diego: Harcourt Brace Jovanovich, 1980), 6; for other versions of the incident see Buchloh 42, 58 n. 22; Bockris 98.

27. Klaus Honnef, *Andy Warhol*, trans. Carole Fahy and I. Burns (Koln: Benedict Taschen, 1990), 50-53.

28. Bockris, 105-106; see also Patrick Smith, *Andy Warhol's Art and Films* (Ann Arbor: UMI Research Press, 1986), 130.

29. Hughes, 49.

30. Hancock, 16.

31. Bourdon, 92.

32. Buchloh, 40.

33. McShine, 55.

34. Bockris, 105; for Paul Warhola's confirmation of the literalness of this bit of autobiography see Bourdon, 99 n. 9.

35. Hancock, 18.

36. Bourdon, 99 n. 6; the inscription of the Exposition and architectural elements also appear on the labels of the commercial product.

37. Bourdon, illustration 111.

38. Livingstone, 68.

39. Danto 134; for the need to avoid unjustifiably limiting the potential meanings of Warhol's art, see John Yau, *In the Realm of Appearance: The Art of Andy Warhol* (Hopewell, New Jersey: Ecco Press, 1993), 19, 29-30.

40. Buchloh, 54-55; a similar tactic can be seen in the arrangement of Brillo boxes displayed at Boston Institute of Contemporary Art in 1966; for illustrations see McShine, 198. The cans are further assimilated to the sites of consumerism by the *Campbell's Soup Can on Shopping Bag* of 1964.

41. Buchloh, 57.

42. Bourdon, 90, reports that four of five cans of soup sold at the time of Warhol's paintings were produced by Campbell.

43. Bourdon, 213.

44. *Popism* reveals the extent to which Warhol saw individuals as being defined by their clothes.

45. Bourdon, 96.

46. For illustrations, see Bourdon, 92-96.

47. For the constitution of allegory in these terms, see Joel Fineman, "The Structure of Allegorical Desire," in *Allegory and Representation*, ed. Stephen J. Greenblatt (Baltimore: The Johns Hopkins University Press, 1981), 31-32.

48. The allegorical traits of contemporary pictorial art are categorized as appropriation, site-specificity, impermanence, accumulation, discursiveness, and hybridization by Craig Owens, "The Allegorical Impulse: Toward a Theory of Postmodernism," in *Art After Modernism*, ed. Brian Wallis (Boston: David R. Godine, 1984), 204-209.

49. Owens, 205.

50. Owens, 206.

51. If the images are assembled as a history of the soup can, they become a modern, individualistic counterpart of the cyclic allegorical series of Thomas Cole discussed by Angus Fletcher, *Allegory: The Theory of a Symbolic Mode* (Ithaca: Cornell University Press, 1964), 375-377.

52. Owens, 208.

53. Owens 209; for images of the prints of 1968 see Honnef, 32-33.

54. Bourdon, 297-298. The cans display other of the characteristics of allegory discussed by Owens. They exhibit a degree of site-specificity in Warhol's desire to display them as being something between art objects and grocery store commodities in the Ferus Gallery exhibition of 1962. The quality of accumulation, the "simple placement of 'one thing after another,'" is evident in Warhol's serial works, but not with the open-endedness attributed to allegory by Owens, 207. There were thirty-two cans at the Ferus Gallery exhibit because thirty-two flavors of Campbell's soup then existed. Warhol's allegory is clearly finite; the possibilities of individuality are limited by the possibilities of mass production. Hybridization, the "hopeless confusion of all mediums and stylistic categories," is a central feature of Warhol's work. In images of solitary cans he combined the media of painting, photography, and silkscreening in fashioning what is, among other things, a critique of the essentialist boundaries separating commercial from fine art.

55. Stephen Greenblatt, "Towards a Poetics of Culture," in *The New Historicism*, ed. H. Aram Veeser (New York: Routledge, 1989), 6.

56. Lucy Lippard, "New York Pop," in *Pop Art*, ed. Lucy R. Lippard (New York: Oxford University Press, 1966), 97-100.

57. Bourdon, 99 n. 8.

SELECTED BIBLIOGRAPHY

Alloway, Lawrence. "Six Painters and the Object." *Collage* (December 1963): 53.

___. "Pop Art: The Words." *Auction* 1, no. 5 (February 1968): 6-9.

Amaya, Mario. "The New Super Realism." *Sculpture International* 1 (January 1966): 19.

___. "Men and the Machine." *Financial Times,* March 23, 1968.

Ashberry, John. " Delacroix, Watteau, Chardin, Boucher, Lancret and American Pop Art." *International Herald Tribure* (Paris), May 15, 1963.

___. Pop Artist's Horror: Pictures Silence Snickers," *International Herald Tribune* (Paris), January 15, 1964.

Battcock, Gregory (Ed.). *The New Art.* New York: E. P. Dutton, 1966.

___. "An Art Your Mother Could Understand." *Art and Artists* 5 (February 1971):12-13.

___. "Andy Warhol: New Predictions for Art." *Arts Magazine* 48 (May 1974): 34-37.

Beauman, Sally. "*a*" a Novel by Andy Warhol." *The New York Times Book Review*, 12 January 1969.

Bell, Larry. "Statement 1963 on Andy Warhol." *Artforum* 5 (February 1965): 28.

Bockris, Victor and Gerard Malanga. *Up-Tight: The Velvet Underground Story*. New York: Quill, 1983.

Bourdon, David. "Andy Warhol." *The Village Voice,* December 3, 1964.

Brainard, Joe. "Andy Warhol's Sleep Movie." *Film Culture* 32 (1964): 12-14.

Brown, Andreas, compiler. *Andy Warhol: His Early Works, 1947-1959.*
New York: Gotham Book Mart Gallery, 1971.

Buchloh, Benjamin H. D. "The Andy Warhol Line" in *The Work of Andy
Warhol.* Dia Art Foundation, Seattle: Bay Press (1989): 52-69.

___. "Andy Warhol's One-Dimensional Art: 1956-1966" in *Andy Warhol: A
Retrospective.* Museum of Modern Art (1989): 39-61.

Cipnic, Dennis J. "Andy Warhol: Iconographer." *Sight and Sound* 41 (Summer
1972): 158-61.

Co, Jeff. "At the 'Plastic Inevitable' Reality Becomes Unreal." *The Pocono
Record* (May 5, 1966).

Coplans, John. "American Painting and Pop Art." *Artforum* 4 (October 1963):
27.

___. "Early Warhol: The Systematic Evolution of the Impersonal Style."
Artforum 8 (March 1970): 52-59.

___. *Andy Warhol.* Greenwich, CT: New York Graphic Society, 1970.
With contributions by Jonas Mekas and Calvin Tomkins.

___. "Andy Warhol and Elvis Presley: Social and Cultural Predictions of
Warhol's Serial Image." *Studio International* 181 (February 1971): 49-56.

Crone, Rainer. *Andy Warhol.* New York: Praeger, 1970.

___. "Form and Ideology: Warhol's Technique from Blotted Line to Films" in
The Work of Andy Warhol. Dia Art Foundation, Seattle: Bay Press (1989):
70- 92.

Crow, Thomas. "Saturday Disasters: Trace and Reference in Early Warhol."
Art in America 75 (May 1987): 128-36.

Danto, Arthur. "Who Was Andy Warhol?" *Artnews* 86 (May 1987): 128-32.

Deitch, Jeffrey. "The Warhol Product." *Art in America* 68 (May 1980): 9-13.

"Drawings by Andy Warhol at Bodley Gallery." *New York Times*, 5 December
1959, 112.

Factor, Donald. "An Exhibition of Boxes." *Artforum* 10 (April 1964): 21-23.

Ferebee, Ann E. "Packaging--Portrait of a Soup Can." *Industrial Design* 9.
(1962): 80-81.

Fineberg, Jonathan D. "Warhol's Paintings Revitalize the Aesthetic of the
Everyday World." *The Harvard Crimson,* 18 October 1966, 18-21.

Gardner, Paul. "Gee, What's Happened to Andy Warhol?" *Artnews* 79 (November 1980): 72-77.

Geldzahler, Henry. *Pop Art, 1955-70*. Sydney: International Cultural Corporation of Australia Limited, 1985.

Gidal, Peter. *Andy Warhol, Films and Paintings*. New York: E. P. Dutton and London: Studio Vista, 1971.

___. "Problems 'Relating to' Andy Warhol's Still Life 1976." *Artforum* 16 (May 1978): 38-40.

Gilles, Xavier. "Warhol, Mao, Warhol, Mao." *Oeil* 226 (May 1974): 26-29.

Glueck, Grace. "Life Imitates Art—Sometimes Violently." *New York Times*, 9 June 1968.

Goldstein, Richard. "*Chelsea Girls*, the Underground Uplifted." *The New York World Journal Tribune*, November 13, 1966.

Guest, Barbara. "Warhol and Sherman." *Artnews* 51 (September 1952): 47.

___. "Clarke, Rager, Warhol." *Artnews* 53 (June 1954): 75.

Hanhardt, John G., and Jon Gartenberg. *The Films of Andy Warhol: An Introduction*. New York: Museum of American Art, 1988.

Harrison, Charles. "London Commentary, Warhol's 'Self Portrait,'" *Studio International* 174, no. 895 (December 1967): 275.

Haskell, Barbara. *Blam!: The Explosion of Pop, Minimalism, and Performance, 1958-1964*. New York: Whitney Museum of American Art in association with W. W. Norton, 1984.

Hess, Thomas B. "Pop and Public." *Art News* 62, no. 7 (November 1963): 23, 59-60.

Hopkins, Henry T. "Andy Warhol." *Artforum* (Los Angeles) 1, no. 4 (September 1962): 15.

Hughes, Robert "King of the Banal." *Time,* 4 August 1975, 65-66.

Johnston, Jill. "The Artist in a Coca-Cola World." *Village Voice*, 31 January 1963: 14.

Josephson, Mary. "Warhol: The Medium as Cultural Artifact." *Art in America* 59 (May-June 1971): 40-46.

Kagan, Andrew. "Most Wanted Men: Andy Warhol and the Anti-Culture of Punk." *Arts Magazine* 53 (September 1978): 119-21.

Karp, Ivan C. "Anti-Sensibility Painting." *Artforum* 3 (September 1963): 26-27.

Kelly, Edward T. "Neo Dada: A Critique of Pop Art." *Art Journal* 23 (Spring 1964): 192-201.

Koch, Stephen. *Stargazer: Andy Warhol's World and His Films*. New York: Praeger, 1973. Second edition, New York: M. Boyars, 1985.

___. "Warhol." *New Republic* 160 (April 26, 1969): 25-27.

Kozloff, Max. "Pop Culture, Metaphysical Disgust and the New Vulgarians." *Art International* 6, no.2 (March 1962): 34-36.

___. "Abstract Attrition." *Arts Magazine* 39 (January 1965): 47-50.

___. "Modern Art and the Virtues of Decadence." *Studio International* 174 (November 1967): 189-99.

___. "Andy Warhol and Ad Reinhardt: The Great Acceptor and the Great Demurrer." *Studio International* 181 (March 1971): 113-17.

Kramer, Hilton. "Andy's 'Mao' and Other Entertainments" in *The Age of the Avant-Garde*. New York: Farrar, Straus, Giroux, 1973, 538-42.

Kroll, Jack. "*The Chelsea Girl*s." *Newsweek,* 14 November 1966: 38.

Kuspit, Donald. "Andy's Feelings." *Artscribe International* 64 (Summer 1987): 32-35.

Leff, Leonard. "Warhol's 'Pork.'" *Art in America* 60 (January 1972): 112-13.

Leider, Philip. "Saint Andy: Some Notes on an Artist Who for a Large Section of a Younger Generation Can do No Wrong." *Artform* 3 (February 1965): 26-28. Includes Larry Bell."From a Statement Written by Larry Bell in September 1963, upon First Seeing an Exhibition of Warhol's Work."

Lenard, John. "The Return of Andy Warhol." *New York Times Magazine*, 10 November 1968, 32-33, 142-51.

Lester, Elenore. "The Final Decline and Total Collapse of the American Avant-Garde." *Esquire* 62, no. 5 (May 1969): 76, 142-43, 148-49.

Levinson, Robert S. "Andy Warhol's Art." *Coast FM and Fine Arts,* 1 September 1969, 30.

Lipman, Jean (ed.). *What Is American in American Art?* New York: McGraw-Hill, 1963.

Livingstone, Marco. "Do It Yourself: Notes on Warhol's Techniques" in *Andy Warhol: A Retrospective*. Museum of Modern Art, 1989, 63-78.

Lugg, Andrew. "Portraits, Still Lifes, Events: Warhol." *New Worlds* 185 (December, 1968): 14.

Lurie, David. "Andy Warhol/'Disaster Paintings." *Arts Magazine* 60 (Summer 1986): 117-18.

Malanga, Gerard. "Andy Warhol: Interview." *Kulchur* 4 (Winter 1964-65): 37-39.

Mekas, Jonas. "Film Independent Award." *Film Culture* 33 (1964): 14.

Nordland, Gerald. "Marcel Duchamp and Common Object Art." *Art International* 8 (February 15, 196): 30-33.

Ogar, Richard. "Andy Warhol Mind Warp." *Berkeley BARB*, 1-7 September 1967: 5.

Patterson, Pat. "A Day at the Factory." *Cavalier* (December 1967): 60-64.

Pavlov, L. "Andy Warhol's 'Factory' of Modernism." *Studio International* 184 (November 1972): 159-60.

Perreault, John. "Andy Warhola, This Is Your Life." *Art News* 69 (May 1970): 52, 53, 79, 80.

Pomeroy, Ralph. "The Importance of Being Andy Andy Andy." *Art and Artist* 5 (February 1971): 14-19.

Preston, Stuart. "Art: North of the Border." *New York Times,* 5 December 1959, 20.

Ratcliff, Carter. *Andy Warhol*. New York: Abbeville Press, 1983.

___. "Andy Warhol: Inflation Artist." *Artforum* 23 (March 1985): 68-75.

Reichardt, Jasia. "Pop Art and After." *Art International* 8 (February 25, 1963): 42-47.

Restany, Pierre. "The New Realism." *Art in America* 51 (February, 1963): 102-4.

Rose, Barbara. "Dada Then and Now." *Art International* 7 (January, 196): 22-29.

___. "The Value of Didactic Art--The *Chelsea Girls* as Cinema." *Artforum* 5 (April 1967): 32-36.

Rosenberg, Harold. "The Art World: Art's Other Self." *New Yorker* 47 (June 12, 1971): 101-105.

Rosenblum, Robert, and David Whitney, ed. *Andy Warhol: Portraits of the 70s*. New York: Random House for Whitney Museum of American Art, 1979.

___. "Warhol as Art History." *Andy Warhol: A Retrospective*. New York: Museum of Modern Art, 1989, 25-37.

Rosenthal, Nan. "Now Let Us Praise Famous Man: Warhol as Art Director" in *The Work of Andy Warhol*. Dia Art Foundation, Seattle: Bay Press (1989): 34-51.

Rothenstein, Michael. "Look No Hands." *Arts and Artists* 12 (March 1967): 13.

Rublowsky, John. *Pop Art*. New York: Basic Books, 1965.

Saarinen, Aline B. "Explosion of Pop Art: Exhibition at the Guggenheim Museum." *Vogue* 141 (April 15, 1963): 86-87.

Scott, Zachary. "New Talent U.S.A.—Prints and Drawings." *Art in America* 50 (Winter 1962): 40-43

Seckler, Dorothy Gees. "Folklore of the Banal." *Art in America* 50 (Winter 1962): 60.

Sheppard, Eugenia. "When Pop Fizzles." *The Sunday Herald Tribune,* 10 January 1965.

Smith,Patrick S. *Andy Warhol's Art and Films*. Ann Arbor: UMI Research Press, 1986.

Soloman, Alan. *Andy Warhol*. Boston: Institute of Contemporary Art, 1966.

Stanton, Suzy. "Warhol at Bennington." *Art Journal* 22 (Summer 1963): 237-39.

Stuckey, Charles F. "Warhol in Context" in *The Work of Andy Warhol*. Dia Art Foundation, Seattle: Bay Press (1989): 3-33.

Swenson, G. R. "The New American 'Sign Painter.'" *Art News* 61 (January 1962): 44-47, 60-62.

___. "What Is Pop Art?—Answers from 8 Painters, Part I: Jim Dine, Robert Indiana, Roy Lichtenstein, Andy Warhol." *Art News* 62 (November 1963): 24-27, 60-63.

___. "The Darker Ariel—Random Notes on Andy Warhol." *Collage* (Palermo), no.3-4 (1965): 104-106.

Taylor, Robert. "Andy Warhol Exhibit Asks Some Questions." *The Boston Sunday Herald*, 16 October 1966, sec. 3, 8.

Thorpe, Lynn Teresa. "Andy Warhol: Critical Evaluation of His Images and Books." Ph.D. diss., Cornell University, Ithaca, NY, 1980.

Tomkins, Calvin. "The Art Incarnate." *New Yorker* 56 (May 5, 1980): 114-18.

Tyler, Parker, "Andy Warhol—Exhibition at Bodley Gallery." *Art News* 55 (December 1956): 59.

Vance, Ronald. "Andy Warhol's 'Drawings for a Boy-Book'. . . ." *Artnews* 55 (March 1956): 55.

Watney, Simon. "The Warhol Effect " in *The Work of Andy Warhol*. Dia Art Foundation, Seattle: Bay Press (1989): 115-123.

INDEX

About the Editor

ALAN R. PRATT is Associate Professor of Humanities at Embry-Riddle University in Daytona Beach, Florida. He is the author of *The Dark Side: Thoughts on the Futility of Life from the Ancient Greeks to the Present* (1994) and *Black Humor: Critical Essays* (1993).

ISBN 0-313-29291-4

HARDCOVER BAR CODE